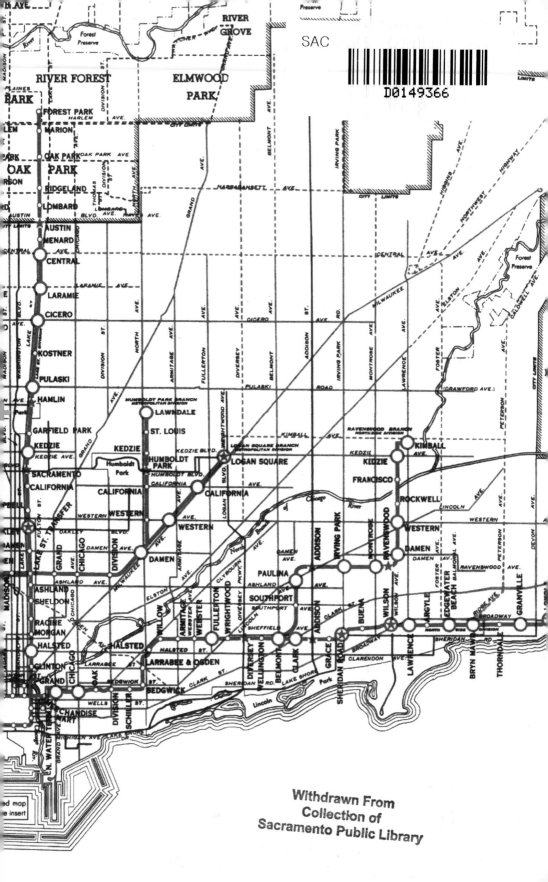

# Chicago Renaissance

# Chicago
# Renaissance

## LITERATURE AND ART
## IN THE MIDWEST METROPOLIS

## Liesl Olson

Yale

**UNIVERSITY PRESS**

New Haven and London

Published with assistance from the foundation established in memory
of Calvin Chapin of the Class of 1788, Yale College.

Yale University Press books may be purchased in quantity for educational,
business, or promotional use. For information, please e-mail sales.press@yale.edu
(US office) or sales@yaleup.co.uk (UK office).

Designed by Sonia Shannon.
Set in Electra type by Integrated Publishing Solutions.
Printed in the United States of America.

Library of Congress Control Number: 2017939706
ISBN 978-0-300-20368-4 (hardcover : alk. paper)

A catalogue record for this book is available from the British Library.

This paper meets the requirements of ANSI/NISO Z39.48-1992
(Permanence of Paper).

10 9 8 7 6 5 4 3 2 1

Endpapers: Map of the Chicago Rapid Transit System, the "Elevated," 1938.
Graham Garfield Collection, courtesy of Chicago-L.org

*To my three boys:*

TEDDY, CONOR, AND JOHN JAMES;

*born in Chicago*

# CONTENTS

# ILLUSTRATIONS

I wrote this book because I was surprised that it had not already been written. When I moved to Chicago in the fall of 2005, I knew embarrassingly little about the literature associated with the city. I had spent more than a decade on the coasts—in California for college and in New York for graduate school. But I was raised for most of my childhood in Kansas City, and I am a midwesterner at heart. Chicago was the biggest American city that I experienced as a child. It was the "tall bold slugger set vivid against the / little soft cities," in Carl Sandburg's words. Given my early memories of Chicago—from my first ride in a fast-moving taxi to the dizzying view atop the Sears Tower—I felt, as a literary scholar, that I should at least know something about how Chicago's writers represented the experience of their metropolis. At the University of Chicago, I had been hired to teach courses that were the offshoot of Mortimer Adler's Great Books curriculum, founded in the mid-1930s, even though my field is transatlantic modernism. I later learned how the formation of this curriculum occurred at a moment when the university was turning away from more specialized degrees in favor of a liberal arts education: but modernism, still so new, was kept at the fringes. I was in search of a book that would give me a sense of Chicago's relation to the social and aesthetic revolutions of the first decades of the twentieth century. How, for instance, was Sandburg—whose work I had barely encountered before moving to Chicago—part of the modernist movement?

It took me several years before I realized more precisely just what I wanted from this book, and by that point I was trying to write it. First, I wanted a book that would consider the significance of the women who helped to build the cultural infrastructure of Chicago. Working in the enormous archives of *Poetry* magazine at the Regenstein Library—where I would sometimes take my students—I was absorbed by the correspondence of Chicagoan Harriet Monroe, who founded *Poetry* in 1912. Monroe surrounded herself with a cohort of young editors, mostly women, who published some of the most important po-

etry of the twentieth century. These well-educated women lived at a time when they might hope that their lives could be as important as men's, but they still experienced significant barriers to sustained professional work and to literary recognition. It became clear to me that Chicago's "midwives of modernism" were especially interesting, numerous, and effective in driving the movement forward—perhaps even more so than in other cities—and that they deserved serious attention.

Second, I wanted a book that would connect Chicago's early literary renaissance from the 1890s through the 1920s to the period of African American cultural ferment in Chicago beginning in the late 1920s through the Second World War. Why were these periods treated in isolation? Wasn't this a problem of working in isolated academic disciplines? In the past decade a burst of attention has been paid to what is now known as the Chicago Black Renaissance, which has altered our very concept of the geographic centers and cultural engines of African American literature. But what happens if we treat the literature of black Chicago as part of—not separate from—the larger narrative of the city, and of the nation? To my mind, the Chicago Black Renaissance fundamentally alters our conception of *American* literary history. We see, for instance, how and why black writers in Chicago were compelled by a primary function of the novel— that is, storytelling—but also by an aesthetic impulse to experiment with form and style. We understand competing pulls within literary modernism itself.

This book is as much an arrival for me as it is a departure. Chicago modernism is a multidimensional subject that has allowed me to synthesize a range of disciplines beyond the literary. But in unexpected ways, I am still thinking about some of my long-standing fascinations, including modernism's engagement with the formal and theoretical dimensions of everyday life, *la vie quotidienne*: those daily routines that are so familiar as to be undifferentiated, one day to the next. French theorists of the everyday have long held that the everyday is the special province of women, who are so embodied in the everyday (cooking, cleaning, childrearing) that they are not aware of the everyday's social and political dimensions, or its revolutionary potential. The problem with this idea, of course, is that it is possible to be entrenched in the everyday and simultaneously mindful of how it can be transformed. This doubleness always seemed palpable to me in my own life but became even more strikingly apparent during the research for this book, which required extensive work in literary and historical archives. I spent countless hours reading material that documented the everyday workings of a dynamic and diverse literary culture in Chicago. I read personal

diaries, daily correspondence, telegrams, photographs, shipping receipts, guest books, and boxes of ephemera. I wanted to learn, among many things, why writers came to Chicago, where they met, what they were reading, by what means they worked, and how they crossed complicated racial boundaries. Out of all of this material—some of it riveting, most of it dull—a picture began to emerge of how modernism was made in Chicago and where the "big ideas" came from. To put it another way, my plunge into archival research, which Chicago modernism seemed to demand, allowed me to see the crucial utility of the day-to-day activities that grounded the bold convictions and artistic experiments of the period.

This book sets forth a series of interlocking stories that illuminate ideas that catalyzed modernist literary development, from the young bohemians of the 1910s to the artistic cohorts funded by the Works Progress Administration. My claim is that Chicago was an extremely important site of modernist literary production through the first half of the twentieth century, at the center of an unfolding dialogue among writers, critics, institutions, and artists about what it means to be modern. A city of arrivers from all backgrounds, a crossroads and nexus, and a place of endless possibility, Chicago was constantly negotiating the experience of the new. For much of its history the "second city," Chicago was often overlooked or patronized by an East Coast literary establishment. But because Chicago lacked the rich cultural history of Europe and even America's eastern cities, Chicago redounded favorably to writers and artists who wished to work outside the supervisory eye of critics. This freedom meant that Chicago modernism became more expansive and varied than in other places. A twentieth-century Chicago Style was never just one thing.

At the heart of the book is a devotion to the language and form of works of art. If Chicago broadly recalibrates our understanding of literary modernism, then I also hope that this book offers a fundamental rethinking of poems and novels. Famous works in the modernist canon—Ezra Pound's "In a Station of the Metro," Ernest Hemingway's *The Sun Also Rises*—look very different when cast in a Chicago light. On the other hand, I treat Sherwood Anderson's finely wrought collection of stories, *Winesburg, Ohio*, as much more than an expression of midwestern regionalism. I recover other works that may be unfamiliar, like Era Bell Thompson's *American Daughter*, for the purposes of illuminating central issues for many Chicago writers, especially the question of how to reach a wide audience. Like the twinned disciplines of history and literature, there are two (often competing) assumptions at play: that a writer—influenced by time

and place, aided by other people—is never the sole maker of his or her work; and that a great poem or novel is an act of the individual imagination, which seems to speak beyond its moment.

Between the chapters are creative interludes, vignettes of highly situated historical moments in which I imagine a crux, a personal revelation, an episode not fully treated elsewhere. Together, these parts make a heterodox book—both story and argument, both history and literary interpretation. Why switch back and forth between these modes? On some level, I am performing an ekphrasis, that is, I am enacting the very thing that I am trying to describe. Which is to say, there is a largeness and heterogeneity to Chicago modernism, a crisscrossing of forms and styles. In my research, I felt a strong obligation to the nuance and substance of the historical material. Much of it was new to me, and I suspected that it would be new to others. For instance, who would guess how strangely vital Gertrude Stein was to the literary life of Chicago? This was a discovery. To explore the ideas that she put forth in her Chicago lectures, which were influenced by her visits to the city, I needed to recount how she even got to the point of delivering them.

My effort to illuminate the granular particularity of modernism in Chicago may seem perversely rooted in the local, at a moment in time when the study of literature is concerned with the global, the planetary, the Anthropocene. And yet, I hope to show that Chicago modernism was not a provincial phenomenon with its own peculiar energies but also international in scope. A strikingly apt image for Chicago modernism is a map with the city as a "dark blotch" of radiating train tracks, to quote Chicago writer Floyd Dell. Chicago modernism is about being in the middle, a multispoked modernism. It's not about being stuck in the middle but about the middle being a thoroughfare. Mobility was never quite as available to women—a significant caveat—though there were women like writer and editor Margaret Anderson who first fled small-town Indiana for Chicago, then onward to New York and Paris. There were many homegrown movements in Chicago—Monroe's *Poetry* was one—but there was also significant traffic in writers, artists, and intellectuals who came into the city and shaped its cosmopolitan culture. Connections between Chicago and other cities in the United States, Europe, and beyond were also built on a circulation of books, art, and periodicals. Writers in Chicago often felt the distinctiveness of the Midwest, but they hardly worked in regional isolation.

As the organizing principle of this book, Chicago in the first half of the twentieth century may appear like a place of the past or a city that seems utterly

familiar. It was not long ago when bookstores were central to literary culture, but it does seem startling that the *Chicago Tribune*'s longtime literary editor Fanny Butcher could simultaneously run a bookstore from 1919 to 1927 while she worked full-time for a daily newspaper. If this was an era with more overlap between literary and commercial spheres—or a city in which those lines were more fluid—then Chicago (especially its newspapers) would often promote this alliance as a civic good. But Chicago writers also decried the materialism of the age, and the processes of modernization that seemed to sweep up art and literature into something sellable. This conflict has not gone away. The question of art's function was heightened by the stylistic experiments of modernism, which still shapes our current literary environment and which presented forms of literary representation that are often difficult, oppositional, scandalous, or opaque. To be sure, there were writers in Chicago whose work was directed at a small coterie of like-minded radicals. But if there is a dominant aesthetic mode to Chicago modernism, then it is defined by a desire to reach mainstream readers, readers in the middle. Without sacrificing intellectual or aesthetic integrity, Chicago authors wanted a clear truck with audience. As a writer, this has also been my aim.

# Chicago Renaissance

# Introduction

T he twentieth century arrived like a long train steaming into Chi-
cago. "Signs were everywhere numerous," writes Theodore Drei-
ser through the eyes of his heroine Carrie. Eager and fearful,
Carrie looks out the window, her small town receding: "Trains
flashed by them. Across wide stretches of flat, open prairie they
could see lines of telegraph poles stalking across the fields toward the great city."
The first major novel set in urban America, *Sister Carrie* (1900) is a turn-of-the-
century seduction story, and the seducer is Chicago:

> To the child, the genius with imagination, or the wholly untravelled, the
> approach to a great city for the first time is a wonderful thing. Particularly
> if it be evening—that mystic period between the glare and gloom of the
> world when life is changing from one sphere or condition to another.[1]

Several decades later, arrivals into Chicago were less likely to be the de-
scendants of European immigrants and more the successors of slaves. Fleeing
sharecropping and lynch mobs, African Americans dreamt of jobs, not seduc-
tion, especially in the city's stockyards, steel mills, and railroads. They came in
droves, choosing snow over cotton.[2] From Mississippi, a young Richard Wright
traveled to Chicago on the Illinois Central, a turning point in his life as he de-
scribes it in his autobiography:

> My first glimpse of the flat black stretches of Chicago depressed and
> dismayed me, mocked all my fantasies. Chicago seemed an unreal city

1

whose mythical houses were built of slabs of black coal wreathed in palls of grey smoke, houses whose foundations were sinking slowly into the dank prairie. Flashes of steam showed intermittently on the wide horizon, gleaming translucently in the winter sun. The din of the city entered my consciousness, entered to remain for years to come. It was 1927.[3]

Where Dreiser's naive Carrie discovers material, erotic, and artistic glamour, Wright finds Dante's Hell, urban blight that deflates his dreams of a Promised Land. But both experience the "din of the city" as a powerful stimulus, a call to change. Chicago marks the transition from "one sphere or condition to another." From small town to great city, farmwork to industry, childhood to maturity, innocence to experience—the journey to Chicago is a break with the past, filled with both wonder and disillusionment. No better description marks the idea of an American character: an attraction to mobility, both literal and philosophical. From Ralph Waldo Emerson's *Self-Reliance* (1841): "Power ceases in the instant of repose; it resides in the moment of transition from a past to a new state, in the shooting of the gulf, in the darting to an aim."[4] Emerson's American optimism lurks beneath Chicago's oratory mode, its frequent and bright boosterism—a local expression of manifest destiny.[5]

What does it mean to be modern? And how was Chicago important to the cultural expression of American modernity? The historical contours of modernization include processes that happened with extreme rapidity in Chicago, from the rise of industrial capitalism to the experience of mechanization in the realm of everyday life. No American city grew so fast. Where the winding Chicago River flows into the southwestern shores of Lake Michigan, Chicago was a swampy marshland in the mid-nineteenth century that was then the greatest game market in the world. It pushed outward like a centrifuge. Even the river was mechanically reversed in 1900, carrying downstate the pollutants of industrial growth. By the turn of the twentieth century, Chicago was an urban transportation center characterized by stench and height, its stockyards and its skyscrapers.[6]

The Indians liked to say that "the first white man in Chicago was a Negro," Arna Bontemps and Jack Conroy claim in their 1945 history of African American migration, *They Seek a City*.[7] The arrival in the 1780s of Haitian-born Jean Baptiste Pointe Du Sable marks a moment of transformation upon land that the

Potawatomi Indians used for centuries as portage. Speculators from the Northeast and consecutive waves of European immigrants followed. Incorporated in 1833 with just 350 inhabitants, the city's population rapidly swelled. The Illinois Michigan Canal, completed in 1848, connected the Great Lakes to the Mississippi River and created a water opening to the Southwest, boosting Chicago's expansion. Trains soon supplanted boats and barges: by the 1880s, more lines of train track fanned in and out from Chicago than from any other American city (fig. 1).[8] Chicago's growth quickly outstripped that of other American boomtowns—Saint Louis, Cincinnati, San Francisco—to become the exemplary gateway city. Between 1870 and 1900, Chicago's population quintupled from about 300,000 to more than 1.5 million inhabitants.

The glitch in Chicago's growth was also its moment to think bigger. ("Make no small plans," Chicago architect Daniel Burnham supposedly said.) The Great Fire of 1871—during which most of the city burned, three hundred people died, and a third of the city's population was left homeless—was followed by national depression from 1873 to 1878, which might have finished the city for good. But Chicagoans, with the help of East Coast investors, dramatically expanded and rebuilt their city. Boosters evoked a spirit of will and possibility, adopting the phoenix as the city's symbol and believing in the *Chicago Tribune's* all-caps exclamation the day after the fire: "CHICAGO MUST RISE AGAIN!"[9] It did. In 1893, Chicago hosted the World's Columbian Exposition, officially marking the four hundredth anniversary of Columbus's voyage to the New World. It was the best-publicized nonmilitary event of the nineteenth century.[10] Nearly twenty-seven million visitors over six months passed through Burnham's White City, a beaux-arts wonder: enormous buildings in exteriors of white plaster—dedicated to such subjects as electricity, transportation, and machinery—gracefully linked by canals and lagoons (fig. 2). At night, electric lamps illuminated shimmering waterways and columns. Just outside the fairgrounds stretched the Midway Plaisance, a pleasure ground of popular amusements, from carnival rides to John Philip Sousa's marching bands to belly dancers. "The lady who could make an apple bound and bounce about by the movements of her abdomen especially delighted me," remembered writer and photographer Carl Van Vechten, who at age thirteen visited the fair with his family from Cedar Rapids, Iowa.[11] Farther beyond lay a city of gray soot and poverty, utility deprived of an aesthetic plan. Still, the fair was a proud proclamation of a city seemingly restored. Chicago was by then the second largest American city, a status it held for the next century.

*Fig. 1. Rand McNally train map of Chicago, 1898, detail. Library of Congress, Geography and Map Division*

Historian Henry Adams—a Boston Brahmin who believed that he was best suited for the eighteenth century—reasoned that the Chicago World's Fair was symbolic of a new era organized around industrial power. Sitting at the foot of a giant dynamo engine in Machinery Hall, Adams felt obsolete. "Chicago," wrote Adams, "asked in 1893 for the first time the question whether the American people knew where they were driving."[12] Van Vechten, by contrast, fell in love with

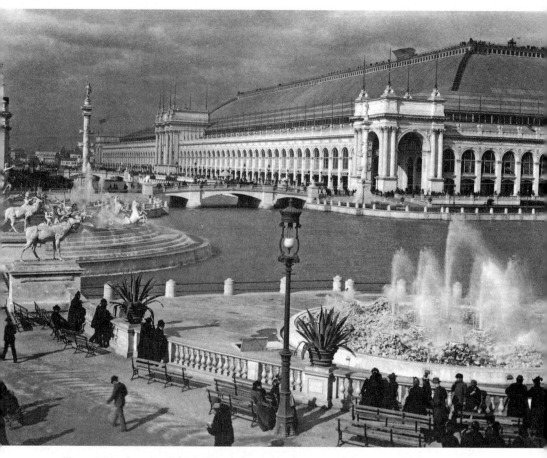

Fig. 2. *Manufactures and Liberal Arts Building, World's Columbian Exposition, 1893.*
*Courtesy Chicago History Museum, ICHi-61710*

the fair's dueling discourses of modernity: highbrow beauty and popular plea-
sure, the White City and the Midway Plaisance. A twentieth-century tastemaker,
Van Vechten would become a man of the times, an advocate of the Armory Show,
the Harlem Renaissance, and the works of Gertrude Stein.[13] He would join Stein
on her first airplane flight—to Chicago—in 1934. And for the homegrown poet
Harriet Monroe, the fair was probably the most significant event in her life. Few
people would later read the long poem that she wrote for the dedication of the
fair's buildings—*The Columbian Ode*—but the fair planted a seed to establish
poetry as a civic institution in her city on par with other arts.

Was the rise of Chicago inevitable? How did it emerge from the marshland
and again from the Great Fire? Chicago sucked the life out of its surrounding

hinterland to become a place of constant renewal and transformation. Chicago was where one thing—nature—changes into something else—capital.[14] At the edge of the frontier, Chicago drew into its economic orbit the vast resources of the region to its west: grain, lumber, cattle, and hogs. With the creation of grain elevators, lumber mills, and meatpacking plants, these natural materials became tradable commodities, which the city's rail and water networks carried to cities across America, particularly to commercial markets in the East. Case in point: by the mid-1880s almost 90 percent of the dressed beef shipped to Boston, New York, and Philadelphia came from Chicago.[15] The growth of Chicago illuminates interdependence, not contrast, between city and country, and the ecological changes brought about by capitalism. In the first half of the twentieth century, Chicago was the nexus of the nation, a crossroads, rarely an endpoint. In America, there was bound to be a city like it.

One hundred years ago and today, Chicago's flat formlessness is palpable. Vast expanses of the Midwest spread out from the city. To the east, Lake Michigan appears a startling expanse of blue and green or crested with rough whitecaps seemingly like an ocean. It is easy to get blasted by gusts coming off the water, which gather force in the wind tunnels formed by gridded streets and monolithic buildings. The wind comes down from the Dakotas; to some, it feels distinct. The city is "windy" for other reasons: boosters, corrupt politicians, political conventions. Chicago's heavily populated business district, the Loop, is circumscribed by elevated tracks, which fan out like tentacles to discrete neighborhoods, historically organized around parishes. It is not possible to walk the whole city—Chicago was never circumscribed like large parts of New York, London, or Paris. "Open" is a frequent word in descriptions of Chicago, both its physical and psychological dimensions. "There is an open and raw beauty about that city," claims Richard Wright, "that seems either to kill or endow one with the spirit of life."[16]

Chicago has inspired a fatalistic belief in the power of place, from early speculators who seized on the city's strategic geography to sociologists of the Chicago School, who explained social relations by understanding the city as an urban laboratory. It is a studied city; it is "the *known* city," according to Wright:

Perhaps more is known about it, how it is run, how it kills, how it loves, steals, helps, gives, cheats, and crushes than any other city in the world. Chicago is a new city; it grew to be bigger in one hundred years than

did Paris in two thousand. There are men now living in Chicago whose fathers saw it in its infancy and helped it to grow. Because Chicago is so young, it is possible to know it in a way that many other cities cannot be known. The stages of its complex growth are living memories.[17]

In 1945—when Wright's words were published in his introduction to St. Clair Drake and Horace Cayton's landmark book *Black Metropolis: A Study of Negro Life in a Northern City*—the Chicago School of Sociology had drawn extensive attention to Chicago, the basis for their studies of urban ecology. According to these sociologists, who extrapolated from Chicago in order to understand cities elsewhere, Chicago was the exemplary modern metropolis, governed by many of the same forces of Darwinian evolution in the natural world. Key sociological studies of the Chicago School analyzed the city's ethnic communities and neighborhoods: the Jewish immigrants of Maxwell Street, the bohemians of Towertown, the many Polish parishes, and the African American migrants arriving on the South Side.[18] If social determinism underlies the work of the Chicago School, then there is also an emphasis on how its inhabitants resourcefully responded to fluctuation, newness, and change. These studies are the flipside of Chicago's transformation of commodities into capital. They ask instead what kind of transformations Chicago had on *people*.

Fiction and poetry give us singular access and understanding into this human dimension of Chicago's history. These imaginative forms allow us to inhabit a world that may be quite different from our own. To be sure, we often turn to fiction and poetry for information about the past, for evidence of the culture in which literary works were produced. Nothing can tell us about the grim conditions in Chicago's sprawling Union stockyards, for instance, better than Upton Sinclair's *The Jungle* (1906). A muckraking journalist who conducted seven weeks of research among meatpackers in Chicago, Sinclair wrote a gut-wrenching novel that allows us to feel the hopelessness of wage slavery in the service of gruesome slaughter. The great capacity of the novel is to offer access to the lives of other people, to open up a space in which we inhabit the consciousness of others. As the Russian critic Mikhail Bakhtin puts it, "We ourselves may actually enter the novel."[19] But of course, Sinclair's novel is first and foremost a story, which Sinclair made up. Its Lithuanian immigrants are characters who never existed, and the novel's narrative structure is an aesthetic frame that real life lacks. Even a work like *The Jungle* does not match the world that it supposedly represents.

The value of the literary in Chicago should not be measured by how closely

the world of fiction resembles the actual conditions of history: that is not the impetus of literature, in Chicago or anywhere else. To put it another way, the greatest Chicago literature is not always *about* Chicago. In his two-part assessment "Chicago in Fiction" (1913), Floyd Dell, an editor at the *Chicago Evening Post* and a bellwether of twentieth-century trends, latched on to a distinction between the actual Chicago and the realm of fiction. Dell claims that the best novels about Chicago render it as a "pervasive influence—a condition and not a place." According to Dell, when novelist Frank Norris returned to his birthplace of Chicago, after many years in California, he was mesmerized by the "outside of things" and enthusiastic "over the town's being a colossus." Norris could not get over Chicago's voracity: he was an awestruck visitor. Most critics celebrated Norris's 1903 novel *The Pit*, which took its name after the Chicago Board of Trade and was published just months after the author's death at age thirty-two. Dell, on the other hand, describes *The Pit* with withering praise: "It is the best fictional guide-book to Chicago in existence."

Dell did not want a travel manual.[20] He predicted that the greatest literature of Chicago would not be bound by the contours of place: "During the next generation we may expect the novels laid in Chicago to take Chicago more for granted, and to settle down to the business of conveying whatever aspect of its life has excited the novelist to the writing-point. When there cease to be novels 'about' Chicago, then Chicago will really have its novels."[21] Chicago was a wonder of the world, a "colossus," a city emblematic of modernity from its stockyards to its trading floor. It was a compelling subject for study. But a writer, thought Dell, must be free to choose the nature of his or her work. Richard Wright had another phrase for the imaginative license that writers in Chicago must find: "the autonomy of craft."[22] For African Americans and new immigrants, this autonomy was especially hard to achieve, because it often required surmounting the constrictions of persistent poverty and systematic racism in Chicago. The imagination could be inspired but also profoundly thwarted by the difficulty of simply trying to survive. Ultimately, the exercise of artistic autonomy produced multiple aesthetic forms and a range of subjects in the work of Chicago writers. For a city that was constantly changing—in Henry Adams's words, that did not know where it was "driving"—it seems fitting that Chicago produced both a desire to describe it completely and a wild diversity of styles and subjects. Heterogeneity is the best register of the "placeness" of Chicago.

Which is not to say that Chicago literature is anything and everything. Through the first decades of the twentieth century, many artists and writers in

Chicago shared a desire to represent the city and simultaneously to rise above its raw brutality. Representing a push and pull between Chicago's economic, industrial, and racial violence and the dream of transcending these conditions became the subject of now-classic works of Chicago literature, from Sinclair's *The Jungle* to Wright's *Native Son* (1940). In Chicago, there is a strong commitment to representing the world, to literary realism as a form of mimesis through which a depiction of the city, in all of its ugliness, is the first step toward trying to reform it. This was certainly Sinclair's aim. But the genre of the novel, in particular, is also a form of fabricating a world, of fictional imagining in two distinct ways. First, a writer transforms the pressures of his or her moment and creates a work of art: this is language's alchemic power. Second, as readers, we allow ourselves to take on other points of view. Reading often means becoming someone else even as we remain ourselves—the experience of immersion in another subjectivity. In this sense, there is no better way to comprehend Chicago— both as an actual site of explosive modernity and as a diverse set of human experiences—than through the literature that the city helped to inspire.

Briefly consider three novels, which share a plot in which protagonists are uncontrollably drawn to Chicago, a godlike but godless power radiating out from its train tracks. In different ways, these novels yield insights into what it would have been like to move to Chicago from a small midwestern town at the turn of the century. But more than this, they give us the *idea* of change and allow us to feel the potential that abides in the big city. Chicago is a metaphor, a "pervasive influence—a condition and not a place"—to use Dell's phrase. As a mode of imagining a world, the literature of Chicago is in the unique position of enacting what it describes. Chicago is the very experience of transformation, of possibility.

First, Dreiser's Carrie. Her initial appearance—in which she takes a train to Chicago—is in a chapter titled "The Magnet Attracting: A Waif amid Forces."[23] If Carrie is her own free agent, then she is also irrepressibly attracted to Chicago's commercial spectacle. "She realized in a dim way how much the city held— wealth, fashion, ease—every adornment for women, and she longed for dress and beauty with a whole heart."[24] Carrie seeks a finer life through material acquisition. She allows herself to live as a kept woman, lavishly clothed and feted—a situation that was a scandal to Dreiser's readers. As for the moral complexities of her desire, material and sexual, Dreiser's narration is always brilliantly ambiguous.[25] Eventually Carrie becomes, not a great actress, but a popular one, with an uncanny gift for imitating people, for impersonation. On stage, her distinctive mark is to embody a yearning most visible in the aspirational drives of Chicago itself.

In contrast, Willa Cather's young opera singer in *The Song of the Lark* (1915), Thea Kronborg, leaves her Swedish immigrant family in rural Colorado and journeys to Chicago with spiritual purpose. Carrying with her a "secret" self, Thea looks out the train window with powerful assurance about where she is going:

> Thea was surprised that she did not feel a deeper sense of loss leaving her old life behind her. It seemed, on the contrary, as she looked out at the yellow desert speeding by, that she had left very little. Everything that was essential seemed to be right there in the car with her. She lacked nothing. She even felt more compact and confident than usual. She was all there, and something else was there, too,—in her heart, was it, under her cheek? Anyhow, it was about her somewhere, that warm sureness, that sturdy little companion with whom she shared a secret.[26]

Thea feels her freedom physically. Her body is "compact": it won't be given away. If Thea chooses a solitary ambition—leaving her parents and her many siblings behind—then Cather's language suggests that Thea is nonetheless her own companion, whose body is self-sufficient. In Chicago, Thea devotes herself to the work of making music, which is both a fulfillment of her creative imagination and a difficult disavowal of a more conventional life. Thea is nearly oblivious to Chicago's material conditions: it is a city that primarily services her musical training. She finds mystical strength in a sentimental painting of a toiling peasant woman by Jules Breton at the Art Institute of Chicago. Breton's *Song of the Lark* (1884) is the work of art after which Cather's novel is named. Thea imagines that the lone woman is some form of herself, gazing beyond the horizon, as the sun lifts to the sky. She greets the day and the future it holds.

A third sort of artist, neither Dreiser's ingenue nor Cather's sovereign spirit, is Floyd Dell's young hero Felix Fay, whose journey to Chicago is loosely based on Dell's own move from Davenport, Iowa, in 1908. Felix is the dreamy idealist of Dell's best-selling 1920 bildungsroman, *Moon-Calf*. After a series of literary and romantic failures—in which Felix explores his ideas about "free love"—Felix feels fated for Chicago. With the certainty that his small-town life can foster neither his literary ambition nor his concept of sexual equality, Felix imagines a railway map:

> He saw again in his mind's eye, as he tramped the road, a picture of the map on the wall of the railway station—the map with a picture of iron

roads from all over the Middle West centering in a dark blotch in the corner. . . .

"Chicago!" he said to himself.[27]

Chicago is both an idea "in his mind's eye" and a visual reality, where converging railroad tracks create a "dark blotch" on a wall map. For this midwestern writer, Chicago is imagined as a geographic darkland, where all "iron roads" led.

Dreiser, Cather, and Dell understood Chicago on the cusp of change: a person arriving into Chicago by the 1880s may have been a child of the nineteenth century, but he or she soon became a product of the twentieth. The unfolding consciousness of each protagonist in these novels is a prism through which to witness the transformations of modernity—particularly the pressures placed on conventional conceptions of gender and sexuality. Artistic and intellectual realization must be achieved outside the confines of bourgeois marriage. That said, *Sister Carrie*, *The Song of the Lark*, and *Moon-Calf* are rarely held up as works of art that mark a rupture with the past. Each is a starting point, a novel that looks ahead without describing what that future might look like. Which is to say: the subject matter of each novel is perhaps more radical than its aesthetic method.

Other writers during the first decades of the twentieth century were even more steadfastly genteel in demeanor, subject, and style. Chicago's small but influential periodical the *Dial* was their literary organ, a magazine that venerated established writers from England and the East. As early as 1893, Chicago writer Hamlin Garland criticized the *Dial* for being unable to "see anything this side of England and the 17th century."[28] The *Dial* was an ideal straw man for the most brazen voices of the literary avant-garde. "Make it new," of course, is the often-cited credo of American expatriate poet Ezra Pound. Pound found a vehicle for his early poetic and ideological aspirations in *Poetry*, a magazine dedicated to vers libre created by Harriet Monroe in 1912, and in the *Little Review*, a periodical of literature and art launched by Margaret Anderson in 1914. In these do-it-yourself "little magazines," literary modernism took root, offering writers artistic freedom from commercial, large-circulation publications. Pound and his admirers never entertained the idea that Chicago had a powerful impact on transatlantic modernism. But it did. And the work of these women is one reason why.

*Modernism*—the term is still brash and unstable—signifies a range of aesthetic tendencies that erupted in part as a response to transformative shifts in transpor-

tation, technology, communication, and production.[29] An art of cities, modernism spread across Europe before the First World War, especially in Paris, London, Vienna, and Berlin, and it was catalyzed by the unprecedented violence and psychic trauma that were the result of modern military technology.[30] In the wry, enigmatic words of Virginia Woolf, "On or about December 1910, human character changed."[31] Woolf's claim has been understood to mean many things, from the revolutionary power of postimpressionist art to the corrosion of Victorian certainties (religious, moral, scientific) dispensed through the works of Friedrich Nietzsche, Karl Marx, and Sigmund Freud. In America, modernism expressed itself with dramatic flair in the bohemian enclaves of New York City, especially areas of Greenwich Village and Harlem. Densely populated urban environments fundamentally altered how individuals perceived the world, whether from the vantage of a train, a factory floor, a skyscraper, or the teeming streets below. If the writers of modernism took a perspective, then it was a vision of multiplicity.

In Chicago, artists and writers were also drawn into the sweeping transformations of the first half of the twentieth century, producing work that was well informed of the most avant-garde expressions in Europe as well as the vernacular cultures of America. The very reasons that have made this city lesser known in the narratives of modernism are also what defined the nature of its art. Located in the Midwest, a region overlooked or habitually patronized by the rest of the country, Chicago was often unknown abroad. Many of the city's cultural institutions were founded around the time of the Chicago World's Fair, in the 1890s. By European standards, these new institutions could hardly set aesthetic standards. There was a freedom in Chicago; it was still just beginning.

Henry Blake Fuller, the first Chicago novelist to receive national acclaim, despised Chicago for the reason, according to him, that attracted everyone else—though he never left. In Fuller's novel *With the Procession* (1895), one character claims: "It is the only great city in the world to which all its citizens have come for the one common, avowed object of making money."[32] Perhaps. This complaint has been leveled at big cities all over the world. Centralized money making is a function of the modern metropolis. What is distinct about Chicago, as an entrepôt, is the visibility of its production of capital: by the turn of the century, the city's appearance was dramatically structured by hundreds of acres of foul-smelling stockyards, enormous grain elevators, and an extensive lumber district along the river. The city could not conceal how its money was made.

Despite—or perhaps because of—critical neglect, geographic remoteness, and the prominence of the city's industries, writers in Chicago produced works

that were vital to the emergence and expression of literary modernism. They experimented with how to register the unsettling yet often thrilling sense of transience and change. Some writers embraced the power of machines, speed, and violence or the oddity of composing on a new piece of technology, the typewriter. Other artists decried the age by emphasizing handmade craft. But perhaps more than elsewhere, modernist writers in Chicago did not completely reject older literary forms. They were not always old in Chicago. The very growth of a literary culture in Chicago coincided with the advent of modernism: its writers and artists were born into a moment of possibility.

Chicago's early burst of literary expression has long been characterized by another keyword and concept: *renaissance*. It suggests a cultural flowering under the influence of classical models, a period of literary and artistic productivity — with the uplift of the phoenix beneath it, in Chicago's case. Typically, the period from the late 1880s through the mid-1920s has been known as the Chicago Renaissance and includes such writers as Hamlin Garland, Theodore Dreiser, Henry Blake Fuller, Robert Herrick, Frank Norris, Carl Sandburg, Sherwood Anderson, and Willa Cather.[33] The word *renaissance* has also been used to describe another important period in Chicago from the 1930s through midcentury, a Chicago Black Renaissance, which vastly expanded and deepened the city's cultural life across the arts.[34] Richard Wright and Gwendolyn Brooks are the most famous writers from this moment, but they are among many others, including Frank Marshall Davis, William Attaway, Margaret Walker, Arna Bontemps, and Willard Motley. Some scholars include Langston Hughes in this group: he spent long stretches of time in Chicago, and for twenty years Hughes wrote a column in the voice of an artless alter ego for the nation's largest "race weekly," the *Chicago Defender*.[35] Hughes may be fundamentally an urban poet, but the Hughes of Bronzeville was in a different world than the Hughes of Harlem. The Chicago Black Renaissance is characterized by a distinct neighborhood and is distinguished by a desire to write for the black working classes — while yet sharing aesthetic concerns characteristic to Chicago more broadly.

That there are significant connections between the two periods of renaissance in Chicago, however, is an unusual idea.[36] And yet we lose something when we cordon off periods of literary history based on race. This is especially true in Chicago, where race has always sharply divided how people experience the city. Why replicate a system that literature often attempts to transcend? Literature's ability is to imagine possibilities, to speak out of the historical moment but also to recast and reframe it. Certainly, most Chicago writers themselves

lived segregated lives in the early twentieth century. But literature circulates where people cannot: which is to say, reading takes place across racial lines. The influence of Gertrude Stein's work on Richard Wright—and the influence of Wright's work on Stein—is one example of this cross-racial circulation.[37] Wright found Stein's work at the George Cleveland Hall Branch library in Bronzeville, soon after she visited the city in 1934. He was transformed by the rhythm of her sentences. Ten years later, Stein read Wright's work when an American GI lent it to her in Paris, and she claimed that he was the best writer in America. These two writers did eventually meet in person, in Paris after the Second World War. The time that they spent together, though, may have been less important than the aesthetic and intellectual interchange that happened when they read each other's work. To put it another way, racial divisions during the first decades of the twentieth century were not easy to transcend—certainly, not in Chicago. But literature was a realm where it could happen.

By the 1930s, interracial associations among artists and writers were not exactly common, but they were vibrant—through integrated "black and tan" music clubs, leftist political groups, and projects supported by the Works Progress Administration (WPA). Another key institution fostering collaboration across the color line—which, like the WPA's government funding, may seem unlikely—was the School of the Art Institute of Chicago, which admitted African American students as early as the 1890s.[38] Networks of friendships, institutional affiliations, and collaborations existed loosely across race and time. The poet, artist, and dancer Mark Turbyfill is one minor figure who bridged both moments of renaissance: mentored by Henry Blake Fuller, Turbyfill was beloved by *Poetry* and the *Little Review*; he trained with Chicago's doyenne of modern dance, Ruth Page, and then became the first teacher for the African American dancer Katherine Dunham in the late 1920s, when she was beginning to study anthropology at the University of Chicago. Turbyfill struggled to create a Ballet Nègre in Chicago in 1929, based on the Ballets Russes, a company from which several prominent dancers decamped to Chicago. Turbyfill failed, but Dunham succeeded over the following decades in building an all-black troupe of dancers who fused the balletic and the vernacular in astonishingly original performances (fig. 3). These forgotten connectors like Turbyfill—the people in the middle of things— allow us to see how greatness emerges out of cohorts, not out of isolation. As Dunham put it in a letter to Turbyfill, "How wonderful that in my youth I knew, was taken over by, and launched on this strange career of mine by people like you."[39]

But it is more than people, periodicals, and institutions that link Chicago's

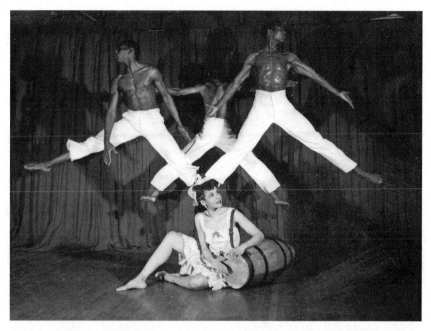

*Fig. 3. Katherine Dunham and dancers, ca. 1940–50. Courtesy Katherine Dunham Photograph Collection, Special Collections Research Center, Southern Illinois University–Carbondale*

first renaissance with its second. It is the idea of renaissance itself. Elite institutions in twentieth-century Chicago did not shake a Progressive era belief in high culture as a means of civic and moral uplift. A sense of noblesse oblige underwrote the financial backing of many of Chicago's powerful cultural institutions—the Chicago Symphony Orchestra, the Field Museum, the Art Institute of Chicago, the Newberry Library, the John Crerar Library, and the University of Chicago—which were collectively understood as a necessary antidote to the industrial utilitarianism that dominated the city's growth and identity.[40] Financier Charles L. Hutchinson, who was involved in more than seventy philanthropies and cultural organizations and served as president of the Art Institute of Chicago from 1882 to 1924, believed that art's power was to counter the most dominant tendency of the age—materialism.[41] If the quality of a society manifests in its art—an idea that Hutchinson and other philanthropists adapted from English cultural critic John Ruskin—then Chicago would ensure that its arts were supported and indeed conspicuous.

In the 1930s and 1940s, residents of Bronzeville were involved in another

form of cultural boosterism, in which art and literature could serve as a means of racial uplift. Indeed the appellation Bronzeville, coined by the neighborhood's newspapers, was itself an act of self-determination, suggesting racial achievement in the thin corridor seven miles long and one and a half miles wide, an urban slum pockmarked by violence otherwise known as the Black Belt (fig. 4).[42] Economic advancement in Bronzeville was a necessary precondition for artistic production, and an inspiration for the arts rather than something that literature needed to counteract.[43] By 1915, the neighborhood boasted a black-owned bank, hospital, and YMCA, as well as political organizations, baseball teams, newspapers, and small businesses.[44] Could literature by black writers—and *for* a black audience—follow suit?

Eventually, yes, if we remember that the Chicago Black Renaissance was a powerful precursor to the Black Arts Movement. But in 1940, soon after *Native Son* was published, Richard Wright explained that he wrote the novel explicitly for white people, that is, in order to make white people feel uncomfortable.[45] The novel's protagonist, Bigger Thomas, a murderer and rapist, also assaulted middle-class black sensibilities. Goaded by the dominant discourse of racial uplift, Wright decided that his novel would radically undermine it. "I do believe he should spend more of his time writing good clean books about Negroes," wrote one woman to the editors of *Ebony* magazine.[46] There is something incongruous about Wright's appearance in the first issue of *Ebony*, a mass-market monthly published in Chicago inspired by the spirit of advancing the race. Its editors announced: "*Ebony* will try to mirror the happier side of Negro life—the positive, everyday achievements from Harlem to Hollywood."[47] A domesticated Wright was pictured at home with his wife and young daughter.[48] *Ebony* laid claim to the literary achievements of Wright while glossing over the complex realities of black life that *Native Son* had exposed. The editors presented Wright as a model of black success.

To retain a conception of renaissance in Chicago is to remember a set of expectations for artists and writers and a public conversation about the role of art for the betterment of the city and the betterment of a race. Of course, many writers in Chicago (from Fuller to Wright) were deeply suspicious of claims about what literature could accomplish. Even Harriet Monroe, a civic booster if ever there was one, understood that literature has a less utilitarian relationship to public life in comparison to an art form like architecture, for which Chicago was internationally renowned. Buildings take physical form; they possess a function; they have a responsibility to their surrounding environment and to the people who inhabit them. Poems and novels take place in the mind. Perhaps

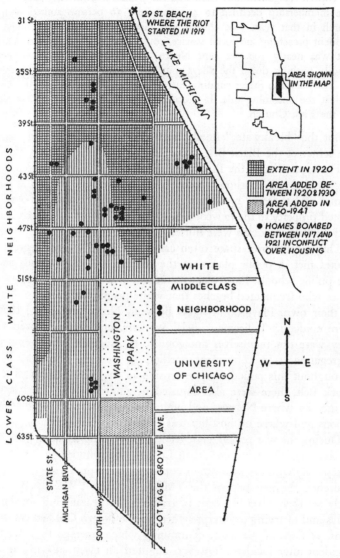

### Figure 6
# EXPANSION OF THE BLACK BELT

29 ST. BEACH
WHERE THE RIOT
STARTED IN 1919

LAKE MICHIGAN

AREA SHOWN
IN THE MAP

31 St.

35 St.

39 St.

43 St.

47 St.

51 St.

60 St.

63 St.

NEIGHBORHOODS

WHITE

LOWER CLASS

EXTENT IN 1920

AREA ADDED BE-
TWEEN 1920 & 1930

AREA ADDED IN
1940-1941

● HOMES BOMBED
BETWEEN 1917 AND
1921 IN CONFLICT
OVER HOUSING

WHITE
MIDDLE CLASS
NEIGHBORHOOD

WASHINGTON PARK

UNIVERSITY
OF CHICAGO
AREA

N
W — E
S

STATE ST.
MICHIGAN BLVD.
SOUTH PKWY.
COTTAGE GROVE AVE.

Adapted from map in *The Negro in Chicago,* Chicago Commission on
Race Relations, University of Chicago Press, 1922.

*Fig. 4. Map from Horace Cayton and St. Clair Drake,* Black Metropolis:
A Study of Negro Life in a Northern City *(1945)*

this makes literature less "big" than towering skyscrapers, but it also gives the experience of reading an untethered freedom, a geographical range. "Nothing ever happens on the printed page," claims Stuart Brent, who opened one of Chicago's most celebrated bookstores in 1946, "It happens in your head. *You* are an engaged participant. Literature alone among the arts can *never* be merely a spectator sport."[49] Literature that is participatory may seem like an idea that inspires postmodern conceptual art, but the point is that literature is uniquely dependent on a reader's expansive imagination. Novels and poems cannot be fixed to particular meanings, moral or otherwise. If during the first half of the twentieth century in Chicago, literature was still understood as a force of good, then there were also those writers who wrote in revolt.

In 1920, America's leading literary critic, H. L. Mencken, took up the case of Chicago. In a piece for the London edition of the *Nation*, Mencken explains that the search for authentic American literature leads to the stockyards:

> Find a writer who is indubitably an American in every pulse-beat, an American who has something new and peculiarly American to say and who says it in an unmistakably American way, and nine times out of ten you will find that he has some sort of connection with the gargantuan abattoir by Lake Michigan—that he was bred there, or got his start there, or passed through there in the days when he was young and tender.
>
> It is, indeed, amazing how steadily a Chicago influence shows itself when the literary ancestry and training of present-day American writers are investigated. The brand of the sugar-cured ham seems to be upon all of them.[50]

With characteristic hyperbole, Mencken claims that most American writers have had some formative experience in Chicago. "The Literary Capital of the United States," he designates the city with the title of his essay. The piece is essentially a backhanded critique of New York, which Mencken calls a "second-hand European" city, rife with cosmopolitan judgment. Acid-tongued yet safe in Baltimore, Mencken kept his distance. "The gargantuan abattoir" and "the brand of the sugar-cured ham" refer to Chicago's meatpacking operations. If American writers are a herd of cows awaiting slaughter—an attitude Mencken sometimes assumed—then almost all have been branded by Chicago.

The big question is what this brand might look like. Is there a dominant style,

or guiding aesthetic, that characterizes Chicago literature? Mencken suggests that the brand has something to do with the newness of Chicago and its money. "The town is colossally rich; it is ever-changing; it yearns for distinction," he writes. "The new-comers who pour in from the wheatlands want more than mere money; they want free play for their prairie energy; they seek more imaginative equivalent for the stupendous activity that they were bred to. It is thus a superb market for merchants of the new."[51] Arrivals into the city are like a posse of precocious originators, insisting that their literature equal the "stupendous activity" of their city. Chicago did not need to "make it new" because it *was* "the new." Perhaps it simply needed to depict itself. This is one way of thinking about modernism in Chicago: rebellion is less evident in the literary styles of Chicago because it is more palpable through the ways that writers often uphold a mirror as a means of social protest. The revolution was to speak straight.

Take a famous case to which Mencken's language alludes: Carl Sandburg's "Chicago," a poem that decries the city for its industrial brutality, corruption, and filth — in blunt language that has no truck with decorum. "Hog Butcher for the World," the poem opens, setting the city as the place where the bloodiest business gets done. "City of the Big Shoulders" is all strength, not intellect or conscience. Chicago is a list of occupations, a place of work: "Tool Maker, Stacker of Wheat, Player with Railroads and the Nation's Freight Handler." The poem was wildly controversial in 1916 when Monroe published it in *Poetry* — Sandburg himself was still unknown but for his reporting on labor and politics in the Chicago newspapers and the socialist press. Yet more than one hundred years later, these lines have become repurposed to describe almost anything related to Chicago, especially if you can sell it. The poem seems to revel in the city's reckless power, but revel it does. Once a means of critique, Sandburg's language unwittingly has become great stuff for civic and commercial boosters.

No doubt Sandburg's larger influence has been eclipsed by his high modernist peers and by the formalist standards that dominated literary criticism in midcentury America. The severe judgment of Sandburg's compatriot William Carlos Williams did not help. Reviewing Sandburg's 1951 *Complete Poems*, Williams criticizes Sandburg for breaking down language to utter "formlessness" without building it back up.[52] Sandburg's seeming lack of discipline, his undoing of poetic form, lacked coherence of thought. Williams himself was on a search for poetic structure, imagining new models to replace what he and other modernist poets had demolished. Formlessness hit close to home. It was the very risk that Williams took with his epic experiment *Paterson*, still unfin-

ished, a poem that drew on distinctly local topographies and American vernac-
ulars and included large sections of prose. Of course, there is a grain of truth
to Williams's critique, though it might be more sympathetically understood:
Sandburg wrote for the disenfranchised masses, in a plainspoken language that
people would understand. Sandburg forged an accessible modernism that was
partly informed by his leftist political impulses. He not only wanted to write
about the working classes but also wanted to be read by them.

With this intention, Sandburg had passionate followers—then and now.[53]
Consider Sherwood Anderson's 1918 "Song of Industrial America," also first
published in *Poetry*. Like Sandburg's "Chicago," Anderson's poem is powerful
for its social critique, not for its formal sophistication or its new poetic technique.
It is a poem that eerily anticipates themes of T. S. Eliot's watershed poem *The
Waste Land* (1922) but without Eliot's masterful play with voice, allusion, and
pastiche. A disembodied speaker wanders through an urban pastoral, seeking
spiritual fulfillment. Near despair, he declaims: "You know my city, Chicago
triumphant—factories and marts and the roar of machines—horrible, terrible,
ugly and brutal.'"" The city threatens the spirit and the cohesion of self and song:
"Can a singer arise and sing in this smoke and grime? Can he keep his throat
clear? Can his courage survive?"[54] These questions may have been relevant to
any artist struggling in a big city, but Chicago made them urgent: industrialism
was everywhere, visible and oppressive. In New York, capitalism was to some ex-
tent cleaner. When Wright first visited New York, in 1935, he was startled by what
he *didn't* see: "We came in along the Hudson River and I stared at the sweep of
clean-kept homes and grounds. But where was the smoke pall? The soot? Grain
elevators? Factories? Stack-pipes?"[55] It was not Chicago, where the only way to
succeed was to rise above the industrial din, creating an insistent song or "chant,"
to use Anderson's word. Often, the ease with which readers understood this song
was crucial to its purpose. To this end, the Chicago brand—or what we might call
a "Chicago style"—is not a coherent aesthetic category but rather the result of a
shared desire among writers to reach the common reader.

Journalism was a good training ground, a daily discourse of words composed
under deadline. Nearly every writer in Chicago had some experience with
newspapers. In the early twentieth century, Chicago was dominated by the *Chi-
cago Tribune*, *Sun*, and *Times* and *Daily News*, as well as the weekly *Defender*.
Neighborhood presses produced numerous smaller newspapers, weeklies, and
publications. Paradoxically, the ephemeral work of writing for the newspapers
may have been the most stable element of Chicago's literary scene, in a city where

many venues—bookstores, writing groups, galleries, salons—sometimes lasted only a few years and rarely more than a decade. Other modernist metropoles like New York, London, and Paris were also centers of journalistic culture, but Chicago's newspapers functioned as an incubator for the literary when there were not always other sites. A few Chicago writers perfected journalism as a durable art, including the turn-of-the-century columns of humorist George Ade and also Finley Peter Dunne, whose "Mr. Dooley" column dished political satire in Irish American vernacular. Perhaps the best material came from Ben Hecht, who captured Chicago's multitudinous array like a young urban flaneur —from jazz age corruption to back-alley slums—in his 1921 vignettes for the *Chicago Daily News*, published in a collection titled *A Thousand and One Afternoons in Chicago*. To put it another way, journalism was not always modernism's obvious fall guy: newspapers were not the commercial sell-out against which so-called real literary pursuits were measured.

Clear-eyed prose for a wide readership, with a touch of the journalistic: this is one trend amid the heterogeneity of Chicago's modernist styles. By the 1930s, Richard Wright theorized that the ability to fashion language for a broad audience—not just a "talented tenth" affiliated with Harlem's intellectual elite— was part of what made Chicago writing distinct.[56] But Wright hardly meant that writers should be slaves to mercantile taste. Championing the idea that a writer must maintain "the autonomy of craft," Wright also claimed a right to aesthetic sophistication.[57] His work might be as finely worked as that of the modernist writers whom he most admired, from Marcel Proust to James Joyce to Gertrude Stein. Wright experimented with the formal dimensions of language while yet, in *Native Son*, committing himself to prose that would make plain Chicago's material conditions. He wanted his readers to be shocked by the stark clarity of what they read but also to be dazzled by it. Wright's social realism, as many critics would call his style, was essentially *part of* his modernism.

To identify realism as a dominant literary mode in Chicago is certainly to take writers on their own terms.[58] It is also to understand the term as a form of praise, a sense of communal commitment to a style that they felt was distinctive to their city. In an envelope of letters that Gwendolyn Brooks saved from other writers, she appended a retrospective note to one that she received from Nelson Algren. Brooks writes: "I respected Nelson Algren as a Chicago pioneer. His realism was clear and exhaustive. He empathized with the poor and put-upon. The Algren eye was straight, sharp: compassionate but cannily assessing. So was the Algren heart."[59] Realism is thus loosely defined: "clear," "exhaustive," "straight,"

"sharp." It is a style with an ethics, a commitment to representing the poor without distorting or romanticizing their lives. Brooks could have been describing her own aesthetic sense. Longtime *Chicago Tribune* book critic Fanny Butcher praised the "unconventional, staccato" style of Brooks's only work of prose, *Maud Martha* (1953), which aimed for a directness so severe that its sentences were "verbless or subjectless." Brooks's writing "is a real shock to parse-proud prose writers," Butcher claims. "But it has an undeniable sparseness, a sharpness, and gives an effect not to be forgotten."[60] Butcher-on-Brooks is conspicuously similar to Brooks-on-Algren, though Algren and Brooks are very different kinds of writers. What is being described seems to be the relationship that a writer takes toward his or her subject and the effect of the work on a reader—not an actual literary style.

In 1941, Algren wrote to Wright, who had left in 1937, about the value of what he called "local realism." Algren cast a gimlet eye on the literary culture of New York, including editors at Harper and Brothers, who were mulling over Wright's recent work following the massive success of *Native Son*.

> It's not difficult to understand the Harper mystification at local realism, distant as they are. It would be difficult to write any other way while living in Chicago, of course. Which is why I wouldn't want to leave here so long as I have writing plans. I'd be afraid to become as mystified as Harper's—or at least encounter difficulty in achieving realism. So when you feel yourself looking at the world through the veil of sophistication common to N.Y. writers, you'd better slip back here for six months or a year to recapture the actuality of *Native Son*.[61]

More authentic, Chicago literature is not occluded by New York's "veil of sophistication," which presumably for Algren beautifies the real face of things. (Loving Chicago is "like loving a woman with a broken nose," Algren writes in *Chicago: City on the Make*.[62]) But Algren's defense of Chicago is both charming and dubious. A work of literary realism is neither more real nor closer to reality than other literary styles. Realism may itself be a mode of mystification—to use Algren's word—through which an imagined world sharpens a reader's awareness of the world in which he or she lives. The great realists of the nineteenth century often set their stories in completely fictionalized worlds: Thomas Hardy's Casterbridge, Anthony Trollope's Barchester. Realism is not just fidelity to fact.

Of course, Algren was writing a letter, not defining literary categories. The frank tone that he takes with Wright—so full of machismo—is probably the best

register of his realism, which is bound up in his idea of what it means to be a man. Men talk straight. Men are not ornate and flowery. Men get to the point. The claim to Chicago realism is also a claim to a masculine style, from Algren back through Wright, Sherwood Anderson, Ernest Hemingway, and Carl Sandburg. In his next letter to Wright, Algren agrees that to write in Chicago is to engage in some sort of prizefight: "Everything in Chicago remains raw and bleeding, as you put it. I still have the feeling that it's a more vital place to write than in N.Y. I like it better to live in too. However, I'd like to visit your effete Babylon for a week or two next winter."[63] If New York is an "effete Babylon"—rampant with Ivy League–educated intellectuals and editors at powerful publishing houses—then Chicago is the truer, more American city. It's a familiar motif (remember Mencken), though not entirely accurate. After all, no place rivaled the University of Chicago for its love of all things highbrow and European.

But the "reality" of Chicago was a powerful idea for many writers, and an aesthetic cri de coeur to write with directness and immediacy. "Write one true sentence," Hemingway would remind himself during bouts of writer's block. "If I started to write elaborately, or like someone introducing or presenting something," Hemingway explains, "I found that I could cut that scrollwork or ornament out and throw it away and start with the first true simple declarative sentence I had written."[64] It would be going too far to say that Hemingway's famously spare prose style proves him to be a Chicago writer. But certain affinities for unadorned clarity become evident when we cast Hemingway's work in the context of other Chicago writers—especially the male writers, like Sandburg and Anderson, whom Hemingway met when he fled Oak Park in 1920 to live in Chicago. It is perhaps not surprising that Hemingway later became Algren's great champion. Or rather, Hemingway imagined himself a boxing coach, standing in the corner. Hemingway's blurb for *The Man with the Golden Arm* (1949) was never used by Doubleday, though Algren apparently stuck Hemingway's letter of congratulations to the door of his refrigerator. "This is a man writing and you should not read it if you cannot take a punch," Hemingway wrote. "Mr. Algren can hit with both hands and move around and he will kill you if you are not awfully careful."[65] The myth created by these men was that Chicago writers went for the direct hit. "You"—the reader—had to be ready for it.

Many women, then and now, wanted nothing to do with the myth of masculine creativity promulgated by some of Chicago's finest writers. The women who

were part of Chicago's modernist movement sometimes worked with men, but also around or against them. Rarely did they claim writing to be a fight for realism. The frequent invocation of "realist" and "realism" seems more obviously to be about audience than about literary aesthetics. To put it bluntly, Chicago is generally not known for breeding difficult or opaque literary forms because its writers wanted to enlist readers by speaking in a language that they would understand. This does not make Chicago less modernist in its literary inclinations, especially if we emphasize modernist literature that aimed at immediate shock. Chicago's "middlebrow" readers were a surprising gauge of what was scandalous. The term is associated with a feminized, consumerist readership — and critics have used it to describe both Monroe's ambitions for the readership of *Poetry* and Butcher's widely read book column in the *Chicago Tribune*, where Butcher worked for nearly fifty years. Simultaneously, Butcher sold modernist writing to a diverse set of readers who frequented her popular bookshop, Fanny Butcher Books, which she ran from 1919 to 1927. Yet these were not female-only places and publications. Monroe and Butcher simply made a point of including work by women — roughly equal to that by men — in what they reviewed, published, and sold.[66]

*To have great poets there must be great audiences too*, Monroe claimed in *Poetry*'s first issue, quoting Walt Whitman. The phrase often appeared on *Poetry*'s masthead or above its list of benefactors at the back.[67] It expresses the flipside to modernist autonomy: a belief that readers should share in the project of creating great poetry, indeed that they *must*. But how could the magazine promote radical stylistic experimentation and simultaneously enlarge an audience for poetry? This was Monroe's perpetual crux. She published a wide range of poetic styles in her magazine, and not all of it formally innovative. One of *Poetry*'s most popular poems — published at the end of the magazine's first year — was Joyce Kilmer's "Trees," which opens with the immensely quotable couplet: "I think that I shall never see / A poem lovely as a tree."[68] Hardly is this *stormy, husky, brawling*. But even the midwestern poets associated with *Poetry* in the magazine's early years, who were groundbreaking at the time — Sandburg, Vachel Lindsay, Edgar Lee Masters — worked in forms that were relatively clear to understand. These poets scorned ornate language, and emphasized poetry's oral qualities, which suited their work for large-scale performance.

Storytelling was often the alluring hook. Masters's popular *Spoon River Anthology* (1915) discloses a small town through more than two hundred dramatic monologues from the already dead, the epitaphs of Spoon River's cemetery.

Each poem suggests the full story of a life. Much later, *A Street in Bronzeville* (1945)—perhaps the most famous collection of poems out of Chicago—was also inspired by stories. Brooks told her New York editor that she wanted to take "some personality, or event, or idea from each of (or many of) the approximate thirty houses on a street in this vicinity."[69] Take the short, six-line poem that opens the collection, "the old-marrieds":

> But in the crowding darkness not a word did they say.
> Though the pretty-coated birds had piped so lightly all the day.
> And he had seen the lovers in the little side-streets.
> And she had heard the morning stories clogged with sweets.
> It was quite a time for loving. It was midnight. It was May.
> But in the crowding darkness not a word did they say.

The repetition of the first and last lines encircles the couple's life. They are a twosome, bound together like the rhyming couplets of the poem itself. Their shared silence may be melancholy, but they are present in the richness of the world, "clogged" with stories, singing, love. The poem itself gives voice to their wordlessness. For Richard Wright, Brooks was narrating Bronzeville, and it felt authentic: "She takes hold of reality as it is and renders it faithfully," he claimed.[70] Wright thought that Brooks should really write fiction. Her editor at Harper and Brothers did, too. The impulse to produce stories-within-poems had the effect of appealing to a wide audience, especially those who preferred to read novels.

But the formal dexterity of Brooks's work, over many volumes, eludes classification. Her second volume, *Annie Allen* (1949)—which won the Pulitzer Prize—divided readers, partly because it seemed so much more modernist than her first book. In the words of her editor, the volume was "more intellectual, more modern, at times very involved and obscure."[71] The black intellectual J. Saunders Redding publicly praised *Annie Allen* but secretly worried about the direction her work was taking: he did not want to see her "fine talents dribble away in the obscure and the too oblique."[72] Langston Hughes's young secretary thought that the index of first lines in *Annie Allen* "reads like a kind of atavistic offspring of the CANTOS." This was meant as a compliment.[73] Over time, Brooks's poetry hit many registers—a heterogeneity that is a mark of her virtuosity as a poet. Her choice to live and write in Chicago also fueled a commitment to bring poetry, even at its most difficult, to a wide range of readers. Brooks

comes out of a tradition of Chicago women devoted to promoting literature for the masses. She taught children; she sponsored poetry contests; she conducted workshops in prisons; she gave countless readings. There is hardly a more populist poet.

But not everyone in Chicago cared about audience. Margaret Anderson in the *Little Review* published many of the same poets that Monroe published—Pound, Williams, Eliot, Sherwood Anderson, Ben Hecht, Amy Lowell. Yet in contrast to Monroe, Anderson took her responsibility to readers more lightly, believing that her magazine in fact bore none at all. The epigraphs affixed on the masthead of the *Little Review* express a sense of art's existence for a coterie, not for everybody: "Read by Those Who Write the Others," and "Making No Compromise with the Public Taste" (fig. 5).[74] No doubt Anderson wanted the *Little Review* to be read by lots of people—she also accepted advertisements and financial support, including donations from the anonymous California benefactress whom Andersen wryly referred to as "nineteen millions."[75] But the magazine's readers were not her central concern. In this way, the *Little Review* embodies a more orthodox understanding of modernism's antipathy to mainstream culture, a classic high modernism that takes its stance outside the commercial marketplace. But if there is a conventional wisdom about modernism that is still worth challenging, then it is the idea that there is a distinction between high and low literary cultures. No place better dissolves this distinction than Chicago.

Margaret Anderson—a compelling, eccentric figure—challenges many ideas about modernism, not just because of the stance that the *Little Review* took toward its readers, but also because of Anderson's theory of how art gets made (fig. 6). Anderson believed that the power of personality, more than ideas or movements, was the impetus behind the most exciting writing of her time. This was likely because of Anderson's own ability to mesmerize men and women alike. While in high school, Mark Turbyfill made a pilgrimage to see Anderson in her office at the *Little Review*, located then on the eighth floor of the Fine Arts Building on South Michigan Avenue. A skyscraper of romanesque ornament, the Fine Arts Building accommodated countless artistic endeavors in Chicago, including at times all of its little magazines. (Anderson first worked at the *Dial*, where she learned "the secrets of the printing room," but she left when the magazine's editor, Francis Fisher Browne, "one day had been moved to kiss me."[76]) Standing near Anderson in her office, Turbyfill handed her his poems: "I saw her hair glowing like a Burne-Jones aureole, her eyes opening wider in sapphire astonishment at my blindness."[77] Three weeks later, he returned with more poems, one of which Anderson published. This was after an

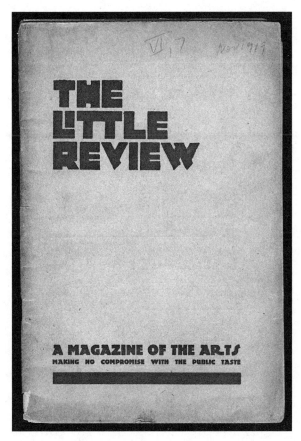

*Fig. 5. Cover of the* Little Review, *November 1919.*
*Courtesy Newberry Library*

episode of economic instability for the *Little Review*, when Anderson camped out on the shores of Lake Michigan for six months in order to save rent—a stunt that brought much attention to the magazine. Writers Ben Hecht and Maxwell Bodenheim walked miles to reach her on the beach and then pinned poems to her tent. Sherwood Anderson came out and told stories around the campfire.[78]

The *Little Review* was not meant for "the public," but Margaret Anderson was herself a very good publicist. Anderson published the September 1916 issue with mostly blank pages, which was her dramatic protest against a lack of acceptable submissions and an advertisement for more. In the first issue, she announced that the magazine was not connected with "any organization, society, company, cult or movement" but rather was "the personal enterprise of the editor." And

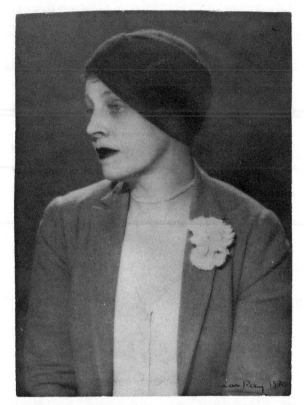

Fig. 6. Man Ray, photograph of Margaret Anderson, ca.
1930. Elizabeth Jenks Clark Collection of Margaret C.
Anderson, Yale Collection of American Literature, Beinecke
Rare Book and Manuscript Library, Copyright: © Artists
Rights Society (ARS), New York/Estate of Man Ray

yet, she wrote her editorial using the collective pronoun "we," and she was clear
about the causes in which the magazine believed: "Feminism? A clear-thinking
magazine can have only one attitude; the degree of ours is ardent!"[79] Anderson
advocated a culture of youth and rebellion, including Nietzschean philosophy
and the anarchism of Emma Goldman, who inspired Anderson with her per-
sonal flair for combining politics and art.[80] She later explained that the *Little
Review* became a forum for heated discussion, namely between her and the art-
ist Jane Heap, who became Anderson's editorial partner and lover: "The quality
of the L.R., its personality, the thing that set it apart from other magazines of its
type was its reflection of these intense conflicts between its editors."[81] On mov-

ing to Paris, Anderson might have been expected to befriend Gertrude Stein, who was also a consummate talker and personality. They apparently clashed: Stein preferred Heap.[82]

The greatest moment of publicity came in 1920, when the *Little Review* was put on trial in New York. Anderson and Heap were charged for obscenity for publishing James Joyce's *Ulysses*, which appeared in serial installments in the magazine over two years. They published more than half of the novel. Their lawyer was the art collector John Quinn—Ezra Pound's friend—who had bank-rolled the *Little Review* for many months. Quinn apparently told Anderson and Heap to remain "meek and silent" during the jam-packed trial, to surround themselves with "window trimmings"—"conservative quietly-dressed women and innocent boarding school girls." It was a bad strategy. Anderson believed that they should have been allowed to speak and that the personality of Joyce himself would have helped convince the jury that *Ulysses* was not obscene: "I nearly rose from my seat to cry out that the only issue under consideration was the kind of person James Joyce was, that the determining factor in aesthetic and moral judgment was always the personal element, that obscenity *per se* doesn't exist. But, having promised, I sat still." The *Little Review* did not win: the women were fined one hundred dollars—paid by an unnamed "lady from Chicago"—and their fingerprints were taken.[83]

It is a tricky idea: that the aesthetic character of a work of art carries within it the "personal element" of the writer. T. S. Eliot would not have agreed. A belief in the impersonality of art was essential to Eliot's poetics and was carried forth by others as a high modernist creed. Even Stein claimed in one lecture that a "masterpiece" stood on its own terms, that its meaning did not depend on the author or a reader's experience of it.[84] An alternative idea—both common and contentious—is that many people, not just a writer, contribute to the making of a literary work. Which is to say, if a writer is an individual creative force, then there are also other satellite figures through whom ideas, institutions, and move-ments are born. "For masterpieces are not singular and solitary births," Woolf claims in her 1929 manifesto, *A Room of One's Own*. "They are the outcome of many years of thinking in common, of thinking by the body of the people, so that the experience of the mass is behind the single voice."[85] Woolf's metaphors, strik-ingly, suggest childbirth and collective physical labor. A work of art is never just the product of pure intellect. Or rather, ideas themselves are born out of the body.

It is not necessary, of course, to agree with either Anderson or Woolf, but it is important to recognize the people who built the cultural infrastructure for

modernism in Chicago. This was a particular kind of labor, mostly unpaid, and largely underacknowledged. Much of it was done by women. They ran bookstores, organized galleries, launched periodicals, and hosted salons. These are people who saw possibility in Chicago and knew how to build an audience for modernism. Margaret Anderson is exemplary, and she had several precursors in Chicago to whom she looked for inspiration—Monroe, especially. And Monroe looked back to Jane Addams, the Progressive era icon of cultural uplift. When Addams and her friend Ellen Gates Starr cofounded Hull-House in 1889, located at the crossroads of Chicago's numerous immigrant communities, they put art and literature at the center of their educational programs. Several leaders at Hull-House espoused the principles of the international arts and crafts movement, offering classes in pottery, weaving, woodwork, and bookbinding. The little theater group at Hull-House performed plays by George Bernard Shaw, Henrik Ibsen, and John Galsworthy—in contrast to sensational blockbusters. Margaret Anderson named the *Little Review* after the "violent vogue" of little theaters in Chicago.[86] Hull-House attracted thousands of immigrants every week, and it also became a platform for Chicago's visitors and local artists, from Frank Lloyd Wright to W. B. Yeats to Harriet Monroe, who lived for three months at Hull-House and composed an operetta that children performed for many years.[87] Gertrude Stein also visited Hull-House during her American lecture tour, but Jane Addams—a tireless traveler—was out of town.[88]

That Chicago audiences were interested and often passionate about modernist art and literature may come as a surprise. Educating the public about modernism was a major concern for some of the city's key cultural arbiters, from Monroe to Katharine Kuh, who ran a gallery from 1935 to 1942 that exhibited the work of the European and American avant-garde and who later became a curator at the Art Institute of Chicago.[89] A photograph of Kuh's gallery taken by the Chicago-born photographer Edmund Teske shows an exhibit of paintings and sculptures by Alexander Archipenko. The "open door" of the gallery, to use Monroe's term, beckons visitors inside (fig. 7). Kuh had vocal detractors in Chicago, including a Sanity in Art group during the 1930s that sometimes stormed through her gallery—a posse of stout blue-hairs who berated the art and any customer who walked in.[90] But Kuh changed the attitude toward modern art in Chicago with her Gallery of Art Interpretation at the Art Institute, the first permanent space in a museum dedicated to visual education for adults. She brought in innovative materials—driftwood from Lake Michigan, color charts, ceramic toys—and drew unlikely comparisons between works of art across time

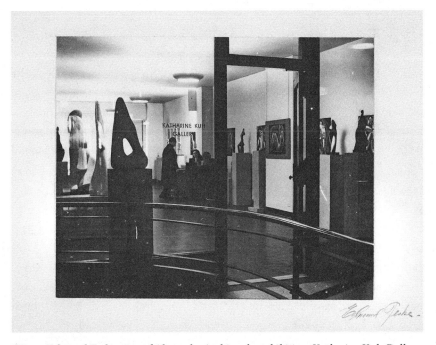

*Fig. 7. Edmund Teske, view of Alexander Archipenko exhibition, Katharine Kuh Gallery, ca. 1930s. Katharine Kuh Papers, Archives of American Art*

periods, from Persian manuscripts to modern advertising designs. Her commentary was spare: she wanted the first taste of modern art to be an unexpected experience in visual comparisons, not a reading assignment. In her droll words, she created a "sugar-coated education."[91]

Kuh did for modern art in Chicago what Monroe did for modern poetry. Which is to say: both Monroe and Kuh believed that art, no matter how experimental, needed to engage the public. Before she launched *Poetry*, Monroe wrote sharp and elegant art reviews—perhaps her finest genre—for the *Chicago Tribune* and other publications. She was one of the few voices of support in Chicago for the 1913 Armory Show, which drew double the number of visitors at the Art Institute of Chicago in comparison to New York. That the show took place in Chicago was a dramatic sign of what could happen in the city, even at the city's most established museum. (The Met in New York had turned it down.) As the Chicago press delighted in the bewilderment of viewers, the crowd's sheer size was a signal, nonetheless, of considerable interest in the radical aesthetic forms that were galvanizing art and literature. Monroe was pleased at

least by the public conversation about art. "We are discussing, even to the point of excitement, a question which has nothing to do with money, floods, reforms, clothes, or any of the usual trials and preoccupations of our little corner of the world," Monroe wrote in the *Tribune*, chastising Chicago for its more typically pragmatic concerns.[92] And yet Monroe herself was immensely practical when it came to modern poetry—including the money that must underwrite its publication. To bring modern poetry to the masses required soliciting help from people who might know very little about the form. This, strangely, was its own kind of autonomy: wealthy philanthropists in Chicago were generally more interested in painting and architecture than in modernist literature. Perhaps this made writers feel untethered from critical expectation. They could do what they wanted.

Freedom to experiment may be a state of mind, but it is also a structural position. By their nature, literary groups in Chicago did not demand the same backing as Chicago's bigger cultural institutions, and this inevitably situated them differently within Chicago's commercial sphere. Guarantors to *Poetry*— including industrialists, meatpackers, lawyers, and real estate tycoons—initially pledged fifty dollars a year for five years, which may have been a large sum for a little magazine, but was nothing like what it took to build the Auditorium Building or fund operations at the Art Institute. This is an important distinction between literature and other art forms in Chicago, especially architecture. The city's most celebrated and visible art form, architecture in Chicago has largely contributed to an understanding of the city's modernism as aligned with the forces of capitalist production.[93] The architects of modernism in Chicago, as in other cities, were also entirely male. Innovative, steel-frame construction expanded in the decades after the Great Fire, allowing for massive structures like office buildings and hotels. Daniel Burnham and John Root's twelve-story Rookery Building (1888), for instance, was used as offices, including those of the architects. Their unadorned Monadnock Building (1891), which at seventeen stories was at the time the tallest office building in the world, housed corporations, banks, and railroad companies (figs. 8, 9). Decades later, the commercial architecture of the New Bauhaus, gleaming and spare, would be replicated in lesser incarnations across the United States. For better and for worse, the legacy of Ludwig Mies van der Rohe is the ubiquitous corporate office park.[94]

Certainly, the architects of the Chicago School would always exert their com-

mercial aura on nearly every new artistic expression in Chicago. There are many examples of architecture's influence, from the metaphors of space and structure that suffuse the poetry of Mark Turbyfill to America's first jazz ballet, John Alden Carpenter's "Skyscrapers" (1926). Monroe was especially keen to architecture. One early detractor of *Poetry* magazine wrote a letter claiming that Monroe "led us to suppose she was building a cathedral" when the magazine actually bore resemblance to "a Woolworth Building." Monroe quickly responded in an editorial that derided the imitative architecture of religious structures in favor of secular, commercial spaces: "A cathedral, did I?" she proclaimed, "Modern cathedrals are second rate—mere imitations. I would rather build a first-rate skyscraper!"[95] Though the formative aesthetic of Monroe's younger years was the classical, beaux-arts design of the White City, to her mind it would have been different if her brother-in-law John Wellborn Root had lived. Monroe eventually shared with her friend Louis Sullivan—who, as an old man, looked back on the White City with blasted hopes—that the decadence of the World's Fair "set back the progress of creative American architecture."[96] Monroe also admired the idiosyncrasies of Sullivan's wayward pupil Frank Lloyd Wright, who played with styles from the buildings of the Chicago School to the Asian motifs of Phoenix Hall, one of the few structures for the World's Fair that was not built in a neoclassical style.[97] For Monroe, new buildings should not mimic the architecture of the past: the University of Chicago's English gothic buildings were unoriginal and un-American. Monroe suggested that Wright should have designed them instead.[98]

But literature, by its nature, does not have the same relationship to commercial interests as architecture. Even the bookstores of twentieth-century Chicago— where literature directly engages with the marketplace—did much more than sell books. In Chicago there were well-stocked bookstores like A. C. McClurg's, Kroch's, and Brentano's, as well as book sections in the big department stores. Smaller places like the Radical Bookstore on North Clark Street and Fanny Butcher's bookshop on South Michigan Avenue were also venues where people could browse, meet others, and hear readings and performances.[99] Under the management of Helen Udell and her two daughters—one of whom was the business manager for *Poetry*—the Radical Bookstore carried socialist and anarchist tracts alongside works by the literary avant-garde. It was one of many places in Chicago where artists and intellectuals gathered together, allied against the industrial din. These places were small and provisional: groups of like-minded writers were spread out and often daunted by the size of Chicago, which was

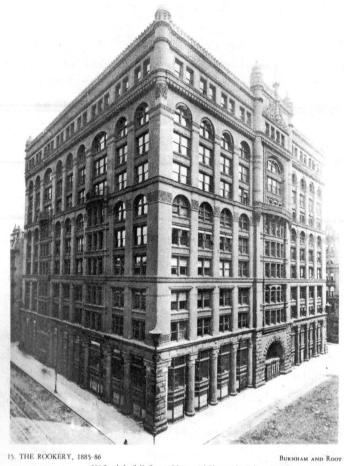

15. THE ROOKERY, 1885-86                                        BURNHAM AND ROOT
209 South La Salle Street. (*Commercial Photographic Co.*)

*Fig. 8. The Rookery Building, 1885–86. Photograph from Carl Condit,*
The Rise of the Skyscraper *(1952)*

very different than discrete neighborhoods like New York's Greenwich Village
or the Left Bank of Paris or London's Bloomsbury. There was no central lo-
cation for artists and writers in Chicago during the first half of the twentieth
century; there were many.

It is striking how often the word "little" is used to describe artistic groups in
Chicago, when little is precisely what Chicago is not. It started with the Little
Room, founded in the 1890s, an informal community that included Monroe,

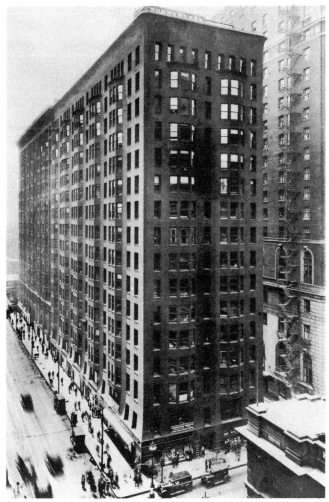

16. MONADNOCK BUILDING, 1889–91                    BURNHAM AND ROOT

The original north half, at 53 West Jackson Boulevard, remains today the final triumph of traditional masonry construction. (*Commercial Photographic Co.*)

*Fig. 9. The Monadnock Building, 1889–91. Photograph from Carl Condit,*
The Rise of the Skyscraper *(1952)*

Fuller, Hamlin Garland, and the sculptor Lorado Taft, among many others. After a concert or play in the Auditorium Building, this group would walk over to the Fine Arts Building on Michigan Avenue and gather in the tenth-floor studio of the painter Ralph Clarkson. Perhaps they would perform music or a short play—but what they really desired was an intimate place to talk. The

desire for littleness was purposefully at odds with the big business of the city in which these artists and writers found themselves. Chicago's "little theaters" and Anderson's *Little Review* similarly and self-consciously stood apart from the commercial drives of the city.

Chicago's lack of cultural traditions may also help to explain the exuberance of its many sites of cultural organizing. The astonishing number of groups founded between the 1890s and the 1920s in Chicago illuminates a desire for organized exchange—social, literary, political—in a city that had few set traditions. This desire for institution-building was visible in Bronzeville during the 1920s and the 1930s as well, which saw the establishment of the Arts Crafts Guild for visual artists and a robust movement to found the South Side Community Art Center in 1940. Black Protestant churches in Bronzeville—which were composed of many more women than men—were also exceptional places for cultural expression, where folk traditions of the rural South were transformed by the conditions of industrial modernity in the urban North. New forms of gospel music and vernacular preaching originated in the black church and migrated to entertainment clubs in and beyond Bronzeville.[100]

For the arts in Chicago, there were always informal gathering places, but there were also many active, dues-paying clubs. When Stein came to Chicago, she lectured at the Arts Club of Chicago, which was devoted to avant-garde art; the Chicago Woman's Club, which promoted reform and education as well as the arts; and the Friday Club, a more conservative literary group of women. She also lectured at the Renaissance Society, a group promoting contemporary art on the campus of the University of Chicago. Other longstanding clubs in Chicago also had a literary bent, including the Fortnightly, founded in 1873 as an intellectual venue for women, and the Cliff Dwellers, founded by Hamlin Garland in 1907 as a male-only alternative to the Little Room. The club was named after Fuller's novel, although Fuller was wary of the honor bestowed to him and refused to join. Purely social clubs, and athletic clubs, also flourished in Chicago, but the point is that there were a remarkable number devoted to a specific cultural program.

Perhaps most illustrious—or most endearingly remembered—are two sites in Chicago that were consciously countercultural: the Dill Pickle Club, and nearby Washington Square Park, also known as Bughouse Square. Outside, and across the street from the Newberry Library, Bughouse Square was Chicago's celebrated forum for free speech. At its height during the 1920s and 1930s, soapbox orators addressed crowds on a variety of topics, usually leftist in bent—feminism, socialism,

theories of labor and revolution. The questionable sanity of some of the speakers gave the park its name: *bughouse* is slang for a mental institution. But debates could be substantial, attracting well-known speakers like anarchists Lucy Parsons and Ben Reitman and poet Kenneth Rexroth. During the 1920s and 1930s, Bughouse Square might overflow in the evening with thousands of people.[101]

In this neighborhood—just blocks from the Gold Coast—literary radicals and the social elite could rub elbows nearby at the Dill Pickle. Located down a narrow alley, the Dill Pickle announced on its door: "Step High, Stoop Low, Leave Your Dignity Outside" (fig. 10). Founded in 1914 by Jack Jones, an organizer for the Industrial Workers of the World, the club presented speakers who debated modern art, free love, Marxism, and psychoanalysis, among many topics, and also staged the plays of Ibsen, Shaw, Susan Glaspell, and Eugene O'Neill. Local artist Edgar Miller often designed the club's vivid hand-crafted programs. Sherwood Anderson, a regular attendee at the Dill Pickle, claimed that it was a place where "the street car conductor sits on a bench beside the college professor, the literary critic, the earnest young wife, who hungers for culture, and the hobo."[102] The Dill Pickle's frequent masquerade balls—where cross-dressing was rife—were especially popular and fostered an underground gay culture. By the 1920s, the Dill Pickle was no longer clandestine: it was a Chicago institution, listed alongside Bughouse Square in popular guidebooks.

Seven miles south of downtown, another enclave of bookstores and salons surrounded the University of Chicago, many of them run by women. Harriet Moody, an early guarantor of *Poetry* and the widow of poet William Vaughn Moody, gave financial support and often room and board to artists, writers, and musicians who came through Chicago. In the 1890s, she launched a successful catering business that supplied gingerbread and chicken salad to the tearooms at Marshall Field's and to the Little Theatre. Later in 1920, she established Sunday night poetry readings at her restaurant, Le Petit Gourmet, on the north side. Hyde Park was also known for the salon of Elinor Castle Nef, the wife of a prominent economic historian, and Gertrude Abercrombie's less conventional, jazz-infused parties, which brought together artists, writers, and musicians—from Thornton Wilder to Charlie Parker and Dizzy Gillespie.[103] In large part because of Elinor Nef—who knew Virginia Woolf and Vanessa Bell—the work of Bloomsbury writers and artists was esteemed among intellectual circles in Chicago almost immediately.[104] After a 1937 trip to London, when the Nefs visited Bell in her studio, Elinor Nef apologized to Woolf with a characteristically apt observation: "I've had no time. *There seems to be no more time in London*

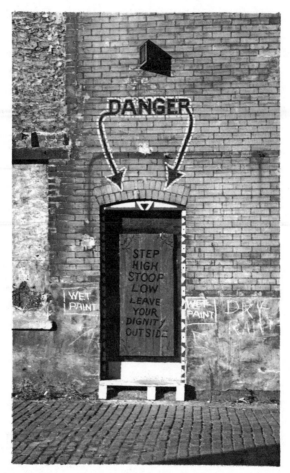

Fig. 10. The Dill Pickle entrance, ca. 1930. Dill Pickle
Papers, Courtesy Newberry Library

*than in Chicago.*"[105] Nef then invited Woolf to speak at the Renaissance Society, and she carted back a painting by Bell, which would later be exhibited there.[106] (Woolf was not as endeared to the Nefs as they were of her: she complained to T. S. Eliot about time taken up by "your compatriots—quondam I suppose you call them," the "Nefs of Chicago."[107]) The sensation that there was "no more time" in London than in Chicago reflects the pace of modern life, structured by the bells of Big Ben or the regulated roar of Chicago's trains. But however similar these cities may have felt—in that they were, first and foremost, *cities*—the extraordinary newness of Chicago was an important difference in comparison to European and even East Coast capitals.

Why did newness matter? Most importantly, it gave artists and writers a sense of liberation. Chicago was a city that was not defined by the richness of its literary past. Chicago was a place of self-creation; anything might happen. You could form your own club and like-minded people might come. The club might not last, but no one was looking over your shoulder and few were demanding that you make art that paid homage to earlier literary forms. The many cohorts in Chicago and the heterogeneity of its literature during the first half of the twentieth century can be explained, in part, by the fact that little was at stake in laying claim to your own literary endeavor. Certainly the city's cultural institutions played an important role in advocating the arts. But cultural boosterism often lacks discrimination; it yells "art!" and wants to support it. This can be immensely frustrating for artists and writers or it can be a climate in which you feel uniquely free.

Consider the significance of a train ride in reverse. Nick Carraway in *The Great Gatsby* (1925) decides to return "back West" after a debauched sequence of reckonings in New York and Long Island Sound. His train ride is a conspicuous reversal of the archetypal Chicago journey, tinged with deflated dreams rather than westward hope. Nick seeks not change but repose. He remembers returning many times home for Christmas, stopping in Chicago's "old dim Union Station at six o'clock" before changing trains:

> That's my middle-west—not the wheat or the prairies or the lost Swede towns but the thrilling, returning trains of my youth and the street lamps and sleigh bells in the frosty dark and the shadows of holly wreaths thrown by lighted windows on the snow. I am part of that, a little solemn with the feel of those long winters, a little complacent from growing up in the Carraway house in a city where dwellings are still called through decades by a family's name. I see now that this has been a story of the West.[108]

If *The Great Gatsby* is a story of the West—"Tom and Gatsby, Daisy and Jordan and I, were all Westerners," Nick realizes—then this West is no longer a frontier, but rather cities and towns of settlement and safety. For Nick, there is nowhere to go but back home, to the past. Historian Frederick Jackson Turner offered a version of the same lament, perhaps curiously, thirty years earlier at a meeting of the American Historical Association during the 1893 Chicago World's Fair. "And now, four centuries from the discovery of America, at the end of a hun-

dred years of life under the Constitution, the frontier has gone, and with its going has closed the first period of American history." Turner's "frontier thesis" claimed America's exceptionalism as fueled in part by its constant movement west, its contact with what many Americans imagined as fundamentally wild.

The power of Turner's thesis lies not in its historical accuracy—the "taming" of the frontier is a narrative of destruction, of violence upon the land and to the people who inhabited it. Rather, Turner's thesis is a kind of metaphor: of American restlessness and individualism, of national character formed by the experience of escaping, in his words, "from the bondage of the past." Indeed, the need to break with convention—the appeal of rupture—is a feature broadly characteristic to American literary history, not necessarily unique to the writings of literary modernism. Many works of American literature hinge on this theme. At the end of his adventures along the Mississippi, Huck Finn aims to "light out for the Territory": his desire is an American impulse. To begin with Puritan ministers in New England, who may seem to us now utterly beholden to a constricted religious life, is also to understand how they were a band of rebellious eccentrics fleeing England, delivering sermons of their own artful invention. Canonical American writers—Hawthorne, Poe, Emerson, Melville, Thoreau, Whitman, Dickinson, Twain, Moore, Stevens, Stein (the list goes on)—have been understood as outcast spirits, forging a new wilderness. Freaks and misfits: if America has a literary tradition, then it is paradoxically composed of writers predisposed to breaking it.

*The Great Gatsby* is chock-full of language latent with ideas about Old World tradition and the wildness of the new. At the end of the novel, though, adventure is the last thing Nick Carraway wants: he seeks a return to conduct and custom. In Fitzgerald's lyrical description of "my middle-west," Nick's train ride to Chicago's Union Station will ultimately take him and fellow travelers to cities that fan out from Chicago. He is not going to Chicago—a city of avaricious bootleggers and crime, in which Gatsby is implicated—but likely farther north to Saint Paul. Which is to suggest, the end of the frontier gave way to the rise of cities, which by the 1920s were old enough to see homes that were "called through decades by a family's name." Midwestern towns were also places of intimate and often claustrophobic social life, as Sinclair Lewis detailed in his wildly popular novel *Main Street* (1920). But convention has its attraction: Nick imagines midwestern security in Chicago's satellite cities. In contrast, Fitzgerald's generation of expatriate seekers—in particular, Hemingway and Stein—identified in surprising ways with the city at the center.

Chicago is "a tall bold slugger set vivid against the / little soft cities," Sandburg claims in "Chicago." Anderson loved Sandburg's language. Here was a poem with a little of the Wild West in it. And if Chicago always seemed untamed—"unformed," to use Anderson's word—then this is what he found liberating when he lived in the city and wrote about it. Permission to experiment, to break from the past—because the past seemed less present—is what Chicago offered artists and writers who spent time there. Yet another resonance of Richard Wright's claim to a writer's "autonomy of craft" is Chicago's freedom from New York, or rather Bronzeville's freedom from Harlem. Chicago's distance from the coasts could be intellectually liberating. Chicago's lack of tradition allowed writers freedom from the eyes of critics and competitors. Ben Hecht, for this reason, looked back on his time in Chicago with deep nostalgia: "We were all fools to have left Chicago. It was a town to play in; a town where you could stay yourself, and where the hoots of the critics couldn't frighten your style or drain your soul."[109] Critical indifference could create an environment that was paradoxically fertile.[110]

Some artists and writers, Wright and Hecht included, nonetheless wanted to move on. Mobility was an antidote to complacency. New York, Hollywood, and Paris were compelling cities of creative ferment. Europe held the special promise of freedom from America's insidious racism. But it was not always clear why people left Chicago other than that they could. Chicago was a thoroughfare, and movement was built into the fabric of the city itself. On leaving Chicago in 1917 with Jane Heap, Margaret Anderson blithely concluded: "Chicago had had all it wanted from us, we had had all that it could give." But Anderson sensed that she lost something in leaving Chicago. It was youth. She never adapted to the way that people talked in New York, which to her felt less passionate, less animated. In Paris, which also "seemed so toned down," she stood out. As she put it: "You feel too dazzling for the situation."[111] Refined and grown-up: this was not Chicago. Her first city was many things, but it was never old. Newness was Chicago's natural mode.

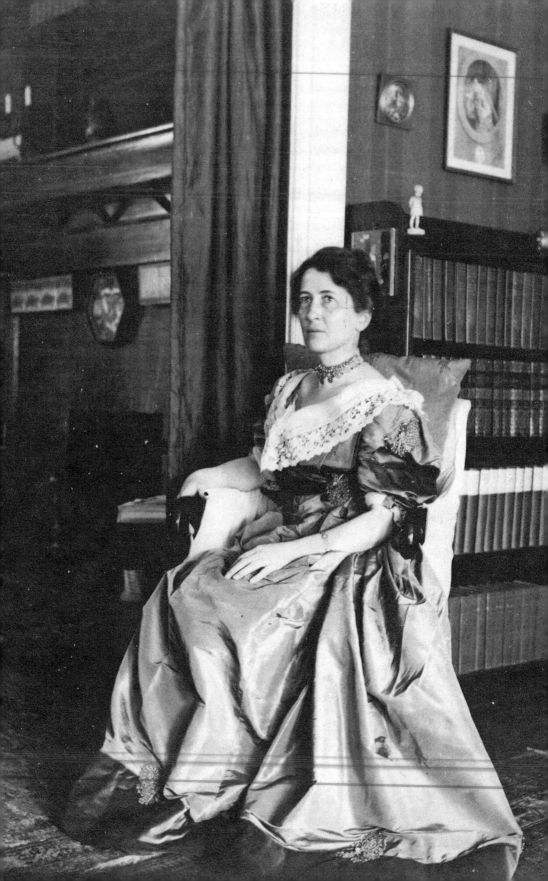

# Chicago, October 21, 1892

HARRIET MONROE AWOKE EARLY in her father's house, where darkness filled the room draped in heavy curtains. She had not been sleeping well, anxious about every detail of her dedicatory poem. *The Columbian Ode* had taken the past two years, a period marked by nervous prostration. Something unsteady lingered within her. She decided to wash and dress, maybe take out her pages and read over the selected stanzas. Like a bride, she prepared herself slowly, fixing her undergarments and fastening her stockings. She stepped into her black and white dress, a fitted bodice with a long silk train, her ceremonial clothes for the opening of the fair.

Monroe was thirty-two, and after years of struggling as a writer, this poem was finally a moment of public recognition. The New World was the *Ode*'s subject, and the rise of Chicago was its revelation. She had been determined to use no classical images in her poem and instead invoked the quasi-mythological figure of Columbia, a feminine personification of the Americas. In 2,200 lines of rhymed verse, Columbia came to Chicago, crowned not with a Greek laurel wreath but with native flowers of the American prairie. Westward expansion; the Indians were tamed or absent. As Monroe would later explain, without irony,

*Fig. 11. Harriet Monroe in her family home, ca. 1898. Harry Hansen Papers, Courtesy Newberry Library*

Columbia moved through vast virgin spaces toward the splendors and triumphs of modern civilization and an era of universal peace.

The men in charge of the fair—commissioners of the poem—had been stunned by Monroe's output. They had even been a bit unkind. Mr. Payne of the *Dial* said certain lines were *wanting in euphony*. Whole stanzas *fell below the high standard of the main poem.* Would she at least remove the fulsome tribute to her brother-in-law, John Wellborn Root? Even his architectural partner Daniel Burnham agreed. Finally, the men selected three sections for a total of ten minutes. And she was paid.

After a light breakfast—she could barely eat—Monroe and her family were on their way. Her father had secured a permit to drive through the cleared and scoured streets in which only official carriages were allowed to proceed. The day was windless and warm; flags hung high from the tops of buildings. Companies of soldiers on horseback, troops of foreign nations, and riders in dress parade galloped toward the fairgrounds in Jackson Park. She shared her nervousness with her younger sister Lucy, clutching her hand. Lucy, too, was an aspiring writer who reviewed for newspapers and the occasional magazine. Their older sister Dora Louise—Mrs. John Wellborn Root—was still in black. But their younger brother, William, whistled like a songbird soaring forth into the wide world.

They could see tall, classical columns towering without roofs and the lagoons that lay empty. Most of Burnham's buildings still stood unfinished. Autumn sun gilded the alabaster glaze of the Manufactures and Liberal Arts Building. It alone was complete, the largest covered building on earth. At forty-four acres, it tripled Saint Peter's in Rome.

The dedication ceremonies could thus proceed. Vice President Morton had taken a train into the Middle West with cabinet members and the Supreme Court justices. Delegates, clerics, and dignitaries came from around the world. Fifteen thousand invited guests would sit in reserved seats, and the main floor

held seventy-five thousand more, with ten thousand in the galleries. One of the fair's top attractions, flares of electricity illuminated the building's enormous dusty dome. Through opera or field glasses, a standing traveler could see the ascending tiers set on stage for the artists of the fair, including one seat for Harriet Monroe.

Monroe liked civic events. She liked businessmen in fancy dress, skyscrapers, and the upholstered seats in a plush Pullman train. She liked the name *Valeria.* She loved Chicago.

Theodore Thomas, director of the newly formed Chicago Symphony Orchestra, had set the selected parts of Monroe's *Ode* to music. A chorus of five thousand assembled at the south end of the building. The famous New York elocutionist Sarah Cowell Le Moyne—who stood six feet tall with a whorl of red hair—was ready to recite stanzas. Le Moyne stepped to the center pulpit. She cleared her voice and then projected as far as possible into the crowd:

> Columbia! On thy brow are dewy flowers
>> Plucked from wide prairies and from mighty hills.
> Lo! Toward this day have led the steadfast hours.
>> Now to thy hope the world its beaker fills.

Sound unfurled through the building in waves. Hundreds of people were gathered around a Mexican band dressed in scarlet and playing "Yankee Doodle" at the north end of the building. But the chorus of voices was already singing. Could anyone even hear the *Ode?* Thomas was brandishing a white handkerchief at the singers in lieu of a baton, which no one could see. He frantically waved at Monroe to signal that she should ascend the stage. Swiftly, she walked down the aisle to the stage through a modulated roar of music, words, and distant applause. She felt, strangely, as if she was traveling along a great edge. Balance and drive; she held herself in the moment and marked it.

Standing on stage, her dress trailing behind her, she was now next to the men. Mr. Burnham tendered the buildings to Mr. Higinbotham, president of the fair. Mr. Higinbotham accepted the buildings and tendered them to the National Commission. President Palmer, of that body, accepted the much-tendered buildings and tendered them in turn to the United States government. Vice President Morton accepted them and tendered them to Humanity.

The chorus sang Handel's *Hallelujah*. This song was very clear. Then Vice President Morton bequeathed laurel wreaths, one on the head of Le Moyne and the other on Harriet Monroe.

The fair would not officially open until late spring. Twenty-seven million travelers, the papers would report, fanned into Chicago to witness exhibitions and to delight in the fair's modern amusements, including the Ferris wheel, moveable sidewalks, impressionist art—and along the midway, Buffalo Bill's Wild West show, which had not been allowed inside the fairgrounds. Ida B. Wells came to the fair and distributed her pamphlet, written with abolitionist Frederick Douglass, *Reasons Why the Colored American Is Not in the World's Columbian Exposition*. Frederick Jackson Turner articulated his frontier thesis at the meeting of the American Historical Association. Without a frontier, would America prosper? Did we realize our exuberance and strength, our radical difference from Europe?

Many visitors, like Henry Adams, came multiple times. It was as deep into the American West as most had traveled, a sparkling assertion of civilization—and what it trampled—built upon the flat American prairie. "As a scenic display," Adams wrote, "Paris had never approached it, but the inconceivable scenic display consisted in its being there at all,—more surprising, as it was, than anything else on the continent, Niagara Falls, the Yellowstone Geysers, and the whole railway system thrown in, since these were all natural products in their place."

Twenty-two years old, Theodore Dreiser traveled from Saint Louis by train,

a journey during which he met a band of young Missouri schoolteachers, one of whom would become his wife. Dreiser covered the fair for the *Saint Louis Republic,* but he missed the Congress on Literature, where writer Hamlin Garland demanded that American writers forge their own local realism, leaving genteel Europe behind. Dreiser had already left. Several years later, editing *Sister Carrie*—whose heroine's first misstep is to talk to a stranger on a train— Dreiser's wife tried to preserve propriety.

After the fair, few people would ever read Harriet Monroe's *Ode.* Her poetry was caught between worlds—between the laurel wreath and the electric bulb. She would struggle as a writer for many years before conceiving a grander vision. For Monroe and for the cultivation of a distinctly American culture in Chicago, the fair was the beginning.

# Porkpackers and Poetry

### FROM CHICAGO TO CHICAGO

In May 1910—a year and a half before the first appearance of *Poetry* magazine—Harriet Monroe embarked on a solo trip around the world. For years, she had diligently saved reimbursements from her freelance reviews of art, music, and drama to purchase the $650 ticket. *FROM CHICAGO TO CHICAGO*, the ticket read. Indeed, Monroe's trip expanded her sense of what Chicago could become as much as it took her away from the city and back again. She traveled mostly by train, an experience that she associated foremost with her hometown. George Pullman of Chicago invented the sleeping car, a brilliant innovation for the kind of trip Monroe planned. Monroe was determined to visit her younger sister Lucy Calhoun in Peking, whose husband was the United States ambassador to China or, in the language of contemporary governmental affairs, "Envoy Extraordinary and Minister Plenipotentiary."[1] *Extraordinary* aptly characterizes the historical moment of Calhoun's appointment. In 1911, an imperial system more than two thousand years old would end in revolution.

Strangely, Harriet Monroe's trip, especially her three months in China, were a major reason why she launched *Poetry*, which became the most important "little magazine" of literary modernism.[2] Published each month in slight, tan-colored issues—measuring five by seven inches—*Poetry* in its early years had a small circulation, under two thousand. This was larger, however, than the circulation of many little magazines.[3] Its influence was extensive and lasting. Monroe would print poems in her magazine that enraged the newly genteel conventions of her city, challenged conceptions of gender and genre, and criticized ideas of Western progress in which she herself had once believed. Unlike other editors who published their little magazines for a few issues or a few years, Monroe never missed an issue. In the magazine's first years, Monroe selected

and edited such poems as T. S. Eliot's "Love Song of J. Alfred Prufrock," Wallace Stevens's "Sunday Morning," Carl Sandburg's "Chicago," H. D.'s "Hermes of the Ways," and Ezra Pound's early cantos. She also published important work by Robert Frost, Langston Hughes, D. H. Lawrence, Rabindranath Tagore, Marianne Moore, William Carlos Williams, W. B. Yeats, and numerous others.

This list of poems and poets—many of whom were unknown at the time—is remarkable, especially because Monroe could not write a memorable line of poetry herself. She had once been a promising poet known in Chicago for *The Columbian Ode* that she wrote for the opening ceremonies of the 1893 World's Fair. Parts of her *Ode* were set to music and sung by a chorus of five thousand conducted by Theodore Thomas, director of the newly formed Chicago Symphony Orchestra. The audience numbered nearly a hundred thousand people in the Manufactures and Liberal Arts Building in Jackson Park, then the largest covered building in the world (see fig. 2). But the style of Monroe's *Ode* was overwhelmingly faithful to classical conventions, marked by orderly end rhymes and methodical metrics. It did not endure. *The Columbian Ode* was published in special red-bound souvenir editions, but so few sold that Monroe burned stacks for winter fuel.[4]

Monroe will never be remembered as a poet. Rather, she was a woman in the middle of things: an editor, a hinge figure, and a dreamer with a pragmatic economic sense. Her around-the-world journey gave her the needed distance from Chicago in order to envision a new start for poetry and for herself. She was fifty years old when she departed, but she attended to her experiences with the clarity and excitement of a child. "Peking, the incomparable, the hoary old capital of dead and dying dynasties!" Monroe begins a chapter of her autobiography titled "The Beauty of Peking."[5]

When Monroe thought about starting a magazine, she was inspired by a guileless belief in poetry's moral and civic values. Poetry, to her mind, should have a more central role in the cultural life of Chicago, which supported institutions like the Chicago Symphony Orchestra, the Art Institute of Chicago, and the Field Museum of Natural History. She also hoped that *Poetry* would become a place for preservation and renovation, connecting English-language poets with older traditions of Asia. Monroe became fascinated by the cultures of China and Japan, as did one of Monroe's first editorial assistants at *Poetry*, the younger Chicago poet Eunice Tietjens, who herself traveled through Asia in 1914. Photographs survive of both Monroe and Tietjens, back in Chicago, donning silk kimonos (figs. 12, 13). Eva Watson-Schütze, the accomplished modernist photographer who would direct Chicago's avant-garde Renaissance Society, took the portrait

of Monroe, which appeared in *Vogue* in a photographic montage of writers and artists. Monroe looks out over her left shoulder, a gaze both wistful and stern.

Over the years, Monroe would publish the work of Chinese poets, translations of classic Chinese and Japanese poetry, and editorials about literature and culture from the Far East. Years after her trip Monroe befriended two important Chinese intellectuals—Wen Yiduo and Hu Shi—each of whom came to Chicago in the 1920s and 1930s and were then part of the Crescent Moon Society in Shanghai, a group of writers first to advocate writing in colloquial Chinese. Monroe's influence through *Poetry* would spread out from the artistic circles of the Midwest to writers around the world.

In many ways it is no surprise that *Poetry* magazine was the place where Imagism began, the Anglo-American movement in poetry associated with lyrical precision and visual immediacy and inspired by Japanese and Chinese verse. In Europe and in America, a fascination with the Orient was seizing hold of artists, from James McNeill Whistler to Frank Lloyd Wright. The exhibits of Chinese and Japanese art at the British Museum, the Museum of Fine Arts in Boston, and the Field Museum in Chicago were joined by a middlebrow obsession with touches of the Orient in domestic design: Chinese fans, embroidered carpets, mounted scrolls in parlor rooms. "I seem to be getting orient from all quarters," wrote expatriate American poet Ezra Pound about London in 1913.[6] In Chicago, Eva Watson-Schütze, inspired by Whistler's famous butterfly monogram, signed her soft-focus photographs of famous figures—from social reformer Jane Addams to visiting poet W. B. Yeats to philosopher John Dewey—with a small abstract butterfly, in homage to Asian motifs. (Watson-Schütze would also photograph the American Orientalist scholar Ernest Fenollosa and his wife, Mary.) And yet, Monroe was educated more deeply than most early twentieth-century writers and artists who dabbled in Sinophilia. Monroe's trip to China opened her eyes to how and why Chicago's cultural institutions were amassing rich collections of Oriental art. It was the spoils of revolution. *Poetry* magazine, to her mind, might cultivate cultural exchange differently.

Before arriving in Peking, Monroe made stops in many great cities with which she would compare the relatively young city of Chicago: Paris, London, Berlin, Moscow, and Saint Petersburg. Each city absorbed her interest but ultimately sharpened her identification with Chicago, which was still growing in leaps and bounds, full of possibility. In Paris she was greeted by her nephew John Wellborn Root II, studying architecture at L'École des Beaux-Arts. In London she witnessed a march of militant suffragists and heard Emmeline Pankhurst

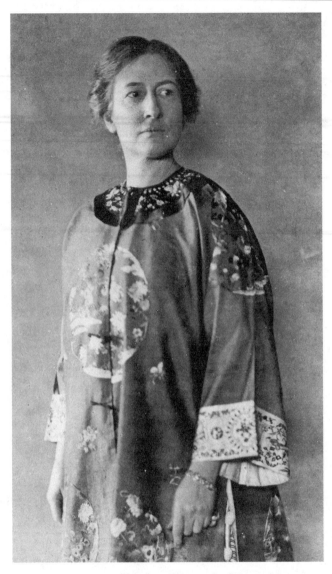

*Fig. 12. Eva Watson-Schütze, photograph of Harriet Monroe,
ca. 1911, published in* Vanity Fair, *August 1920. Courtesy Poetry
Foundation and Condé Nast*

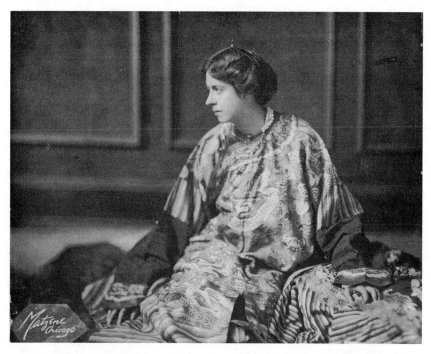

*Fig. 13. Eunice Tietjens, ca. 1914. Eunice Tietjens Papers, Courtesy Newberry Library*

speak on the steps of Saint Albert's Hall.[7] The writer and suffragist May Sinclair, who became Monroe's good friend, introduced her to Charles Elkin Mathews, the bookseller in Piccadilly who in 1907 published the poems of James Joyce, a writer who was then widely unknown. Monroe would include Joyce's work in the May 1917 and November 1917 issues of *Poetry*. Mathews recommended other works he had published: Ezra Pound's *Personae* (1909) and *Exultations* (1909), two small volumes, brown and crimson, lettered in gold. "That is real poetry!" Mathews had told her. "Virility in action," wrote the *Daily News*. "A queer little book that will irritate many readers," wrote the *Evening Standard*.[8] Monroe read Pound's work for the first time during the eleven-day journey from Moscow to Peking on the Trans-Siberian Railway.

For the rest of Monroe's life—and after—Pound tried to exert his influence. He volunteered to be *Poetry*'s "foreign correspondent" in his first letter to her from London in 1912. "I *do* see nearly everyone that matters," he wrote.[9] Pound ambitiously sought to be at the center of an avant-garde literary scene, and his powerful and peculiar stamp on modernist writing is indelible. "The Pound Era" is a conception of modernism now both reviled and still difficult to

dismiss.[10] Brilliant, ideological, and deeply flawed, Pound felt that he could best choose the poems to be published in *Poetry*. However, in terms of discovering new poets, cultivating their work, and choosing when and how their poems would appear, Monroe was more than Pound's equal. She realized that "who matters" meant more than Yeats, Eliot, and Pound, and also included poets from the Midwest, African American writers, and minor poets who wrote a few important poems. (And included the great poet Wallace Stevens, whose work she published when he was still unknown and whom Pound never acknowledged in his letters to Monroe.) In the profuse correspondence between Monroe and Pound, Pound's voice is voluble and dominant. He often takes credit for Monroe's significant achievements as editor, and he violently disagrees with her about how to cultivate an audience for poetry. Pound even commandeered Monroe's unfinished autobiography after she died unexpectedly at age seventy-six while climbing the mountains of Peru. Pound demanded from the editor and publisher of Monroe's autobiography that he add his own notes before it was published—they conceded—and from his radically self-important point of view, he altered Monroe's presentation of him.[11]

To temper Pound's voice and tell Monroe's story by drawing on a range of different historical records—and to understand her story in the context of Chicago's burgeoning cultural scene—is to breathe life into some of the most important poems of the twentieth century, including Pound's. Looking closely at Monroe's editorial role also illuminates the tenuousness of modernist experimentation rather than its entrenched status. In the middle of "major men," to use Wallace Stevens's phrase, Harriet Monroe is a figure who worked behind the scenes, who was less pretentiously modern but extremely influential upon modernist writing. Her "middleness" is as much a personal trait as it is a mark of her city. Like others whom Frederick Jackson Turner at the Chicago World's Fair first celebrated with his "frontier thesis" for escaping "the bondage of the past," Monroe could be viewed as a product of her geography, of growing up in a city more proximate than East Coast cities to American expansion.[12] For Monroe, Pound's London was only one connection within a wide network of people, places, and poems. She felt instinctively that London—the center of the British Empire and the English language—needed to see beyond its borders. In a draft of a 1914 letter to Pound, Monroe explains why she must reject his enclosure of poems. She writes (and then crosses out) an admonishing sentence that reveals her geographic vantage: "Oh little indoor England and its tiresome little adulteries!" she writes. "For the love of heaven, get out doors!"[13]

Overall, what distinguished Monroe as an editor and what could be said to make her distinctly a Chicagoan was her openness to outside influence. Chicago during Monroe's lifetime was a busy thoroughfare, a massively growing city through which many people passed. Before cities farther west grew and developed an economic and cultural pull, Chicago was the biggest American city next to New York, and distantly trailed by Philadelphia. Monroe herself was a constant traveler. Her big trips included an 1897–98 Grand Tour of Europe, many trips to the Southwest, and most importantly her 1910 adventure around the world. Her knowledge of global cultures came not only from literature but also from firsthand experience in Chicago and much further afield.

Deeply engaged in the cultural fascinations of her time and class, Monroe over the years published poems of various aesthetic affiliations. "The editors hope to keep free of entangling alliances with any single class or school," Monroe wrote in her magazine's second issue. "They desire to print the best English verse which is being written today, regardless of where, by whom, or under what theory of art it is written. Nor will the magazine promise to limit its editorial comments to one set of opinions."[14] Monroe invoked the language of Washington's 1796 farewell address in declaring *Poetry* magazine "free of entangling alliances." The language signals both an American independence, in the sense that Monroe cultivated homegrown poets, and an internationalism, in the sense that Chicago was its own arbiter, engaged with all of the world. This open-door policy attracted criticism both then and now. Some readers felt that the magazine lacked editorial vision, that its hodge-podge of literary styles did not project a clear view of what contemporary poetry might be. But Monroe's open-door policy was not a tepid statement about accepting various styles and subjects. It was Monroe's most personal and overriding editorial thumbprint, a mark of her curiosity and receptiveness to the crisscrossing modernisms that came and went through Chicago.

## LA BELLE JASMINATRICE

There is so much to be said, and a new world to say it in.
LUCY CALHOUN TO HENRY BLAKE FULLER, 1918

Lucy Calhoun was a rare link between China's dying empire and Chicago's cultural boom. What Calhoun brought to Chicago in terms of Chinese art, textiles, pottery, and design was equaled by Harriet Monroe's importation of Chinese aesthetics to American poetry. When Monroe arrived in Peking, Calhoun

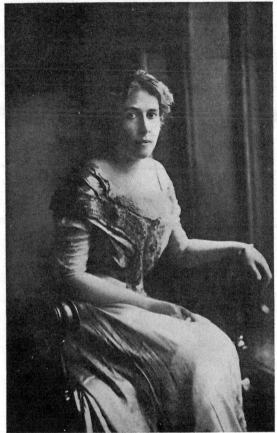

*C. E. Lemunyon, Peking*

Fig. 14. C. E. Lemunyon, photograph of Lucy Monroe
Calhoun, 1910. From Harriet Monroe, A Poet's Life (1938)

immediately introduced her sister to a high-level world of diplomats, writers,
collectors, and expatriates. Subject only to American laws, the Calhouns lived
in a neoclassical building within the Legation Quarter, a sheltered enclave south-
east of the Forbidden City. (Lucy's first letters home to Chicago refer to break-
fasts of kidney omelets and waffles presented by Chinese servants.[15]) An official
portrait taken of Lucy Calhoun in Peking reveals not a sign of her Chinese sur-
roundings. She is romantically bathed in light from an interior window (fig. 14).

William Calhoun's focus as ambassador was chiefly economic. His aim was
to deepen America's access to Chinese markets through strong financial invest-
ments. Before his appointment, Calhoun had been a prominent attorney in
Chicago who specialized in interstate commerce. He worked in the Rookery,

one of the world's earliest skyscrapers, designed by Daniel Burnham and John Wellborn Root, Lucy and Harriet Monroe's brother-in-law. William Calhoun had only brief diplomatic experience abroad, in Cuba and Venezuela. At the farewell banquet given by the Chicago Bar Association, he advocated the need to promote United States trade. But before they left, William and Lucy Calhoun both admitted to their fundamental lack of knowledge about Chinese culture, politics, and language.[16]

The life of Lucy Calhoun has attracted little attention despite her importance to Chinese-American relations and to Chicago. Before she married in 1904, Lucy Calhoun like Monroe had been a freelance art critic for a Chicago newspaper—the *Chicago Herald*, the *Tribune's* rival. She also wrote a weekly "Chicago Letter" for the New York journal the *Critic*, reporting on Chicago's cultural scene for an East Coast audience.[17] In a different capacity than her husband, Lucy Calhoun became a key figure of diplomacy during and after the couple's residence in Peking. She was a hostess. Calhoun quickly immersed herself in Chinese culture, and she became proficient in Mandarin. During gatherings at the Calhouns' legation home—which "set the fashion for dancing"—she taught Chinese officials Western dance steps and warmly welcomed delegates from around the world.[18] Calhoun also became a talented photojournalist documenting the years she spent in Peking, and she frequently contributed to American newspapers and periodicals about Chinese politics and culture.[19] After William Calhoun's death in 1916, she joined her niece Polly Root to serve at the Red Cross hospital in Neuilly, France, during the First World War. Lucy Calhoun eventually returned to Peking permanently in 1922 and established her home in an ancient temple, which became a gathering place for Americans and European scholars. Through her sister Monroe, Calhoun also formed an epistolary friendship with Wallace Stevens, to whom she sent tea, small figurines, and illustrated postcards. For a poet circumscribed by his life as an insurance attorney in Hartford, Connecticut, the gifts of "la belle jasminatrice," as Stevens called her, became an imaginative journey elsewhere.[20]

A postcard photograph that Calhoun sent to Chicago writer Henry Blake Fuller in 1928 depicts her salon, in which her visiting niece Polly Root poses. Dressed in a Western-Chinese style, Root perches on a sofa created from recycled architectural fragments, new and antique, Western and Chinese, petting a seated dog.[21] Now knowledgeable about the intricacies of Chinese art and design, Calhoun writes to Fuller on the back of the photograph: "The rug is black

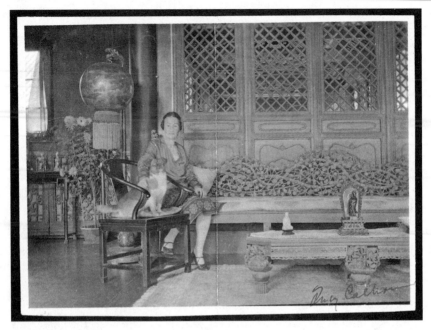

*Fig. 15. Polly Root, 1928. Henry Blake Fuller Papers, Courtesy Newberry Library*

fur, the furniture is dull gold and the walls and ceiling are full of color" (fig. 15).[22] Foreigners could own no property in China, but Calhoun leased the old temple for nearly twenty years. During this time Calhoun was Monroe's direct source of the complexities of China's political and cultural climate.

Harriet Monroe's 1910 visit to see her sister in China amplified her lifelong preoccupation with the role of public institutions in building civic culture. Chicago had been culturally reborn after the Great Fire with the elaborate staging of its World's Fair just over twenty years later, an event in which Monroe and her family played a significant role. John Wellborn Root had been Daniel Burnham's business partner in designing the classically lavish White City, which put Chicago on the international map. Root died suddenly in the winter of 1891 before his plans for the fair had been realized. Monroe lionized her brother-in-law Root in the biography she wrote of him.[23] Likely, she was in love with him. More certainly, his architectural aims inspired her advocacy for poetry as an institution that the city should also support. What she witnessed in Peking was the flipside of visionary urban creation: the unraveling of an ancient civilization. China's cultural riches, at this moment, were vulnerable to widespread destruction amid violence and political turmoil.

In 1910, China's last imperial dynasty—the Qing—was wobbling under pressure for reform from students, military, and young officials. The Qing Dynasty was composed of a confederation of Manchu tribes who had conquered and then culturally merged with their Han Chinese subjects. The Qing had most recently been under the autocratic rule of the Empress Dowager Cixi, who violently resisted challenges to imperial power. Ten years before the Calhouns arrived in Peking, Cixi with the help of conservatives had supported the Boxer Rebellion and ordered the massacre of the diplomatic community in Peking, a crisis ended by an international army, including American soldiers.[24] In 1908, as she was dying, Cixi named Pu Yi, the infant nephew of the emperor (whom she had imprisoned), heir to the throne—a scene elaborately imagined in Bernardo Bertolucci's 1987 film *The Last Emperor.* The uncertainty of China's future under the reign of this complicated court—as well as the rise of warlordism that imperial misrule inspired—induced many Manchu princes to sell their collections to American and European collectors. "I am not conscious that the Manchu princes are selling their treasures," Lucy Calhoun writes somewhat naively in 1912, "but I have been getting some lovely paintings of late."[25] For museums back in Chicago, Lucy Calhoun became a key liaison, making purchases of art and textiles for Chicago's Antiquarian Society, Art Institute, and Field Museum.

Lucy Calhoun introduced Harriet Monroe to another visitor, the art collector and railroad magnate from Detroit, Charles Lang Freer. Freer was then building a collection, in time, donated by him in trust to the Smithsonian Museum in Washington. Monroe's "very deep plunge into Chinese art" was "guided" by Freer, she wrote, to whom "impoverished mandarins [revealed] their rarest treasures."[26] The Calhouns arranged for Freer to see parts of the Forbidden City, for security escorts during Freer's travels, and for shipping of Freer's art back to the United States.[27] Freer was also a collector of the work of another American who had long lived abroad, James McNeill Whistler. Whistler titled his portraits "arrangements" and "harmonies" and signed them with a tiny butterfly tailed with a stinger. (In 1894, Whistler had painted a life-size portrait of Monroe's friend Arthur Jerome Eddy, the Chicago lawyer, art collector, and Armory Show organizer.) Neurasthenic, and by nature a solitary man, Freer said that he collected art to ease the stresses of his demanding railroad business. "What I am picking up here is worth much more to me than Pressed Steel," he had written earlier to his business partner back in Detroit, "a good name for my new findings would be pressed or compressed joy."[28]

One strange and remarkable Chinese painting that Lucy Calhoun acquired and gifted to the Art Institute is worthy of consideration in the context of her sister's editorial mediation between East and West. In 1913, when the Calhouns left Peking, Lucy Calhoun and two others from the legation secured a last-minute audience with the Empress Dowager Longyu and the child emperor Pu Yi within the walls of the Forbidden City. In a 1913 letter to her oldest sister, Dora Louise Root, Lucy Calhoun describes in vivid detail how the empress dowager sent to their carriage a tall painting of lush tree peonies, a symbol appropriate to parting, rolled within a wooden box (figs. 16, 17).[29] The short inscription on the right reads, "1911, first month, first ten-day period, a work of the imperial brush"—that is, of the emperor.[30] But in 1911 the emperor would have been five or six years old. Calhoun in her letter suggests that the hand of the painting is likely the dowager empress's—the large red seal on the painting is hers—but the uncertainty confers upon the painting a mysterious charm. The elaborate multiple mountings on the painting, the bold and shiny paintwork, and the cobalt blue cloisonné enamel rollers (not visible) also contribute to the painting's bizarre decadence, as if an expression of a dying empire.

*Tree Peonies in Full Bloom* is as much a work of art as it is a vivid souvenir, the mark of a moment between a chaotic dynasty and revolution. Lucy's dramatic farewell to the empress dowager and Pu Yi—and her long description of this departure in her letter—makes it likely that Monroe and other family members would have seen the painting when the Calhouns brought it back to Chicago. The painting is not quite "petals on a wet, black bough," famous words soon after 1911 to be associated with *Poetry* magazine. But these bright peonies nonetheless connect Monroe's China with a Chinese aesthetic that would startle and inspire the readers of her magazine.

Harriet Monroe's education in Chinese culture came not only from her sister but also from the great Sinologist and polymath Berthold Laufer. Laufer was curator of Asian anthropology at the Field Museum. Born and educated in Germany, Laufer had worked with Franz Boas in New York and then been wooed by the Field, an institution that supported his academic, deeply historical, artifact-focused research.[31] The Chinese and Tibetan halls at the Field Museum were unrivaled in the world. They were particularly notable for Laufer's discarding of Western ethnocentrism, a characteristic that did not describe other exhibits at the museum.[32] Harriet Monroe reviewed Laufer's exhibit halls for the *Tribune* in 1911 and 1912, and she noted the significance of Laufer's collecting at a pivotal moment in China's history when many collections in China,

as she knew firsthand, were at risk of destruction.[33] Railroad money from Chicago's Blackstone family funded Laufer's 1907–10 trip through China and Tibet, where he acquired approximately eight thousand items for the museum plus collections of books for the Crerar and Newberry Libraries.[34] Laufer became an adviser to the Art Institute, to Chicago collectors, to Charles Lang Freer, and to Rue Carpenter and Alice Roullier at the Arts Club of Chicago. Beginning in 1917 with an exhibit of Frank Lloyd Wright's Japanese woodblock prints—and a lecture by Wright on "the humble Japanese print" as an icon of modernity—the Arts Club's involvement with Asian art continued through the 1930s with exhibits of Chinese and Japanese porcelains, pottery, paintings, and jade.[35]

What were the reasons for this surge of orientalism in Chicago? Was it the intoxication of the exotic? The appropriation of non-Western aesthetic forms into the modern? To be sure, the exchange between cultures was neither even nor symmetrical. A significant irony is that Chicago built its collections of Asian art and culture with money from American railroads, an industry that depended on the cheap labor of Chinese immigrants. The Blackstone business was unrelated to the transcontinental railroad in the American West, where most Chinese immigrants in the 1860s were employed. But nationwide fears that Chinese workers were an economic threat to labor prompted the passing of the anti-Chinese Exclusion Act in 1882. In Chicago, widespread prejudice against the Chinese persisted even as the city's cultural institutions accumulated and showcased a particularly rich collection of Chinese art and culture. By 1922 Harriet Monroe was deeply sympathetic to the plight of Wen Yiduo, a Chinese poet who had come to Chicago to study at the Art Institute and who wrote works that expressed indignation at the inferior social and economic status of the Chinese in America. His most famous poem, "The Laundryman's Song," is about the plight of these Chinese, and it was written in Chicago.[36] Wen would become a cultural icon when he returned to China, as the first to adapt the rhythm of spoken Chinese to the meter of Chinese verse and then as a political martyr when the government assassinated him in 1946.[37]

But Monroe in her reviews of Chinese art in Chicago shows little awareness of the complexities of her city's relationship to China. She navigates a fine line between advocating preservation by Western collectors and essentially supporting cultural pillage. She notes with dismay the looting by Chinese rebels of the Peking palaces of Duanfang, a Manchu viceroy with the greatest collection of Chinese art in the world, which was to build a National Museum in Peking.[38] (He was also the only Chinese official at his level to have visited Chicago—in

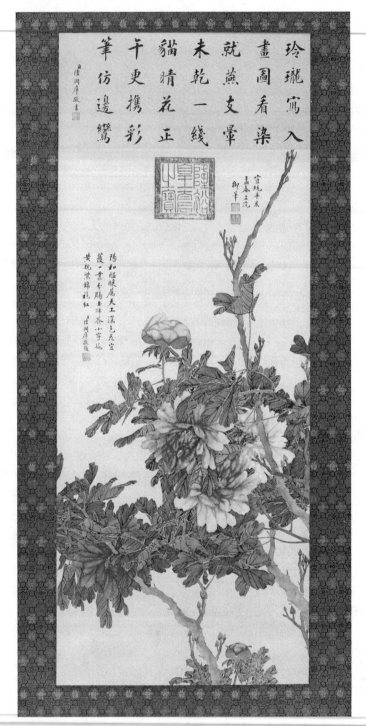

Fig. 16. Tree Peonies in Full Bloom, *hanging scroll, 1911. Ink and colors on silk, 51 9/16 × 20 1/2 in. The Art Institute of Chicago*

*Fig. 17.* Tree Peonies in Full Bloom, *scrollbox, 1911.Wood, 6 ¾ ×
35 ⅞ × 5 ¾ in. The Art Institute of Chicago*

1906—touring places like the stockyards and Hull-House.[39]) The collections
that Freer and Laufer brought back to American museums were also aided by
China's political turmoil—products of a different sort of looting only in that
money was tendered.[40]

In many ways poetry was better suited than other art forms as a medium of
cultural acquisition and exchange. "A poem cannot be exhibited and bought
and possessed by some private or public collector in the manner of a painting
or a statue," Monroe explains in her autobiography.[41] The physical mobility of
poetry distinguishes it as an art form: words on a page, lines often committed
to memory. This is a fact that Monroe at first bemoaned, as she advocated for
the value of poetry in economic terms that her new city and its businessmen
would understand. According to Monroe, poetry was not financially supported
in comparison to other arts in Chicago, a city that wanted to demonstrate its
cultural centrality as witnessed by the World's Fair, visible and grand. Archi-
tecture was understandably Chicago's tremendous accomplishment. But the
limitations of poetry as a genre also became for Monroe its great strength. Her
magazine could more easily travel; it was cheap; it could potentially garner a
large audience if Monroe could build its readers.

Furthermore, the promotion of poetry as a civic institution was at less risk of
carrying out cultural pillage than other Chicago institutions—whether this was
in China, Chinatown, Maxwell Street, or Bronzeville. Monroe sought poetry

from other countries and from her own "boiling and bubbling Chicago," as she put it, an ever-changing city shaped by an influx of immigrants and migrants.[42] *Poetry* published work from Italian immigrant Emanuel Carnevali, whom Monroe employed briefly as the magazine's associate editor in 1919, and of course from Carl Sandburg, the son of illiterate Swedish immigrants. Monroe took risks in publishing many other poets who would never become as well known, including a Syrian poet who called himself Ajan Syrian (whose work led the issue that also included Eliot's "Love Song of J. Alfred Prufrock") and a Chicago furrier originally from Lithuania named Max Michelson. In her autobiography, Monroe wonders about the obscurity of poets such as these who wrote beautiful verse, then disappeared.[43] The modernist movement thrived in variety and polyglot—hardly did every poet stand out over time, and the early decades of *Poetry* illuminate a robust exchange of cultural forms between poets who became renowned and those who did not. Certainly, poets might appropriate from other traditions in patronizing and derivative ways, but the circulation of poetic styles was free and often fruitful.

Poetry as a mobile medium also availed itself to absorb rapidly and address the international conflicts of the twentieth century, from the early revolutions in China to the unprecedented violence of the First World War. As a volunteer in France, Lucy Calhoun described this "new world" as needing a new language. Calhoun's search for expression found parallels in many of the explosive, experimental works of the twentieth century. A famous sentence from Ernest Hemingway's *Farewell to Arms* (1929)—a novel set in Italy during the war—articulates this turn away from the elaborate, genteel language of an earlier era. "I was always embarrassed by the words sacred, glorious, and sacrifice and the expression in vain," Hemingway's protagonist Sergeant Henry thinks.[44] The abstracted language of war bore little resemblance to lifeless bodies on a battlefield. What were the right words?

"There died a myriad," wrote Ezra Pound of the First World War in his 1920 poem *Hugh Selwyn Mauberly*. In this autobiographical work, Pound describes his early verse as struggling to find new forms in the wake of civilization's losses. "The age demanded an image," he writes.[45] When many Anglo-American poets looked to Eastern poetry to find directness of expression, lack of abstraction, and powerful immediacy, they were finding what they thought was a language stripped of romantic fog. Pound fully articulated this discovery of a new aesthetic in his creative 1919 edition of Ernest Fenollosa's *The Chinese Written Character as a Medium for Poetry*. Pound subtitled this work "*an ars poetica*," and described it

as "a study of the fundamentals of all aesthetics."[46] Based on the notes that Fenollosa's widow gave to Pound in the autumn of 1913, the text describes Chinese written characters—"ideograms"—as luminous, concrete particulars whose origins refer to actual things. Pictorial form, for Pound, freed language from abstraction and provided a compelling inspiration for English-language verse. After rejection from several editors, *The Chinese Written Character as a Medium for Poetry* was finally published in Margaret Anderson's *Little Review* in four installments, September through December 1919. (It was never sent to Harriet Monroe.) With two earlier publications that emerged from Pound's creative editing of Fenollosa's notebooks—a collection of poems, *Cathay* (1915), and a collection of Japanese plays, *Noh* (1916)—Pound became a powerful interlocutor between Eastern aesthetics and English-speaking writers. He is a figure much more widely known than Harriet Monroe for promoting Chinese verse. T. S. Eliot argued that Pound in *Cathay* may have been "the inventor of Chinese poetry for our time."[47] But Pound was not proficient in Chinese. Nor did he ever visit China.

## IN A STATION OF THE METRO

The air of the Orient can be felt ever so slightly in *Poetry* magazine's first issue, October 1912, through the figure of Whistler. In this issue, Monroe published two poems by Ezra Pound: "To Whistler, American" (fig. 18), and "Middle Aged." The first poem was inspired by Whistler's *Artist in His Studio* (1866), a painting that features women in Asian dress, Japanese scrolls, and blue-and-white porcelain.[48] The poem defines Whistler as a singular American, though he spent most of his life (like Pound) abroad. Many readers were offended by Pound's description of Americans as a "mass of dolts." Of course, Pound was never one to embrace the multitude. But Monroe stood by the blunt lyrics, the rough metrics, and the immediacy of Pound's vernacular. The poem speaks *to* Whistler but also to other American artists of Pound's era who felt the freedom of their country as an obligation even as they lived away from it: "for us, I mean, / Who bear the brunt of our America / And try to wrench her impulse into art." Whistler's courage to experiment and often to fail—that he "tried and pried / And stretched and tampered"—establishes him as an American in the tradition of one of the country's greatest political leaders, "Abe Lincoln." Whistler in Pound's poem becomes the emancipator of art.

A few months later, in the April 1913 issue, Monroe left indentations between

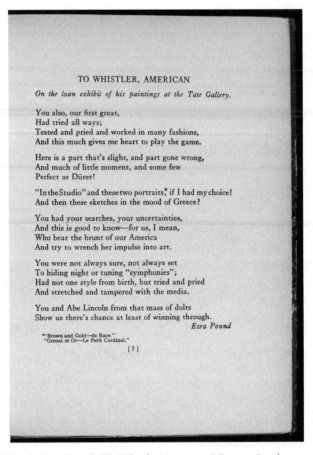

*Fig. 18. Ezra Pound, "To Whistler, American," Poetry, October 1912*

the broken phrases of a poem that would become Pound's most famous and one of the memorable poems of literary modernism (fig. 19). Pound said that it began as thirty lines describing his vision at a metro stop in Paris. Six months later he reduced the poem by half. A year later he carved the poem down to its final, haiku-like lines.[49] In the end, the poem is like a cultured Chinese pearl.

Much has been written about this iconic poem of Imagism, a movement affiliated with other poets published in *Poetry* like H. D., Richard Aldington, F. S. Flint, and Amy Lowell. The poem's lyrical precision and visual sharpness might be summed up by Pound's manifesto in the March 1913 issue of *Poetry* in which he states that an Imagist poem should represent an "emotional and intellectual complex in an instant of time."[50]

What has been overlooked about this poem is that Harriet Monroe chose it

IN A STATION OF THE METRO

The apparition    of these faces    in the crowd :
Petals    on a wet, black    bough .

*Ezra Pound*

Fig. 19. Ezra Pound, "In a Station of the Metro," Poetry, April 1913

from among many batches of poems that Pound sent to her. She included it as the last poem in a series of eleven poems by Pound that led the issue. Monroe also decided how this poem was printed on the page. These facts are key to its meanings. Consider how the poem was published later in 1916 in Pound's collection *Lustra* (fig. 20). In a 1914 version, a comma was placed after the word "petals," but Pound changed his mind in future publications and reverted to the *Lustra* version.[51] Subsequent publications of the poem—including New Directions' widely circulated 1957 *Selected Poems of Ezra Pound*—completely standardized spacing among title, words, and punctuation.

In the *Poetry* magazine version, visible at the top of the page are lines from "A Pact," Pound's poem about Walt Whitman (fig. 21). Whitman is a poet who "broke the new wood" and allowed Pound and others "a time for carving." "In a Station of the Metro" is its own island at the bottom of the page. The white space around the poem emphasizes the poem's spareness, like a slim spring branch on a Chinese scroll. Reading the poem as Monroe had it printed forces a slowness of breath. Each phrase is unhurried. The spaces between phrases in the poem contrast with the long rush of the far indented title, the rush of a train from the metro. The metro station is mechanical in contrast to what is seen in the station in fragments, "faces" as "petals."

## In a Station of the Metro

THE apparition of these faces in the crowd ;
Petals on a wet, black bough.

Fig. 20. Ezra Pound, "In a Station of the Metro," Lustra, 1916.
*By permission of New Directions Publishing Corp.*

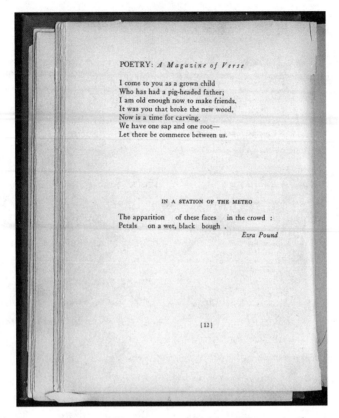

POETRY: *A Magazine of Verse*

I come to you as a grown child
Who has had a pig-headed father;
I am old enough now to make friends.
It was you that broke the new wood,
Now is a time for carving.
We have one sap and one root—
Let there be commerce between us.

IN A STATION OF THE METRO

The apparition    of these faces    in the crowd :
Petals    on a wet, black   bough .

                 *Ezra Pound*

[12]

*Fig. 21. Ezra Pound, "In a Station of the Metro," Poetry, April 1913*
*(full page)*

The visual markings of the poem—its punctuation, emphasized by spaces—underscore the poem's typographical mechanics. Manuscript drafts of the poem (written haphazardly on the back of a letter from Pound to Monroe) show that Pound played with indentation and spacing (figs. 22, 23). Pound often used periods and commas with extra spaces. At various times he expressed frustration with modern printing methods and the standardizations of the typewriter.[52] But "In a Station of the Metro" is the only poem in the series of eleven in which Monroe maintains typographical oddities. Essential to this poem's appeal to Monroe is its odd punctuation and spacing, which she retained. The colon or the semicolon is the contested punctuation, and the visual link between the images of the poem rather than the words "as if" or "like." A symbol replaces words. This point about the poem anticipates Pound's obsession with the "ideogrammic method," which he developed from Fenollosa. "In a Station of the Metro" indeed

bunches words together in groups, as if to imitate Chinese written characters that combine many into one to make meaning.[53] As Fenollosa cum Pound claims, the uses of a Chinese word "throw about it a nimbus of meanings."[54]

But Pound received Fenollosa's notebooks *after* "In a Station of the Metro" was published. In fact, Fenollosa's widow sent Pound the notebooks in the fall of 1913 after she herself read Pound's poems in *Poetry*.[55] Harriet Monroe's publication of this poem prefigures the explosion of Imagist styles that would emerge once Pound began advocating Fenollosa as the master of Chinese aesthetics. By the time she published "In a Station of the Metro," Monroe herself had not only read deeply into Chinese culture but also knew Fenollosa's work. Monroe read and reviewed Fenollosa's two-volume *Epochs of Chinese and Japanese Art,* hastily published by Mary Fenollosa in October 1912. This was the same month as *Poetry* magazine's first issue and a full year before Pound received Fenollosa's notebooks. Monroe glowingly reviewed the work for the *Chicago Tribune* in December 1912. Appreciating Fenollosa's training and philosophic breadth, Monroe claims that his study reveals the fundamental unity between East Asian art and the art of the West. Fenollosa's mind, according to Monroe, was "equipped with knowledge of east and west beyond the opportunity of any earlier investigator."[56] Three issues into her adventure with publishing *Poetry* magazine, Monroe here advocates the possibility of creatively conjoining cultures through the project of poetry.

"In a Station of the Metro" is not simply about Pound's vision at a metro stop in Paris, which he formulated into his famous Imagist credo. The history and aesthetics of this poem also belong to its first editor Monroe, to what she would have recognized as "compressed joy" and what she herself would have experienced in the disjunctions of train travel. "In a Station of the Metro" is an imprint of the network of people, poems, languages, and artifacts that fascinated Monroe and which she brought back to Chicago. The poem "bear[s] the brunt of our America," as Pound said of Whistler: it is fitting that it was first published in the geographic and cultural nexus of the country.

Years later, in 1934–35, Monroe took another extended trip to China to visit her sister. Seventy-five years old and internationally known for her editorship of *Poetry,* Monroe was nonetheless still wide-eyed, absorbing the changed currents of the world. She was also still writing poems. In her diary, Monroe composed two stanzas that invoke the opening and closing lines of Rudyard Kipling's famous "Ballad of East and West" (1889), which claims: "East is East, and West is West, and never the twain shall meet." As Monroe noted in her review of

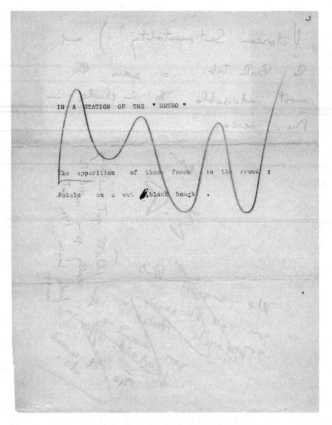

*Fig. 22. Ezra Pound, "In a Station of the Metro," ms. draft.* Poetry
Magazine Records, Courtesy Special Collections Research Center,
University of Chicago Library

Fenollosa's work, this claim is a "specious dictum."[57] In her own poem, Monroe
doubts Kipling's "word":

"For East is East and West is West" —
Perhaps the word was true
Before the Seven Seas were one,
Before the man-birds flew.

The steadfast sun shows youth the way
Above rebellious gales —
Now it is westward to Cathay
The headlong Future sails.[58]

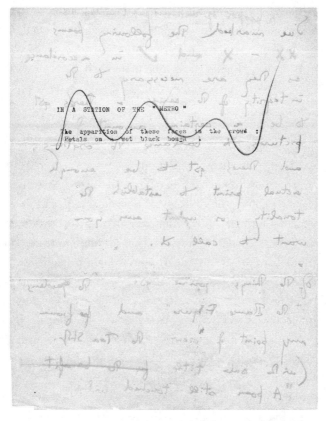

*Fig. 23. Ezra Pound, "In a Station of the Metro," ms. draft.* Poetry
*Magazine Records, Courtesy Special Collections Research Center,*
*University of Chicago Library*

This is not the genteel language of *The Columbian Ode.* But neither is it the
spare perfection of "In a Station of the Metro." Compared to many ground-
breaking poems published by Monroe, the formalism of her own work is still
strangely antiquated. Yet Monroe's poem is also prescient for how it conceives
of the "rebellious" geography between East and West. Cultures converge with
more efficient modes of travel, from the steamer and the train to the introduc-
tion of "man-birds," or airplanes. Monroe does not mourn the decline of the
railroad in favor of more efficient modes of travel; the poem looks "headlong"
to the future. Time will continue to close geographic boundaries and the young
will naturally look "westward," all the way to China. "Poetry travels more easily
than any other art," Monroe wrote to Howard Elting, a financial supporter of
*Poetry,* a sentiment that carries with it Monroe's expansive geographic vision

for *Poetry*.[59] Indeed, unlike other art forms that inspired Monroe to launch her magazine, poems during her era were physically mobile, less tied to the place where they were made, performed, or displayed. Monroe's magazine was both a product of Chicago and strategically untethered to it.

## A BRAVE LITTLE SONG

Harriet Monroe returned home to Chicago after her 1910 trip around the world with an idea. At first she talked about it only with friends. She spent a month living in a rural cottage in Lake Forest on grounds owned by Arthur and Mary Aldis, the wealthy patrons of Chicago art and theater. They gave her confidence. (A dreamer himself, Arthur Aldis was the principal reason the Armory Show would come to Chicago in 1913.) Then during the winter and spring, Monroe ventured out to meet people whom she knew by name only.

She worked her way through buildings in Chicago's downtown Loop, talking with lawyers, bankers, real estate tycoons, and "porkpackers" about poetry. Monroe explained what was exciting about the new vers libre, not the classical, academic poetry that she had once written. Her ideas about poetry had changed over the years, though her desire for a large public audience for it had not. Monroe sailed past secretaries. "In visiting men's offices I developed certain rules," Monroe would later explain: "As the idea of such a magazine seemed a bit amusing even to me, it was quite the natural thing to enter with a smile and laugh with the magnate if he thought my scheme ridiculous; and I never resented refusals from people I could not persuade. . . . But I would not be stopped by secretaries, those polite evaders whom big men placed at their doors to turn away importunate solicitors like me."[60] Both certain that her magazine deserved consideration and also willing to belittle herself before "big men" (a classic move), Monroe navigated the egos and ambitions of a business class that wanted to build the city's culture—or Culture with a capital C—in order to win support for *Poetry*. Monroe's achievements eventually made her a civic match for the men of the city though she was equally versed in the polite, feminine talk of her era.

One of the most notable qualities of *Poetry* magazine was (and is) the origin of its money. Chicago money gave impetus to many cultural endeavors, but Monroe's securing of guarantors who would initially give fifty dollars for five years was an unusually successful strategy. The older literary magazine the *Dial* was a model of financial security, but it was consistently conservative and apolitical in its approach to literature. And the fifteen-year run of the *Little Review*

depended on the sporadic patronage of admirers of its starry-eyed editor, Margaret Anderson. Even Monroe's young editorial assistant Eunice Tietjens was seduced by Anderson's charm. Tietjens pawned her diamond engagement ring from her first marriage to support the *Little Review*. (She never got it back.[61])

When Anderson and her partner Jane Heap moved the *Little Review* to Paris, Gertrude Stein told her that in Europe they would have to pay their artists. This says more about Stein's desire for cultural value than it suggests a truth. "Well neither do I consider it good principle for the artist to remain unpaid," Anderson apparently told Stein, "it's a little better than for him to remain unprinted, that's all."[62] Many editors of little magazines conflated the marketplace with a readership, like that of the *Dial*'s, that they did not wish to address. This disdain for audience — the illusion of autonomy — is a familiar modernist move, every bit Ezra Pound.

In her less flamboyant manner, in her desire for a broad audience for modern poetry, and in her relationship to money, Monroe was different. Monroe's systematic fundraising was partly the result of her long experience with the difficulty of making money as a young writer and her knowledge of the risky financial margins of publishing. Monroe's 1893 World's Fair *Ode* was also at the center of an influential copyright case that demonstrates the degree to which money for poetry was also Monroe's demand for civic recognition, both then and when she founded *Poetry*. Monroe had hoped that the literary quality of her *Ode* would give her "a certain prestige with the Eastern magazines."[63] But it was the scandal over printing the *Ode* that brought her publicity. The *New York World* in its coverage of the fair had reprinted Monroe's *Ode* without her permission. Monroe with the help of her father, a Chicago lawyer, then sued the newspaper for copyright infringement. She won. The US Court of Appeals affirmed the ruling and the Supreme Court refused to hear the case, forcing the *World* to pay Monroe five thousand dollars. With this (then) hefty sum, Monroe eventually set sail for a Grand Tour of Europe in 1897–98. This was more than ten years before her first trip to China.

Let us return briefly to this earlier period in Monroe's life — before China and before her idea to launch *Poetry*. The turn of the century was also a turn for Monroe, a moment of profound disquiet that would loom beneath her future success. She felt that she might never become a thriving writer, and she did not know what else she should try to be. Monroe was forced to face the relation between art and economics. She was unmarried and dependent on her father, whose law practice was struggling. During her year and a half in Europe, Mon-

roe met many artists, writers, and intellectuals, including Thomas Hardy in London and Auguste Rodin in Paris. She considered the conditions that give rise to great works of art and why many American artists worked abroad. Surveying the gothic designs of Amiens, the royal gardens of Ermenonville, and the art of the Vatican, she also thought about money. Despite what she felt was the superiority of American democracy over the tyranny and feudalism of a European past, Monroe was worried that the scientific progressivism of the United States might be at odds with the creation of great art.[64] Europe's old models of artistic patronage were not a social and economic viability in America. How was she ever going to make a living as an artist in Chicago? A childhood feeling persisted: her certainty that "to die without leaving a memorable record would be a calamity too terrible to be borne."[65] When she returned home, at thirty-nine, she had what we would now call a nervous breakdown following a bout of pneumonia.

A friend of Monroe's from the Fortnightly Club—the venerable women's literary organization in Chicago—gifted her a railroad pass to Phoenix to recover. In a small boardinghouse at the edge of a silver desert, she sat in a sea chair and absorbed the sun. When she felt strong enough, Monroe decided to visit the Grand Canyon, a trip to the south rim that took eighteen hours from Flagstaff in a dusty, hot stagecoach. It would be two years before the Santa Fe Railroad finished the final spur. Here in the Grand Canyon, Monroe came to believe that America had unique, awe-inspiring resources to stir its artists, resources derived from the natural world. It was not the art and culture of Europe that inspired Monroe to continue writing but the grandeur of the American West.

This is the scene of Monroe's 1899 epiphany. One morning she ventured alone to the edge of the canyon's rim and lay down on her stomach. She looked deep into its silent glow. Inching forward, pausing, she felt the full force of her own insignificance. With the passing of a morning cloud over the sun, the abyss darkened. The canyon drew her into it, tempting her with the lure of death.[66] Suddenly, Monroe was startled by a flap from within a juniper bush. She looked up to see an oriole, trilling its exit, a tiny pioneer flying out above the canyon. The bird seemed wildly at home in the canyon's vast emptiness, singing a "brave little song," offering her "a message personal and intimate."[67] Ultimately, the oriole saved Harriet Monroe from terror. It was art in the form of birdsong.

The freedom of the oriole above the canyon became a symbol of the possibilities of the American artist, the imaginative risks that American landscapes could inspire. Monroe promptly wrote "The Grand Cañon of the Colorado," which the prestigious *Atlantic Monthly* published in December 1899. "It is as

though to the glory of nature were added the glory of art," she wrote, "as though, to achieve her utmost, the proud young world had commanded architecture to build for her and color to grace the building."[68] Monroe's revelation of America's artistic potential conjoins "nature" with architecture, the art form of which Chicagoans were most proud. The public relations department of the Santa Fe Railroad read the piece and gave her an open railroad pass for the rest of her life in exchange for the free publicity. And Monroe returned to the West throughout her life. In 1908 and 1909 she spent weeks in the Sierra Nevada with John Muir and his Sierra club. "The imagination grows in the wilderness," she wrote, "grows strong and keen and daring."[69] Cities would always be a site of modernist invention, but poetry, Monroe felt, should not lose touch with the unrestricted forces of nature, the freedom and terror of expansive American topography. "Nature," she declared in a 1918 *Poetry* magazine editorial, was "the ultimate modernist."[70]

Strikingly, *Poetry*'s modernism looked to the Southwest as often as it looked to the Far East. A few of the most influential artists and teachers of Monroe's time also conjoined these two cultural traditions to emphasize the craft of artistic practice and to revitalize modern artistic production by drawing on the "primitive."[71] Consider a photograph of Monroe in her Cass Street office (fig. 24). Taken sometime between 1912 and 1922, the photograph shows Monroe in modern workaday dress, at a desk stacked with manuscripts and letters. A native American pot sits atop Monroe's desk. This pot hints at *Poetry* magazine's participation in the "Indian craze" of the early twentieth century.[72] Monroe and others involved in *Poetry*—notably, Ralph Fletcher Seymour, the magazine's first designer and printer, and Alice Corbin Henderson, Monroe's most important editorial assistant—looked to native art and culture as inspiration for modernity's broader interest in formal abstraction and artistic innovation.

Seymour was a member of the Cliff Dwellers, an all-male Chicago club for artists founded in 1907 by Hamlin Garland. The club's name derives from the 1893 novel *The Cliff Dwellers*, by Henry Blake Fuller, Garland's friend, which itself refers ironically to both Chicago skyscrapers and the Anasazi cliff dwellers of the Southwest.[73] Seymour's designs for the club—programs, cards, menus, and even napkins—display a striking blend of American Indian design with patterns from the arts and crafts movement (fig. 25).

A fascination with native American and New Mexican cultures emerged in several early issues of *Poetry*, largely through the efforts of Alice Corbin Henderson. Henderson was the magazine's first reader of submissions (and equally responsible for discovering the work of Sherwood Anderson, Edgar Lee Masters,

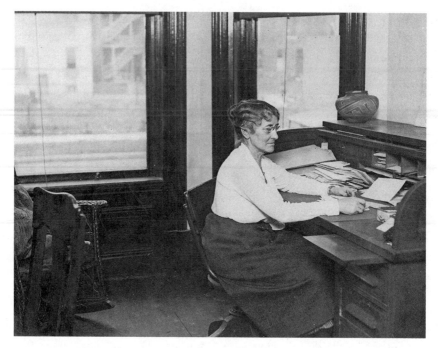

*Fig. 24. Harriet Monroe in* Poetry *magazine's Cass Street office, ca. 1912–22.*
*Harry Hansen Papers, Courtesy Newberry Library*

and Carl Sandburg). Henderson also published several well-received volumes
of poetry, under the name Alice Corbin, and she edited an important collection
of Southwest poetry, *The Turquoise Trail* (1928). Tuberculosis forced Henderson
to move from Chicago to Santa Fe in the spring of 1916, though she continued to
work for the magazine, and she was a vital connection to the arts scene in New
Mexico, including the community around Mabel Dodge Luhan. (Henderson's
daughter married the son of Luhan; the poet Witter Bynner was best man.)
Henderson also befriended Willa Cather and worked for D. H. Lawrence as a
part-time assistant and typist: the work of both writers appeared in *Poetry* largely
because of Henderson's influence. In a special August 1920 issue devoted to "New
Mexico Folk-Poems," Henderson's essay "The Folk Poetry of These States" lays
claim to the uniqueness of American poetry by virtue of its origins in native songs.
"It may be," Henderson writes, "that the folk-spirit is a necessary sub-soil for any
fine national flowering."[74] Henderson believed in the spiritual vitality and purity
of native American life, which modern civilization apparently lacked.

For Henderson, Seymour, and Monroe, the Southwest was "America's Ori-

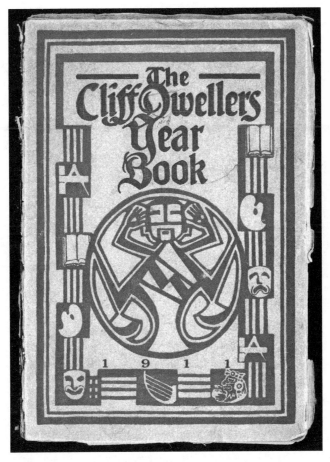

*Fig. 25. Cliff Dwellers yearbook, 1911. Cliff Dwellers Papers,*
*Courtesy Newberry Library*

ent," an elaborately imagined idea of otherness and a region of exotic but accessible travel.[75] In 1901, when Monroe and her sister Lucy visited the ancient city of Walpi, Arizona (three years before Lucy would marry William Calhoun), they paid money to witness a Hopi Snake Dance. Monroe called the ritual "my most authentic experience of our wildest West."[76] Monroe idealized American Indian cultures as an embodiment of the "authentic" forces of nature even as these ideals are belied by the economic complexities of her contact. In Monroe's photographs of a Hopi Antelope Dance, it is evident that other Anglo visitors also paid money to watch the religious ceremony turned into a spectacle (fig. 26). (The actual dance has been concealed here, in respect to its sacred

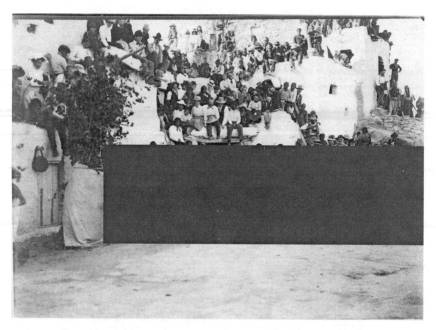

*Fig. 26. Harriet Monroe, photograph of Hopi Antelope Dance, 1901. Harriet Monroe Papers, Courtesy Special Collections Research Center, University of Chicago Library*

nature.) Indeed, the Santa Fe Railroad, which would sponsor Monroe's future travel, had an economic interest in commodifying the very experiences in which the Monroe sisters took part, including the "most weird unique and most amazing" Hopi Snake Dance.[77] One 1917 poster for the railroad depicts a Hopi dancer literally straddling the logo of the Santa Fe (fig. 27).

Monroe's romanticized belief in the authenticity and wildness of the American West informed her conception of how great American art could be made. It also pointed to where the money to support art in Chicago would come. As the Santa Fe Railroad poster illustrates, culture and artistic inspiration were also tied to industry and commercialization. Monroe's conception of nature and native Americans is deeply connected to terrain that was the source of Chicago's rapid growth during her lifetime. The vast hinterland beyond Chicago fueled its urban markets with grain, lumber, meat, and other commodities, making Chicago the most important economic center of the midcontinent.[78] Monroe recognized the cultural and aesthetic values of a sacred Hopi ritual, but she also implicitly recognized the economic exchange that took place when she watched it. Similarly, Chicago industrialists plundered not only the art of the Orient but also the natural

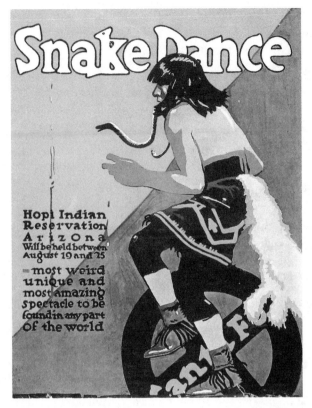

Fig. 27. *Santa Fe Railroad poster, 1917. From Michael E. Zega
and John E. Gruber,* Travel by Train: The American Railroad
Poster, 1870–1950 *(2002)*

resources of the American West, made vast amounts of money, built the city, and
funded its cultural institutions along the way. If Chicago writers bore the "brand
of the sugar-cured ham," to use H. L. Mencken's phrase, then it was the mark of
Chicago's proximity to the West. The "brand" was both aesthetic and economic.
The origins of Chicago's money were impressed upon its art.

## PORKPACKERS

A decade after Monroe's epiphany in the Grand Canyon, when Monroe sought
support for her magazine, money in Chicago was still what might be called
"new" and derived from the "wild" West to which Monroe was so deeply at-
tached. American poet John Gould Fletcher, whose work Monroe would pub-

lish, describes Chicago on his first visit in 1914 as if the city provided riches for a gluttonous child:

> I had never before stopped overnight in this city, and the contrast to New York and Boston was tremendous. Here was another America, the America of the great plains and the great Northwest, with its fierce scrambling animal energy, its vast stores of iron, copper, nickel, wheat, corn, cattle, hogs—a city of naïve boastful greed, of childlike exaltation over its own prowess.[79]

Many of the most prominent Chicagoans of Monroe's time were men and women who had made recent fortunes from Chicago's rapid growth. A few of Monroe's guarantors were prominent patrons of the arts—like Charles L. Hutchinson, president of the Art Institute; Arthur Jerome Eddy, the lawyer painted by Whistler; and her friend Charles Lang Freer from Detroit. But others were in fact the plunderers of "iron, copper, nickel, wheat, corn, cattle, hogs." These men included lumber baron Martin A. Ryerson, Edward Ryerson of Ryerson Steel, Howard Elting of the Adams and Elting paint company, and Ernest A. Hamill, president of the Corn Exchange National Bank.[80]

Consider another guarantor, Charles H. Swift of meat-packing fame, a name included in nearly every historical account of *Poetry* magazine's guarantors (fig. 28). Swift is the "porkpacker" whom Ezra Pound and others invoked to embody the Chicago readers and patrons who helped to underwrite *Poetry*. "You ought to leave as durable and continuing a monument as possible to the fact that you extracted from among the porkpackers a few less constipated and made them PAY money for the upkeep of poesy," Pound wrote to Monroe in 1931.[81] Similarly, a Philadelphia paper reported skeptically on the first issue of Monroe's magazine with an article titled "Poetry in Porkopolis," which declared that in Chicago "the proceeds of pork" were used "for the promotion of poetry."[82] "Porkpacker" here refers wryly to the philanthropists who established the cultural institutions of their city ("porkopolis") rather than to the actual laborers in the stockyards, a force composed largely of new immigrants and African Americans. Gustavus Swift—Charles's father—started a meatpacking empire in Chicago exploiting this cheap source of labor. He made extraordinary money with the invention of the refrigerated boxcar. From his packinghouses in the Union Stock Yards, Swift's trains fanned out over the country delivering dressed meat. When Chicagoans had complained about the by-products and pollutants emanating from the stench of the stockyards, the Swifts generated an effective

*Fig. 28. Charles H. Swift, undated. Courtesy Special
Collections Research Center, University of Chicago Library*

scheme. They employed hundreds of their workers in making from remainders many useful products—soap, buttons, glue, hairbrushes—generating a money-making industry of its own.[83]

Charles Swift's patronage of the magazine illuminates a rapport between Chicago's commerce and its culture, built upon Monroe's all-embracing conception about her magazine's audience. Swift's relationship to *Poetry* also raises several questions. How did Swift's involvement in an industry specific to Chicago—meatpacking—characterize his patronage? And was his patronage of *Poetry* unusual or fairly typical of civic-minded corporate support of the arts? Did he even read the poems published in the magazine?

Swift and other members of his family did not actually support *Poetry* in its first years, despite what the Philadelphia newspaper and other critics assumed.

Swift's name is not listed in the magazine under "contributors to the fund" until 1921. Almost certainly Monroe would have asked Swift to contribute to her magazine in 1911, but the record of his letters to Monroe shows that he waited. His first letter to the magazine in 1920—in response to either a recent editorial about the magazine or possibly a recent request for financial support—states that, except for his own subscriptions, he "has no record of ever having made a guarantee or contribution." That is, Swift had an individual subscription to the magazine (three dollars a year in 1921), but he did not contribute more than this amount and he had not been an initial guarantor. In this same letter, Swift writes that readers may "wonder at times at some of the verse which is published," but nonetheless the magazine "is a very worthy publication, and I for one would dislike to see it discontinued." The awkward double negative of Swift's sentence suggests passivity about supporting the magazine's continuation. But perhaps the magazine as a commodity conducive to Chicago's cultural prestige seemed cheap at the price. Swift in his letter offers to support the magazine with his money, to which Monroe responds with a full report of the magazine's finances, including amounts pledged by its contributors.[84] Swift then sends one hundred dollars with a promise for future contributions of the same amount, a guarantee equal to what others pledged. But why might Swift have been reluctant to support *Poetry* magazine in its earliest years?

Some literary context provides room for speculation. In 1911, Swift would have known the most recent literary sensation to put Chicago on the map, Upton Sinclair's *The Jungle*, published in 1906. Sinclair's best seller had fictionalized the gruesome working conditions at the meatpacking yards run by Chicago's Big Three packers: Philip Armour, Nelson Morris, and Gustavus Swift. The source of immigrant misery depicted in *The Jungle* is the unchecked capitalism and massive exploitation of workers by the packing companies, which Sinclair had hoped to expose in a push for socialist reform. Sinclair's muckraking novel examines with great pathos the tragedies wrought upon a Lithuanian family, but it is the novel's graphic account of how meat was made that shocked the American public. "I aimed at the public's heart," Sinclair famously said, "and by accident I hit it in the stomach."[85]

Harriet Monroe had admired Sinclair's novel and wrote to him in 1911 when she was circulating the idea for her magazine and building a fund for it among writers and patrons. Sinclair sent Monroe his best wishes for the magazine but declined to contribute: "I have the misfortune of being taken for a rich man," Sinclair writes to Monroe, "which is both embarrassing and expensive."[86]

Monroe's great strength—and also considered by some her weakness—was how she married her belief in a wide literary audience with her belief in the value of what writers could produce. She did not condescend to patrons as if they might not understand what she published. Nor did she treat poets as if they were a venerated elite. Monroe addressed Charles H. Swift in the same terms that she addressed Upton Sinclair and Ezra Pound. Conversely, *Poetry* was one of the few magazines of its era to pay its contributors and to award substantial literary prizes, thus acknowledging that literary work did not transcend the marketplace. Monroe was convinced of poetry's value as a progressive force in society—in the sense that her friend Jane Addams promoted literature as a moral good and in the sense that Sinclair's novel could impel the Pure Food and Drug Act of 1906. Monroe also believed in poetry's value as artistic labor on par with the work of painters and sculptors, who were more frequently paid for their work. Her advocacy of these values along with her constant desire to expand her magazine's audience irritated Ezra Pound, who wanted freedom from the qualitative opinions of readers outside the small literary set that he valued. "You cling to one pernicious heresy. That of the need of an audience," he wrote to her in 1914. "Once and for all dammmm the audience. They eat us. We do not eat them."[87]

Pound was referring to *Poetry*'s famous motto: "To have great poets there must be great audiences too." The line was taken from America's prodigious poet of inclusiveness, Walt Whitman. Monroe placed this motto not on the magazine's cover but above the list of contributors printed at the back, suggesting that they were in fact the audience to which the lines from Whitman referred. The placement also acknowledged the cultural exchange between the magazine and its contributors, offering them a free advertisement (fig. 29). Monroe's distinctive ambition was to make poetry readers out of her porkpackers, to cultivate the artistic passions of civic-minded men and women. In turn, she believed, this broader audience would enrich—in every sense of the word—the production of poetry.

But why would Charles H. Swift in particular read and support the magazine? Given the fact that Sinclair's literary effort had been such a devastating indictment of his family's meatpacking practices, it is striking that Swift supported a magazine (in *any* amount) with ties to the literary progressivism of an earlier era. It is possible that Sinclair—to Swift and to many Chicagoans—seemed disconnected with the efforts of *Poetry* magazine, given Sinclair's employment at a socialist newspaper that sent him to Chicago for a few weeks to research *The Jungle*. Monroe's project was by contrast literary, homegrown, and a potential source of pride.

Nonetheless it is notable that Swift wanted to support the magazine after its

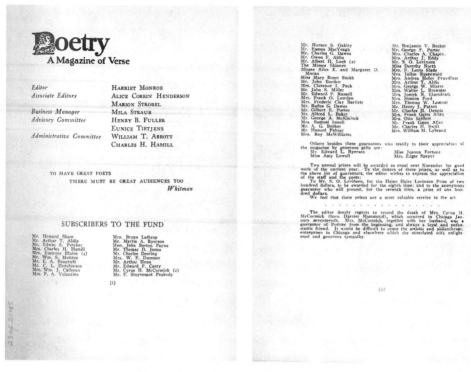

*Fig. 29. Subscribers page,* Poetry, *March 1921*

March 1914 issue, in which Monroe published "Chicago Poems," the work of another relatively obscure newspaper reporter, Carl Sandburg, who at the time was covering labor and politics in the local press. Sandburg's series begins with a poem that personifies the city in the form of a "hog butcher," straight from Swift's stockyards (fig. 30).

To read these familiar lines is to hear how a century has deepened and mellowed the coarse charge of their first publication. Sandburg's poem is practically Chicago's pledge of allegiance. Over the years the poet himself became Chicago's public bard with his instantly recognizable shock of white hair—a man known less for his radical socialist politics than for his Pulitzer Prize–winning biographies of Lincoln, musical performances, and whimsical stories for children (fig. 31).

But in 1914 this poem infuriated many readers. Monroe's editorial assistant Eunice Tietjens—the one dressed in a kimono—recalled that Sandburg's poems "roused a veritable storm of protest over what was then called their brutality. Many Chicagoans were furious at seeing the city presented in this, to them, unflattering

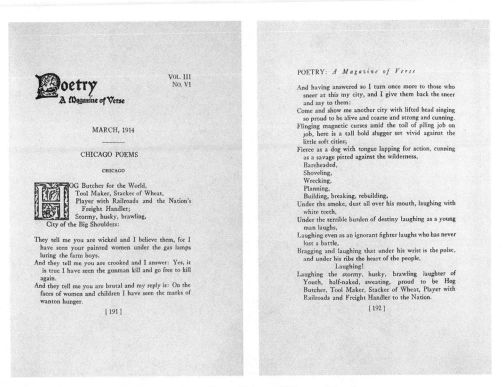

*Fig. 30. Carl Sandburg, "Chicago," Poetry, March 1914*

light."[88] Editors at the *Dial* publicly upbraided its younger upstart, "a futile little periodical," for publishing "jargon" rather than real poetry.[89] In 1963, when Fanny Butcher wrote her last literary column for the *Chicago Tribune* before retirement, she recalled the furor over Sandburg's poem. "Passionate arguments over today's most avant garde painting," Butcher writes, "are mild" in comparison.[90]

Divine like a mythological titan towering over urban industries, Chicago in Sandburg's poem is "stormy" like a force of nature. It "plays" with trains in a way that a young boy might arrange his toys or like a god in a tempest might destroy what humanity has made. ("As flies to wanton boys are we to th' gods," shouts Lear on the heath, "They kill us for their sport.") Three sonic booms ("Stormy, husky, brawling") proclaim that Chicago will not make melodious art. Following Whitman's "barbaric yawp," Sandburg's song is loud like the workers it employs. Sandburg builds upon Whitman's democratic inclusiveness, acknowledging in the next stanza "painted women" who lure "farm boys," a "gunman" who goes free, and "the faces of women and children" marked with "wanton hunger." It looks forward to the "howl" of a generation embodied by

*Fig. 31. Carl Sandburg, undated.*
*Courtesy Newberry Library*

lines from Allen Ginsberg, "starving hysterical naked." The "big shoulders" of modern man are a wild departure from Monroe's *Columbian Ode*, in which the female figure of Columbia is wreathed in flowers of peace and progress. Sandburg's "Chicago" reckons with the grim power and imperfect pride of the city as much as it proclaims the city's ars poetica and a future for American poetry.

It is difficult to determine what Charles Swift thought about Sandburg's poems or how other members of the Swift family reacted to another sensational literary work originating in their stockyards. The Swifts may have loved the poem. Since Charles Swift began his long and significant financial support for the magazine six years after the publication of Sandburg's poems, his reaction was in all probability not like the *Dial*'s. Indeed, over the years Sandburg's poem has been read as a paean to capitalism's energy rather than a critique of its inhumanity. Sandburg's poem has been used as an advertisement for countless goods produced in Chicago. For Swift, the poem could easily be appropriated as a celebration of his family's industry. A "big man" of Chicago, Swift may have identified, however problematically, with the "big shoulders" of the city's workers.

The Swift family's patronage in fact became crucial to *Poetry*'s legacy. Charles's younger brother Harold, who became the vice president of the meatpacking company, established a fund at his alma mater, the University of Chicago, for the preservation of the magazine's archives. Harold Swift was then the chairman of the university's board of trustees, and he knew that the archives would be a cultural boon to the university. A cache of letters during 1929–31 between Monroe and Harold Swift detail how he in fact donated five thousand dollars of his own money to set up the fund and to ensure that Monroe's papers would be handed over to the university after her death.[91]

Evidently, the uproar over Sandburg's poems in 1914 did not come from the porkpackers who were members of the Swift family. The uproar came from a literary audience familiar with the genteel poems of the *Dial* and the oratory style of a dedicatory ode like the one Monroe wrote for the Chicago World's Fair. Chicago's industrialists—seemingly less "literary"—were surprisingly open to modernist writing, not because they did not read or understand the poems in *Poetry* but because the formal and aesthetic categories by which art was judged were not as urgent to them. Less was at stake. Industrialists did not get in the way of artistic development in Chicago by determining aesthetic standards. Bulldozing ahead was what they were about.

When the notorious Armory Show came to Chicago in 1913—a story told in the next chapter—it was not the industrialists of the city who made the most fuss. It was art students along Michigan Avenue who actually held a "mock-trial" against the French painter Henri Matisse and then burned copies of his works. And when Gertrude Stein made her visits to Chicago in 1934–35—a story told in chapter 4—the crowds of people who lined up to see her included many who stood outside academic and institutional literary culture. Readers were drawn to Stein and her work in what became a celebration of Chicago's different cultural constituencies. The origins of *Poetry* suggest that the industrial tycoons of the city were also surprisingly open to the vers libre of modern poetry. Perhaps they themselves had taken risks in the rapidly expanding city and were willing to support Monroe's enterprise as well.

Harriet Monroe was wise to include in her 1921 letter to Charles Swift a list of the magazine's contributors, a list that served as implicit pressure. Swift may have supported *Poetry* because his peers and those closest to him did. Eventually, Swift became an important patron of many of Chicago's cultural organizations, most likely encouraged by Claire Dux, his much younger wife, whom he married, at age fifty-two, at the University of Chicago's Bond Chapel. A Prussian soprano who was "the golden Claire" of central European opera houses,

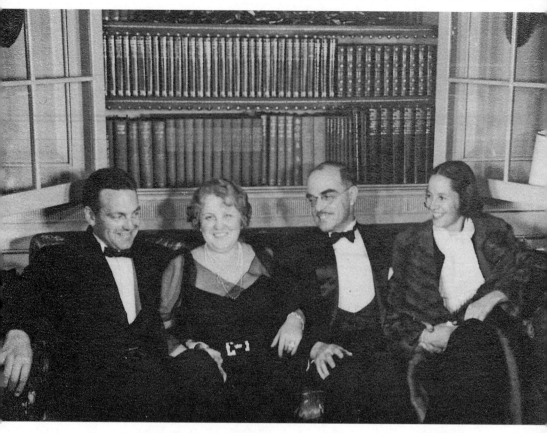

*Fig. 32. Robert Hutchins, Claire Dux Swift, Thornton Wilder, and Maude Hutchins at
the home of Barney and Bobsy Goodspeed, 1935. Fanny Butcher Papers,
Courtesy Newberry Library*

Claire Dux Swift achieved fame with the Chicago Civic Opera Company.[92] In
1934, she appears in photographs at the penthouse apartment of Bobsy Good-
speed, sitting next to Thornton Wilder and between Robert Hutchins, then
president of the University of Chicago, and his wife, Maude Hutchins, who was
a painter and a writer and a friend of the singer (fig. 32). This is the same dinner
party attended by Gertrude Stein, Alice B. Toklas, and various others central
to the artistic community in Chicago who convened during Stein's visits. Years
later, Wilder would remember this group with great nostalgia: "From time to
time I go into a daydream about the Chicago years which were so happy for
me," Wilder wrote to Bobsy Goodspeed, "and with many a moment of grati-
tude to you for unforgettable hours in your house and your company—what

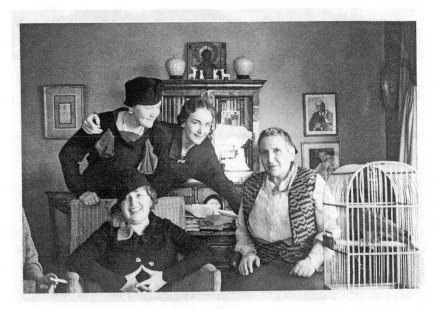

Fig. 33. *Claire Dux Swift, Fanny Butcher, Bobsy Goodspeed, and Gertrude Stein at the home of Barney and Bobsy Goodspeed, 1935. Gertrude Stein and Alice B. Toklas Papers, Yale Collection of American Literature, Beinecke Rare Book and Manuscript Library*

good times!"[93] In another photograph taken during Stein's visit in Chicago, Claire Dux Swift sits with Bobsy Goodspeed, Fanny Butcher, Stein, and the Goodspeeds' beloved parrot (fig. 33). (Stein called it "Basket parrot" in relation to her many Parisian poodles named Basket.) This urbane circle of friends that Wilder remembered was ultimately indebted to Harriet Monroe.

A generation older than this group, Monroe set the scene for the convergence in Chicago of artists and patrons. If there was a myth that Chicago was a place where established culture, avant-garde art, and the business classes fraternized, then it guided her efforts. Monroe's magazine was itself an organizing principle—not just a venue for publication but a standard for artistic experimentation backed by civic interest. The magazine doggedly maintained monthly publication through the lean 1930s and put into prominence some of the key poets of Chicago's Black Renaissance even as it stayed international in scope. Monroe likely would have been invited over to the Goodspeeds' apartment —and certainly to the Gertrude Stein events—if she had been in town. But at this moment in time in 1934, at age seventy-six, Harriet Monroe was making her second trip to China.

# Ohio and Chicago, 1912

IT WAS LATE NOVEMBER, AND the country prepared for Thanksgiving. Most businesses were shuttered. Sherwood Anderson, feeling dulled, sat at his desk at the Anderson Manufacturing Company in Elyria, Ohio. Age thirty-six, he was the company's president.

He rubbed his temples and thought about the past. As a boy, Anderson and his brothers helped his father brush coats of paint on cracked Ohio barns and stencil pictures for advertisements and road signs. His childhood nickname had been "Jobby." Even now, Anderson felt the weight of always trying to make money. His wife came from a well-to-do family—she was better educated, and she had traveled to Europe—and they had three young children he must support. He rarely joked any more. The language of the company's catalog, which he had written, did not pun on Shakespeare's magical island. The Anderson Manufacturing Company was the manufacturer of mail-order roof paint, a "roof-fix cure for roof troubles."

He pulled a pen from his breast pocket and wrote a short note to his wife. "There is a bridge over a river with cross-ties before it. When I come to that I'll be all right. I'll write all day in the sun and the wind will blow through my

*Fig. 34. Sherwood Anderson, ca. 1920. Sherwood Anderson Papers,*
*Courtesy Newberry Library*

hair." He got up and walked out to see his secretary. Through a window behind her, small factory machines glistened with rain in the fields along the Black River. He mumbled something, which she would remember much later as very strange. "My feet are cold and wet," he said. "I have been walking too long on the bed of a river." Then, without stopping to put on his overcoat, he walked out.

As if in a fugue, Anderson walked for four days. He tramped through river-beds and woods, splattering his business suit with mud. He heard a voice in his head: "You must leave all that life and everything that has been a part of that life behind you." He filled his pockets with corncobs from the fields and gnawed on them like an animal. He tried to build a campfire, but his head ached. He rested on a bridge and then followed the train tracks. He made it all the way to Cleveland. In a pharmacy, he finally sat down, asked where he was, and handed the druggist his address book for help.

They took him to a hospital, where he dictated notes about wanting to gather apples and corn. His son Robert needed the corn. As if he were some kind of modern-day Hamlet, he repeated a phrase about wanting to go to El-sinore, wanting to go to Elsinore. Later, when they took him back to Elyria, he tried in vain to explain himself—to the men at the Elks' Lodge, to his panicky wife. He told them that he could no longer sustain the sham. He talked about middle-class American respectability, about needing to live for his art.

After a couple of hopeless months at his desk, telling himself that maybe his family could follow, Anderson took the train by himself to Chicago, where he had worked before getting married. He packed four manuscripts of novels that he had written during moments at his office and late through the night. His older brother Karl, already in Chicago, took *Windy McPherson's Son* down to the Fifty-Seventh Street studios of writers Margery Currey and Floyd Dell. They called themselves bohemians and lived separately in the dilapidated store-fronts on the old 1893 fairgrounds.

Currey hosted the parties: Carl Sandburg, Ben Hecht, Susan Glaspell, Eu-

nice Tietjens, Maurice Browne, and Vachel Lindsay. She introduced Anderson
—older, aloof—to the sculptress and "new woman" Tennessee Mitchell, who
had ended her affair just over a year ago with lawyer and poet Edgar Lee Mas-
ters. Named after a nineteenth-century suffragist, Tennessee made money by
tuning pianos and teaching dance. She electrified Anderson. Theodore Dreiser
sometimes came down to the studios when he was in Chicago, having discov-
ered "varietism," the pleasure of more than one woman. And enthralled with
Anderson's novel, Dell helped to get it published by John Lane in England.

Dell was himself a transplant from Davenport, Iowa, always in search of the
next new thing. He would move on to New York and praise Anderson's writing
in the radical socialist journal the *Masses*: "The thing which captures me and
will not let me go," Dell wrote, "is the profound sincerity, the note of serious,
baffled, tragic questioning which I hear above its laughter and tears. It is, all
through, an asking of the question which American literature has hardly as yet
begun to ask: 'What for?'"

Anderson could only ask the big questions: What does this life mean? What
is success? Can people ever truly understand one another? He moved into
a boardinghouse on Cass Street, just north of the *Poetry* office. The women
dressed in trousers and everyone was an artist. "Little children of the arts," he
called them, who gave him his greatest happiness. They inspired the people of
*Winesburg, Ohio*, the collection of stories set in a fictional small town. Ander-
son also painted: he saw abstract forms in his mind and felt sensations that only
color could express. Later, he wrote to Alfred Stieglitz and to Georgia O'Keeffe,
saying that he tried to paint like her. "But the materials of the painter's craft
seemed to me to lie far outside my way of life," he would finally admit.

Anderson was breaking things down and trying to build them back up—
crafting his art, crafting himself. He cultivated a slow, slightly southern drawl,
like a folk poet searching in the heart of the city. He grew his hair long and
began wearing scarves. Margaret Anderson and Harriet Monroe both took to

him. Monroe would soon publish Anderson's "Mid-American Songs," a series of poems that opens with the rebirth of a wanderer: "I am of the West, out of the land, out of the velvety creeping and straining. I have re-solved. I have been born like a wind. I come sweating and steaming out of the cornrows." From cornfields to Chicago—the triumph of industrial America—he listened to the roar of machines and felt unbound.

# Stink of Chicago

## SHERWOOD ANDERSON AT THE ARMORY SHOW

Two months after Sherwood Anderson arrived in Chicago, he went to see the International Exhibition of Modern Art—better known as the Armory Show. The show had come to the Art Institute of Chicago from New York, where it had been housed informally on burlap partitions at the Sixty-Ninth Regiment Armory on Lexington Avenue between Twenty-Fifth and Twenty-Sixth Streets, the venue that gave the show its name. The Metropolitan Museum of Art had turned it down. Anderson was joined by his older brother Karl, who contributed a work to the show. The brothers were part of a massive crowd at the museum, an astonishing 188,650 visitors over just twenty-four days, an attendance more than double that of New York.[1]

For Sherwood Anderson, the Armory Show dramatically illuminated the flight from roof paint—in Elyria, Ohio—to the freedom of the artist. Walking through the teeming rooms at the Art Institute, he was in a raw state, keenly vulnerable to the explosive, radical works by the European and American avant-garde, from those by Paul Cézanne, Vincent van Gogh, and Paul Gauguin to examples by the fauves and cubists. At this moment, he also thought of himself as a painter as much as a writer. Mesmerized by what they saw, the Anderson brothers visited the museum each day during the show's run. Around the same time, they were reading aloud to each other the strange, playful prose poems in Gertrude Stein's *Tender Buttons*. (Years later, Anderson and Stein would become close friends.) Both Anderson brothers felt "a new approach to nature in art," as Sherwood described the experience. "Color was speaking in its own tongue. We walked about in the streets at night talking."[2]

Sherwood Anderson had also, finally, found his own tongue. If the show opened up possibilities for painters and sculptors in Chicago, then it simul-

taneously had a particular influence on the city's writers—like Anderson, and including others like Harriet Monroe, Floyd Dell, and the writers who came to Dell and Currey's salon down on Fifty-Seventh Street. Monroe convinced the *Tribune* to send her to New York to preview the show, which she described in four successive articles that track her dawning awareness of its importance. Unlike most newspaper writers (with the exception of Dell), Monroe supported the Armory Show for adding "new voices in the chorus" and "giv[ing] to American art a much needed shaking up."[3] Indeed, Monroe's art criticism is the medium in which her prose sparkles and her argument is at its most powerful. She then wrote five more *Tribune* articles about the exhibit when it came to Chicago. Monroe possessed an eye for the visual, including the visuality of poetry on the page, which she expressed through her editorship of *Poetry*. Her arrangement of lines, stanzas, and typographical mechanics owes something to her sustained engagement with the painterly avant-garde. Anderson's deep, emotional contact with modernist painting would shape his writing in unexpected ways, too. As Chicago was developing a complex, often contradictory relationship to modernist art, Anderson was fashioning himself in multiple ways, unresolved as to whether he was a bohemian artist or a midwestern businessman. For him, Chicago was a place of transformation, of grappling with the kind of person he wanted to be.

Monroe's reviews of the Armory Show are decidedly temperate, which in this case made them radically different from the storm of negative reviews. The museum was "being desecrated," according to the *Chicago Examiner*. One of Paul Gauguin's nudes was "profanely suggestive, even the face is detestable in its evil leer."[4] Transformations wrought upon the female nude—the highest subject of aesthetic beauty by the standards of the School of the Art Institute—inspired the sharpest critiques. On the last day of the exhibit, students at the School of the Art Institute held a "mock-trial" on Michigan Avenue against Henri Matisse—holding up an effigy dubbed "Henry Hair Mattress"—and then burned copies of three of his paintings, all of which were female nudes (fig. 35).[5] Disdain for these works expressed a conventional idea of what a woman should be: recognizable, to be sure, but also passive and demure. And in the case of Gauguin's Tahitian women, one detects a racist preference for European models.

But for the new bohemians, the Armory Show was liberating. Dell wrote an unpublished story of autobiographical epiphany set at the show, "The Portrait of Murray Swift," which begins as two urban flaneurs study paintings. They could

Students Burning Futurist Art and Celebrating Cubists' Departure

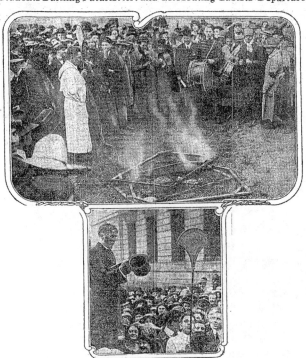

*Fig. 35. "Students Burning Futurist Art and Celebrating Cubists'*
*Departure," Chicago Daily Tribune, April 17, 1913*

be the Anderson brothers. "A modern art that is really modern should be able to interpret me to myself," Murray Swift proclaims. When a Chicago postimpressionist painter completes Swift's portrait, he feels a sharp pang of recognition, much like what Dell actually felt on viewing the fauve-colored portrait made of him by Swedish-born artist B. J. O. Nordfeldt, painted in Chicago around the time of the Armory Show (fig. 36). Against a flattened surface of greenish yellow, a rakish Dell in modern dress holds a walking stick and gloves; a dash of green clouds his face. The asymmetry of his posture in the painting gives him an air of uncertainty. Dell felt that the painting, uncannily, captured his personality: "observant, indecisive, inadequate."[6] This may as well have been what Anderson called color "speaking in its own tongue." It was a new language, and the writers in Chicago wanted to learn it.

In his rapturous review of the Armory Show in the *Friday Literary Review*, where he was editor, Dell espoused a new theory about the relationship be-

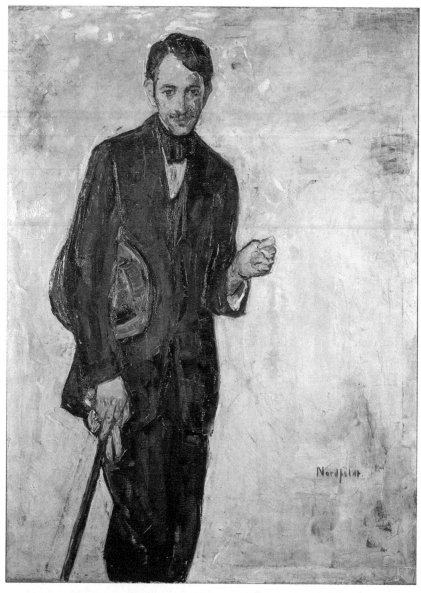

Fig. 36. B. J. O. Nordfeldt, *portrait of Floyd Dell, undated.* 8 ½ × 37 ⅛ *in.*
*Courtesy Jerri Dell and Newberry Library*

tween the arts: "The arts do fertilize each other; they liberate each other from their own tradition. . . . The artistic effects characteristic of one medium of expression awakens a fruitful envy in the imagination of workers in another medium."[7] After reading Dell's review, Monroe wrote him a quick note: "It is the best recent art criticism I have seen," she writes, "and absolutely the best thing on this exhibition, east or west, which has appeared in all the welter of print."[8] (This was excessive self-deprecation, since Monroe herself had written nine reviews in total. She then asked Dell why he had yet to submit anything to *Poetry*.) Dell, Anderson, and Monroe indeed felt "fruitful envy" when viewing the Armory Show: each was spurred to write editorials, reviews, poems, stories —and in Anderson's case, his greatest works of art.

Chicago painter Manierre Dawson—an exceptional artist, underappreciated outside of Chicago—experienced the Armory Show much like Anderson did, despite his very different background. For Dawson, the Armory Show was a celebration of artistic experimentation and a validation of something deeply personal amid the pressures to become successful in more respectable terms. Dawson grew up on affluent Prairie Avenue, in a highly literate, artistic family—"old settlers" with deep ties to Chicago's commercial industries. Manierre Dawson's brother Mitchell became a lawyer in their father's successful firm while pursuing a career as a poet (and editor of the short-lived little magazine *TNT*). Self-taught as an artist, Manierre Dawson wanted to pursue his art, but his father pressured him to become an engineer. Dawson worked at the prestigious Chicago architectural firm Holabird and Roche, at the same time committing himself to sculpture and painting. His elegant, autumnal *Portrait of Mrs. Darrow* (1911) shows the influence of Chicago architecture on his experimentation with abstraction (fig. 37). It is based on Titian's *Man with a Glove* (c. 1520) but reconceives the figure's head, white lapels, and torso as geometric shapes balanced deep within a plush, dark background. (Mrs. Darrow, the sister-in-law of the famous Chicago lawyer Clarence Darrow, did not actually sit for the painting.) Dawson's portrait of Mrs. Darrow finds resonances with the cubism of the European avant-garde, but Dawson's work is also distinctly homegrown, an expression of modernity from both the Midwest and abroad.

Like Anderson, Dawson found an ally in Gertrude Stein, who was the first to buy one of his paintings in 1910, when Dawson visited her in Paris during his tour of Europe.[9] He was twenty-two years old, and encouraged and inspired by what he saw on the walls of Stein's rue de Fleurus salon. Back in Chicago, he continued to experiment with form and color, including *Wharf under Moun-*

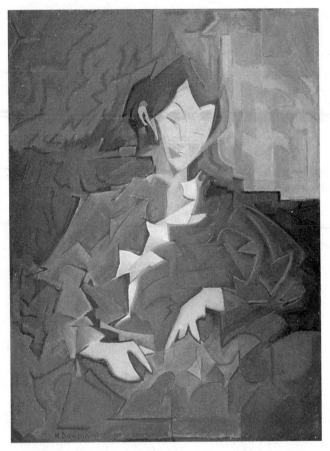

*Fig. 37. Manierre Dawson, Mrs. Darrow, 1911. Oil on panel,*
*32 ¼ × 23 ¾ in. The Art Institute of Chicago*

*tain* (1913), which was included anonymously in the Armory Show, but only in
Chicago—not in New York (fig. 38). A Duchamp-like painting in blues and
greens, *Wharf under Mountain* had been chosen last-minute by painter and Ar-
mory Show organizer Walter Pach when he visited Dawson's studio in Chicago.
To Dawson's surprise, Pach gave the painting its title—suggesting a scene—
strangely incongruous with anything in Chicago, where there is neither wharf
nor mountain.[10] For the Anderson brothers, to see Dawson's painting alongside
so many other works of avant-garde art was to see how Dawson's Chicago was
connected to an international burst of modernist experimentation. Dawson was
no regional oddity but part of a much larger movement. "I had thought of my-
self as an anomaly and had to defend myself many times, as not crazy," Dawson

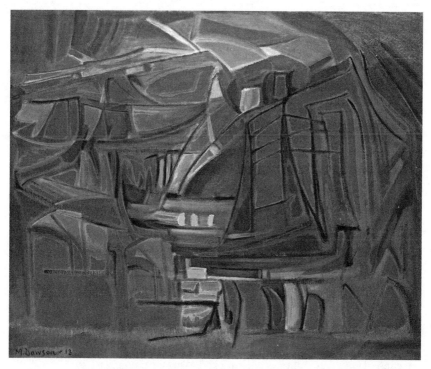

*Fig. 38. Manierre Dawson,* Untitled (Wharf under Mountain), *1913. Oil on canvas,*
*18 × 22 in. Norton Museum of Art*

wrote in his journal during the Armory Show. "These are without question the
most exciting days of my life."[11]

The Armory Show in Chicago illuminates a breakthrough moment in the
history of modernism, a moment of balance between the old and the new. The
venerable rooms of the Art Institute, itself a stalwart architectural remnant of
the World's Fair, was yet the place where Anderson's rejection of bourgeois
values was mirrored in new, radical visual forms. Perhaps the most distinctive
feature of the Armory Show's incarnation in Chicago was that it was mounted
at a cultural institution like the Art Institute, the only public museum in the
United States that would allow it. Not only does Chicago's Armory Show dif-
fer from New York's, but also from the much smaller version of the show that
was exhibited in its third and last stop at Boston's Copley Society, a local arts
organization. Here, just three hundred works (none by Americans) left barely
a mark on old Boston's insular artistic scene, almost like it never happened.[12]
In Chicago—which lacked an artistic tradition of its own—the show was more

powerfully understood as an expression of things to come. Few galleries in Chicago exhibited contemporary art in 1913, and the Art Institute had a monopoly on exhibitions of visual art in the city. It is thus even more surprising that the museum—by all means conservative, civic-minded, and dependent on loans from wealthy Chicago collectors—became the showcase for what critics called "the freak exhibit."[13]

The show highlighted the incongruous. Here was the new modernist art installed in the city's most established cultural institution, supported most by Chicago philanthropists (rather than students), and visited by people of every class. It almost didn't happen. Indeed, the story of the Armory Show in Chicago—and the force with which a midwestern public took to the experiments of the modernist avant-garde—reflects a sense among artists and writers in Chicago that the city was a place where anything might transpire. To fathom how the Armory Show was allowed space at the Art Institute, and to understand why so many more people came to the show's Chicago incarnation, is also to identify what made the museum a distinct expression of the democratizing impulse within Chicago's cultural scene at the time. Cultural uplift has its good: the Armory Show in Chicago summoned several establishment figures who were yet deeply sympathetic to the rejection of conventional ways of living and of understanding art.

## FRENCH AND THE ARTHURS

We cannot make a joke of our guests. It becomes a serious matter.

WILLIAM FRENCH TO CHARLES HUTCHINSON, FEBRUARY 22, 1913

Director of the Art Institute William French was trained in the ways of French academic painting. He was not one of the voices at the Art Institute who advocated the work of the Armory Show. He liked classically balanced figures like those created by his brother, the talented sculptor Daniel Chester French, whose most famous work is the seated *Abraham Lincoln* at the Lincoln Memorial in Washington. In early March 1913, however, French dutifully traveled to New York to view the much-publicized Armory Show and see whether it should be brought to Chicago. The Association of American Painters and Sculptors (AAPS), a group of antiacademy artists, had organized the enormous exhibit—approximately 1,250 works by European and American artists.[14] French toured the show with the painter and president of the AAPS, Arthur Davies, whom he thought "eccentric."[15]

On his train journey back to Chicago, French wrote a long letter to the Art Institute's president of the Board of Trustees, Charles Hutchinson, then traveling in Europe. French's letter is a mixture of strong opinion, detailed description, and anxiety. At age sixty-nine, French had developed clear standards of artistic merit. He criticized much of the work on display: Henri Matisse was "a joke," Odilon Redon "irrational," and Vincent van Gogh "unbalanced and insane." He continued, "The choice is between madness and humbug. How then should these artists have admirers among reasonable people! In the same way the most irrational religious cults attract followers—Bahaism, Teedism, Theosophy, Mormonism, not to mention more fashionable present-day isms, all have respectable disciples. It is simply unaccountable. We have to give it up!" French did not want the Art Institute to be duped by a big "joke," and yet he wanted to enable Chicagoans to see what they could otherwise see only in Europe and New York. French confided in Hutchinson that despite the "exhilaration" he felt "in the absurdity of it all," he still thought it would be "reasonable and right" to display some of the works (not all of them) "so that our public may know what they are." The risk, it seems, was that this art would cultivate religious devotion with a peculiarly American strain.[16]

French's relationship with "our public" was part of the Art Institute's founding conception of itself as a unique, democratic museum: the institution courted large numbers of visitors and made sustained efforts at public education in a spirit of Gilded Age uplift. In a 1904 *Chicago Tribune* piece that French wrote for the museum's twenty-fifth anniversary, he celebrated the enormous number of art students in the city ("more than 7,000") and the fact that "no other city in the world has an art museum so well attended." With characteristic Chicago boosterism, French also pointed out that the museum's galleries were distinctly "enriched" with works donated by Chicago collectors. "In other American cities," he wrote, "[works of art] . . . are kept aloof from the public for the special delectation of the few who are wealthy enough or fortunate enough to possess them."[17] French died in 1914, just one year after the Armory Show. He was extolled by Chicago sculptor Lorado Taft, at the time the city's most eminent and prolific public artist, who was also an eloquent declaimer of his generation's lofty ideals.[18] According to Taft, French realized the greatest "ideal of [the Art Institute's] founders that it shall be a glorified 'neighborhood center' for the entire community."[19]

The School of the Art Institute was unusual, too, in that it accepted African American students as early as the 1890s, a policy advocated by Charles Hutchin-

son in contrast to other premier art academies. Taft and his brother-in-law Hamlin Garland, writer and founder of the all-male Chicago club for artists, the Cliff Dwellers, were particularly strong supporters of African American artists, including the expatriate Henry Ossawa Tanner and Chicago painter William Harper.[20] The Art Institute itself collected the work of African American artists and gave a one-person exhibition to Harper in 1910—right after his death—the first major museum show for a black artist in the country. In 1927 it held "The Negro in Art Week," an exhibition reclaiming the links between African and African American art. By the 1940s, following the demographic shifts of the Great Migration, many black artists in Chicago had received training at the Art Institute, including William Edouard Scott, William McKnight Farrow, Archibald Motley Jr., Charles Dawson, Charles White, Walter Ellison, Eldzier Cortor, and Margaret Burroughs. Nevertheless both the museum and the school could have had a stronger commitment to the struggles of African American artists: Dawson describes the highly competitive atmosphere that existed *among* African American artists in Chicago during his time there, 1912–17, not helped by the Art Institute's fickle decision-making.[21] Moreover, the decision to allow the 1913 Armory Show—which was significantly influenced by the museum's founding principles of public education—did not highlight the work of black artists, because none were included in the show.

What exasperated French was the show's formal and aesthetic radicalism. When the Armory Show actually opened, French had decamped to California on a trip that was part lecture tour and part vacation. French had planned the visit in November 1912, but for him the timing was convenient. "I am myself going to California before the exhibition opens," he wrote to an acquaintance, "and I find myself not very sorry, for it irritates me very considerably."[22] Chicago newspapers had a field day, noting the remarkable coincidence of the Armory Show and French's absence.

French's indecision about the Armory Show is symptomatic of Chicago—and maybe America's—ambivalence toward modernism, especially when it came from abroad. Opinions about aggressive stylistic experimentation could be extreme but in this case institutional structures at the Art Institute were still loose enough to let the Armory Show happen. The museum's other decision makers were also out of town during the planning and installation of the show. Hutchinson was still traveling in Europe as was his good friend Martin Ryerson, a founding trustee and the most important donor to the museum's collections. Ultimately, the lack of a centralized decision-maker at the museum allowed two charismatic

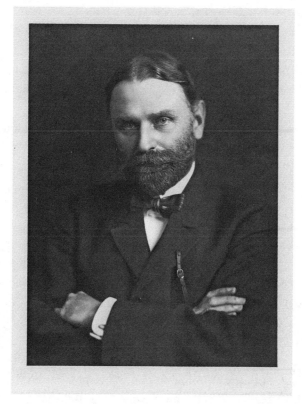

*Fig. 39. Arthur Aldis, undated. Courtesy Chicago History Museum, ICHi-23614*

Chicagoans to take charge. Both were collectors attracted to the new modernist aesthetic: real estate baron Arthur Aldis and Arthur Jerome Eddy, the art critic and lawyer painted by Whistler. Aldis was the reason that the Armory Show ultimately made it to Chicago, and Eddy was the brashest proponent of the show during its run.

Relatively little is known about Arthur Aldis, though he must have been a striking, charismatic presence (fig. 39).[23] An avid traveler, Aldis met the American painters and critics Arthur Davies, Walter Kuhn, and Walter Pach in the summer of 1912, when he was in Paris for his brother's wedding. Davies, Kuhn, and Pach had founded the Association of American Painters and Sculptors, the group behind the Amory Show. Kuhn embarked on a grand tour of Europe to meet dealers and artists and collect works for the show—from Cologne to The Hague, Berlin, Munich, and Paris. Pach lived in Paris and brought Davies and

Kuhn to meet Gertrude and Leo Stein. Through the Steins, they visited artists
in their studios, including Constantin Brancusi, the Duchamp-Villon brothers,
and Odilon Redon.[24] Davies and Kuhn arrived in London to see Roger Fry's
controversial *Second Post-Impressionist Exhibition* at the Grafton Galleries.[25]
Kuhn's letters home to his wife, Vera, brim with the excitement of being ex-
posed to a world of aesthetic revolution.[26]

Far from home and without so much as a letter to the Art Institute's board of
trustees, Aldis single-handedly assured the AAPS men that the Art Institute of
Chicago would welcome the Armory Show after it closed in New York. Only
then did he get others at the museum—particularly French—to commit to the
exhibit. One wonders at Aldis's powers of persuasion: there is no record of the
Armory Show in the board of trustees minutes.[27]

Aldis's vision was characteristically prescient and undaunted by details. With
his Chicago real estate fortune, he lavished support on artists and sculptors and
dedicated himself to socially progressive causes, including the National Associ-
ation for the Advancement of Colored People and the Chicago Urban League,
a resettlement organization assisting African Americans. The Armory Show was
not the only time Aldis assumed full authority over museum exhibitions. The
reason that the Art Institute held "The Negro in Art Week" was because Aldis
overrode others at the Art Institute to give the exhibit space. Mary Aldis, his
wife, was also a key figure in the avant-garde art world: it was in a cottage on
the Aldises' rural Lake Forest estate where Harriet Monroe had lived after her
return from China, gathering courage to launch *Poetry* magazine. Here Mary
Aldis constructed a theater and established the Lake Forest Players, one of the
first in the "little theater" movement, before she moved east to Provincetown.
She also supported artist Tennessee Mitchell—Sherwood Anderson's second
wife—whom Mary Aldis took to Italy in 1923, when the marriage was falling
apart.[28] Arthur and Mary Aldis likely had an open marriage; she found numer-
ous lovers in her theater world.[29]

Like his wife, Arthur Aldis knew how to stage an event. Because of Aldis,
the opening of the Armory Show at the Art Institute became a glamorous fund-
raiser. "I have never seen so many automobiles at the Art Institute as there were
yesterday afternoon and evening. It seemed that every one of our best citizens
who were in town were all here," wrote the museum's business secretary to
Hutchinson the day after the exhibit opened.[30] The museum had scrambled to
install the show. Unbelievably, it opened just ten days after closing in New York.
Six hundred and thirty-four works arrived late on Friday evening, March 21,

and all but the sculptures were installed by Saturday night. The show, as Aldis wanted it, opened on the afternoon of Easter Monday, March 24.

The other Arthur—Arthur Jerome Eddy—was a constant presence at the Art Institute during the Armory Show. He gave impromptu gallery tours, lectured twice to packed audiences, and was often quoted by the press. After Eddy had first seen the work of Whistler and Rodin at the 1893 Chicago World's Fair, he became the city's great proselytizer of modernist art.[31] He was known as "the man that Whistler painted" after he commissioned a portrait from the expatriate American artist in 1894 (fig. 40). Eddy insisted that Whistler's portrait remain with the title that Whistler had given it, *Arrangement in Flesh Color and Brown*, without his own name.[32] A few years later, Rodin created a bust of Eddy (fig. 41). Eddy's love of modernist art was part of his larger self-fashioning as a Renaissance man: he touted his knowledge of fine wines, dance steps, and facility as a fencer and angler. He was also apparently the first person in Chicago to own a bicycle, a sign of his modernity.[33] (A bicycle was not a horse.)

Eddy had untempered enthusiasm for all things new. Unlike almost every other Chicago collector, Eddy did not buy works of Old Masters.[34] Eddy was enamored of the Armory Show when he saw it first in New York, where his law practice often took him. He quickly bought twenty-five paintings from the show. New York lawyer and *Little Review* patron John Quinn purchased forty-one works, the most of any collector. In hindsight, however, Eddy's eye seems superior: the dozen or so cubist and fauve works that Eddy purchased were probably the most significant works in the show.[35] Newspapers inaccurately assumed that Eddy also had bought Marcel Duchamp's *Nude Descending a Staircase, No. 2* (1912), the painting that was the biggest scandal, constantly surrounded by crowds (fig. 42). This inaccuracy was not helped by Eddy's having made a point of actually identifying and outlining the nude in the painting (fig. 43).[36]

But for the AAPS men organizing the Armory Show, Eddy was a "source of annoyance."[37] Apparently Kuhn and Davies—who had traveled throughout Europe, selected the works, organized and underwrote the show—felt sidelined by Eddy's proprietorship over it. "It's a lucky thing that we insisted on our preface to the catalogue otherwise this Chicago bunch would have claimed it all," Kuhn wrote.[38] One detects a sharp note of East Coast snobbery in Kuhn's assessment of Eddy. Despite acknowledging the efficiency and skill of the Art Institute's installation of the show, Kuhn wrote to Davies: "The very sponsors with the possible exception of Aldis look upon this thing in the usual 'Porky' parvenu manner."[39]

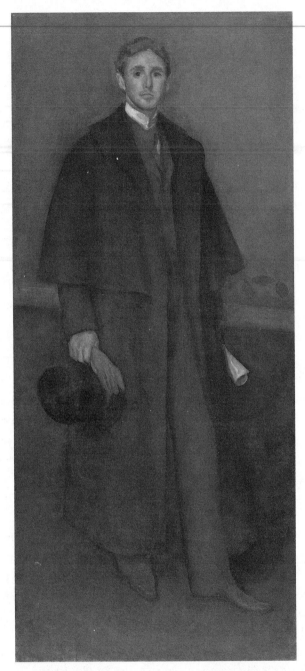

Fig. 40. *James Abbott McNeill Whistler*, Arrangement in
Flesh Color and Brown: Portrait of Arthur Jerome Eddy,
*1894. Oil on canvas*, 82 ⅝ × 36 ⅜ *in.*
The Art Institute of Chicago

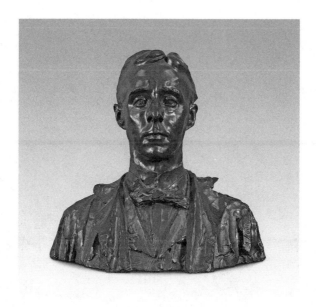

*Fig. 41. Auguste Rodin,* Head of Arthur Jerome Eddy, *1898.*
*Bronze, h. 18 ¾ in. The Art Institute of Chicago*

John Quinn—a very different kind of collector—also disdained Eddy's en-
thusiasm, which he took to be distinctly aspirational, and midwestern. Quinn
has long been regarded as a heroic upholder of the modernist avant-garde. Not
only did Quinn support Margaret Anderson and Jane Heap with money and
legal aid when they went to trial for obscenity after serializing chapters of Joyce's
*Ulysses,* but Quinn also befriended and financially helped many other writers,
including Joseph Conrad, Yeats, Pound, and Joyce. Yet Quinn could be severe
and imperial, as his response to Chicago's cultural scene reveals. (He was once
described as possessing "Napoleonic arrogance."[40]) Quinn derided Eddy's most
important work of art criticism, *Cubists and Post-Impressionism* (1914), in which
Eddy explained the theoretical underpinnings of modernist art and drew deeply
from his own extensive collection and correspondence with artists. Quinn read
the book and wrote to a friend: "It is monstrous. Horrible on the outside, cheeky
as hell on the inside. Conceited, laughable, just what one would expect from a
Chicago 'ass-pirant.' . . . It seems to have everything jumbled and pitchforked
together without rhyme or reason, and it doesn't seem he understands or knows
in the least."[41]

Quinn had a New Yorker's view of the Midwest, despite (or perhaps because

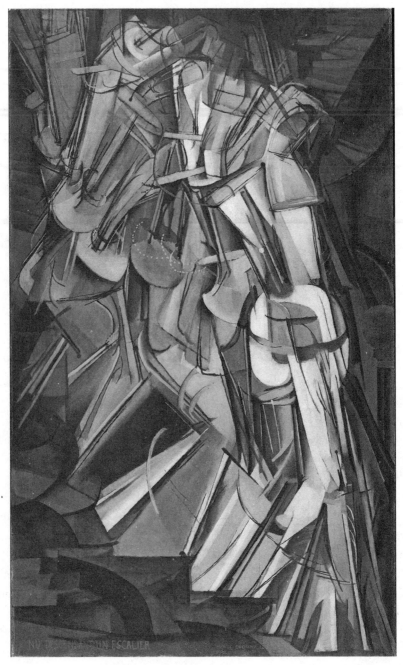

Fig. 42. *Marcel Duchamp,* Nude Descending a Staircase, No. 2, *1912. Oil on canvas, 57 ⅞ × 35 ⅛ in. Philadelphia Museum of Art, object number 1950-134-59. Copyright: © Artists Rights Society (ARS), New York/Estate of Marcel Duchamp*

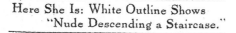

Here She Is: White Outline Shows
"Nude Descending a Staircase."

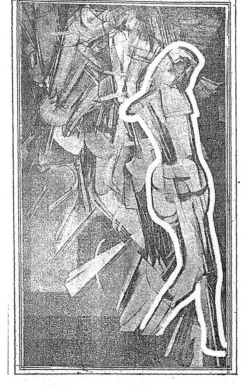

Fig. 43. *"Here She Is: White Outline Shows
'Nude Descending a Staircase,'"* Chicago Daily
Tribune, *March 24, 1913*

of) having grown up in Ohio. A few years later, after the publication of Sherwood Anderson's third novel, *Poor White* (1920), Quinn wrote a remarkable letter to Anderson, whom he had never met, in which he seemingly praises the novel but uses similar language to ridicule Anderson's conception of midwestern art: "Somewhere in the book, but I have not marked the place and cannot lay my hands on it now, you speak of a great art about to be born. I don't see a great art being born either in Ohio or in Indiana or in Illinois, as they are today, even if all three were pitchforked into one, one on top of the other, and Chicago on top of all." Quinn also included his own marked-up copy of *Poor White*, in which he had excised what seemed to him to be unnecessary words—

including "the eternally recurring phrase, 'Bidwell, Ohio.'"[42] Never mind that Anderson's most famous work, *Winesburg, Ohio,* had a very similar title.

Midwestern support of modernist art—and midwestern art itself—was clearly a target of mockery, especially from the art world's cosmopolitan trifecta, New York, London, and Paris. Like Quinn, Ezra Pound could disdain the seemingly uncultured "porkpackers" of Chicago who funded *Poetry*—and indeed Pound and Quinn were friends and coconspirators in their crusade to elevate modernism. In contrast, Chicagoans like Eddy and his friend Harriet Monroe committed themselves to what they found distinctive in Chicago. Having traveled the world and seen other great cities, Monroe in particular worked to convince naysayers and elitists that Chicago was a cultural center equal to other great modernist metropoles, and also that the city was valuably different. Artists in Chicago, too, either embraced or fled the city's rawness and rapid expansion, its aesthetic indifference, and the visibility of its dominant, dirty industries. A different kind of art would emerge from Chicago—as Anderson's *Winesburg, Ohio* attests. "The stink of the stockyards is in my clothes," Sherwood Anderson wrote in a 1917 letter to writer and critic Waldo Frank, explaining why he would not go to New York.[43]

As for Eddy's *Cubists and Post-Impressionism,* perhaps it is a book that only a Chicagoan could have written. Impassioned and promotional, *Cubists and Post-Impressionism* was nevertheless the first American book that expressed an appreciation for the subject. Written in a deliberately nontechnical style, it was extremely influential to many artists and critics, including Georgia O'Keeffe, whose responsiveness to what emerged out of Chicago was due in part to a formative year in 1904 when she had studied at the School of the Art Institute.[44] Published by Chicago's oldest bookstore and publisher, A. C. McClurg and Company, the book, with its illustrations (twenty-two in color, forty-seven in black and white) and letters from artists, provided an abundant resource for understanding contemporary art. In the book, Eddy explains why the role of the collector should be subservient to works of art—as his own name would be subservient to Whistler's portrait title. He disparages private collections that kept art from the public:

I have the conviction that no man has *the right* to appropriate to himself the work of the great masters. Their paintings belong to the world and should be in public places for the enjoyment and instruction of *all.* It is the high privilege of the private buyer to buy the works of *new men . . .* but when the public

begins to want the pictures the private buyer, instead of bidding against the public, should step one side; his task is done, his opportunity has passed.[45]

Eddy valued great art of the past—which should "belong to the world"—but he believed that his money should support the art of the new. A collector should promote a kind of aesthetic progress. And, according to Eddy, "the public" bears the responsibility of telling a collector when it is time to give his works of art a place in public culture. Here was a parallel expression to Monroe's idea of a broad audience for modern poetry: Eddy's idea that the public was crucial to museums, not just as viewers, but also as goads to curators and collectors.

Eddy was not entirely alone in his thinking about the relation between art and "enjoyment and instruction for *all*," but he was distinct. In Chicago, Jane Addams and her cohort of women reformers believed that arts education could improve the lives of the poor. Armed with the ideals of the arts and crafts movement, Addams understood art as an antidote to the commercial drives of her city. Art served as a means to illuminate moral and ethical values—to make an individual *better*. Similarly, the great and idiosyncratic Philadelphia collector Albert Barnes worked closely with educator John Dewey in developing his foundation as a school that advanced progressive arts education rather than a museum. But because his collection was used primarily for study, public access was severely restricted. Eddy was more radical than the progressives Addams, Barnes, and Dewey; and in comparison to someone like John Quinn, Eddy was antithetical. Quinn believed that the best place for art was in the home, where a collector could live with it. "Peripatetic exhibitions cheapen art," Quinn wrote. "Art, great art, the great art of Matisse and Picasso is never of the mob, the herd, the great PUBLIC."[46] Quinn recognized the "greatness" of art by Matisse, Picasso, and other avant-garde artists (and bought it), but he disdained the idea that it would be subjected to the gawking eyes of onlookers in a museum.

If Quinn is a New York elitist, then Eddy is Chicago's champion of democratic art. This is different than saying that Eddy wanted new art forms that would engage the masses: rather, he wanted the masses to engage new forms of radical art. Eddy "aspired" to educate people, from the person on the street to those at the highest levels of civic life. It was an aim shared by Monroe, whose many *Tribune* reviews of the Armory Show emphasize the range of visitors to the Art Institute and each person's equal right to an aesthetic opinion. The Armory Show, she wrote, "offers the glad hand to any one, young or old, who has something special and personal to say in modern art."[47] This was not a

mere platitude by Monroe. The tremendous publicity that accompanied the
show—most of it hyperbolic and negative—attracted thousands of visitors to
the museum who might never have entered its lion-flanked doors otherwise. The
museum extended its hours from 9:00 a.m. to 10:00 p.m. to accommodate the
crowds, including on Sunday—the likely day that working-class citizens would
visit the museum. "The attendance on the free days runs from 13,000 to 18,000
'souls,'" the Art Institute's business manager reported to William French.[48] His
quotation marks around the word "souls" suggested that he was singling out
the kinds of visitors who came to the museum. Perhaps they skipped a Sunday
church service, or maybe they bore some resemblance to Russian serfs.

Sherwood Anderson, for instance, was not a well-educated connoisseur.
He was a writer from a small town who was cultivating the "stink" of his rural
roots and his plainspoken midwestern demeanor. Thousands of visitors to the
Art Institute who packed the exhibition halls were also mostly midwestern and
unfamiliar with the artists whose work was on display. What inspires the most
curiosity about the Armory Show—and yet can never be known fully—is how
these visitors experienced the art. Not everyone was like Sherwood Anderson
and Manierre Dawson, both of whom kept journals. And not everyone was a
newspaper reporter looking to document a good controversy. If sheer numbers
tell a story, then the Armory Show in Chicago might be considered as a kind
of credentializing experience. People wanted to go to the show and form an
opinion of it. They needed to go and see what the commotion was all about.

## BLISS

Consider, again, the painting that received the most attention by the crowds
and by the press: Marcel Duchamp's *Nude Descending a Staircase, No. 2* (1912)
(fig. 42). This was the show's gem. One reporter wrote that people in New York
waited up to forty minutes to view the *Nude* and vent their feelings of "disbelief,
their rage, or their raucous laughter."[49] The previous year, the painting had
been on view in Barcelona and in Paris, but it had not caused such contro-
versy.[50] Duchamp's *Nude* struck an American nerve, something responsive in
American audiences, that old Puritan streak.

As with other pieces of art on display at the Armory Show, what was imme-
diately radical was the painting's departure from visual verisimilitude, its distor-
tion to pictorial representation. The painting is large: nearly five feet tall and
three feet wide. Monochromatic, it is composed of complex and varying shades

of brown, tan, black, and gray. A series of geometrical planes plot the body's angular movement through space. This "nude" refuses to recline in a sensual, timeless pose. She is all forward motion, each step caught in a serial frame, like the time-lapse photography that inspired Duchamp. Her body—for the head is barely visible—flaunts the power of a modern machine.

Or is the figure actually a man? What troubled many viewers was the difficulty of identifying just what the figure *was*. Despite the title, this painting seemed to be neither a nude nor a staircase. It was as if the painting was a riddle—which Arthur Jerome Eddy, by outlining and identifying the actual *Nude*, could solve. Among many descriptions newspaper reporters gave the painting, a few stand out: a "pack of brown cards in a nightmare," an "orderly heap of broken violins," and "an explosion in a shingle factory."[51] (The press coverage delighted Duchamp.) This "Nude" was a far cry from the idealized proportions of Daniel Chester French's stately sculptures.

Gender-bending and explicit sexuality certainly contributed to the controversy surrounding Duchamp's *Nude*, as it did with other paintings in the Armory Show. Reformers—including the Chicago school superintendent—believed that children should not be allowed to see the works on display. Pregnant women were also advised to stay home.[52] Conservative morality fueled a minor scuffle over a display of a female nude just days before the Armory Show opened. Allegedly, Chicago's mayor Carter Harrison IV encouraged the police to remove a reproduction of Paul Chabas's painting *September Morn* from a front window of a Michigan Avenue gallery, even though the painting had won a medal of honor in Paris the previous year (fig. 44).[53] Formally, the sentimental painting is nothing like Duchamp's *Nude*; the problem was the nakedness of the young girl and her visibility to pedestrians. But the episode, like the Armory Show, raised the larger question of *who* could view and judge contemporary art. Should it be presented to the man (or woman) on the street?

Just a few days after their Matisse effigy, art students put on a one-act burlesque, "The Trial of September Morn," in which they put clothes on Chabas's naked girl. *September Morn* was donned in red underwear and white linens.[54] Students may have been opposed to public indecency and the works in the Armory Show, but something about these extended "trials" suggests that they were also having fun. Mayor Harrison, too, was not particularly zealous. A well-educated man of cultivated taste—and, like Eddy, a bicyclist—Harrison might have been motivated by political gain. In his fifth term as Democratic mayor, he was only now cracking down on Chicago's prostitution and gambling in an

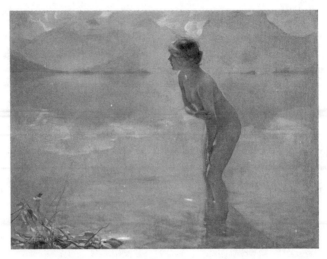

*Fig. 44. Paul Chabas,* September Morn, *1912. Oil on canvas,*
*64 ½ × 85 ¼ in. The Metropolitan Museum of Art*

effort to garner the votes of an increasing number of urban reformers. In 1911,
Harrison even closed down the infamous high-end brothel the Everleigh Club,
whose proprietors, Ada and Minna Everleigh, were not unfamiliar to writers
like Theodore Dreiser and Edgar Lee Masters.[55]

Reformers with political clout might condemn the Armory Show—and get
the mayor's attention—but press accounts also register the humor and playful-
ness of responses to the works on display. The Armory Show was ripe with possi-
bilities for Chicago newspapers, which thrived on sensational features as much
as objective reporting. From the many newspaper accounts that present Chica-
go's moralism with some irony, one gets the sense that countless museumgoers
may simply have laughed at what they saw.

Gertrude Stein, not surprisingly, was the writer most affiliated with the Ar-
mory Show (she had lent several paintings). The press gleefully ridiculed her
work as much as it did Duchamp's. Stein's word portraits of Pablo Picasso and
Henri Matisse had been the text of the August 1912 issue of Alfred Stieglitz's
*Camera Work,* accompanied by photographs of fourteen paintings and sculp-
tures by these two artists. (Sherwood Anderson prized the issue.[56]) Stein's *Por-
trait of Mabel Dodge at the Villa Curonia* appeared in *Arts and Decorations*—a
more widely circulated periodical—in a special issue arranged by the AAPS and
for sale at the Armory Show. A wealthy American patron of the arts, Dodge had
also published the portrait on floral paste paper by a commercial press in Flor-

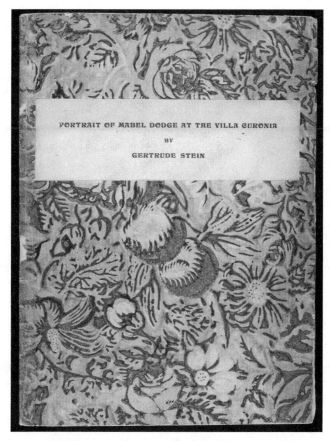

Fig. 45. *Cover of Gertrude Stein,* Portrait of Mabel Dodge at the
Villa Curonia *(1912). Courtesy Newberry Library*

ence; it was then distributed free (fig. 45).[57] This word portrait—which Stein
had written on visiting Dodge at her Italian home—was supposed to serve as
an advertisement for the exhibit. It was sent to the Art Institute by the Armory
Show's organizers weeks before the show opened in Chicago. The book was
beautiful; it was also very funny.

Stein apparently wrote the piece while listening to Dodge's erotic escapades
with her son's tutor in the room next to Stein's at the villa.[58] "It is a gnarled di-
vision that which is not any obstruction and the forgotten swelling is certainly
attracting," Stein writes, in her typically elliptical way. "It is attracting the whiter
division, it is not sinking to be growing, it is not darkening to be disappearing,
it is not aged to be annoying. There can not be sighing. This is this bliss."[59]

Stein's extended use of participles evokes continuous movement, inwardness, and change: this portrait is very much *alive*. Her language throughout suggests experimentation with painterly form, the arrangements of a living space, and the physical charge of sexual attraction.

And yet, the influence of visual images on the structures of Stein's language is slippery, and not easy to chart. Does she—can anyone—put pictures into words? Stein turned to the visual, as did many writers of her moment, because she felt that language was not the paradigmatic means of expressing meaning, even as language possessed qualities that seemed to her extralinguistic. That is, Stein understood that putting pen to paper is a graphic exercise. If we accept the idea that the twentieth century produced the "pictorial turn," when a culture of words evolved into a culture of images, then Stein is certainly a writer who embraced this turn rather than feared it.[60] Chicago reporters were hyperbolic, but essentially right, in suggesting that Stein's language came out of her exhilarating engagement with modernist paintings: they imagined that Stein had written the piece in "the thralls of cubic excitement." "The first cubist writer in the world," she was dubbed.[61]

Stein's unorthodox organization of words was a precursor to the confluence of the literary and visual in the writers whom she influenced in Chicago, from Anderson to Ernest Hemingway to Richard Wright. Each of these writers had a period when they produced sentences like Stein's, when they imitated her style. Like Duchamp, Stein was influenced by the new photography, especially that of Stieglitz, and by how photography freed up writers to experiment with modes of realism that were not about verisimilitude. And for the writers who learned from Stein, a literary apprenticeship involved breaking down literary language and building it back up. Stein helped them to see the structure of sentences— how to play with prepositions and feel the force of conjunctions; and how to lessen the priority of nouns or, as she put it in "Poetry and Grammar," "in doing very short things I resolutely realized nouns and decided not to get around them but to meet them, to handle in short to refuse them by using them."[62] But of course, language is not just about structure or the connotative resonances of putting different words together: it is primarily a means with which to communicate with others. To take Stein's language and shake it through the sieve of Chicago is to retain its appeal for mainstream readers. The work of Anderson, Hemingway, and Wright—in different ways—underwent this Steinian process and came out transformed, refined, and highly readable.

Stein had her fans, especially in Chicago, but her work also received a fair

share of derisive parody. In their spirited appraisals of the Armory Show and of Stein's "cubist" writing, Chicago newspapers boasted their wit. Two weeks before the show opened in Chicago, the *Tribune* printed an unsigned poem that caricatured Stein and cubist art. Consider the first four of nine stanzas:

> I did a canvas in the Post-
>     Impressionistic style.
> It looked like Scrambled Eggs on Toast;
>     I, even, had to smile.
>
> I said, "I'll work this Cubist bluff
>     With all my might and main,
> For folks are falling for the stuff,
>     No matter how inane."
>
> I called the canvas *Cow With Cud*,
>     And hung it on the line.
> Altho' to *me* 'twas vague as mud,
>     'Twas clear to Gertrude Stein.
>
> I have forgotten her remark;
>     'Twas something, tho,' like this:
> "The sinking rising lightens dark
>     To be, while being, bliss."[63]

Stein's word portraits are nothing like the easy-rhyming quartets of the *Tribune's* parody. She is imagined as appreciating *Cow With Cud*, a cubist imitation with a distinctly midwestern title, "hung" out "on the line" like an item of laundry. But this is not just laundry. A faux grandiloquence hints at Hamlet ("to be or not to be") that ends not in death but in "bliss." Stein's artistic enjoyment becomes sexual pleasure. If the *Tribune's* poet is any register of a public response to the Armory Show, then the new art inspired not only real artistic transformations in Chicago's literary sphere but also playful imitation, perhaps a simpler indication of the show's widespread influence.

Years later, in 1934–35, when Stein would come to Chicago, her style was embraced by readers who appreciated her sexual punning and clever wordplay. Laughter was an essential and vital response to Stein's work, as the Chicago

women who gathered around Stein that year understood. Stieglitz introduced Stein's portraits in *Camera Work* by condoning laughter: "We wish you the pleasure of a hearty laugh at them upon a first reading. Yet we confidently commend them to your subsequent and critical attention."[64] Laughter was not a rejection of Stein's language—or the works of the Armory Show. Rather, it could be part of the aesthetic experience and understanding of the work itself. Indeed, when she visited Chicago, Stein would explain how to read her works by encouraging readers to yield to the pleasure of rich word associations—the *bliss* of language. This word bears comparison to what Hélène Cixous and Roland Barthes, much later, called *jouissance*, that capability of language to surprise and jolt a reader beyond what can be expressed in words. Stein emphasized a reader's surrender to language without necessarily being able to articulate exactly how that language operates. If Stein's writing is a kind of *écriture féminine*, then it challenges the conventional priorities of the sentence by emphasizing the materiality of language itself, the pleasure of the medium. "Understanding and enjoying is the same thing," she said.[65]

The Armory Show in Chicago upset standards of aesthetic judgment: whether you thought that this was good or bad (or funny) determined your opinion of the show. The *Chicago Evening Post* documented the abandonment of rules established by European academies of art: "The exhibition is certainly a terrible leveler. With all the established canons abandoned, the layman is as good as the critic and the critic is no better than the king."[66] Visitors who were uneducated in classical standards of art evaluation suddenly may have felt, for the first time, on equal footing with men like the museum's director, William French. But as much as French resisted the show—and left town during its run—it is too easy to call him an elitist. He was not John Quinn. A central function of the Art Institute was to expose and educate people about art across time periods, genre, and style. The museum essentially had an "open-door policy," to use Harriet Monroe's phrase, in regard to its visitors.

And yet, this does not mean that the museum in 1913 was ready to embrace modernist art. Even in the 1920s, and after the sudden death of Arthur Jerome Eddy, the museum did not purchase Eddy's collection, which his family sold off piecemeal over many years.[67] An unwitting auctioneer sold several pieces from Eddy's collection in 1937 to Katharine Kuh, a daring, young Chicago gallerist who recognized the worth of what she got for $110: two paintings by Wassily Kandinsky, four works by Alexej von Jawlensky, a rayograph and painting by Man Ray, a work by Gabriele Münter, and an early color lithograph by Pierre

Bonnard.[68] (Eddy's collecting was always eclectic.) Kuh was eventually hired by the Art Institute, and in 1954 she became the museum's first curator of modern painting and sculpture. Kuh would spearhead the museum's bold program in education, bringing modernist art to the masses. But the institution took a long time: it was not until 1933, twenty years after the Armory Show, when the Art Institute fully paid homage to modernism, a year marked by the return of works by Picasso, Matisse, and even Duchamp's *Nude* as part of the museum's huge *Century of Progress* exhibitions celebrating Chicago's centennial.[69]

This span of time—from the 1913 Armory Show to the 1933 World's Fair—has generally been thought of as a period when Chicago critics and its public learned to appreciate modernist art, including the work of many immigrant artists like Polish-born Morris Topchevsky, Russian-born painter Rifka Angel, and Todros Geller, who emigrated from the Ukraine and eventually moved to Chicago.[70] The first two artists were included in J. Z. Jacobson's *Art of Today: Chicago, 1933*, a groundbreaking compilation of work by fifty-two Chicago artists—more than half born in Europe—which was published to coincide with the fair.[71] We might fill out this narrative of so-called progress by remembering just how many people in Chicago went to the Armory Show, that is, by remembering not just the artists but also the many viewers. We can never fully know the range of experiences at the Armory Show or how those experiences filtered through Chicago's wider public, including among its many working-class and immigrant communities. Numerous artists beyond those included in *Art of Today* also found footing in Chicago after the Armory Show.[72] The literary scene, perhaps inevitably, given the nature of mastering the English language, did not give rise to such a remarkable array of European-born artists. But the exchanges between the visual and the literary were particularly vibrant in Chicago, magnified by this moment when the Art Institute opened its doors to nearly everyone.

If the Armory Show tested the Art Institute's principles of democracy, then it did so only through the most powerful men in Chicago. In a "big men" moment, to use Monroe's phrase, Arthur Jerome Eddy in fact took Mayor Harrison on a personal tour of the Armory Show. It is a scenario that inspires the imagination: the city's well-known and idiosyncratic cultural patron courting the city's most prominent, and lately reformist, politician, through rooms stacked with avant-garde art. It would be illuminating to know what they discussed. In his memoir, *Growing Up with Chicago*, Harrison suggests that the tour was an education. He spent "hours" at the show with Eddy, whom he calls "an intimate

of many years standing."[73] The experience certainly strengthened Harrison's de-
sire to collect art. He amassed a great collection of postimpressionist art, which
he later donated to the museum. He was not reelected in 1915 but beaten by
William Hale "Big Bill" Thompson, under whose watch Chicago ran foul with
crime, race riots, graft, and gangsters. The stink of Chicago, indeed. But Har-
rison had other lives to lead. It was at the Armory Show in Chicago, Harrison
writes, when he became—to use his own words—"a modernist."[74]

### PEORIA AND PARIS

The Armory Show sent ripples through many groups of artists and writers in
Chicago, from those who gathered at the Fifty-Seventh Street salon or turned
up at the Dill Pickle, to those who talked at clubs and galleries, or wrote for
the little magazines. For someone like Sherwood Anderson, who bridged many
worlds, the show validated why he had left the old forms of respectability and
restraint behind. And for some civic-minded Chicagoans, it was the moment
that crystallized an ambition to put Chicago at the center of avant-garde art.
Chicago did not let the Armory Show come and go: its influence remained
even after its paintings and sculptures were packed on trains headed back east.
The Arthurs—Eddy and Aldis—were proponents of what became an important
new establishment, the Arts Club of Chicago. Carter Harrison was also invited
to the club's founding meeting in 1915.[75] Ultimately, though, several women
were responsible for the club's vision and its remarkable success.

Located for its first two years in the Fine Arts Building, where many creative
plans in Chicago were hatched (from the Little Room to the first offices of the
*Dial, Poetry,* and the *Little Review*), the Arts Club was the earliest place to see
modern art in the United States, before the Museum of Modern Art opened
in New York in 1929. The club also organized programs and lectures that illu-
minated contemporary literature, theater, dance, and architecture. A group of
individuals affiliated with the University of Chicago likewise established the
Renaissance Society to support the visual arts, though the society did not be-
come committed to the avant-garde until the late 1920s, under the leadership
of photo-secessionist Eva Watson-Schütze (one of the artists included in *Art of
Today*). Watson-Schütze joined Alfred Stieglitz in the movement to foster pho-
tography as a fine art; she looked to the women of the Arts Club as a source of
institutional inspiration.

Many of the most important artists of the twentieth century received their

first solo exhibitions in the United States at the Arts Club. The club brought Picasso's work to Chicago, his first major US show in March 1923, with a catalog introduction by Bloomsbury artist Clive Bell.[76] Other artists who exhibited during the Arts Club's early years, an astonishing list, include Constantin Brancusi, Georges Braque, Marc Chagall, Salvador Dalí, Jean Dubuffet, Arshile Gorky, Marsden Hartley, Fernand Léger, Robert Motherwell, Isamu Noguchi, Jackson Pollock, Auguste Rodin, Georges Seurat, and Henri de Toulouse-Lautrec. Shows by these artists were complemented by exhibitions of non-Western art that bore some relationship to modernism, like Chinese porcelains, African masks, and Egyptian sculpture. The Arts Club was decidedly international in its outlook, to some extent overlooking Chicago's many gifted and idiosyncratic artists. The Renaissance Society, by contrast, exhibited some work by Bronzeville artists in the 1930s.

In the first two years of the Arts Club, members debated its reach. When it was decided that exhibitions should *not* give preference to Chicago, artist and interior designer Rue Carpenter became president.[77] Carpenter came from an established Chicago family; her father was a great benefactor to the Art Institute's collection of European art. She married the famous Chicago-born composer John Alden Carpenter, who helped to guide the club's music program and whose best-known pieces include the ragtime-inspired *Skyscrapers* (1923) and, with Langston Hughes, a collaboration called *Four Negro Songs* (1926). The other key figure at the Arts Club was Alice Roullier, who was the club's exhibitions coordinator through the early 1940s. Not surprisingly, records from the club reveal that Harriet Monroe was an early chair of the club's literature committee, made up of five other members and including Fanny Butcher.[78] The club became a stylish venue for a range of events (it also served fine cuisine), supported by members who paid annual dues and by professional artists who joined the club at lower rates. The aim of the Arts Club, according to Roullier, was to bring to Chicago "the Art of the 20th Century *in the making.*"[79]

It would have been impossible for Carpenter and Roullier to understand art and literature along entirely midwestern or even primarily American lines. Carpenter traveled often with her family to Europe, where she found friends among other expatriate Americans, including Sara and Gerald Murphy, the couple after whom F. Scott Fitzgerald modeled Nicole and Dick Diver in *Tender Is the Night* (1934). Photographs from the 1920s show Carpenter and her daughter Ginny preening with Sara Murphy on the beach in Antibes, like three graces in swimwear (fig. 46). With a bit less glamour, Roullier learned the business

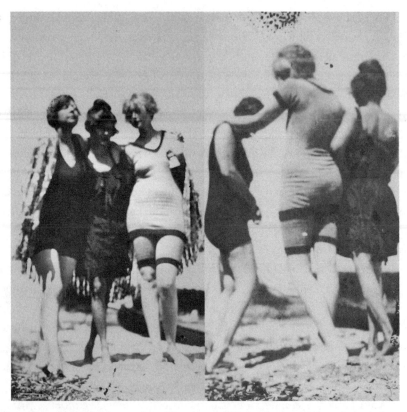

*Fig. 46. Rue Carpenter, Sara Murphy, and Ginny Carpenter, 1923. Sara and Gerald Murphy Papers, Yale Collection of American Literature, Beinecke Rare Book and Manuscript Library. From Deborah Rothschild, ed.,* Making It New *(2007)*

of art from her French father, Albert Roullier. His gallery—one of the few in Chicago—specialized in prints and drawings and operated out of the Fine Arts Building. Alice Roullier spent every summer in France. Her friend Thornton Wilder, who taught at the University of Chicago, told her that he felt "the true radiant France in you," though she never moved permanently away from Chicago.[80] When Fanny Butcher went to France for the first time in 1929—and met Hemingway—Roullier went with her. Roullier was also with Butcher when she met Stein and Toklas in the French countryside in 1931.

Carpenter and Roullier forged important friendships with artists from around the world. Over the years, many artists gifted work to Carpenter and Roullier and showed gratitude with portraits made of them in Chicago when visiting. The Romanian sculptor Constantin Brancusi drew *Hommage à Ma-*

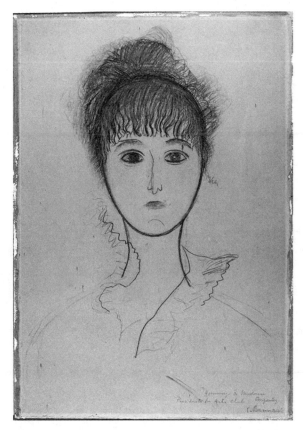

Fig. 47. Constantin Brancusi, Portrait of a Woman
("Hommage à Madame Carpenter"), undated. Black crayon
and pencil on paper, 24 ³/₈ × 16 ⁷/₈ in. The Art Institute of
Chicago, Copyright: © Artists Rights Society (ARS), New
York/Estate of Constantin Brancusi

*dame Carpenter* in 1917, an elegant portrait marked by the oval geometry of Carpenter's head and eyes (fig. 47). And in 1935, the Russian-born surrealist Pavel Tchelitchew drew Roullier with an air of mystery rendered in dark ink, finely shading her heavy-lidded eyes. He inscribed it with words similar to Wilder's: "à Alice qui m'a donné un peu de Paris à Chicago" (fig. 48). Correspondence between these two women and the artists whom they chose for exhibitions is often detailed, playful, and intimate. The French artist Fernand Léger—a modernist in love with the aesthetics of the machine age—sent Roullier a colorful New Year's card penciled with bright, balloonlike flowers, his geometries softened (fig. 49).

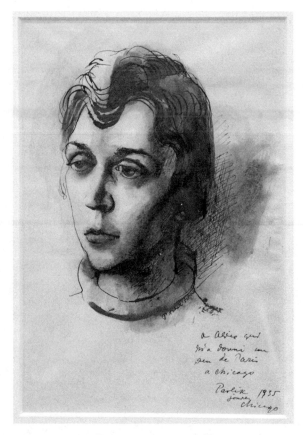

*Fig. 48. Pavel Tchelitchew, ink sketch of Alice Roullier, 1935.
Courtesy Arts Club of Chicago*

Léger was particularly enamored with Chicago and the Arts Club. In 1931, soon after Carpenter's early death and in memory of her, Léger celebrated the visual power of Chicago in an essay for a Paris periodical that Wilder later translated and published in the *Chicago Evening Post*. His description of the city takes a perspective that was likely gained from the high windows of the Arts Club itself, located then in the North Tower of the Wrigley Building: "Oh, splendid panorama of great smokestacks with their plumes of smoke parallel, as though on parade drill. On each factory the name as clearly written as on a great boat. Where is the giant orchestra that can do justice to this spectacle? . . . Here is the highest point of mechanical beauty." The mechanical and industrial power of the city was immensely alluring to Léger. To live in Chicago was to inhabit an explicitly visible modernity. Chicago was the embodiment of

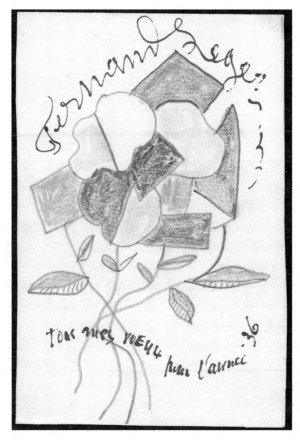

Fig. 49. Fernand Léger postcard to Alice Roullier, 1936.
Courtesy Arts Club of Chicago and Newberry Library

machine-age art, created by an architectural god: "Bridges, more bridges," writes
Léger, "Chicago is a city hung from above."[81]

Apart from tributes by famous artists, it is striking how little is known about
the women of the Arts Club. Though the club kept a meticulous archive, nei-
ther Carpenter nor Roullier left much of an individual record. Carpenter's work
as an interior designer was ephemeral: many of the spaces that she designed
were private, like the Fortnightly Club—Chicago's oldest women's club—and
the exclusive Casino Club, whose rooms are rarely photographed. She also de-
signed, among other places, two early locations of the Arts Club and Fanny
Butcher's bookshop in the Pullman Building, and in 1910, she redecorated
Louis Sullivan's Auditorium Theatre. Butcher's bookshop no longer exists, and
the Auditorium Theatre now bears little trace of Carpenter's work. Except for a

brief 1930 piece for *Vogue*, Carpenter never articulated a design philosophy.[82] Alice Roullier's legacy is even more scant: when she closed her father's gallery in 1953, she had few resources of her own. Letters between Roullier and Duchamp reveal her efforts to sell paintings she owned by the futurist painter Joseph Stella, though Duchamp was not able (or inclined) to help her find a buyer.[83] Roullier had already donated most of her art to the Art Institute.[84] Roullier died in 1963, seemingly impoverished. Nearly nothing is known about her last decade.

Ironically, it was perhaps the Art Institute who benefited most from Carpenter and Roullier and the work of the Arts Club. Early on, Carpenter worked out an agreement with Charles Hutchinson and Robert Harshe (president of the museum from 1921 to 1938) that allowed the Arts Club to use one of the museum's rooms for exhibitions. The club also maintained its separate exhibition quarters. The museum agreed—and gave the Arts Club one of its best skylit spaces on the second floor, which the Arts Club used from 1922 to 1927. It was a mutually beneficial arrangement to allow avant-garde art into the museum, exposing it to a wider audience, but under the auspices of the Arts Club rather than the museum.[85] Of course, unlike a museum, the Arts Club exhibited work for sale, but the club also saw its mission as educational. In her 1922–23 report to the Arts Club Exhibition Committee, Roullier explained: "By maintaining this gallery we have extended our sphere of usefulness and are reaching a large and democratic Sunday public which materially broadens our educational field."[86] The arrangement worked out well until 1927, when the Art Institute decided that it wanted more control over the exhibitions, and the Arts Club did not want to have its exhibitions monitored. With little ill will—Carpenter and Roullier were deft at maintaining important business relationships—the Arts Club continued showing avant-garde art in their own exhibition rooms. But with this move, there was a bigger social barrier to be crossed in coming to an exhibit at the Arts Club: invitations were sent, and the club's rooms, designed by Carpenter, exuded an air of luxury.

In this same year, 1927, Duchamp came to Chicago to install an exhibition of work by Brancusi. Brancusi was dissatisfied with how his work had been shown in New York—and so he sent his friend Duchamp, who was well acquainted at this point with Chicago and the Arts Club.[87] Duchamp arranged Brancusi's work to great effect, away from the walls with ample space between sculptures, in the Arts Club's rooms (fig. 50). A central piece in the exhibition was a sculpture made of highly reflective bronze on a wood and stone base called *Golden*

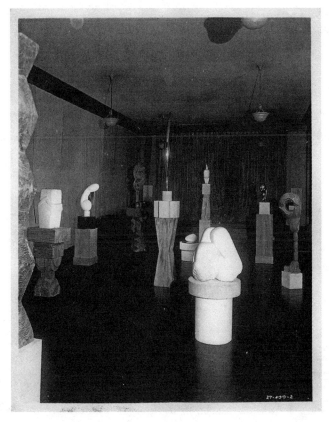

*Fig. 50. Brancusi exhibit installed by Marcel Duchamp at the Arts
Club of Chicago, 1927. Courtesy Arts Club of Chicago*

*Bird* (1916). Already, *Golden Bird* had inspired artists and writers. "An incandescent curve / licked by chromatic flames / in labyrinths of reflections," wrote poet Mina Loy.[88] In 1921, the *Little Review* issued a "Brancusi Number" in which a photograph of *Golden Bird* and many other Brancusi sculptures appear. Ezra Pound celebrated Brancusi's aesthetic in the issue's opening essay. "Above all he is a man in love with perfection," Pound writes of Brancusi's work.[89] Pound had probably seen *Golden Bird* exhibited in New York or in the collection of the patron who owned it: the Ohio-born New Yorker John Quinn.

The Arts Club—which rarely purchased pieces for the club itself—bought *Golden Bird* from Quinn for twelve hundred dollars. Many years later, in 1990, in order to raise money for the club's new (and current) home, the Arts Club sold the piece to the Art Institute for twelve million dollars.[90] Thus, it is with

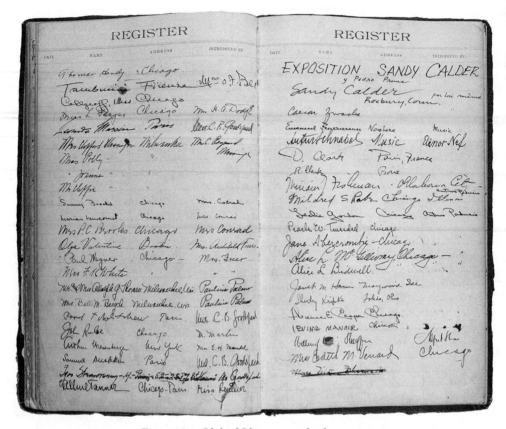

Fig. 51. *Arts Club of Chicago guestbook, 1924–44.*
*Courtesy Arts Club of Chicago and Newberry Library*

some retrospective irony that the "peripatetic" *Golden Bird* was brought to Chicago, eventually saved the Arts Clubs, and now stands—it would be to Quinn's horror—in a museum envisioned for the public.

    The location of the Art Institute and the Arts Club of Chicago—that is, in the Midwest, where it was impossible for Quinn to imagine a "great art being born"—created an audience for modernist art that was both local and international. In the club's enormous guestbook, for instance, during a 1934 exhibition of Alexander Calder's work, one finds the names of visitors from Paris, France, and Peoria, Illinois (and in the following pages, from Cairo, Toledo, and Moscow). This is typical, although it does not give a full sense of visitors (not everyone signed it) and the guestbook spans only the years 1924 to 1944 (fig. 51). What is difficult to know about the Arts Club, like the Armory Show, is how various

visitors from around the Midwest and the world reacted to the contemporary art on display. Exhibitions at the Arts Club might reflect the conditions of modernity with which urban dwellers were becoming familiar—Chicago's bridges and great smokestacks, according to Léger, "with their plumes of smoke parallel." And yet the art was like nothing else. The club's consistently groundbreaking exhibitions became the turf on which Chicago newspaper critics argued about the nature of contemporary art.

Consider, again, Sherwood Anderson, whose career as a writer was deeply embedded in Chicago from 1913 through the early 1920s. Anderson was also experimenting as a painter at least until 1924, completing lush portraits and abstract watercolors that reflect the style of more notable modern painters. It seems likely that Anderson would have visited the Arts Club since his own watercolors were on exhibition there in October 1920.[91] This fact is surprising, because the Arts Club was not particularly interested in exhibiting artwork from the Midwest. And Anderson was then fashioning himself as a working-class artist with straw between his teeth. But the exhibition could not have been big, and it was probably brief. Lamentably, no catalog or photographs exist of Anderson's work, but it is possible to reconstruct some idea of his painting during this period, why he was committed to it, and how painting affected his work with words.

Anderson's descriptions of his paintings emphasize his attraction to variations in light and the movement of color in the natural world. Two of his watercolors —there are few that remain—bear some resemblance to the work of Georgia O'Keeffe, whom he referred to as "my painting mother" (figs. 52, 53).[92] Anderson first saw O'Keeffe's work at Stieglitz's 291 gallery when finally persuaded to visit New York in 1917.[93] Anderson's friendships with O'Keeffe and Stieglitz may have been the most important of his life. His letters to them are passionate, earnest, and mystical.[94] Inspired by the couple, Anderson also felt envy. "You or O'Keeffe would get something from it, make it live," Anderson wrote to Stieglitz in 1923 about the flamboyant soil of the Reno desert, where he had traveled: "I've tried, but can't seem to catch it."[95] Anderson likely showed them his paintings from this period.[96] And works by Stieglitz and O'Keeffe were his most valuable possessions: "Georgia's painting is on the mantle beside my bed and I have some of your photographs in my workroom where I see them every day," he wrote in 1925. "Almost everything else I have fades after a time but these keep on living. They give me something every day."[97]

"Color impulses" is the phrase that Anderson used to describe his watercol-

*Fig. 52. Sherwood Anderson, untitled watercolor, ca. 1924.*
*Sherwood Anderson Papers, Courtesy Newberry Library*

ors on exhibit at the Arts Club. Apparently, the work was accompanied by text, which suggests Anderson's desire to emphasize an intersection between word and image. But the conservative critic of the *Chicago Tribune*, Eleanor Jewett, did not find Anderson's words clarifying. Jewett's review of January 23, 1921, is titled, "A Riddle Is Posed for You to Read in Arts Club Show." She described Anderson's paintings as evoking the sea, a tropical storm, and a great deal of red earth. For Jewett, the exhibit was a "chaos of design."[98] Anderson was hardly in the same aesthetic camp as Jewett, who sat during the 1930s on the board of trustees of the "Sanity in Art" movement, whose aim was to stamp out modern art. But he was attentive to criticism of the show. "I've got my water colors hung in Chicago now, and there is a good deal of discussion as to whether I am insane, decadent, or a new note," he wrote in a letter.[99]

Anderson's paintings are neither insane nor decadent, but they are not particularly good. Anderson suspected that his paintings—which came easily and quickly to him—may have been most valuable as a vehicle for what was to come in his writing. After a trip to Alabama in 1920, when he likely painted some of the work for his Arts Club exhibition, he sensed that his paintings were a preliminary exercise. On his train journey back to Chicago, he wrote to

Fig. 53. *Sherwood Anderson, untitled watercolor, ca. 1924.*
*Sherwood Anderson Papers, Courtesy Newberry Library*

friends: "In the end that is where my painting may count most, to give more color and a sweeter roll to the old boat I call my prose."[100] With his paintings, Anderson wanted to express experiences that he thought might exist beyond language, what he felt to be primal emotions. Frequently, in his letters and memoirs, Anderson alludes to unfulfilled sexual longing, and his phrase "color impulses" (like Stein's "bliss") suggests that Anderson's impetus to paint was bound up in his desire for sexual freedom. He also idealized the folk traditions of the American South, particularly of African Americans, which he believed were more sensual and connected to the rhythms of the natural world. Indeed, one gets the sense that Anderson's worst primitivism underlies his impassioned use of paint.

Anderson lived in Chicago during the first wave of black migration from the rural South to the industrial North; he later spent time in the South, particularly in New Orleans. He imagined that African Americans embodied a preindustrial past more closely connected to the body, for which he expressed envy and admiration. However wrongheaded, Anderson's notion of black sexual power in a modernized white world was treated seriously by several writers and artists with whom he communicated his feelings about race and sexuality,

including Harlem Renaissance writer Jean Toomer, who himself expressed a fraught relationship to being black in America.[101] Anderson admired Toomer's stunning 1923 work *Cane*, and for Toomer, the stories Anderson wrote were like "natural elements, like the rain and sunshine, of my own sprouting." He wrote to Anderson, "It is hard to think of myself as maturing without them."[102] Toomer's praise strangely conformed to Anderson's idea of African Americans as more "natural," as if Toomer was a "sprouting" tree rather than a human being.

Anderson's conception of race, of course, trapped black people in a bygone era and sidelined the immediate struggle for political agency and civil rights. A small watercolor that Anderson likely painted after a period in New Orleans during the 1920s is essentially a racist caricature. A black woman in profile wears a pink spotted handkerchief on her head; her exaggerated lips are pursed; the whites of her eyes contrast against mottled purple skin (fig. 54). It's unclear whether the portrait is meant to be slightly abstracted. More likely, Anderson lacked the skill to capture the woman's expression more finely. Especially in conjunction with Anderson's other watercolors, this profile seems to bind the woman to the green growth and soil that Anderson also painted during this period. This is not the machine-age world of Léger's bridges and smokestacks. But neither is it a compelling folk portrait.

Ultimately for Anderson, language was the medium that more effectively expressed the "impulses" that Anderson felt surged through the living world. Because language was a way of representing experiences at further remove from the colors and patterns of nature, writing down words forced Anderson to give form to what he felt was unformed inside of himself. Certainly, writing was bound by the conventions of appropriate (and publishable) language, but these limits became useful grips for Anderson. Chicago was where he felt his writing take shape in the best stories he would ever compose.

*Winesburg, Ohio*—writing that Anderson described as hard work and "craft"—is the fullest expression of what Anderson experienced when he moved to Chicago. What he absorbed from the Armory Show and elsewhere is everywhere evident. The collection is shaped by both midwestern and international influences, both Peoria and Paris. Beneath the concentrated realism of its prose lies the influence of modernist experimentation across genres: Stein's linguistic repetitions, the new photography, and the perspectival distortions of the painterly avant-garde. Modernist in design, the stories are preoccupied with ordinary moments, focusing tightly on character and less on plot. Throughout, the muted omniscience of the narrator hovers, asking: How can language register the feverish inner life

*Fig. 54. Sherwood Anderson, untitled watercolor, ca. 1920s.*
*Sherwood Anderson Papers, Courtesy Newberry Library*

of the town's inhabitants? However modest Anderson's stories may seem, *Winesburg, Ohio* is an expression of minimalism at its most technically honed.

The interlocking stories of the collection present multiple points of view from various people who live in a small midwestern town. Anderson's attention to the collective life of a community took a cue from Edgar Lee Masters's *Spoon River Anthology*, which Anderson admired, and found a later counterpart in Gwendolyn Brooks's *Street in Bronzeville*. All three collections illuminate the lives of common people in groundbreaking styles that were nonetheless accessible to mainstream readers. Many of the characters in *Winesburg, Ohio* are plagued by sexual longing, a lack of fulfillment, and a profound questioning of their own aspirations: a lonely young woman who runs naked through the streets in the rain; a mother who remembers dressing up in men's clothing and

riding a bike; a telegraph operator who despises women; a popular minister who is also a peeping tom. Some reviewers were shocked by what they felt to be the collection's frank portrayal of desire. "Fully half of the twenty-four bits of fiction are of a character which no man would wish to see in the hands of a daughter or sister," wrote the *New York Evening Post*.[103] *Winesburg, Ohio* was almost immediately enlisted in the moral controversies surrounding modernist art.

It is striking to note that as these short stories were first being published in small periodicals—and Anderson met writers and editors from New York—he became more committed to Chicago and to fashioning himself as a midwesterner.[104] In truth, he did not really know what kind of artist he should become, and he was never sure what defined artistic success. But he felt a strong instinct to stay in Chicago. "You know how I have had the notion that nothing from my pen should be published that could not be read aloud in the presence of a cornfield," he wrote in November 1917 to Waldo Frank, one of the Ivy League–educated editors of the little magazine *Seven Arts*, whom he met on his visit that year to New York. Anderson claimed to Frank that he was "not a sophisticated fellow in the sense you are."[105] But this was part performance: Anderson's years in Chicago exposed him to a "sophisticated" cultural scene as much as these years inspired him with the twinned images of agriculture and industry that mark the 1917 poems of *Mid-American Songs* published in *Poetry*. Chicago's cultural life was nonetheless still very much "open," to use Monroe's word, and "unformed," to use Anderson's. "One isn't beset by a little body of opinions," Anderson wrote in a 1918 letter about Chicago, "because there is no opinion."[106] This sense of possibility committed Anderson to Chicago, where literary opinions were his own to make.

### LITTLE CHILDREN OF THE ARTS

When I visit any other great city of the world I am a guest.
When I am in Chicago I am at home. Something loose, unformed,
undisciplined alive in Chicago is in me too. It is a little what I am.
I am more than a little what Chicago is.

SHERWOOD ANDERSON, 1926

Sherwood Anderson apparently wrote the first story of *Winesburg, Ohio*, "Hands," in one fell swoop on the backside of manuscript pages for a novel that he had brought with him to Chicago. This would have been sometime in late 1915 or early 1916, a few years after the Armory Show, when Anderson was an unknown writer and right before his first novel was published.[107] The story describes a

former schoolteacher, Wing Biddlebaum—accused of pedophilia—who has fled his past life and lives on the fringes of town. Biddlebaum is an outcast and a character who enables others in Winesburg to define themselves: "Wing Biddlebaum, forever frightened and beset by a ghostly band of doubts, did not think of himself as in any way a part of the life of the town where he had lived for twenty years."[108] And yet everyone in Winesburg knows where Wing lives and feels a strange collective pride concerning Wing's remarkably expressive hands. He is one of them, but different. Wing stands at the limits—of geography, of acceptability—of the town itself.

"Hands" contains moments of artistic self-definition: the prose is "crudely stated," in the story's words, as the narrator strains to create a new mode. The title of the story becomes a leitmotiv of the collection, in which hands are symbolically revealing, bound up in a person's labor and artistry. "The story of Wing Biddlebaum's hands is worth a book in itself," the narrator laments. "Sympathetically set forth it would tap many strange, beautiful qualities in obscure men. It is a job for a poet."[109] "Hands" asserts a desire to articulate—or to gesture toward, to draw on the story's own metaphor—emotions that seem inexpressible. Implicit in the story is an awareness of the bounds of genre: would poetry or painting be better suited to express the truth about Biddlebaum? As Anderson wrote the stories of *Winesburg, Ohio*, in language that probed its limitations, he was testing his own self-definition as an artist.

When Anderson finished his first draft of "Hands," he walked outside to a bar down the street, bought everyone drinks, and then finally mustered enough courage to go back and read what he had written. He realized that it was good, and he broke down into tears. He had put into words the wordless, that which he had been trying to express in his paintings, and what his lonely character Biddlebaum expressed in the physical touch of his hands. "It is solid," Anderson said to himself, "It is like a rock. It is there. It is put down."[110] As much as "Hands" is a product of Anderson's experience in Chicago—and the aesthetic revolution that shaped him—it is also a story that simultaneously stands apart from the particularities of its making. He realized that it was a work of art.

Anderson's stories were part of the larger artistic transformations of the twentieth century in which the materiality of the medium is made evident in the work of art itself. In the penultimate story, "Sophistication," two characters, George Willard and Helen White—both on the cusp of adulthood—find each other after the town fair and take a walk through the outskirts of town. As evening falls, they kiss and embrace; they climb a hill and chase each other down; they speak very little. The end of the story marks a moment of emotional significance

between George and Helen but does not elucidate what the moment means: "For some reason they could not have explained they had both got from their silent evening together the thing needed. Man or boy, woman or girl, they had for a moment taken hold of the thing that makes the mature life of men and women in the modern world possible."[111] What is "the thing needed"? Perhaps it is a numinous communion between two people, a bond beyond language. The success of Anderson's story derives partly from the fact that he does not try to tell us. The final sentences of the story call attention to what language can and cannot perform, and the absence of words deepens the story's emotional heft. To leave words out—as Hemingway would learn from Anderson—is its own form of structuring emotion.

For Anderson, composing these stories also gave solidity to what he felt was unformed inside himself. He wrestled energetically with how he was to become an artist in Chicago. Chicago seemed to be a push and pull between newfound freedoms—so visibly expressed in the work of the Armory Show—and inevitable restrictions: between the ambition to work in experimental ways and the familiar allure of making money. Anderson's choice to abandon his family back in Elyria opened up a new world in Chicago of younger artists and writers; and yet, he felt somewhat outside of this circle, and he clung to more conventional ideas about what it means to be an artist and a man.

Mayor Harrison would say that Chicagoans' two major desires were to make money and to spend it.[112] Whether or not this was unique to Chicago, the desire to make money would always afflict Anderson. Chicago did not temper his dreams of financial success. Like other artists and writers, Anderson became part of the commercial world that flowered during a period of tremendous industrial growth in Chicago. He quickly took a job writing copy for a large advertising firm, Taylor-Critchfield, where he had worked years earlier before his first marriage. Anderson worked in advertising until 1922, even after he became a well-known writer with the full publication of *Winesburg, Ohio* in 1919. When he befriended young Hemingway in Chicago, in 1920, Anderson was a senior executive. Despite what he wrote about the "stink" of his clothes, Anderson regularly donned the suit of an ad man. In previous years Anderson had even written a column for the firm's in-house newsletter that earnestly celebrated the life of the American businessman.[113] The Chicago newspapers liked to claim Sherwood Anderson as someone who could be part of different worlds: his scrapbook contains newspaper clippings with titles like "Business Man Writes a Series of Novels," and "An Advertising Man Who Writes Good Fiction."[114]

But it was hardly to find an advertising job that Anderson left Elyria for Chicago. Anderson attempted to forge a new identity as a writer and artist, stead-

fastly in opposition to a culture of respectable money-making and family life. He found in Chicago the ability to give voice to "sensations" and "forms," in his own words, that were the wellspring of his most powerful fiction. Would Anderson have produced lasting works of art if he had not gone to Chicago? From the Armory Show to the forums, plays, and parties of the Dill Pickle, Anderson was influenced by a new urban bohemia. His praise for the Dill Pickle's founder Jack Jones—in the form of a newspaper advertisement with a striking woodcut by Polish-born Chicago artist Stanislaw Szukalski—is directed at artists who need a place apart from a "dark and dreary commercial world" (fig. 55). Anderson's phrase for the tenants of his Cass Street boardinghouse, "little children of the arts," also refers to very specific artistic developments in Chicago: the early social group in the Fine Arts Building that called itself the Little Room; the "little theater" movements of Maurice Browne, the Lake Forest Players, and Hull-House; and Margaret Anderson's *Little Review*, which published Anderson's artistic manifesto, "The New Note," in its first issue in March 1914. Chicago's artistic scene was "little" in name yet completely galvanizing.

Consider Anderson's "New Note," which reflects his understanding of Chicago's bohemian culture but also his struggle to find a place in it. Anderson's experience in business and advertising and his age set him apart: he was ten years older than Margaret Anderson and of a different generation than the cohort of younger Chicago writers who also contributed to the magazine's first issue— including Floyd Dell, Vachel Lindsay, Margery Currey, and Eunice Tietjens. "The New Note" takes the tone of a wise man advising his "little children." In the piece, he summons "last year's exhibit," the Armory Show, and praises the "ardent young cubists and futurists, anarchists, socialists, and feminists." But frankly, he claims, the appeal to newness is "as old as the world": "Simply stated, it is a cry for the reinjection of truth and honesty into the craft: it is an appeal from the standards set up by money-making magazine and book publishers in Europe and America to the older, sweeter standards of the craft itself." To be "new" is not enough. Anderson presents himself as a writer committed to "craft," a word suggestive of vocation and physical labor. "Craft" claims writing as its own kind of work, apart from the "money-making" of book publishing. Anderson's hope is that the "new" art will not succumb to the demands of the commercial world but stay true to a longer tradition. "The New Note" may seem to take a stab at Ezra Pound's demand to "make it new," but it also shares Pound's disdain for commercial influences on art. "Do not be led aside by the many voices crying of the new," he concludes. "Be ready to accept hardship for the sake of your craft in America—that is craft love."[115]

# JACK JONES—"THE PICKLER."

### BY SHERWOOD ANDERSON.

ARE you a struggling poet, groping your way through a dark and dreary commercial world? Have you written a prose masterpiece that some money minded publisher will not publish? Are you an eager young feminist, longing to lift womankind into the higher life? Have you painted or sung or sculped or thought something that the dull minded world does not appreciate?

What have you done? What have you to say? Jack Jones and the Dill Pickle are looking for you.

Jack Jones is the father, the mother and the ringmaster of the Dill Pickle in Tooker alley, just off Dearborn, north of Chicago avenue, on the north side.

You may have visited the neighborhood. There is a charming little park just around the corner from the Pickle. It is filled with benches and trees and the big, grim, wise looking Newberry library looks down on it. Before Jones came to gather together what he calls his "trained band of nuts" the poor homeless nuts lived with the squirrels in the park. On warm summer Sunday afternoons they came forth in droves. One by one they climbed upon soap boxes and talked to the sad eyed loafers gathered about.

Two years ago Jones, the Pickler, arrived. None knew where he came from and you'll never find out from Jones. For a time he worked as a house painter and ran the Pickle as a week-end diversion.

Then trade began to look up. The nuts were gathered out of the park and to their amazement found themselves in a big, comfortable room filled with brightly painted chairs and a pulpit from which to talk until they were weary. Something happened to them.

What happened is the secret of Jones. The nuts talked and everybody laughed. In spite of themselves the nuts began to laugh. "There it is. Don't you see," said Jones, chuckling and wagging his head, "the proletariat and the working stiffs are just like the painters and the poets. They'll laugh if you give them a chance. Even a skinny, long haired poet will laugh if you give him a hand and a warm place to sit."

At that the Pickler might have been overlooked had it not been for the highbrows. Several months ago our very best thinkers began to make their way, rather sheepishly at first, into Tooker alley, and now you are likely to find any one there. The street car conductor sits on a bench beside the college professor, the literary critic, the earnest young wife, who hungers for culture, and the hobo. Jack Jones is always in the background. To every guest he puts the same question, "Are you a nut about anything?" he asks. "Don't you want to talk to the Picklers?"

Jack Jones and the Dill Pickle are two

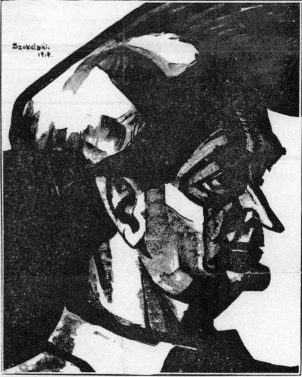

**JACK JONES.**

(Drawn especially for the Wednesday book page of The Daily News by Stanislaw Szukalski.)

bright spots in the rather somber aspect of our town. The highbrows don't walk with Jones on Michigan avenue yet, but that may happen any day. Besides the Sunday evening affairs in the Pickle itself, he is now putting on a strictly artistic and very literary affair every Thursday evening. The street car conductors and the nuts from the park seem to be following Jones into this new venture. On almost any Thursday evening the Dill Pickle chapel is filled with the devotees of the arts. When things grow a bit heavy and dull Jones cheers up the children of the arts as he formerly cheered the park hangers-on. Bright eyed, alert, filled with good natured laughter and a born showman. Jones and the Dill Pickle may go very far.

It would be a delightful surprise if Jones the Pickler should achieve in Chicago what Maurice Browne, with his Little theater, and all the more serious minded yeomen who have tried so hard to make a home for the arts among us, have failed to do.

In the meantime Jones isn't worrying. If art wants to come and make its home in the Dill Pickle he'll be ready for it. If things grew dull he'll chuckle and try to stir up a row. If you go to see him he'll ask you the same question he asks every one else—"Are you a nut about anything? Don't you want to talk to the Picklers?"

What have you done? What have you to say? Jack Jones and the Dill Pickle are looking for you.

Reprinted from the Wednesday Book Page of The Chicago Daily News
Wednesday, June 18, 1919.
Henry Blackman Sell, Literary Editor

*Fig. 55. Sherwood Anderson, advertisement for the Dill Pickle Club, 1919, woodcut by Stanislaw Szukalski. Sherwood Anderson Papers, Courtesy Newberry Library*

As Hemingway would later insist, the "craft" of writing requires hours of toil, day after day, to arrive at "one true sentence."[116] It is genuine work. Both Anderson and Hemingway—and later, Richard Wright—conceived of their writing as labor, a difficult process of composition that would produce a well-wrought style. Wright's 1937 call for writers to assert the "autonomy of craft" pinpoints the necessity of making art that rises above competing forces—whether this is politics, the marketplace, or the expectations of readers.[117] This conception of writing as craft was formed in Chicago during periods when these writers also held jobs in other fields—advertising and journalism—through which they used their skill with words primarily in order to make money. As Anderson was becoming a writer in Chicago, he still felt bound to the obligations of more commercial work, not just because of the income, but also because it was central to Anderson's idea of himself as a man. Furthermore, American advertising during the years when Anderson wrote for Taylor-Critchfield was filled with rhetoric from the days of traveling salesmen in the American countryside, selling their wares.[118] For Anderson, advertising could be imagined as a kind of physical work and art as a kind of labor.

Ultimately, the formation of American manhood becomes the great theme of *Winesburg, Ohio*, as the stories loosely track the growth and development of the young newspaper reporter George Willard. In the final story, "Departure," George boards a train at the Winesburg station, headed to Chicago, anxious "to meet the adventure of his life." But George's desire is formless—he has little idea of what this adventure should be. Anderson's "Departure" reverberates with many other train journeys in the history of Chicago literature. Yet it is also a very strange moment. Waiting for the train to depart, George takes out his pocketbook and discreetly counts his money. He then closes his eyes, dreaming, and entirely misses the moment when the train leaves the station:

> With the recollection of little things occupying his mind he closed his eyes and leaned back in the car seat. He stayed that way for a long time and when he aroused himself and again looked out of the car window the town of Winesburg had disappeared and his life there had become but a background on which to paint the dreams of his manhood.[119]

The distinctive pared-down prose of these final two sentences of *Winesburg, Ohio* is built on the repetition of "and," which joins together George's thinking, sleeping, and being "aroused," like the slow roll of the departing train. Sleepy

yet yearning, George is not moving but the train is. Will he be a passive or active creator of his life? We see in these simple sentences how Anderson's prose became a guide for Hemingway. "Paint," here, is the most telling word. It underscores a tension between form and formlessness, between what can be expressed and what is still inexpressible. To "paint" over Winesburg—to leave his past and become an artist—is to become a man. And yet, Anderson's language suggests deception: his past obscured, manhood is only a dream.

If George is a kind of substitute for Anderson, then he is also an archetype of the midwestern dreamer who heads to Chicago, from Dreiser's *Sister Carrie* onward. But there is a more literal way in which *Winesburg, Ohio* reflects the forces of Anderson's Chicago. The characters in the collection were versions of Anderson's real-life community, the "little children of the arts" who lived in the Cass Street boardinghouse. In his memoir, Anderson explained it this way: "The idea I had was to take them, just as they were, as I felt them, and transfer them from the city rooming house to an imagined small town, the physical aspects of the town having, let us say, been picked up from my living in several such towns."[120] This process of "transfer" allowed Anderson to imagine the lives of people with whom he felt a bond of creative life, and yet people whom he did not really know well. He felt both kinship and fundamental difference because of his age and his past experience in business. He also felt a jolt of sexual difference, a complicated mixture of fear and attraction to what he had never known.

The emphasis on sex—and sexual deviance—in *Winesburg, Ohio* is partly a result of Anderson's exposure in Chicago to a gay, urban subculture. In his memoir, he describes an episode in Chicago when he first sees "homosexuality that was unashamed." Another time, he meets a woman at his boardinghouse who is "crying on the stairs": wearing men's clothing, the woman tells him that she is in love with another woman who does not love her. "It may be that I had been too much with business men, advertising men, laboring men, men who felt the practice of the arts in some way unmanly," Anderson writes. "These new people, in some way a bit hard to explain, emphasized in me, shall I say, my maleness. At least they gave me a new confidence." Anderson felt that the sexualities of his rooming house friends were "a terrible problem," but he also felt that he could "sympathize with them in their plight."[121]

However patronizing Anderson's reactions might seem, Anderson's "sympathy" ran deeper as well. His conflicted relationship to advertising produced his own feelings of emasculation that he performed with profound self-contempt. Anderson describes how he and other colleagues at Taylor-Critchfield who

also aspired to become writers might address each other as "Mable" and "Little Eva": "We are little male whores. We lie with these business men," Anderson writes.[122] Here, Anderson degrades advertising as a betrayal of principles, an act of prostitution. But in other instances, the money that he earns from his work in advertising sustains Anderson's sense of what a man should be.

The exquisite complexities of *Winesburg, Ohio*—and its wise, beleaguered tone—reflect the many competing forces that Anderson felt in Chicago, particularly between the work of making money and the work of making art and how this work defines one's masculinity. Perhaps what caused a fundamental conflict in Anderson—and which inspired his best work—was an antiquated definition of manhood that he could not abandon, despite his exposure to Chicago's artistic bohemia. Anderson could not rid himself of the idea that ambition, intellect, and money were the province of men. His marriage to Tennessee Mitchell suffered when she began to realize, in her forties, her own promise as a sculptor. (They divorced in 1924.) "Were I a Frenchman I would make a bon mot to the effect that all women, when the man does not want them, think of him as either impotent or crazy," Anderson wrote to a friend during his divorce— supposing that a woman thinks of herself only as an object of sexual desire.[123] Anderson may have been inspired by the idea of gender equality, of being free from the bounds of a traditional marriage, and yet he was confused by a persistent desire for affirmations of masculine authority and visible success.

But the confusion yielded greatness: works of art that exist far beyond the internal contradictions of Sherwood Anderson himself. No American writer explores masculinity better. Anderson was, in this respect, an ideal mentor to Hemingway, whose voice as an emerging writer and journalist was cultivated through the act of imagining how female readers—especially in Chicago—would respond to his work. For both writers, Chicago was a place of artistic vibrancy at particularly impressionable periods in their lives. It was a new, unsettled city that fostered both experiment and also critical anxiety about the kind of art that the city should produce. It was a city of powerful, money-hungry titans and sophisticated, behind-the-scenes women—women who ran the publications, exhibitions, bookstores, and salons where Chicago's art and literature thrived. It was a city whose patrons espoused art for the masses and whose mayor, for a time, could be called a modernist. It was a city built by large laboring classes and powerful industries that yet attracted the unformed dreams of artists. It is not easy to reconcile the forces of Anderson's Chicago. It was his "home" because the city's conflicts were his own.

Fig. 56. Souvenir pocket mirror with photograph of Fanny Butcher on board ship for second trip to France, 1931. Fanny Butcher Papers, Courtesy Newberry Library

# Paris, May–June 1929

SPRING IN PARIS ON THE CREST of a wave, just before the crash. Fanny Butcher knew enough French to eat and sleep alone. Her bookshop had sold, and she finally had money. She had sailed with Alice Roullier, the daughter of a Frenchman who ran one of the few galleries in Chicago. On stepping off the gangplank, Alice had become as inherently Parisian as the old pink lights in the Tuileries Garden. But Fanny was not the slightest bit homesick, imagining the figures of Flaubert and Zola haunting the old cobbled streets, wandering in the bosky Bois de Boulogne, tilting her head up to see the statue of Napoleon atop the column in the place Vendôme. She was in love. She wore her best blue suit, with pearls, a peacock feather pinned to the netting on her hat. She drank the dark, bitter coffee. When she caught her reflection in the window of an antique shop on the rue des Saints-Pères, she thought, I am still a young newspaper girl from Chicago.

She wrote dispatches for her thousands of *Tribune* readers back in the Midwest, imagining that they were with her: the shopgirls, clerks, businessmen, and mothers. She noted the pink and white chestnuts, the gray stone set against the blue sky, the inspiring vaults of Notre Dame. "All of the modern lift and rise in architecture is inherent in those columns. They mount higher and higher and give you that same sense of soaring power that skyscrapers do."

Everything circled back to Chicago. She and Alice visited artists and sculp-

145

tors with an eye to exhibits at the Arts Club. Alice liked Fernand Léger, a dar-
ling of the *Little Review*, who had seen action on the front and nearly died
from mustard gas at Verdun. He imagined industrial man-birds and modern
machines, godless geometries of surface and color. Alice and Fanny told him
that he should really see the Merchandise Mart, a colossal rhomboid on the
banks of the Chicago River, the largest building in the world.

Alice provided introductions to French writers, whose work Americans knew
in translation: André Maurois, Colette, Georges Duhamel. Fanny wrote down
addresses in a tiny three-inch diary that fit inside her pocketbook. She found
her old friend Ferb in a deluxe suite atop the George V Hotel. They dined on
the rooftop balcony as the sun sank beyond the mansard roofs. Nobody could
make Fanny laugh harder than Ferb, who became more effusive as the lights of
the city sparkled below. The French had given a new name to their production
of *Show Boat*, adapted from Ferb's novel: *Mississippi*. Ferb mocked the local
pronunciation: "Mee-eese-see-pee."

Ferb was surprised to hear that Fanny had given up her little Chicago book-
shop, tucked perfectly into a corner of the Pullman Building across from the Art
Institute. She had been so good at selling books! Remember the dapper customer
who came in looking for Keats? He had walked out holding T. S. Eliot, Claude
McKay, and Carl Sandburg—wrapped in distinctive lemon yellow paper and
tied with orange tape. Ferb had supplied a testimonial, which for many years
Fanny used in her advertising: "Fanny Butcher knows what you're talking
about, even if you don't." But the workload was immense, and the executives at
Doubleday had asked her if she would sell.

It had been the only way to get her across the Atlantic. When she found
Sylvia Beach working behind the stacks of books and signed portraits at Shake-
speare and Company, Fanny felt no nostalgia for her own shop. Miss Beach
had heard of it, and they talked for more than an hour. She had one of the most
intelligent faces that Fanny had ever seen. She said nothing when Fanny asked

about seeing James Joyce, but two days later, Fanny received a note: "Would you like to interview Mr. Joyce, at three o'clock today?" He lived at a respectable address, even dull, just off the rue de Grenelle.

Several minutes early, Fanny stood outside the heavy door to his apartment, and finally knocked. Joyce pulled the door open, slowly, and the room inside seemed a vast shadow, the drapes closed across the windows. She could not discern the stacked paintings hanging on the walls. Nearly blind, he moved with angular jolts, as if nervous. First he made her promise that she would not write anything about him for an American newspaper or magazine. When she asked him if he might ever come to America, where his books were praised, where he had eager admirers, where *Ulysses* had first been published, he replied with a perfunctory "no."

It was like depositing your last dime in a payphone and getting a dial tone. He said *yes* or he said *no*. Every time she clutched her handbag to signal departure, he would utter a whole sentence. Finally, after an hour and a half, he accompanied her back to the door with his first smile: "I have really enjoyed this afternoon greatly. Do be sure, please, the next time you are in Paris to let me know and let me see you." Mystified by his formality, she suspected it must be a protective shroud, his suffering underneath it.

Hemingway would surely be easier. She had kept up with his whereabouts from Sherwood Anderson, who had sent him off to Paris five years ago with letters of introduction to Miss Beach and Gertrude Stein. Fanny's readers would want to know about their boy from Oak Park. She would try to see him, despite how she had panned *The Sun Also Rises* in the *Tribune*. His self-seeking characters still irritated her.

Butcher met him in a café perched on the Left Bank. The linden trees glittered above the small tables set along the street, bustling with young men and women. A decade younger, Hemingway was not even thirty, still dimpled and handsome. But he exuded the coolness of a killer. He ordered a bottle of

Sancerre, *très froid*. She did not really like to drink, but she took small sips. He did most of the talking.

In high school, he chuckled, he had used the penname Ring Lardner. "I worked like hell on those yarns." He mentioned all of the other writers whom he knew at the *Tribune*. He spilled names. He told her that Dreiser had turned up in Paris two years ago on his way to Russia, in love with Marxism but inspired by American capital. The French translator of *An American Tragedy*, he cracked, certainly improved Dreiser's prose. Hemingway told her that even Fitzgerald thought his own masterpiece sounded more wonderful: *Gatsby le Magnifique*. "Best thing he'll ever write," Hemingway whispered as in confidence. "Zelda wrecked him." He ordered another bottle, and a dozen oysters shining on a bed of shaved ice. He showed her how to eat them with a tiny two-pronged fork. A young Englishwoman said sitting next to them, "I say, we ought to toast something."

She supposed he was nice. He looked a little drunk, a slight sheen to his brow. She told him that she looked forward to his next novel, that he was becoming a writer of power and individuality. She hoped that he would take good care of himself. Her readers would see the golden glow within him, corn and wheat fields, the heartland. From across the street, the pealing bells of the old Église Saint-Germain-des-Prés suspended talk for a moment. She would like to go inside the cold, medieval dark. She felt, in a flash, like a very wise matron.

THREE

# Hemingway's Readers

## GOOD LADIES

When Ernest Hemingway's first novel, *The Sun Also Rises*, was published in 1926, his mother, Grace Hall Hemingway, sent him a disapproving letter. She wrote from Oak Park to Paris, where Hemingway was living with his first wife, Hadley, and their young son. Included in his mother's letter was a newspaper clipping: Fanny Butcher's (unsigned) review of the novel in the Saturday books section of the *Chicago Tribune*. The review was also reprinted in the Paris edition of the *Herald Tribune*, where Hemingway had likely already seen it. Butcher felt that Hemingway had wasted his homegrown talent:

> "The Sun Also Rises" is the kind of book that makes this reviewer at least almost plain angry, not for the obvious reason that it is about utterly degraded people, but for the reason that it shows an immense skill, a very honest and unimpassioned conviction about how writing should be done, a remarkably restrained style, and is done in an amusing and clever modern technique.[1]

Hemingway's "genuine gift," according to Butcher, had been used for "sensationalism and triviality." There was too much drinking and too much sex—even though the novel's protagonist is impotent. (Butcher, however, does not use this word in her review.) In a characteristic move, Butcher also assumed to know how her readers would respond to the new novel, as if her readers were mothers much like Grace Hall Hemingway. "Your sensitiveness," Butcher wrote in an odd turn of phrase, "objects violently to it."[2]

Indeed, Hemingway's mother objected violently to the story of dissolute expatriates whom Gertrude Stein in conversation with Ernest Hemingway called

"the lost generation," a comment that Hemingway used as an epigraph for his novel. Despite—or perhaps because of—her own skill as a painter and a musician, Grace Hall Hemingway had clear ideas about how art, in her words, should "exalt the nobility of life." In her lengthy handwritten letter—a neat, flourishing, cursive script—she explains why she is deeply concerned for her "Dear Boy Ernest": she has heard rumors of his dissolving marriage and adultery; she suspects that he is drinking too much; and she is embarrassed by what her neighbors in Oak Park are saying about his novel:

> The critics seem to be full of praise for your terse style, and ability to draw word pictures but the decent ones always regret that you should use such great gifts in perpetuating the lives and habits of so degraded a strata of humanity.
>
> I belong to a Current Books Study Class and we have lectures from the literary critics of the various News Papers.
>
> I could not face being present when your last book was to be reviewed, but one of the class told me afterward what was said—That you were prostituting a really great ability to the lowest uses. It is a doubtful honor to produce one of the filthiest books of the year.
>
> What is the matter—? Have you ceased to be interested in loyalty, nobility, honor and fineness of life? . . . If you are going through domestic disillusionment or drink has got you—throw off the shackles of these conditions and rise to be the man, and the writer God meant you to be.[3]

The "literary critic" from one of Chicago's newspapers who spoke in Oak Park was almost certainly Fanny Butcher, as Hemingway guessed in his defensive letter in reply to his mother, which he waited two angry months to send. Hemingway aligns Fanny Butcher with his mother and with the conservative values of Oak Park—the leafy suburb eight miles west of Chicago called the "middle-class capital of the world" and known for its homes designed by Frank Lloyd Wright.[4] (No stranger to marital scandal himself, Wright famously said of Oak Park: "There were so many too many churches for so many good people to go to."[5]) With a typical touch of misogyny, Hemingway's letter accuses his mother, no less, of disloyalty.

I am sure the book is unpleasant. But it is not *all* unpleasant and I am sure is no more unpleasant than the real inner lives of some of our best Oak

Park families. . . . And if the good ladies of the book study club under the guidance of Miss Butcher, who is *not* an intelligent reviewer—I would have felt very silly had she praised the book—agree unanimously that I am prostituting a great talent etc. for the lowest ends—why the good ladies are talking about something of which they know nothing and saying very foolish things. . . . We have different ideas about what constitutes good writing—that is simply a fundamental disagreement—but you really are deceiving yourself if you allow any Fanny Butchers to tell you that I am pandering to sensationalism etc. etc. . . . Dad has been very loyal and while you, mother, have not been loyal at all I absolutely understand that it is because you believed you owed it to yourself to correct me in a path which seemed to you disastrous.[6]

His pride wounded, Hemingway belittles Butcher in the same terms that he belittles his mother and the "good ladies" of Oak Park. They know "nothing" regarding the subject of his novel or what constitutes good writing. As for the breakup of his marriage, Hemingway writes his letter from Gstaad, Switzerland, where he was vacationing in the Alps with his wealthy mistress (and soon-to-be second wife). "By now," Hemingway writes to his mother in this same letter, "Hadley may have divorced me."

Six months after his reply to his mother about *The Sun Also Rises*, Hemingway still had Fanny Butcher on his mind. He confides in a letter to his father: "I know you don't like the sort of thing I write but that is the difference in our taste and all the critics are not Fanny Butcher."[7] A day later he writes to F. Scott Fitzgerald—whom he is clearly trying to impress—and objects to Butcher's recent praise in the *Tribune* of the popular American writer Louis Bromfield. Through various distribution networks—including the *Chicago Tribune European Edition*—Hemingway kept up with the Chicago newspapers wherever he lived.[8] In his letter to Fitzgerald he calls Butcher "the woman with the Veal Brains."[9] Constantly comparing his literary output to Fitzgerald's, Hemingway declares: "It was this [Butcher's review] that moved me to write again."[10] Butcher's opinion stokes Hemingway's competitive edge.

There are good reasons why Hemingway fixated on Fanny Butcher, who was like Harriet Monroe in that she was a sharp reader and an influential editor, but she did not write a line of exceptional poetry or fiction herself. First of all, Hemingway associated Butcher with his mother, with whom he vehemently disagreed on many matters and yet nonetheless would have liked to please with his

work as a writer. Butcher was different from Grace Hall Hemingway in many respects—younger, less religious, devoted to her career in journalism, and familiar with avant-garde art. Butcher also ran a successful bookshop for seven years and waited until age forty-seven to marry. But Hemingway lumped Butcher together with his mother in his opinion of women who had little experience of the world and who had a purely emotional response to what he wrote. Second, Butcher was central to the literary life of Chicago, the American metropolis that Hemingway knew best and the place where his first mature writing, apart from journalism, was published (by Monroe in *Poetry* magazine).[11] Butcher's opinion of new writers was extremely powerful, especially in Chicago. Last—and less obviously—Butcher represents a kind of reader for whom Hemingway in many ways wrote: he needed a reader capable of being shocked, since this is what his fiction often *aims* to do.

Hemingway fundamentally changed the nuance and style of American prose, and he was also a classic male show-off, aware of his talent. This attitude comes through in his writing, especially in his early work. Here his prose often boasts specialized knowledge of violent or frank subject matter—bars, prostitutes, crime. The effect can be like reading a student's experiment with a fifty-cent word. And yet, by the time of *The Sun Also Rises*, Hemingway's narrator Jake Barnes speaks to "you" with the calm authority of someone who has experienced the world in ways that "you"—or Fanny Butcher—never would. The use of the second person is one distinct manifestation of Hemingway's emphasis on a difference between the knowledge of the narrator and that of the reader. And yet second-person narration also intimately solicits "you" as a main character in the story: a technique Hemingway lifts from travel guides and popular journalism to assume what "you" might do. Of course, the use of the second person is not pointedly limited to a specific reader. But the authoritative presumption of Hemingway's style clearly displeased Butcher. And the novel inflamed her conservative streak.

What is most compelling about Butcher—and makes her a striking lens through which to understand Hemingway's work and Hemingway's relationship to Chicago—is how she is at once both Victorian and modern. Her life itself spanned eras: born in 1888, she lived to be ninety-nine years old. Butcher might once have been like a good lady of Oak Park, but gradually she recognized those values as outdated. With one foot in the past and the other in the present, Butcher actually embodies a kind of quintessentially modernist position: a desire to "make it new" while yet harboring nostalgia for what has been lost. This

push and pull finds resonances in Chicago itself; Chicago's cultural transformations in the twentieth century were never entirely freed from their origins in the 1893 World's Fair, an event that itself advanced cultural uplift and neoclassical principles—a tension between the ideals of renaissance and the revolutions of modernism. Butcher was just as full of Chicago boosterism as the men and women who organized the fair.

In her review of *The Sun Also Rises* Butcher claims to have heard that Hemingway "is quitting Paris and coming back to Oak Park, Ill, to live": her disappointment in the novel is also a disappointment with Chicago's wayward son.[12] But Butcher did not automatically disapprove of expatriate life and sexually explicit work. She recognized the importance of James Joyce's *Ulysses* and spent an awkward, stilted hour with Joyce during her first trip to Paris.[13] She also promoted writers whose style was difficult (Joyce, Gertrude Stein) and whose subjects could be grim (Joseph Conrad, Carl Sandburg, Saul Bellow). Moreover, she discerned the promise of great writers—like Eugene O'Neill, F. Scott Fitzgerald, and Carson McCullers—the first time their works appeared in print.[14] Butcher was never deeply familiar with African American literature, but she found *Native Son* "never to be forgotten"—it was listed on her top ten best books of 1940—and she later esteemed the work of Gwendolyn Brooks, whom she met at least a few times.[15] It irritated Hemingway that Butcher did not like *The Sun Also Rises*, since she sympathized with many of the young writers, like Hemingway, emerging out of the little magazines of modernism to which she subscribed.[16]

The story of the relationship between Hemingway and Butcher illuminates something about Hemingway's fraught relationship to audience and to home. Through Butcher, Hemingway also reveals his conception of the American Midwest and how this conception affected the shape of his prose. Although Hemingway initially disparaged Butcher, he welcomed a widespread readership when she and other critics reviewed his work positively. His bluster in the face of Butcher's early criticism ("I would have felt very silly had she praised the book") was not quite truthful. Late, unpublished correspondence between Hemingway and Butcher testifies to his attention to Butcher and to readers who he felt shared her literary sensibility. Sometime soon after the publication of *The Sun Also Rises*, Butcher became, amazingly, Hemingway's dependable ally. They corresponded for many years, and Butcher corresponded with Hemingway's fourth wife, Mary—whom Butcher had known first as a reporter in Chicago during the 1940s—for many more years after Hemingway's death.

Take a remarkable 1952 letter that Hemingway wrote to Butcher about the success of *The Old Man and the Sea*. The novel had been printed in its entirety in a single issue of *Life* magazine, a publication with a massive circulation.[17] Hemingway mentions in this letter his wife Mary and Butcher's husband, Dick Bokum. He invokes Butcher's spouse and his own as if to suggest that his readers were mainly conventional married couples. But Hemingway was aware that nothing was conventional about either couple. "I was happy to have a lot of people read it," Hemingway writes. "That is what I write for. That and for people like you, Dick, me and Miss Mary." He adds these loaded sentences—which Butcher also proudly quotes in her autobiography: "I always think of you as the most loyal friend that I have. But I know that you wouldn't ever write a line of criticism that was influenced by friendship."[18]

How did this friendship emerge? And was it really a friendship? For Hemingway to claim that Butcher would never "write a line of criticism that was influenced by friendship" seems a bit menacing, as if warning the critic not to be too critical. If Butcher was Hemingway's friend, then she was also an important gauge of his audience. Hemingway both elicits and rejects readers like Butcher who retain a touch of Victorian sensibility. Hemingway was unlike Ezra Pound (whom he knew in Paris) in that Pound had little respect for American readers. But Hemingway was also different from Harriet Monroe, who wanted the widest readership possible for modern poetry. Undoubtedly Hemingway welcomed the good opinion of his fellow artists and writers, but he also wrote for people who were less self-consciously literary: readers who would like to know about developments in art and culture, alongside the daily news. Butcher and those who were devoted to her *Chicago Tribune* column were this audience. To put it another way, Hemingway was trained in how to write for a mass market. And in this ability to reach a wide audience—without sacrificing aesthetic integrity—Hemingway falls in line with a number of Chicago modernists, from Carl Sandburg and Sherwood Anderson to Gwendolyn Brooks and Richard Wright.

In her reviews, Butcher celebrated the pleasures of "hammock novels," as she called them, as much as she valued the works of experimental modernism.[19] "At the Public Library it has been said 'When Fanny Butcher recommends a book we get many inquiries for it from shop girls,'" newspaperman Harry Hansen noted in 1920 with much condescension toward Butcher.[20] The *Chicago Tribune* actually posted a photograph of Butcher in the windows of its office building to "capture feminine favor," in the words of its advertising office (fig. 57). Hemingway's mentor in Chicago, Sherwood Anderson, also disparaged

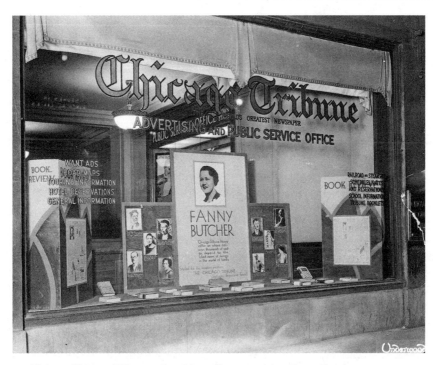

*Fig. 57.* Chicago Tribune *advertising office, promoting Fanny Butcher, ca. 1930s.*
*Fanny Butcher Papers, Courtesy Newberry Library*

Butcher as a reader whose taste shaped popular opinion. "One is so likely to hear of the reaction of the Fanny Butcher type and so little likely sometimes to hear of the others," Anderson wrote in a 1923 letter in which he also derides many kinds of women, from his second wife, Tennessee, to "these feminists, man!"[21] What comments like these reveal is a popular awareness of Butcher as a voice for "middlebrow" women readers—that is, for a feminized, consumerist readership.[22] These readers could be, however, genuinely supportive of avant-garde art and writing, as they were in the case of Gertrude Stein. Hemingway's works—like Stein's—were valued by a Chicago audience not only as cultural capital but also as an experience of new, strange, and sometimes shocking language.

In his novels and in his earlier dramatic 1926 letter to his mother, Hemingway aggressively distrusts his mother's older, Victorian values of "loyalty, nobility, honor and fineness of life." And yet Hemingway also uses the language of "disloyalty" to rebuke his mother and years later "loyalty" to enlist Butcher. She is the "most loyal" friend that he has. He has not thrown off the words of the

past. Consider the thoughts of Lieutenant Henry in Hemingway's A *Farewell to Arms* (1929), a novel set on the Italian front during the First World War. *A Farewell to Arms* succeeded *The Sun Also Rises* and secured Hemingway's reputation as a preeminent American writer. The first sentence of this passage, quoted earlier, framed Lucy Monroe Calhoun's search for a "new" language and Ezra Pound's promotion of Imagism's powerful immediacy:

> I was always embarrassed by the words sacred, glorious, and sacrifice and the expression in vain. We had heard them, sometimes standing in the rain almost out of earshot, so that only the shouted words came through, and had read them, on proclamations that were slapped up by billposters over other proclamations, now for a long time, and I had seen nothing sacred, and the things that were glorious had no glory and the sacrifices were like the stockyards at Chicago if nothing was done with the meat except to bury it. There were many words that you could not stand to hear and finally only the names of places had dignity. Certain numbers were the same way and certain dates and these with the names of the places were all you could say and have them mean anything.[23]

The words "sacred," "glorious," "sacrifice," and "in vain"—as if straight from the conversation of Grace Hall Hemingway—belong to a world in which Lieutenant Henry no longer believes but still haunts him. Propped up as empty war propaganda by "billposters," this language is frustratingly inadequate to his experiences on the front. Lieutenant Henry instead espouses a new, spare idiom. Hemingway's use of "you" in this passage establishes a characteristic tone of authority through which the narrator's point of view is *your* point of view. The passage is also notable for how Hemingway's metaphor of dead meat at the Chicago stockyards conjures the more substantial reality of the bodies of dead soldiers. The subtext is Sandburg's "Hog Butcher for the World": raw words from a poet whom Hemingway met during his time in Chicago. Chicago for Hemingway is a touchstone for cataclysmic changes in literary language and an embodiment of the clear-eyed realism that Hemingway sought to produce in his writing.

As in the story of Harriet Monroe, whose promotion of modern poetry arose from the ambitious, civic claims of the 1893 World's Fair, the story of Hemingway's development as a writer has origins in an earlier artistic era. This era is embodied by Grace Hall Hemingway, who continued to influence and shadow

her son's famously stark prose and his choice of scandalous subjects. Grace Hall Hemingway's language and the language of her son illuminate a dramatic break between the old and the new, one might even say between Oak Park and Chicago. But Hemingway, too, was an archetypal modernist in that he could not entirely abandon the values and the style of that which came before him. Despite his posturing, Hemingway of course was the writer whose work most embodied what had been "lost."

Hemingway liked to present Oak Park as a place in which he overcame the Victorian values of his parents and then left as soon as he could—after high school for the *Kansas City Star* and seven months later to join the Red Cross ambulance corps in Italy. (He arrived in Europe on a ship called the *Chicago*.[24]) But childhood is never abandoned. When Hemingway's great admirer Malcolm Cowley visited Oak Park in 1949 to research a piece on Hemingway for *Life* magazine, Cowley wrote in his notes, "My God, he had a trauma about Oak Park."[25] The local newspaper editor explained to Cowley: "no doubt" Grace Hall Hemingway "is responsible for Ernest."[26] His artistic impulse—although so different—was hers.

It is much more, however, than Hemingway's extraordinary bursts of machismo that his relationship with his mother and to Oak Park helps to explain. The audience that Hemingway cultivated for his work and his sustained interest in values emerge out of his relationship to the American Midwest, of which Oak Park is just the beginning. His clearest commitment to the Midwest is evident in the settings of many of his stories: from the forests and streams of upper Michigan to the bars and brothels of Chicago and Kansas City. These are places for Hemingway that are as much imagined as they are real, ensconced in a set of values that many Americans identified with a pastoral way of life, even as the Midwest was becoming industrialized.[27]

The economy of Chicago was tightly bound to its vast hinterland for the raw resources that the city's industries transformed into tradable commodities: this interdependence between city and country is also an apt metaphor for Hemingway's Midwest.[28] As an economic and cultural center, Chicago created the suburban dream of safety in Oak Park and also a desire for rural escape. Upper Michigan, for the Hemingway family, fulfilled this desire and became the setting for many of Hemingway's Nick Adams stories in his early collection *In Our Time* (1925). Chicago was also the city that inevitably attracted Hemingway—as a place to work and write—after he returned from the First World War. The city was where Hemingway found a literary community, inspiration from the visual

arts scene, and also relative autonomy from his family. Hemingway's represen-
tation of the Midwest not only as a particular geography (Chicago–Oak Park–
Michigan) but also as an interlocking set of values emerges in his work even as
he moved from Italy to Paris to Key West to Spain to Cuba and to Ketchum,
Idaho.

The Midwest's lasting and central presence in Hemingway's writing ulti-
mately emerges in two ways, which sometimes overlap and sometimes are quite
distinct. First, his perception of audience was founded there, as he took his
mother and her set as a kind of foil for the voice he wanted to develop. At times
this voice can seem stridently adolescent, but in other ways it enabled the par-
ticular modernist, macho idiom for which he became famous. That is, Heming-
way's prose bears the mark of a writer aiming to shock a reader, the first of whom
was his mother. The list might also include his high school English teacher
Fannie Biggs, his four sisters, his four wives, and of course his great mentor
Gertrude Stein (the "mother of the avant-garde," as she has been called, and
the godmother to Hemingway's first son).[29] But to read Hemingway's work this
way is to limit it to autobiographical resonances that privilege his conflict with
maternal figures. Though Hemingway at first affiliates Butcher with his mother,
ultimately his relationship with Butcher illuminates much richer terrain: his
conception of a mainstream audience, which is ultimately a midwestern one.

Second, the Midwest is important to Hemingway because of the time that
he spent in Chicago during an impressionable period in his life. Between the
First World War and his move to Paris, his year and a half in Chicago was
deeply formative to the development of his writing. Though Paris is the city in
Hemingway's life that has been most spectacularly mythologized, Hemingway's
Chicago is also key to his work: as a place of artistic development and publi-
cation, important critical reception, and imaginative inspiration. In Chicago
Hemingway met influential literary figures and wrote for popular publications
where he practiced his prose and sharpened his understanding of audience.
The literary scene in Chicago and the extraordinary diversity of his neighbor-
hood on the near North Side contributed to a fledgling "Chicago style" that
is the foundation on which Hemingway's mature prose is built. When he left
Chicago, he remained connected to the city through its newspapers, its literary
culture, and his family in nearby Oak Park. Chicago for Hemingway was both
a place and a moment in his life that reflected back to the past and forward to
what would be written with a voice that he found there.

## NAUGHTY PEOPLE

It may be that we should all have stayed in Chicago.

SHERWOOD ANDERSON, CA. 1930S

Hemingway lived in Chicago for a year and a half during 1920–21, when H. L. Mencken claimed that Chicago had become "the literary capital of the United States." It was the first year of national Prohibition: Chicago was also becoming a capital for organized crime and violence, which was more largely symbolic of a social turmoil that fascinated Hemingway and which he documented with absorption. Hemingway arrived in Chicago in a state of recovery from two major injuries: from shrapnel in his legs inflicted on the Italian front (war wounds that he would exaggerate) and from a "Dear John" letter sent to him by his first major love, an American nurse who worked in Milan (heartbreak that he would downplay). His time in Chicago was characterized by a renewal of physical and intellectual energy. It is a period in his meticulously annotated life and work that rarely receives attention, absorbed into the nebulous middle ground between boyhood and adulthood, or between the trenches of Italy and the bohemian glamour of Paris.[30] But at twenty-one, Hemingway was open to an array of Chicago influences.

Hemingway was drawn into a heady atmosphere created by ambitious writers, journalists, editors, publishers, and advertising men who worked for the city's newspapers. Harry Hansen, literary editor of the *Chicago Daily News*, nostalgically describes this world in *Midwest Portraits* (1920) in an opening description of Schlogl's, the North Side German American restaurant that attracted the newspaper crowd. Schlogl's was male-only. There on a mythic afternoon Hansen finds Ben Hecht, Sherwood Anderson, Eugene Field, Maxwell Bodenheim, Carl Sandburg, and Llewellyn Jones. Anderson also looked back fondly at Schlogl's, describing how the young writers "gathered around a big table" and talked about "Henry Mencken [who] was our great hero." "Henry made a great mistake," Anderson writes. "He should, at just that time, have made a grand tour as Gertrude Stein did later, picking as Gertrude did just the right moment. In Chicago we would have delivered the town over to him."[31] Hemingway's early writing reflects the primacy that these young journalists gave to Mencken's pronouncements. Years later, a very different cohort of literary ladies in Chicago would celebrate Stein—whose grand tour in Chicago Mencken

should have modeled—as the preeminent voice of modernist writing. Mencken and Stein: Hemingway was captivated by both.

When Hemingway writes about Chicago or alludes to Chicago in his work, he implies that the appeal of the place derives in part from the sheer variety of its population and the city's dramatic contrasts and conflicts. Hemingway was interested in Chicago for the same reasons that his mother and father preferred Oak Park. "Father and mother planned a long time before you were born," Hemingway's father wrote to his youngest daughter, "that our children should have good healthy bodies and some good food and a nice place to live and grow up without all the naughty people of the cities to bother them."[32] One could speculate who these "naughty people" of Chicago were, given the city's economic and racial diversity—its immigrant laborers, its African Americans migrating from the South, and the young women working in the city whom a federal report called "women adrift."[33] To move to Chicago after the war was, for Hemingway, a necessary break with his boyhood home: the war sharpened his critique of the complacency and insularity of Oak Park. Chicago amplified his sense of the cultural and social transformations that the war had indelibly impressed on him.

Hemingway lived and worked in a neighborhood on the Near North Side that was as diverse as Oak Park was homogeneous. During the 1920s, according to the Chicago School of Sociology, the vicinity was both "the gold coast" and "the slum," a mix of fashionable apartments, hotels, rooming houses, and immigrant tenements. Close to the downtown Loop, the neighborhood fluctuated with new arrivals. "Wave upon wave of immigrants has swept over the area," writes sociologist Harvey Warren Zorbaugh, "Irish, Swedish, German, Italian, Persian, Greek, and Negro—forming colonies, staying for a while, then giving way to others."[34] Politics and art joined forces in the neighborhood's sites of cultural exchange. Here was the freewheeling Dill Pickle Club located down Tooker Alley; the Radical Bookstore on Clark Street; and Bughouse Square, where soapbox orators engaged political radicalism and often attracted vociferous hecklers in the public park.

Hemingway kept to this neighborhood in the four different North Side apartments where he roomed. Only the apartment at 1239 North Dearborn Street still stands, where Hemingway lived briefly with his first wife after they married in September 1921 and before they set sail for Paris. In his first apartment, at 1230 North State Street, he lived with Bill Horne, a close friend from Yonkers who had served with Hemingway in the same Red Cross ambulance unit.[35] Hem-

ingway and Horne frequented the Greek lunchroom Kitsos and drank cheaply at the nearby Venice Café, reliving their days in Italian towns amid Chicago's Italian immigrants.[36] He next moved to 63 East Division Street, an apartment that housed a rotating band of bachelors: "The Belleville" on Division was a seven-room apartment leased by Y. K. Smith, one of Hemingway's childhood friends from summers in Michigan who worked at Taylor-Critchfield, the same advertising firm for which Sherwood Anderson worked.[37] With a marble entrance hall, a curving staircase, and a cook named Della, "The New Domicile is a wonder," in Hemingway's words to his sister Marcelline. "[The apartment is] much larger than the old one—and with an elevator and a view from my front window looking down over the queer angled roofs of the old houses on Rush street down to the big mountain of the Wrigley building, green of the new grass along the street and trees coming out—wonderful view."[38] Hemingway liked to box on the roof (fig. 58). It was also at this apartment where Hemingway met red-haired Hadley Richardson—they would marry—who came up from Saint Louis to attend a party. The city's visual vibrancy, jazz clubs and theater scene, along with the walking paths of Lincoln Park, were a relief from the constrictions of his parents' Oak Park home, where Hemingway had convalesced.

Sherwood Anderson was the clearest literary influence on Hemingway at this time. In Chicago, they were part of the same crowd of writers, artists, and advertising men. Anderson lived nearby with his second wife, Tennessee, whom he had married in 1916, a few years after Anderson's own wild flight to Chicago. *Winesburg, Ohio* had been published to critical acclaim in 1919, and Anderson was, when he met Hemingway, a highly regarded writer. They met during a gathering at the Division Street "domicile," and later Anderson invited Hemingway out for long walks in rural Palos Park, where Anderson also retreated.[39] For Hemingway, Anderson was an earnest if conflicted man and a gifted storyteller—recounting tales about his childhood in Ohio and his erratic business career. Twenty years older, Anderson gave advice, and he is the chief reason why Hemingway went to Paris rather than back to Italy. Anderson would send Hemingway off with letters of introduction to Stein, whom he had met the previous year, and to Sylvia Beach.

In Chicago, Hemingway also met Carl Sandburg and apparently read aloud to him one night from *The Rubaiyat* of Omar Khayyam. Known for his own musical, crowd-pleasing performances, Sandburg appreciated Hemingway's bravura.[40] In letters home and to his friends, Hemingway flaunted his new life in Chicago: "Wish't you were here," he writes to Horne, who was traveling in

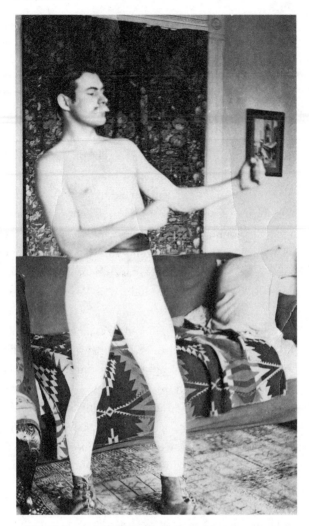

*Fig. 58. Ernest Hemingway wearing a fake mustache and
pretending to box, ca. 1920. Courtesy Ernest Hemingway
Collection, JFK Library*

Milwaukee: "We have an excellent time. Carl Sandburg and Sherwood An-
derson come over, we have wine in abundance, good claret every night on the
table wit[h] dinner, You'd better come home. You know how Della cooks."[41]
In the era of Prohibition, Hemingway's love for Italians was not just nostalgic.
In one letter he claims to have found a wine and cognac supplier in the Nine-
teenth Ward, a neighborhood at the time populated by the Italian mafia.[42]

Hemingway's fascination with Chicago was also visual, from the exhilarating view atop his roof to the modern paintings he studied at the Art Institute. It was here, not in Paris, where Hemingway was first exposed to impressionism.[43] Enamored of all things French, the Art Institute had a special connection to impressionism, which was crystallized by the 1893 World's Fair, where many impressionist paintings were on display, and which marked a turning point for American acceptance of the movement.[44] Some of these paintings later ended up at the Art Institute, including significant works by Cézanne that likely would have been on view during Hemingway's year in Chicago.[45] Hemingway returned many times to the museum, which was nearby, and where his mother used to take her children on trips when Hemingway was a child. The museum's collections, like those in the Jardin du Luxembourg and in Stein's rue de Fleurus salon, informed Hemingway's own commitment to writing with a self-conscious attention to his medium.

Consider Cézanne's *Bay of Marseille, Seen from L'Estaque* (ca. 1885), then on display.[46] It is a grand and culminating work for the artist in which the visibility of the brushstrokes and strict geometry foreground Cézanne's exacting technique (fig. 59). For his whole life, Hemingway would claim the painter as a major influence: indeed, Cézanne achieved what many modernist writers themselves wanted to do. ("If one could give a sense of my mother's personality one would have to be an artist," writes Virginia Woolf, "it would be as difficult to do that, as it should be done, as to paint a Cézanne."[47]) Perhaps it is the element of abstraction in Cézanne's work that inspired Hemingway's desire to compose essential sentences, stripped of ornament. Perhaps it is the prominence of each comma of paint, which bears comparison to Hemingway's ability to hone a sentence, to arrange and carefully repeat words of one or two syllables. Or perhaps it is Cézanne's large-scale landscape that conceptualized a solid and sublime order to the natural world, which informed Hemingway's description of the young war veteran Nick Adams in the solitary woods of Michigan. "I was learning something from the painting of Cézanne that made writing simple true sentences far from enough to make the stories have the dimensions that I was trying to put in them," Hemingway writes in his romantic memoir *A Moveable Feast.* "I was learning very much from him but I was not articulate enough to explain it to anyone. Besides it was a secret."[48]

Hemingway's enigmatic explanation of the relation between the formal qualities of Cézanne's work and the "dimensions" of his own stories only obliquely explains how painting shaped his writing. If Hemingway understood the nature

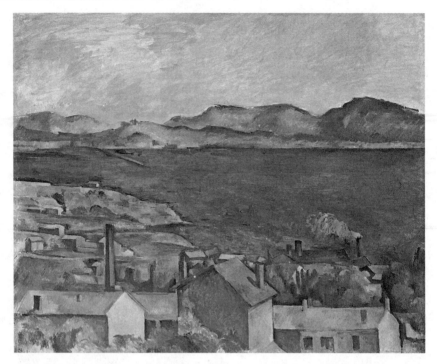

*Fig. 59. Paul Cézanne,* The Bay of Marseille, Seen from L'Estaque, *1885.*
*Oil on canvas, 31 ⅝ × 39 ⅝ in. The Art Institute of Chicago*

of Cézanne's influence, then the relation between the visual and the literary is
nonetheless still an inscrutable "secret," something he did not wish to share. As
in the case of Gertrude Stein and Sherwood Anderson, Hemingway's emotional
contact with Cézanne's work was also bound up with the visceral excitement
they felt standing in front of particular paintings. Each of these writers wished
that their own writing might replicate that excitement in a reader. As Heming-
way explained in *A Moveable Feast*, he wanted his stories to "make people feel
something more than they understand."[49] The primacy of sensation—to "feel
something" rather than "understand"—bears resemblance to Anderson's "color
impulses" and Stein's "bliss." Here were writers inspired to experiment with
words, to make readers feel the materiality of language comparable to how one
might look closely at the application of paint on a canvas. And then—in a sud-
den flash—to see and feel the complete work of art.

Perhaps most importantly, Hemingway's comments about Cézanne under-
score his inability to articulate the *nature* of influence, at a moment in his life—
his early twenties—when he was most open to it. Before he moved to Paris,

Hemingway was at an age of intense receptiveness, which is why it is worth considering what he did, whom he met, and what he wrote during his time in Chicago. The "secret" of his development as a writer lies not only in his first successful publications but also in the lesser-known stories and articles that emerged out of this period. Unlike Anderson, Hemingway always thought of himself as a writer, never anything else. In his steadfast pursuit, he frustrated his parents by refusing to go to college, instead seeking worldly excitements beyond the campus classroom. The experience of Chicago was part of his self-education. In Chicago—as he relived the war with Bill Horne, connected with old Michigan friends, met new ones, listened to Sherwood Anderson, studied paintings, and fell in love with Hadley Richardson—he was, of course, also writing.

## CHICAGO STYLE

Like many of the writers he admired, especially those in Chicago, Hemingway first found employment with newspapers. After he finished high school in Oak Park, Hemingway took a job at the *Kansas City Star*, where he worked for six months before heading off to the war. He wrote for the *Toronto Star* on his return in 1919 and continued to freelance articles during his time in Chicago and his first years in Paris. If little has been made of Hemingway's Toronto and Chicago journalism, then it may be because of the persistent myth that Hemingway's first job at the *Kansas City Star* during 1917–18 was the most important apprenticeship to his fiction.[50] No doubt the elements of the *Kansas City Star* story are compelling. The newspaper's style sheet begins with these directives: "Use short sentences. Use short first paragraphs. Use vigorous English. Be positive, not negative."[51] In a 1941 interview, Hemingway claimed: "Those were the best rules I ever learned for the business of writing. I've never forgotten them. No man with any talent, who feels and writes truly about the thing he is trying to say, can fail to write well if he abides with them."[52] But as several scholars have noted since Hemingway originated this myth of influence, the style sheet was barely known by reporters at the *Star*, and furthermore, Hemingway may have telephoned in most of his beats, rather than written and typed the *Kansas City Star*'s "vigorous English" himself.[53]

Hemingway's occasional features for the *Toronto Star* are more revealing—especially because it is certain that he wrote them. Living in Chicago, he composed light, wry pieces about everyday subjects that he knew something about—like camping and fishing, boxing, and vacation destinations.[54] He also

took on weightier subjects, demonstrating his interest in global politics, which he later covered when he lived in Paris and served as a foreign correspondent. Chicago's spectacular crime, bootlegging, and violence provided him with stories that had sensational, otherworldly appeal. In "Wild West," Hemingway describes the outrageous murder rate ("a murder every forty-eight hours") and the corruption of the city's police force. The city is a place where urban outlaws, "bad men," roam an "enormous smoky jungle of buildings." In "Ballot Bullets," he writes about gun-slinging power relations in the Nineteenth Ward, which is essentially displaced mafia politics. To his mind, Chicago politics is just war by another name. In "Chicago Never Wetter Than Today," he describes how shockingly easy it is to get a drink: "Anyone wanting a drink in Chicago now goes into a bar and gets it."[55] The prose of these pieces is not deftly crafted, but it is straightforward, vivid, with an ear for dialogue and a flair for comedy. Indeed, the ironic humor of the pieces is the most consistent feature. Hemingway never liked to confuse his journalism with his fiction—he took his fiction much more seriously—but his newspaper writing was distinctly his, and not entirely an anathema to his modernist style.

To be sure, he wrote for newspapers primarily because he needed the "seeds" or "Jacksonian" or "the ready." His letters to friends and family are riddled with slang, particularly words for *money*. The *Toronto Star* was not a steady source of income, and he tried to find other employment in Chicago, too. Bill Horne thought Hemingway should find a job writing advertising copy. He wrote to Hemingway: "Allow me to state that the one kind of work that is least irksome, that pays most for the ounce of brain put into action, that holds the most variety of any inside work, that is the greatest and at the same time the most deceiving bluff at work in all the world is work in an advertising agency."[56] Hemingway followed Horne's advice, writing a letter to the *Tribune* explaining how he was "very anxious to get out of the newspaper business and into the copy writing end of advertising." But his letter to the *Tribune* did not produce a job. (It was his second attempt at trying to find a position there.)[57]

He finally found work with another publication, the *Co-Operative Commonwealth*, a glossy monthly magazine that was a cross between journalism and advertising. It was a dubious publication about which little is known.[58] The title likely refers to a highly popular book by Laurence Gronlund, published in 1884, which applied Marxist ideas to American capitalism, arguing that the structure of capitalist competition overwhelmingly exploits the working classes.[59] Indeed, the magazine masked itself as a publication of the cooperative movement,

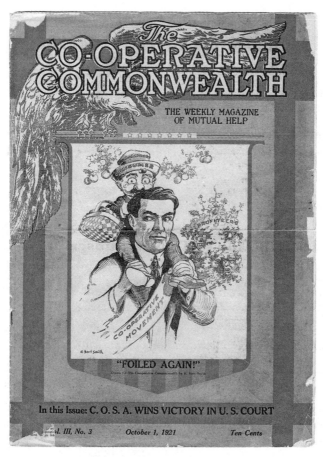

Fig. 60. Cover of the Co-Operative Commonwealth, October 1,
1921. Courtesy Ernest Hemingway Collection, JFK Library

although Hemingway heard persistent rumors that it was corrupt.[60] Subtitled
"The Weekly Magazine of Mutual Help," the publication pictured a wide-eyed
"consumer" on its cover who rode on the broad shoulders of "the cooperative
movement," protected from voracious "profiteers" lurking in the backdrop (fig.
60). The anticapitalist rhetoric of the magazine, however, was belied by the
fact that the magazine's assets were the heavily mortgaged properties of its sole
trustee, who made profits off the magazine's advertisements.[61] Hemingway de-
scribes what he wrote for the magazine in a letter to Hadley Richardson: "Boy's
Personals, the Country Division, Miss Congress's fiction, bank editorials, chil-
dren's stories, etc."[62] Pleased with his salary of fifty dollars a week, Hemingway

bragged to his mother in December: "The mag has 65,000 circulation and this month eighty pages of reading matter and about twenty of ads. Most of the reading was written by myself. Also write editorials and most anything. Will write anything once."[63] Hemingway is exaggerating. The one surviving issue of the magazine, dated October 1, 1921, is only sixteen pages long.[64]

This surviving issue of the *Co-Operative Commonwealth* includes columns called "The Commonwealth Children's Page," and "Lois Lay's Home Makers' Page," replete with cost-saving tips and recipes. These columns, geared predominantly toward female readers, were fairly standard stuff for newspapers at the time. Most newspapers spun out a woman's page—the section of the newspaper, for instance, like the one for which Fanny Butcher began writing when she started at the *Chicago Tribune* in 1913. Her first column, signed with a pseudonym, was called "How to Make Money at Home." (Butcher gives tips about how to make soap, can preserves, and sew lampshades.[65]) Like Hemingway, Butcher started as a journalist of all trades, including writing for the *Tribune*'s society pages and tracking the busy Chicago crime beat. Hemingway's writing for the *Co-Operative Commonwealth*, like Butcher's for the *Tribune*, was wide-ranging.

One article in the sole surviving issue of the *Co-Operative Commonwealth* stands out for its subject matter not its style. And yet Hemingway likely wrote it. Titled "The Iceberg Patrol," the article describes US Coast Guard ocean liners tracking the flow of icebergs known as "White Death." The article focuses on the danger that icebergs pose to transatlantic travel: "Only one-eighth of the iceberg is above water, and great spurs and jagged prows of ice that can rip a ship's plates open as easily as a fish is scaled project under water for a hundred yards or more."[66] This passage is remarkable in retrospect, knowing what Hemingway would write years later in *Death in the Afternoon* (1932): "If a writer of prose knows enough about what he is writing about he may omit things that he knows and the reader, if the writer is writing truly enough, will have a feeling of those things as strongly as though the writer had stated them. The dignity of movement of an ice-berg is due to only one-eighth of it being above water."[67] The iceberg metaphor applies to Hemingway's economy with language, his ability to suggest depths of meaning with a few precise words. The metaphor is Hemingway's most famous expression of how good writing is made. But the *Co-Operative Commonwealth* and *Toronto Star* pieces are not the stuff of Hemingway's iceberg style. Hemingway's commercial writing in Chicago was powered by a different economy. Hemingway was motivated by money made from colorful, funny, promotional prose.

Hemingway's journalism days in Chicago have been obscured by the belief that this kind of journalism is unrelated to the writing that made Hemingway famous. But Hemingway's journalistic filler may have been what made him famous: he knew how to write for a popular audience. Hemingway's attempt at writing "one true sentence," as he would later describe his aim, was strangely and perhaps ironically supported by the fact that he was trained in the business of composing articles that were a blend of journalism and advertising.[68] The daily circulation of newspapers in Chicago was rife with the kind of writing that employed Hemingway. The city was well known for its features writers who created stories and character sketches alongside the "objective" news. In high school, Hemingway actually mimed the humor of *Tribune* sports writer Ring Lardner in pieces he wrote for the school paper, even calling himself Ring Lardner Jr.[69] The most arresting *Kansas City Star* stories attributed to Hemingway are also feature stories rather than news. One piece describes a YMCA dance full of soldiers and art students who discuss Whistler and Chicago's art colony while outside in the snow a prostitute weeps.[70] The reader to whom Hemingway's narrator addresses his short stories—and to whom the narrator and protagonist of *The Sun Also Rises* tells his story— retains something of the reader to whom Hemingway sold his early journalism. And like Butcher, who addressed "you" in her literary columns, Hemingway's use of the second person is one lingering feature of this highly marketable style.

How conscious was Hemingway of his use of "you"? Was it a long-crafted technique? Certainly, "you" can be traced back to Hemingway's first sketches and short stories composed while he was employed as a journalist in Chicago. Published posthumously, these pieces were contained in the trunk that Hemingway packed for storage in his parents' Oak Park home before he left for Paris.[71] Critics have referred to a "Chicago style" that characterizes this material, and there is a strong through-line to Hemingway's first published works.[72] What is most striking about the early writing is how it seems to be directed specifically at Hemingway's hometown peers, as if he is showing off his experiences as a war veteran and an urban flaneur. More specifically, moments of second-person narration demand a reader's complicity in the narrative's set of values: this is a feature of Hemingway's narration that he would never shake.

Take the early story "The Mercenaries," which takes place at Café Cambrinus, a fictional bar on Wabash Avenue.[73] In the opening paragraph, a knowing narrator instructs "you" what will happen if you want to enter the backroom of

the bar. Arcane literary language invokes the biblical metaphor of a camel that passes through the eye of a needle:

> When you enter the room, and you will have no more chance than the zoological entrant in the famous camelneedle's eye gymkana of entering the room unless you are approved by Cambrinus, there will be a sudden silence. Then a varying number of eyes will look you over with that detached intensity that comes of a periodic contemplation of death.[74]

The narrator, singled out, achieves a nod from Cambrinus to proceed to the back. He then drinks exotic liqueur with a Frenchman and an American sergeant. The sergeant offers a comical and violent account of a duel with a man in Taormina, Sicily, named Il Lupo. The story ends, amazingly, in an obscure joke about doughnuts. Hemingway's story is hardly his best but rather a kind of boast: the narrator flaunts his knowledge of Chicago's seediest bars and his ability to befriend rough, eccentric criminals. The "you" to whom he tells his story is taught how these experiences could one day be "your" experiences.

When Hemingway moved to Paris, he continued to write back to an audience that he first conceptualized in Chicago. His first collection of short stories, *In Our Time* (1925), published four years after he left Chicago, invokes Chicagoans in its epigraph:

> A GIRL IN CHICAGO—Tell us about the French women, Hank. What are
>     they like?
> BILL SMITH—How old are the French women, Hank?[75]

The epigraph's second question is from Bill Smith, the younger brother of Y. K. Smith, with whom Hemingway lived at the Belleville on Division Street. Though somewhat inscrutable given that none of the stories in *In Our Time* feature "French women," these questions conjure Hemingway's imagined readers: Chicagoans unfamiliar with the firsthand accounts of European life, war, and sport that Hemingway depicts in his work. The questions imply that Hank's knowledge is intimate, as if he is an authority on matters of sex. The now classic Hemingway style that characterizes the stories of *In Our Time*—the unadorned sentences and straight dialogue—tempers the more brazen loquacity of this "Chicago style."

Hemingway seems to have written best about the Midwest when he lived

away from it. As was the case for the older writer James Joyce—whose work Hemingway encountered in Paris and deeply admired—Paris was the place where a faraway home could be remembered and re-created in prose. "Joyce has a most god-damn wonderful book," Hemingway brags to Sherwood Anderson about *Ulysses*, around the same time Hemingway was writing the stories of *In Our Time*.[76] Anderson is seemingly stuck in an American literary hinterland, where *Ulysses* had been banned after Margaret Anderson and Jane Heap went to trial for publishing half of it. Expatriates in Paris: Joyce imagined Ireland; Hemingway imagined the American Midwest. *In Our Time* sets Chicago as a hovering, off-scene presence, a metropolis upon which the wilderness is contingent, and a place of return after the war. Place is predominantly rural: the rivers, streams, and woods of upper Michigan, where seven of the fourteen short stories are set. Hemingway's Midwest is not rendered through thick, materialist description—or any style resembling Joyce's—but through concentrated, spare detail. Indeed, it is curious what kind of influence Joyce had on Hemingway's published work, since many of Hemingway's letters at the time are rich with the verbal punning, allusiveness, and circuitous comedy derivative of Joyce. If *Ulysses* is modernism at its most cosmopolitan and virtuosic, then *In Our Time* is modernism at its most hard-boiled, with a strain of Chicago in it.

The train back to the nexus of Chicago often appears as an option for the wanderers and expatriates in Hemingway's stores. Two stories from *In Our Time*, "The Battler" and "Big Two-Hearted River: Part I," begin on the train tracks, lines that connect the city to the country and an important material and metaphorical feature of Chicago. In "The Battler," Chicago is a point of reference and experience, an urban backdrop to the trickery that occurs in the marshlands of Michigan. Nick Adams gets kicked off a traveling freight train and encounters an old prizefighter and a sympathetic ex-convict:

> "Glad to meet you," Bugs said. "Where you say you're from?"
> "Chicago," Nick said.
> "That's a fine town," the negro said. "I didn't catch your name."
> "Adams. Nick Adams."[77]

Chicago is an origin that binds Nick, for a brief episode, to men of a different age, race, and life experience. All of the characters in "The Battler" have spent time in Chicago, and they will pass through Chicago again. For Hemingway, this quality of Chicago—the heterogeneity and mobility of its inhabitants—

was part of its allure. The community that he found in Chicago of journalists, admen, artists, and writers was also the city's appeal at a highly impressionable moment in his life. Chicago was a "domicile" through which Hemingway passed, a place of transition from one place to the next. But the transition itself was formative. He would look back on Chicago not just with affection but also with a reader in mind. Hemingway's Chicago was a diffuse force, not primarily written about, but written *for.*

When Hemingway and his new wife, Hadley, left Chicago to set sail for France in December 1921, he wrote home to his family with the experience of an urbanite who knows the ways of the world:

> Everything is very lovely and we're getting off in excellent style. Wish you all a Merry Christmas.
>
> Keep away from the stockyards is my advice until the strike is settled. Keep all the kids away too. They must find a new playground.[78]

To "keep away from the stockyards" during the violent clashes between police and meatpackers during the 1921 strikes was no doubt unneeded advice to his family ensconced in Oak Park. The racial and class conflicts that characterized industrial Chicago were a reason why Hemingway's parents did not want to live there and why the city seemed more authentic and compelling to their eldest son. Hemingway's note of farewell is an apt reflection of his year and a half in Chicago, not only because of the iconic stockyards that appear in many of the most famous passages of writing about Chicago but also because of Hemingway's authority. The departing son now tells his family, with a note of irony, what they should not do. This tone was developed during his time in Chicago, and it was reflected in the pieces of journalism and in his early short stories written while he was living there. Hemingway's creation of a distinctive, knowing voice— directed, at times, straight to a reader—is also the most striking feature of his first major novel.

## THE SUN ALSO RISES

What are the values of *The Sun Also Rises*? And are they *your* values? These are unavoidable questions asked by this novel. American war veteran Jake Barnes seeks your intimacy and judgment. Involved in a complicated and disastrous love affair, Jake thinks to himself: "That was morality; things that made you

disgusted afterward. No, that must be immorality."[79] The shiftiness between "morality" and "immorality" was indeed unpalatable if "you" happened to be Hemingway's mother or Fanny Butcher. Jake finds little solace or certainty in the imperatives of sex, marriage, and religion. What is known about Jake is that he is a reporter from Kansas City. Fair payment for work seems the only value to which he clings.[80] His experience in the war is the shared, unspoken trauma of his generation, and yet the war is also the cause of his peculiar and isolating injury. Surviving the war has left Jake and his companions not victorious but adrift and self-indulgent, with no clear sense of what constitutes moral behavior. Jake's sense of himself as someone who has "had plenty to worry about one time or other" marks his disillusionment in a novel riddled with questions about where meaning can be found.[81] Only Jake's *afición* for bullfighting seems to serve, temporarily, as a substitute for love, family, or religious conviction.

Hemingway's sporadic, conspicuous use of the second person in *The Sun Also Rises* derives from the novel's preoccupation with values. As a narrative device, "you" can function on many levels. Hemingway's "you" works primarily to establish a distinctive tone through which Jake's point of view ought to be the reader's point of view.[82] Hemingway's "you" emerges out of the rhetoric of advertising and journalism, including how-to columns and travel guides. Jake attends to the detailed facts of his story like a Baedeker guide: "The first meal in Spain was always a shock with the hors d'oeuvres, an egg course, two meat courses, vegetables, salad, and dessert and fruit. You have to drink plenty of water to get it all down."[83] The tip could be aimed at an American about to take a trip to Spain for the first time. Jake is your seasoned guide. The assumption is that "you" have never been to Spain. But one day you will go, and your experience will be like Jake's—who himself was once like "you." Second-person narration in *The Sun Also Rises* also elevates the protagonist's experience to a general human experience. This elevation of singular to universal constitutes the novel's distinctive, ironic moralizing about values, what Jake refers to as his "fine philosophy."

"Value" is a recurrent word in *The Sun Also Rises*, usually invoked with humor and distance. "You must get to know the values," says the preposterously named Count Mippipopolous, who courts Jake and Lady Brett Ashley one evening over bottles of champagne. Later after dining lavishly at the count's expense, Jake thinks, "Food had an excellent place in the count's values. So did wine."[84] With a similar lightness belied by anguish, Jake notes the values of his old Catholicism gone awry: on a train to Spain, worldly fleets of pilgrims com-

mandeer the dining car; in Pamplona, Jake prays at the cathedral for "a lot of money" and feels himself a "rotten Catholic"; and during the festival Brett becomes an exotic inversion of the Virgin Mary, "an image" around which all of the villagers dance.[85] Jake notices on several occasions the contrast between his life and other people's bourgeois comforts. He shares a taxi with his newspaper colleagues Woolsey and Krum, who do not join him for drinks after reporting from the quai d'Orsay but instead return to work, "wife and kids."[86] Implied is that newspaper writing is a more conventional kind of work—to which Jake is still attached—than the work of the writers with whom Jake associates in Left Bank cafés. Later, on the train to Spain with his friend Bill Gorton, who is visiting Jake from Chicago, the men meet an American "Mother" and "Father" (who refer to each other as such), and their young son, Hubert. Dialogue with this American family reveals a set of conventions about gender and marriage ("You know how the ladies are," Father says).[87] And yet the couple and their son share a friendly if old-fashioned intimacy, a companionship that Jake's attention suggests may also be somewhat enviable, though clearly never a choice for Jake.

In manuscript drafts for *The Sun Also Rises*, early chapters lay out a distinct set of religious values embodied by Jake's mother against which he rebels. Jake remembers the funeral of his alcoholic uncle Jacob after whom he was named, and his mother's admonition: "Drinking was coupled with gambling as a sin which my mother would rather see me in my grave than do."[88] On Fitzgerald's advice and to the great improvement of the novel, Hemingway cut these sections, which then suggests that Jake's emptiness is an embodiment of a much grander disillusionment, apart from his ties to family. An anxiety about middle-class respectability is transformed into the novel's sustained meditation on where to find meaning when all the old values seem to be broken. What remains, however, is a lingering sense that Jake's story is still *being told* to readers who may be just as close to the values of his mother as they are to Jake's ironic and empty philosophy.

*The Sun Also Rises* presents several moments of metanarration that also draw attention to the larger question of how the story has been constructed for a particular kind of reader. With an assumption that his reader does not know Spain, for instance, Jake describes the "old gentleman" from whom he buys tickets for the bullfights: "I went to the Ayuntamiento and found the old gentleman who subscribes for the bull-fight tickets for me every year, and he had gotten the money I sent him from Paris and renewed my subscriptions, so that was all set.

He was an archivist, and all the archives of the town were in his office. That has nothing to do with the story."[89] This last sentence compels a reader to dwell on Jake's attention to relevant details. Jake meticulously records his expenses and travel arrangements—as if maintaining a travel report, or an "archive" of events that will help him tell his "story." The events of his story are far from objective, however, and shaped by his pervasive bias about other characters. Jake's anti-Semitic portrait of Robert Cohn is the most obvious example of his bias, the novel's lack of foundation outside of Jake's point of view. The "you" to whom Jake tells his story is drawn into a judgment on Jake's trustworthiness. Addressed as an intimate, a reader may feel the weight of Jake's claims for friendship: can you be a friend with this man? Are you already?

To put it another way: *The Sun Also Rises* demands to know what you think of the characters in it. The reactions from Fanny Butcher and Grace Hall Hemingway elicited by *The Sun Also Rises* were in this way unsurprising because Jake *asks* for judgment. Hemingway sets up this invitation to judge Jake in the novel's opening sentences: "Robert Cohn was once middleweight boxing champion of Princeton. Do not think that I am very much impressed by that as a boxing title, but it meant a lot to Cohn." Intimate, seemingly casual, faintly defensive, Jake tells you what "not to think." The pronoun "you" is implied in the surprising imperative of the second sentence. Hemingway immediately establishes a slight sense that Jake is trying to prove himself, against a claim that has not yet been made, but will be. A reader at the novel's start is thus prompted to track who "impresses" Jake, and why, if it is even possible to impress Jake at all.

Fanny Butcher is an important register of one contemporary and widespread reaction to Jake's behavior. But over time readers have come to celebrate Jake's conduct as an expression of the "Hemingway code," a set of personal standards by which a man controls his experiences and tests his toughness.[90] Behavior that was at first shocking to Butcher and Grace Hall Hemingway has become conduct to be praised. Responses to the novel have overwhelmingly included moral evaluations of its characters, a fact that emphasizes how the novel invites a reader addressed as "you" to make judgments. In the annals of literary scholarship, Lady Brett has not fared well. Critics have noted Brett's lack of values, her "apparent nymphomania," and her "unusually active heterosexual appetite."[91] Brett makes some readers nervous, still.

Whether a reader admires the characters in *The Sun Also Rises* or finds them distasteful, the novel is powerfully engaged with the question of how values

have been shaped. Is Jake's "fine philosophy" typical of his generation's? Jake's narrative style is to make pronouncements based on his own experience that yet transcend his life to become the way of the world. The First World War is the event that has changed Jake and his friends, a conflict that will forever define "before" and "after"—the way that life once was, and the way that it now is. Jake's involvement in the war, however, is never described directly but looms below the surface, like the unseen iceberg of Hemingway's famous metaphor. The question remains: Can Jake convincingly claim that this event fundamentally has changed not just him but also "you"? Writing for a broad audience, including Americans who had never traveled abroad, never eaten a Spanish meal, and most importantly, never witnessed the war, Hemingway's use of "you" invites his readers to lay claim to experiences that may have been entirely unfamiliar to them.

Ultimately, "you" looks to the past—what the narrator has done—and to the future—what a reader will do. It could be considered a style with a sense of prolepsis, an awareness of future events. A powerful embodiment of the push and pull between the narrator and the reader, Hemingway's "you" claims a distinctive modernist position. "You" is a form that recognizes an older era and yet commits itself to the new. Hemingway's narrator has knowledge of the transformation that takes place between these two poles. *You are going to see things differently, too,* he seems to say. And what is remarkable is that a reader at first resistant to this transformation—a reader like Fanny Butcher—did in fact change over time to embrace the modernist values espoused by Hemingway's new idiom.

There are many examples in the works that followed *The Sun Also Rises* in which Hemingway sustains second-person narration. It is an essential Hemingway habit. Second-person narration in *A Farewell to Arms* (1929), for instance—a novel that Butcher praised—marks the novel's most heightened moments. Addressing "you" is part of the novel's larger power of directness. *A Farewell to Arms* is an unusual novel in the modernist canon because it treats the violence of the First World War explicitly. More typical are descriptions of violence on the battlefields of Europe through oblique, bracketed, indirect styles. In *A Farewell to Arms*, Hemingway describes battalions, military formations, retreating armies, and bloody, wounded bodies. "You" are addressed as if you have been privy to the war's physical horror and to the psychological and moral dissolution that follows such exposure.

Consider the first paragraph of chapter 31, which follows after a cliffhanger.

Lieutenant Henry has just broken from a line of formation in which officers are being unjustly questioned, and executed, by embittered Italian soldiers during the retreat at Caporetto. Henry has jumped into a river, fleeing his likely death. But will he survive in the icy water?

> You do not know how long you are in a river when the current moves swiftly. It seems a long time and it may be very short. The water was cold and in flood and many things passed that had been floated off the banks when the river rose. I was lucky to have a heavy timber to hold on to, and I lay in the icy water with my chin on the wood, holding as easily as I could with both hands.[92]

Like the famous opening of the novel ("In the late summer of that year we lived in a house in a village that looked across the river and the plain to the mountains"), this passage is marked by words of only one or two syllables, few and simple adjectives, and verbs that resist the intense suspense and heightened drama of Henry's situation. Henry does not know what to do. The use of "you" in the first sentence seems to distance him from not knowing and implies, almost comically, that the experience might be yours. Though no one but Lieutenant Henry floats down this river, Hemingway's use of the second person claims Henry's particular experience for everyone.

There is a striking link between the tone established by Hemingway's use of "you," here and elsewhere, and one of the central preoccupations of Hemingway's work. He shares with Sherwood Anderson a fixation on the question of how manhood is made. In Hemingway's work, soldiers, matadors, boxers, and big-game hunters engage in physical and often violent tests of power. Even Jake Barnes's emasculating impotence draws attention to the larger question of whether he is still a "man" and the larger social power that accompanies sexual virility. But it is not just Hemingway's subjects that illuminate his fascination with manhood. Hemingway's pronounced use of second-person narration illuminates why, more precisely, Hemingway's prose is so frequently called "masculine." Second-person narration in Hemingway's work is an aggressive challenge to the reader: a colloquial yet stylized test to take part in the story's action. It has origins in the braggadocio of Hemingway's "Chicago style." Hemingway's direct address to his reader also has the effect of amplifying the very presence of a reader—the telling of the story from *me* (Jake Barnes, Lieutenant Henry) to *you*. A remarkable fact of Hemingway's early reception is that the critic whose

opinion most mattered to him took notice of this pattern in Hemingway's style. H. L. Mencken claimed that a specific kind of reader lurked in the shadows of Hemingway's prose. This reader was decidedly a *she*. And she was from the Midwest.

## LADY MIDWEST

I'd no more think of visiting Chicago without waiting on you than I'd
think of visiting Rome without leaving my card on His Holiness.

H. L. MENCKEN TO FANNY BUTCHER, MAY 1932

*The Sun Also Rises* practically begs for attention from H. L. Mencken—the most influential literary critic of Hemingway's time—because the novel is loaded with references to him. Jake claims that too many men "get their likes and dislikes from Mencken." Jake talks with his friend Harvey about how Mencken is "all right," but he "just can't read him." And fellow writer Bill Gorton degrades Mencken in a drunken, bawdy speech.[93] Hemingway also satirically dedicated to Mencken his novella *The Torrents of Spring* (1926), a work that parodies the realism of Sherwood Anderson (and caused, not surprisingly, a rift in their friendship). But much to Hemingway's chagrin, all of these ploys to draw Mencken's attention failed.[94]

Mencken knew Hemingway's early work and may have reviewed his collection of avant-garde vignettes printed privately in Paris as part of a series edited by Ezra Pound. The vignettes were called, in lowercase letters, *in our time* (1924). They were later included as interludes between the stories of *In Our Time* (1925). A pithy, unsigned notice in *The American Mercury* bears Mencken's verbal shenanigans:

> The sort of brave, bold stuff that all atheistic young newspaper reporters write. Jesus Christ in lower case. A hanging, a carnal love, and two disembowelings. Here it is set forth solemnly on Rives hand-made paper, in an edition of 170 copies, and with the imprimatur of Ezra Pound.[95]

Dismissive, authoritative, funny: this description foresees how Mencken finally would review Hemingway's work. It was *Death in the Afternoon* (1932), Hemingway's detailed account of Spanish bullfighting with long detours about writing that inspired Mencken to write a review. Here, Mencken takes the opportunity

to appraise Hemingway's whole career. He admits to Hemingway's talent at description and the fineness of *A Farewell to Arms*. But Mencken excoriates Hemingway for his attempt to shock a reader with sensational details, a point that Butcher had made much earlier in her review of *The Sun Also Rises*. Ultimately Mencken's critique is remarkable because he identifies the motivation for Hemingway's indecency essentially in Hemingway's mother.

The reader who Hemingway always "keeps in his mind's eye," according to Mencken, is the woman who lives in Oak Park: "Only too often he turns aside from his theme to prove fatuously that he is a naughty fellow, and when he does so he almost invariably falls into banality and worse. The reader he seems to keep in his mind's eye is a sort of common denominator of all the Ladies' Aid Societies of his native Oak Park, Ill."[96] Mencken—who had praised Chicago for its authentic American literary voices—felt that the conservative values of its closest western suburb remained as an origin in Hemingway's work. Hemingway's prose is inspired by a cheap desire to shock a particular kind of reader. "Take out the interludes behind the barn, for the pained astonishment of the Oak Park *Damenverein*," Mencken writes, "and it would be a really first-rate book." He finishes his review with a comic disparagement of Hemingway's aimed-for audience: "Mr. Hemingway describes his principal wounds in plain English. They will give the Oak Park W.C.T.U. another conniption fit. The Hemingway boy is really a case." For Mencken, Hemingway is merely a "boy" showing off to his mother. In 1920, Hemingway did in fact speak about his wartime experiences to the Ladies' Aid Society in the Petoskey, Michigan, public library, an irony that Mencken could not have known.[97]

As if nodding to Fanny Butcher, Mencken reiterates Butcher's critique, with the difference that he himself seems unruffled. Mencken was familiar with Butcher's review of *The Sun Also Rises* and her objection to the shock value of Hemingway's subjects. The two influential critics were close friends. They first met in 1920 when Mencken walked into Fanny Butcher Books while he was covering the Republican National Convention in Chicago. Their friendship was flirtatious: he was the only person to call her "Amanda" (her middle name), telling her that it was the "gerundive of the verb amo" and means "about to be loved."[98] She called him "Heinie." Consider a photograph in which they stand together in Butcher's bookshop reading a volume of *The American Language*, Mencken's seminal examination of American English (fig. 61). The photograph is an apt expression of a belief shared by both critics that American writers had their own immediate resources to fundamentally reshape the rhythms of the

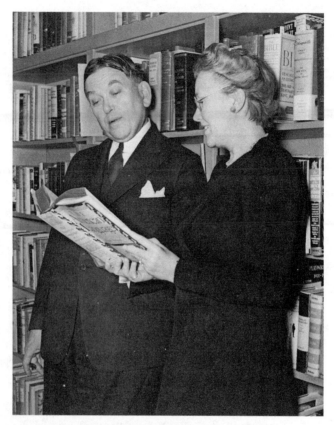

*Fig. 61. Fanny Butcher and H. L. Mencken, ca. 1920s.*
*Fanny Butcher Papers, Courtesy Newberry Library*

English language. Both were deeply interested in the development and pres-
tige of American literature—and for Butcher, American midwestern writers in
particular. This is one reason why Butcher eventually became such a strong
advocate of Hemingway's work. Her change of critical opinion is illuminating
to trace in comparison to Mencken's critique because more was at stake for her
in how Hemingway was received.

What did it mean, in the 1920s, to be midwestern? For Butcher, it had some-
thing to do with being nice. In reviews, Mencken was acerbic; Butcher was
generous. "I was inclined to the soft, not the hard, criticism of a book," Butcher
explains in her autobiography, "but we [Mencken and I] usually agreed in our
conclusions."[99] At the time of Mencken's review, however—December 1932—
Butcher had indeed softened her critique of Hemingway's work and become his
avid fan. *Death in the Afternoon* did not give Fanny Butcher a conniption fit.

(Hemingway inscribed her copy of the book "To Miss Fanny Butcher, whether she likes it or not."[100]) In her *Tribune* review, she lavished praise on what made her squeamish: "There are pages in the book which literally turn you inside out," she wrote, "not for the obvious reasons of their chronicling bloodshed and death, but for something horribly, honestly real in them."[101] Using the same turn of phrase as in her much earlier review of *The Sun Also Rises* ("not for the obvious reasons") and also directing her review to "you," Butcher this time decides that Hemingway is the "real" thing.

Butcher also liked proudly to claim Hemingway as a son of the Midwest, a term that she used loosely and positively. In her numerous articles, reviews, and reminiscences about Hemingway from the 1920s until Hemingway's suicide in 1961, Butcher rarely missed an opportunity to emphasize his childhood roots, beginning with her erroneous claim in her critical review of *The Sun Also Rises* that Hemingway is "quitting Paris and coming back to Oak park, Ill., to live."[102] Alternatively, for other critics, "midwestern" could be a patronizing epithet attached to Hemingway. Lillian Ross writing for the *New Yorker* in a 1950 profile describes Hemingway's clipped way of speaking as "Indian talk" and notes that he speaks with "a perceptible Midwestern accent," which is a damning detail from her vantage.[103] To claim Hemingway as a midwesterner, for Ross, is to treat him as an unlearned, drunken simpleton.

Ross's editor and founder of the *New Yorker*, Harold Ross (no relation to her), famously described his magazine as being "not for the little old lady in Dubuque," a quip suggesting that midwestern readers were not particularly clever or urbane. But Ross was himself mocked by a Chicago publication that Butcher would have known, the *Chicagoan* (1926–35), a magazine modeled on the *New Yorker* and self-consciously defensive about Chicago's relationship to New York. A 1929 cartoon from the *Chicagoan* called "New Yorker's Map of the US" shows Dubuque to be a city imagined as nearly every American city, including Chicago, with the exceptions of New York, Hollywood, Palm Beach, Reno, and Atlantic City (fig. 62).[104] For New Yorkers, the Midwest is most of America.

The Midwest during the 1920s and 1930s was in fact changing as a concept to include much more of the western United States. Western regions wanted to lay claim to the wholesome, bourgeois values associated with the Midwest. In newspapers and popular periodicals "midwestern" conjured a pastoral way of life, an ideal somewhere between raw wilderness and urban industrial evils.[105] Even through the 1940s when the widespread industry and changing demographics

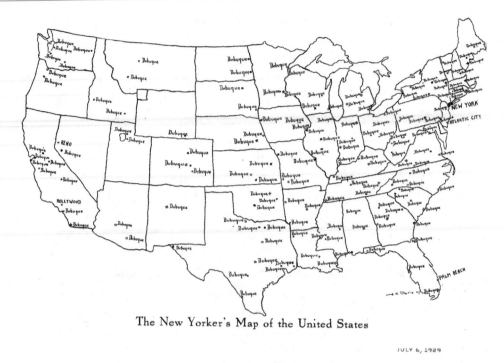

The New Yorker's Map of the United States

JULY 6, 1929

*Fig. 62. Cartoon from the* Chicagoan, *July 6, 1929.*
*Courtesy Quigley Publishing Company, a division of QP Media, Inc.*

of the Midwest were difficult to overlook, the language that Butcher uses to describe Hemingway's midwestern roots strikes a quaint, romantic note. In a 1947 piece on Hemingway, Butcher wonders if Hemingway "has really changed much fundamentally from the boy born in Oak Park, Ill., with the fine, solid, down-to-earth qualities which Midwesterners seem to draw from the soil . . . the way good Midwestern corn and wheat grow tall and nourish mankind."[106] Even though Oak Park had not seen corn and wheat fields since Chicagoans fled there to live after the 1871 Chicago fire, Butcher associates Hemingway's midwestern origins with the purity of an agrarian way of life. The Midwest is an imagined ideal as much as it is real. Strikingly, Butcher finds in Hemingway a set of healthy midwestern values as if his work might "nourish" readers—a far cry from her initial claims of his "sensationalism and triviality." Butcher gleans that Hemingway's work is indeed about values, which she eventually decides are the right ones.

Butcher's response to Hemingway's work not only illuminates a contemporary critical conversation about Hemingway but also pinpoints the central question of *who he is writing for*, a question that she and Mencken identified as es-

sential to how Hemingway directs his narrative. Mencken felt that Hemingway wanted to prove he was "a naughty fellow" to Oak Park ladies. Nearly a century after the publication of his first novel, the roots of his style are buried in the distinctive voice of authority that remains: whether the acid-tongued conversation of Parisian expatriates or the anatomy of the bloody *toreo*, Hemingway's subjects derive in part from his vital urge to demonstrate worldly expertise.

For admirers of Hemingway's work, the authority of his prose is powerful, the simplest exertion of dominion over his subject. And yet, a work like *Death in the Afternoon* suffers in many places from Hemingway's exercise of authority over a reader he patronizes, especially when he uses second-person narration. "If you are a woman and think you would like to see a bullfight and are afraid you might be badly affected by it," Hemingway instructs his reader near the beginning, "do not sit any closer than the gallery the first time."[107] Here, Hemingway's "you" pinpoints a woman like his mother who would balk at the violence and blood of a bullfight. The work actually presents a character named "Old Lady," a novice who has never attended a bullfight and to whom much of *Death in the Afternoon* is directed. It is an astonishing acknowledgment and revelation—that Hemingway's "you" is an actual character. After nearly two hundred pages, the narrator confesses: "We threw her out of the book, finally."[108] If this is a comic moment, then it is also an inevitable assertion of artistic autonomy: the book may be inspired by the narrator's control over a questioning female reader, but it will fail unless he liberates himself from her expectations.

Hemingway liberated himself, and he didn't. Butcher is the best representative of an ideal Hemingway reader—in whom we can locate the origins of his authority—because she is more complex than a disapproving Victorian mother and yet more middlebrow than East Coast critics like Mencken and Ross. Butcher remained Hemingway's "loyal" reader because she was both inside and outside the milieu of Hemingway's novels and the literary circles of which he was part. And she, too, wrote for newspaper readers. Butcher could grasp the world of Grace Hall Hemingway and the world of a writer like Gertrude Stein and just where these worlds overlapped. Of course, Butcher became important to Hemingway's commercial success, as she was for Stein, which he no doubt understood in his 1952 letter in which he claims that she "wouldn't ever write a line of criticism that was influenced by friendship." Hemingway identified in Butcher an influential woman at the center of Chicago's literary world. Mencken also sensed Butcher's importance: she was to Chicago what the pope was to Rome. Carl Sandburg called her "Miss Chicago, Lady Midwest."[109]

Unlike many writers who began as Chicago newspapermen and then left for

New York or abroad (Floyd Dell, Ben Hecht, Harry Hansen), Butcher started at the *Tribune* in 1913 and stayed there for the rest of her career. Adventure for her was literary and vicarious. She worked too hard at the *Tribune*—for nearly fifty years—to have time for much else, especially when she was simultaneously running her bookshop. (At one point in the 1920s, she collapsed from exhaustion.) In her autobiography, *Many Lives—One Love*, Butcher dedicates an entire chapter to Hemingway as she does for seven American writers. It is as if her life is dependent on theirs. Butcher possessed "many lives" through her "one love" of books. Only after she sold Fanny Butcher Books in 1927 did she travel to Paris, with a list of appointments and with Alice Rouiller (who was half French) as her guide.

Butcher likely met Hemingway for the first time on this trip, in 1929. It was when she met Joyce. But her diary shows no record of a visit with Hemingway. Her autobiography gives the fullest and most wistful account:

But most of [his work] was in the future for Ernest Hemingway that crisp, cloudless day when we met in Paris, and were almost on sight lifelong friends. Although we too seldom met again, it didn't matter. Rumors came of Ernest's breaking with old friends in spectacular disagreements. Perhaps we were never personally close enough to have such a duel either in public or in private. I know each of us never distrusted the other's honesty as writer or critic, the other's sincerity as friend.[110]

There is something both pitiful and wonderful in Butcher's sense of Hemingway, given what we know about Hemingway's early letters that make mean-spirited reference to her. Butcher feels that she was a "lifelong friend" to Hemingway but then also allows that she was "never personally close enough" to him. Butcher claims Hemingway's "honesty" and "sincerity" as if making a nervous wish.

Nowhere does Butcher describe how she criticized Hemingway's first novel. In her autobiography, she claims to have felt that *The Sun Also Rises* "was something to really get excited about," as if she had praised the novel.[111] In a 1980 interview—when Butcher was ninety-two years old, and long after Hemingway had died—she said that Hemingway was her favorite writer.[112] Adjusted according to her highly selective memory, Butcher commemorates her relationship with Hemingway even though they met only a few times after their initial meeting in Paris: on occasion in Chicago and once in Cuba during Butcher's 1947 trip with her husband. They exchanged Christmas cards every year (figs. 63–66).

*Fig. 63. Front of Christmas card from Ernest and Mary Hemingway to Fanny Butcher and Richard Bokum, 1950s. Fanny Butcher Papers, Courtesy Newberry Library*

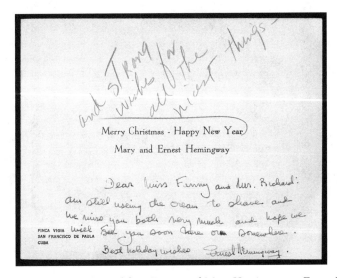

*Fig. 64. Inside of Christmas card from Ernest and Mary Hemingway to Fanny Butcher and Dick Bokum, 1950s. Fanny Butcher Papers, Courtesy Newberry Library*

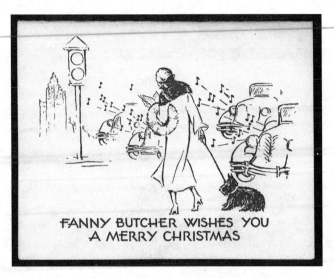

Fig. 65. Christmas card from Fanny Butcher, 1920s.
Fanny Butcher Papers, Courtesy Newberry Library

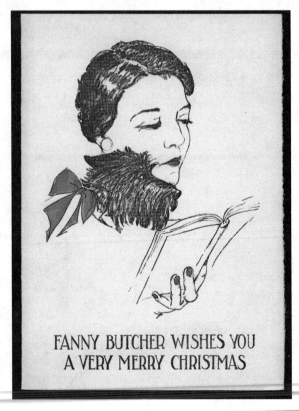

Fig. 66. Christmas card from Fanny Butcher, 1920s.
Fanny Butcher Papers, Courtesy Newberry Library

The cards that Butcher saved from Ernest and Mary Hemingway include one of Ernest sailing his fishing boat *Pilar* off the coast of Cuba. Inside, Hemingway thanks Butcher for her gift to him of shaving cream—for his chronic sensitive skin. The note is personal and somewhat maternal. But ultimately, Butcher and Hemingway's relationship developed into the Christmas card variety: rarely extending beyond generous well wishes, and yet sustained with ceremony and affection every year. Butcher's stylish black and white and orange cards nearly always feature her reading a book, with her small dog nearby. (After 1935, when she married, the cards depict her husband, too.) The difference in self-presentation is striking: a smart, urban woman with her head in a book; a bare-chested man sailing the high seas, on a boat that Hemingway apparently crewed to search for German U-boats. Yet Butcher's self-fashioning suggests that the activity of reading is not passive: even when she is crossing the street, she is reading a book.

But does it really matter if they were friends or not? What is clear is this: as a loose embodiment of Hemingway's ideal reader, Butcher haunts his prose. She exerted an active power over what Hemingway wrote, the "you" that embodies the modernist position between past and present. It is striking to think that when Hemingway moved to Chicago in 1920—an unknown, unpublished writer, recently returned from the war—he joined the circle of aspiring writers that included Fanny Butcher. In 1920, Butcher was still trying to write a novel, an aspiration that she would soon give up as her reputation and her workload at the *Tribune* increased.[113] Butcher and Hemingway did not meet in Chicago at this moment, though his friends—including Sherwood Anderson—visited her bookshop, which she had just opened in the Pullman Building, not far from the museum and symphony where Hemingway often walked. But it was in Chicago that Hemingway originated a style aimed at readers like her.

# Chicago, November 7, 1934

THE PARROT SQUAWKED; THE phone rang. Bobsy Goodspeed tossed the sheets and picked up the receiver. Barney had already left for a board meeting. She was perched seventeen stories high in a modern penthouse apartment of brick and Indiana limestone, at the edge of Lincoln Park. As the sun rose above the lake, light flooded in from the plush carpet to the vaulted ceiling. The busiest person in town, according to the *Tribune*, Bobsy kept two telephones in her bedroom, which rang all morning from 8:30 to 11.

It was Carl Van Vechten calling from New York. They were still very nervous about the flight to Chicago. He loved to fly—really, *he* was not frightened—but Miss Stein and Miss Toklas had never been on an airplane and he was anxious for them. Bobsy assured him it was worth it, a few hours in the air and they would arrive for the premiere!

Bobsy's throaty voice was like a balm. She reminded him that Virgil Thomson was conducting the opera himself, and she appealed to Carl's love of spectacle. The Auditorium Theatre had been redesigned by Rue Carpenter: Pompeian red upholstery and the entire ceiling lacquered in gold. The performers—gospel singers from Harlem—would be framed by a sparkling stage of pink cellophane.

*Fig. 67. Gertrude Stein and Alice B. Toklas, November 1934.*
*Fanny Butcher Papers, Courtesy Newberry Library*

With proceeds going to the Vocational Society for Shut-Ins, a philanthropic fa-
vorite, the evening would bring out Chicago's very best gowns. Afterward, there
would be a supper party at her home, and everyone must spend the night. Bobsy
promised that she and Fanny would be waiting at the airport, likely with an
entourage of reporters. Fanny had let the word out.

After much coaxing, Bobsy hung up the phone. Of course, Carl had seen
*Four Saints in Three Acts* in Hartford and New York already—indeed, he had
written the program notes. The opera was "like a dream in which you lie back
indolently and let things happen to you." Thomson's music gave Stein's words
a rolling grandeur, an ecclesiastical power. You didn't need to know what it
meant. Stein had said as much herself, and now she was telling crowds of Amer-
icans how to read her work. "If you enjoy a thing you understand it," Stein
claimed. After thirty years in France, she discovered on arriving in America
that she had become a celebrity. She was startled to see her name repeated in
electric lightbulbs on a New York City marquee: *Gertrude Stein has arrived in
New York Gertrude Stein has arrived in New York Gertrude Stein has arrived
in New York.* It was precisely as she would have put it.

If Stein made it to Chicago, the Arts Club—where Bobsy was president—
must have her first. Intimacy and exclusivity were the club's calling cards, and
its members adored all things from France. This past summer, Bobsy had filmed
the antics of her friends and artists in Paris, mostly atop the balcony of her hotel.
Henri Matisse had looked a little lost, taking his hat on and off in the sun. The
composer Nicolas Nabokov had talked straight at the camera. Léonide Massine
had danced with campy elegance in a full suit. Gertrude and Alice had been in
the countryside, and Bobsy had traveled out to Bilignin to see them. With the
camera rolling, the women shook the little paw of the poodle named Basket.
Then Gertrude performed in the garden, taking a hoe to the turnips, laughing.

At her dinner parties in Chicago, Bobsy showed these films. Lately, she had
taken to wearing dramatic silk capes, arranging the seating and lighting like an

artist herself. She stood tall and dark-haired, a thick brow defining the square face that her friends described as handsome.

At two o'clock, after a shampoo and wave, Bobsy set off with her chauffeur to meet Fanny and drive out to the Municipal Airport: one flat, white building in a field of runways, the most active airport in the world. Fanny had not yet finished her busy day at the *Tribune.* She would have to return to the office after they met the plane, finish three pieces, then dress and hurry to the opening of the opera. She was also still negotiating Stein's schedule with the rigid administrators at the University of Chicago. But to sit next to Bobsy in her swift limousine—her head resting back on the head cushion—made Fanny feel that all things were possible.

The flight was delayed. Reporters and photographers wandered in and out of the terminal, checking their equipment and scanning the sky. After an hour, nearly everyone waited in the windy chill, in heavy coats and fur hats. Dark blue clouds hung heavy; the air felt thick and damp. Finally, they heard a faraway hum and could see a dark line getting larger. The plane looked a little wobbly, the wings tipping back and forth. It seemed as if the plane might fly over the terminal and keep heading west. The air traffic controller vigorously waved a red flag at the end of the runway. The plane suddenly descended with a whirring roar of propellers. Cameras flashed. The plane taxied and stopped with a screech.

Several long minutes passed before the door cranked open and the steps were lowered. Gertrude bowed through the low door and stepped out, beaming. She was dressed like a European peasant, in a long woolen skirt and heavy shoes. Alice stood behind her, a wool cap pulled low over her brow. They were clutching little voodoo dolls and held them in the air. Later, Stein explained that Carl had given them the amulets to calm their fears. "Miss Stein, were you scared?" a reporter asked. She smiled at him. "No. The air seems so solid," she replied. Stein described how the view from the airplane gave her great pleas-

ure: straight lines and quarter sections, regular divisions that make everything clearer, from one state to another. "I have always been with cubism," she said. "Going over America makes anyone know why the post-cubist painting was what it was."

The crowd made space for the women to walk to Bobsy's waiting chauffeur, who opened the door of the car with a composed bow. Behind them staggered a pale and shaken Carl, trailing after the women. Bobsy stepped back, linked her arm into his, and pulled him in.

FOUR

# Stein Comes to Chicago

## LA STEIN

By the 1930s, Gertrude Stein had accumulated many friends from Chicago: Sherwood Anderson, Fanny Butcher, Manierre Dawson, Bobsy Goodspeed, Ernest Hemingway, Alice Roullier, and Thornton Wilder. Later, her heady friendship with Richard Wright marked the last year of her life. Stein's work was regularly praised and parodied in the Chicago newspapers. Her word portrait of Mabel Dodge had been used to advertise the 1913 Armory Show when it came to Chicago; and Fanny Butcher never missed an opportunity to mention Stein in her book column for the *Chicago Tribune*, the most widely circulated paper in the city.

When Stein and Alice B. Toklas arrived in Chicago in 1934 (accompanied by the American writer and photographer Carl Van Vechten), Butcher and Arts Club president Elizabeth Fuller Goodspeed (known as Bobsy) were there to greet them. A consummate New Yorker and patron of the Harlem Renaissance, Van Vechten had vivid memories of Chicago, about which he reminisced. He spent his years as a University of Chicago undergraduate going to theater, opera, and African American vaudeville clubs—the last a fascination shared with Stein.[1] Stein, Toklas, and Van Vechten were chauffeured by Butcher and Goodspeed and seated, just a few hours later at the Auditorium Theatre, for the city's premiere of *Four Saints in Three Acts*, which Stein had written with Virgil Thomson. The opera—which she had not yet seen—was performed by an African American cast, as it had been done at its controversial premiere back east. The next day, "simply gowned" Stein and Toklas, who wore "pendant gold earrings," were at the center of the society pages.[2]

By this point, Stein had become a literary celebrity with the publication of *The Autobiography of Alice B. Toklas* (1933), a work that wryly narrated the life of Stein from the point of view of her lover.[3] The work's accessible style attracted

scores of readers previously uninterested in Stein's more experimental writing. Stein was delighted by the welcome that she received on returning to the United States, where she had not lived since 1903, the year that she left for France. Van Vechten told her that in America she was "on every tongue like Greta Garbo."[4] Across the country, in every town and city, she was greeted by crowds.

During the year of Stein's American lecture tour, she visited Chicago four times. "You'll be amused to know that GS still prefers Chicago to other cities of U.S. and still finds Texas the most interesting," Toklas wrote in 1935 to former Arts Club director Rue Carpenter's daughter Ginny (who lived in Texas).[5] Stein's year included engagements at the most prestigious colleges and universities, though in Chicago there were initial difficulties: "Everywhere else it had all been easy but here [in Chicago] the trouble began," Stein explains in *Everybody's Autobiography* (1937). "For the first time they were making arrangements that did not please me and I was beginning to say so."[6] The University of Chicago, unlike other institutions, was initially resistant to Stein, causing much confusion about when and where and to whom Stein would lecture.[7] Butcher and Goodspeed stepped in to straighten out affairs. In fact, it was the literary ladies of Chicago who greeted Stein and Toklas every time they returned to Chicago during the tour and enthusiastically applauded the work of "La Stein," as Butcher called her. Finally, "Poetry and Grammar," sponsored by the university's English department, was delivered at International House on November 28, 1934, and "Pictures" the following week, sponsored by the Renaissance Society. "The Ren" was located on campus but only loosely affiliated with the university; under the leadership of photographer Eva Watson-Schütze, the Ren rivaled the Arts Club as one of the most vibrant venues for avant-garde art and performance.[8] Stein delivered both lectures to packed audiences.

It is perhaps surprising to realize just how popular Stein became during her lifetime and just how central Stein was to the literary life of Chicago. Stein spoke all over the city to many nonacademic audiences. She gave lectures at the Chicago Woman's Club, a progressive philanthropic club for well-to-do women, and at the Friday Club, an all-women's club that supported culture and the arts.[9] Stein also drew huge crowds at her December book signing at Marshall Field's. In her diary, Butcher describes how the store was "so jammed that they wouldn't even let us off the third floor. . . . We nearly lost our lives getting to [Stein and Toklas]."[10] Apart from her *Tribune* pieces, Butcher wrote about Stein in her memoir *Many Lives—One Love* (1972), describing Stein's conflict with the University of Chicago: "I had seen her in Bilignin [France],

and I had helped iron out some of the difficulties of her speaking at the University of Chicago, difficulties that proved what an invincible force does when it meets an immovable object."[11] Presumably, Stein is the "invincible force" and the University of Chicago is the "immovable object," though the ambiguity is revealing. Stein's enormous personality is both an agent and also an absence in the critical reception of her work.

Why did a mainstream reading public embrace Stein, whose experimental language is famously difficult? And why did the University of Chicago at first resist a writer who had become a literary celebrity? The story of Stein's time in Chicago raises questions about the performance of being a writer—in particular, a writer whose work the public does not wholly understand. It is also a story that reveals the connections between gender, literary celebrity, and Chicago's relation to the most experimental writers of literary modernism. Most importantly, Stein's 1930s visits to Chicago illuminate a tension between the avant-garde and the institutional, between Stein's radical experiments with language and the University of Chicago's famous curriculum of Great Books, which was being launched in the 1930s by university president Robert Hutchins and his newly hired philosophy of law professor Mortimer Adler.

In Chicago, Stein found herself moving among various communities, including huge public audiences, an intimate group of literary ladies, and a university crowd. She was wonderfully adept at performing for these different groups. Stein explained to a reporter in 1935, "I like ordinary people who don't bore me. Highbrows do, you know, always do."[12] Stein gave tips about how to read her work, and she did not disparage those who might be called "middlebrow," as another famous modernist, Virginia Woolf, used the term.[13] (One of the pleasures Stein discussed with Fanny Butcher was their mutual love of popular mystery novels.[14]) Stein's ease with mainstream readers may have contributed to her attraction to Chicago, which was perceived by many people—particularly Hemingway—as a place where middlebrow literary opinion presided. As a long-time resident of France who was yet an American, a society lady who yet appeared manly, a Radcliffe-educated woman who was distanced from university culture, and a famous writer whose major works were mostly unknown, Stein's affiliations were both inside and out.

Once the University of Chicago experienced the success of Stein's first visit to campus, President Hutchins asked Stein if she would return later in her tour to deliver another set of lectures. Stein accepted, and in February 1935, she and Toklas stayed for more than two weeks in Thornton Wilder's Hyde Park apart-

ment while Stein met with students and wrote and delivered lectures specifically for the University of Chicago audience. The University of Chicago Press eventually published these lectures as *Narration*.[15] Stein later wrote to Wilder: "I love Chicago and I guess I liked the two weeks there in your apartment and with all your family the best of everything, and I think I tell everybody so so much so that Alice tells me not to because it is not polite to the others but it is true and we did have a most awfully good time there."[16] During these two weeks, Stein won over Hutchins; he "presented [Stein] with beautiful red roses and a call of felicitation" before they left.[17] Of course, the rose was Stein's flower: on her stationery was an insignia of a rose encircled by her most famous words, "a rose is a rose is a rose."

Chicago's "geography," a word that Stein uses in several of her book titles, is an important concept for Stein, and crucial to understanding why she loved Chicago both literally and aesthetically. Chicago came to symbolize a geographic center that reflected, for her, much of America. "Whenever we see a lake we think of all of you," Stein wrote to Bobsy Goodspeed, whose apartment offered a dramatic view of Lake Michigan, "and whenever we do not see a lake we think of all of you and there are lots of lakes in this country."[18] Stein experienced the enormity of America on her lecture tour, and she wondered how language might represent the uniqueness of the American geography and its idioms. Her idea of geography signifies not only physical location but also the spatial arrangement of words on a page. In her *Narration* lectures at the University of Chicago, Stein vaunted the mobility of American people and how they forced the American language to have "a different feeling of moving."[19] "Moving" language, according to Stein, rejects classical narrative structure, rejects a "beginning and a middle and an ending."[20]

This idea about language's flexibility and openness was related to Stein's love of American vernacular, which inspired her distinctive use of the English language. Her early story "Melanctha" (1909), for instance, attempts to bring attention to the materiality of language by replicating African American speech. The story tracks the emotional arc and internal turmoil of a love relationship, expressed through extended sentences built with simple repeated words and phrases. Melanctha's lover Jeff tells her:

> I don't know anything real about you Melanctha, dear one, and then it comes over me sudden, perhaps I certainly am wrong now, thinking all this way so lovely, and not thinking now any more the old way I always before was always thinking, about what was the right way for me, to live

regular and all the colored people, and then I think, perhaps, Melanctha you are really just a bad one.[21]

A young Richard Wright read "Melanctha" soon after he moved to Chicago from Mississippi and was powerfully influenced by it. He was, in his own words, "awed and overcome." In his journal, Wright describes how Stein's language "made me hear something that I'd heard all my life, that is, the speech of my grandmother who spoke a deep Negro dialeck colored by the Bible, the Old Testament."[22] For Wright, Stein's stylized language draws emotional weight from harnessing the authority and cadence of scriptural texts. Stein's language, of course, is neither imitative nor true to African American speech—as many critics of "Melanctha" then and now have noted.[23] And yet, her style for Wright was its own kind of accuracy. "All of my life I had been only half hearing," Wright explained in a 1945 review of Stein's work, "but Miss Stein's struggling words made the speech of the people around me vivid. From that moment on [after reading "Melanctha"], in my attempts at writing, I was able to tap at will the vast pool of living words that swirled around me."[24] Stein's language sharpened what Wright heard and how he recorded speech. Her strange experimentalism made words sound exactly right.

Critics of Stein's work disagree about many things, particularly how to understand its specific kind of difficulty. Compelling arguments have been made that suggest two very different approaches. On the one hand, critics who champion avant-garde experiments with language argue that Stein wants the interpretation of her work to be governed individually by each reader. Wright's emotional response to "Melanctha," for instance, is bound up in his memory of his grandmother and his aims as an African American writer. The meaning of Stein's work is specific to the experience of an "autonomous" reader every time the text is read. Thus, a reader's past and personality—and a reader's sense of an author behind the text—can be very much a part of a text's meaning. In contrast, other critics argue that Stein's texts are themselves autonomous, that Stein's commitment is to putting forth impersonal ideas apart from the reader or Stein herself.[25] To look at how Stein herself advanced her work is to see how she created these two very different models: how she promoted an emotional response to her work among a mainstream reading public, and how she promoted ideas and impersonality among a university crowd.

Essentially Stein sought fame—which meant a positive, widespread response from all kinds of readers, across lines that demarcated class, gender, and

geography. This fact explains why she welcomed varied responses to her work. But Stein also wanted her works to stand on their own, to have ideas in them that would make them great, and this fact upholds readings of Stein's writing that emphasize its impersonality. Stein wanted it both ways.

The story of Stein's visits to Chicago expands our conception of what it means to "understand" Stein's language. It is often characterized by humor, self-reflexivity, sexual punning, and musicality that immediately appealed to many readers even as they were outspoken about not "getting it." And as many readers instinctively understood when reading Stein's work, you were allowed to laugh. During Stein's lifetime the reception of her work—especially among the educated but academically unaffiliated—was characterized by pleasurable sensation and interpretative openness. Rather than trying to locate the essential meaning behind Stein's texts, many of Stein's readers were encouraged to hear it, sense it, and laugh at it without feeling that they understood it. The incomprehensibility of Stein's work actually had the effect of promoting sensory "bliss." In her explanations about how to understand her work, Stein raised the larger issue of how to understand *any* literary text, as if complete mastery could ever be achieved. Stein may be the mother of the avant-garde, but she was never so ahead of her times as to obscure, to her mind, the primary aim of a literary text—which is immediate, effortless pleasure.

## WIVES

It is the things they do not understand that attract them the most.

GERTRUDE STEIN ON THE AMERICAN PUBLIC, 1934

Stein and Toklas mostly traveled by train throughout their 1934–35 lecture tour. It was Bobsy Goodspeed who realized that they should take a last-minute flight from New York to Chicago not to miss the city's premiere of *Four Saints in Three Acts*. (In an era of letters and trains, Goodspeed made phone calls and likely footed the cost of the flight. [26]) Goodspeed was an important, glamorous cultural arbiter in Chicago; from 1932 to 1940 she succeeded Rue Carpenter as president of the Arts Club, where she continued the club's groundbreaking exhibits of avant-garde art and where Stein would give her lecture "What Is English Literature." Goodspeed's husband, Charles "Barney" Goodspeed, was also a public figure; he was a Republican Party leader and a trustee of the University of Chicago. [27] (The Goodspeeds owned a parrot to whom he and Stein

apparently talked politics.[28]) After the opera, the Goodspeeds hosted a late-night supper party at their North Side penthouse on Lakeview Avenue. Bobsy Goodspeed served her famous "clear turtle soup," and Stein and Toklas spent the night.[29] The next day, they flew back to New York—with promises to Goodspeed to return to Chicago for a more extended stay.

Stein would never forget this first flight and first trip to Chicago. When she looked down on America, she saw many places all at once, a geographical composition below her that she compared to the paintings that she collected, a few of which she had lent for the 1913 Armory Show. Flying to and from Chicago clarified, for Stein, not only the origins and direction of modernist art but also her understanding of who was receptive to it. It was the literary ladies of Chicago—Butcher, Goodspeed, and a few others—who were most eager to know Stein and her work.

In contrast, Stein did not have an advocate at the University of Chicago until Goodspeed introduced her to Thornton Wilder on Stein's second trip to Chicago. Despite the age difference (Stein was sixty, Wilder thirty-seven), the two became fast friends. Stein and Wilder shared a mutual friend in Mabel Dodge; they also shared the experience of fame and the necessary obfuscation, to some degree, of their homosexuality. Wilder had won his first Pulitzer in 1928 for *The Bridge of San Luis Rey* (his second Pulitzer in 1938 was for the wildly popular play *Our Town*). Partly because of his success, Wilder was offered a special lectureship at the University of Chicago by President Hutchins, who had been Wilder's classmate at Oberlin and Yale. Indeed, even within an academic setting, the famous writer-in-residence—an offensive new position from the point of view of the professors—first welcomed Stein.[30]

Fanny Butcher, who could herself navigate among the various groups of readers in Chicago, was helpful in boosting Stein's popular reception. Before she became the familiar voice of the *Tribune*'s book column, Butcher had worked her way through the University of Chicago—commuting to campus at first, though her mother complained that she was not "working gainfully" but was "just pleasuring [her]self."[31] Butcher graduated in 1910 and soon began her career in journalism. Her simultaneous ownership of Fanny Butcher Books, which she ran from 1919 to 1927, was a job that combined pleasure with gain and kept her attuned to the market appeal of certain books (or lack thereof). Her cultural clout came also from her friendships with famous writers—especially Hemingway—and including others like Sinclair Lewis, Edna Ferber, H. L. Mencken, and Willa Cather.

Butcher's readers could rely on her to introduce new books in a bright and straightforward manner. As Hemingway understood, Butcher was a quintessential midwesterner. She was born in Kansas and spent almost all of her life in Chicago. Her literary sensibility was both ambitious and consciously common sense. For example, consider a passage from her *Tribune* column (written months before Stein's first visit) describing Stein's *Making of Americans*, the challenging tour-de-force that Stein called the "History of a Family's Progress."[32] Butcher was undaunted by how the novel narrated this "progress," with its insistent interplay of reiteration and repetition. As in other reviews, including her anonymous review of *The Sun Also Rises*, Butcher makes use of the second person "you":

> You, as reader, have something of the feeling of a rock against which the sea of her words beats constantly, in rhythm, in flow and ebb . . . and although she writes more of ideas than she does of the actual doings of her characters, when you have finished "The Making of Americans" you know all the members of the Hersland family better than you have known any human beings you have met in literature.[33]

Butcher's use of "you" assumes knowledge of how a reader will *feel* about *The Making of Americans*; and yet Butcher's presumption is belied by her trust of the reader's ability to understand a very difficult novel. She celebrates the reading experience as both purely sensory—the reader's "feeling" is vital to the book's meaning—and purely intellectual—this is writing of "ideas." These modes dominate (and often polarize) Stein's readers, but to Butcher they pose no conflict. Butcher offers her readers access to Stein's work by emphasizing a reader's centrality as well as the text's essential intellectual greatness.

In Chicago, Stein was also welcomed by Alice Roullier, the exhibitions co-ordinator for the Arts Club. Roullier had met Stein and Toklas in 1931 during one of her annual trips to France, when Butcher accompanied her. Roullier arranged an exhibit of paintings by Stein's friend Francis Rose, on view at the club when Stein was in town. Stein lent thirteen works to the exhibit, and Rose's portrait of Stein was featured on the cover of the exhibition catalog (fig. 68). Maude Hutchins, the stunning wife of the University of Chicago president, also joined these women in their adulation of Stein. Adopting Stein's terminology, one could say that it was a group of American "wives" who surrounded her.

Stein made a clear distinction between husbands and wives, describing in *The Autobiography of Alice B. Toklas* how Alice sat with "the wives of geniuses"

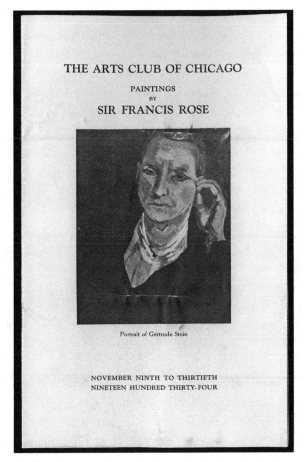

THE ARTS CLUB OF CHICAGO

PAINTINGS
BY
SIR FRANCIS ROSE

Portrait of Gertrude Stein

NOVEMBER NINTH TO THIRTIETH
NINETEEN HUNDRED THIRTY-FOUR

*Fig. 68. Sir Francis Rose, drawing of Gertrude Stein, 1934, from exhibit catalog, Arts Club of Chicago. Courtesy Arts Club of Chicago and Newberry Library*

and she conversed with the geniuses themselves, the men.[34] But in Chicago, gender played out differently. Indeed, two of Stein's lectures in Chicago took place at women-only venues—the Chicago Woman's Club and the Friday Club. At the Friday Club (which rented rooms for large events at yet another women's club, the Fortnightly), there were so many "excited and jittery women" who came to hear Stein that the social committee reported on the "nightmare" of nearly running out of food:

But after the November 30th meeting, nothing has fazed the Committee. That was Gertrude Stein day. Her subject was "Repetition." So was ours.

On and on we counted. It was a nightmare and we ended by serving luncheon to three hundred and five excited and jittery women. They ate and argued in practically every room of the Fortnightly.[35]

To eat and argue: this was Stein's idea of a good salon. Stein would later voice conflicted feelings about the ways in which widespread fame, which now included this feminized readership, both overshadowed her work and inhibited her usual flow of writing.[36] But at the time of her tour, as she recounts it, she fully enjoyed the attention she received from the nationwide press—it had been a long time coming—and in particular from Chicago women.

In private circles, Stein's formidable presence was also exciting. "Gertrude massive," Butcher writes, "with a head like a Roman emperor's on a body like a modern stone block sculpture."[37] That she already looked like a work of art inspired many people to paint her portrait, most famously Picasso in 1906. Stein happily posed for many avant-garde artists—from sculptor Jo Davidson to painter Francis Picabia to photographer Man Ray: she is one of the most photographed, painted, sketched, and sculpted women of the twentieth century.[38] Perhaps the visual medium expressed something about Stein that words could not.

Among the women she met in Chicago, Stein seemed to encourage more than usual playfulness, especially as they performed in front of the camera (figs. 69, 70). In photographs from a later dinner party at the Goodspeed home—where Stein and Toklas returned for several nights—the women are crowded on a sofa, framed by men. They pass around a flower that duplicates the bloom in the Bernard Boutet de Monvel portrait of Bobsy Goodspeed above them. The Goodspeed home, designed by David Adler, housed paintings by Picasso, Calder, Matisse, and another portrait of Bobsy Goodspeed by the American impressionist Martha Walter. Goodspeed wears a dress that resembles the one she wears in the portrait, and she flirts with the flower held to the nose of Richard Bokum, Fanny Butcher's future husband (they married in early 1935).

The self-awareness evident in these photographs—the play with surface representation and identity—is like a performance directed by Stein herself. Bobsy Goodspeed is the central star: mimicking her portrait, she poses for yet another replication. Notice the standing lights on either side of the sofa. Goodspeed was an amateur filmmaker who created entertaining movies of avant-garde artists and writers—Constantin Brancusi in his studio, clowning with Marcel Duchamp; Colette at a café, playing with a monkey.[39] During the Stein dinner

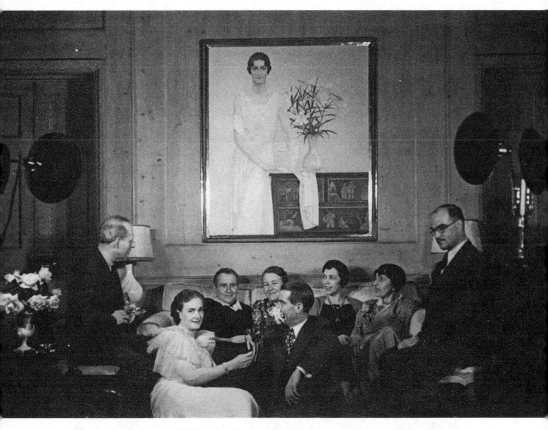

*Fig. 69. At the home of Bobsy and Barney Goodspeed, 1935: Gertrude Stein, Fanny Butcher, Alice Roullier, Alice B. Toklas (all on sofa); Barney Goodspeed (seated at left), Bobsy Goodspeed (with flower), Richard Bokum, and Thornton Wilder (seated at right). Fanny Butcher Papers, Courtesy Newberry Library*

party, Goodspeed made a silent film of the evening, which shows her sitting at Stein's feet with her arms on Stein's knees. When Barney Goodspeed presents his wife with a flower, she passes it on to Stein, who gives it to Thornton Wilder. Wilder then gets up and gesticulates madly; he tries to kiss Stein—everybody laughs—and Stein waves him away. Indeed, the men seem pushed to the periphery. And the women seem to have picked up on the indirect charm of a writer who constructs an autobiography from the point of view of her lover.

The film and the many photographs of this evening at the Goodspeed home also bear a comparison to Stein's writing. Take Stein's *Tender Buttons* (1914), which is similarly attentive to pictorial compositions in its playful, pun-

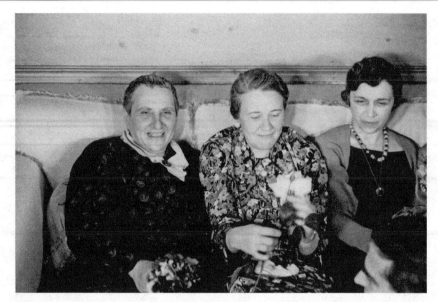

Fig. 70. *Gertrude Stein, Fanny Butcher, and Alice Roullier at the home of Bobsy and Barney Goodspeed, 1935. Fanny Butcher Papers, Courtesy of the Newberry Library*

ning and yet serious fashion. *Tender Buttons*—which was published during Stein's lifetime and thus available to Chicago readers—is part of a larger movement clearly embraced by Bobsy Goodspeed in the design of her home. Through a combination of sexual tropes, *Tender Buttons* concludes:

> The care with which the rain is wrong and the green is wrong and the white is wrong, the care with which there is a chair and plenty of breathing. The care with which there is incredible justice and likeness, all this makes a magnificent asparagus, and also a fountain.[40]

Is this a home filled with modernist art? The colors and subjects of this art may be technically "wrong," and yet the art is composed with emphatic "care." The aim is not visual verisimilitude but rather a fidelity or "justice" to what is represented. It is a different kind of "likeness." The interior, feminized spaces suggested by *Tender Buttons*, like the Goodspeed home, cultivate domestic comfort and freedom, where there is "a chair and plenty of breathing." This is a realm of women at the center and men on the fringes. If ever there was a humorous phallus, then it is a "magnificent asparagus." If you do not get it the first time, then there is also a "fountain."

In fact, there is some speculation that these women were open to exploring

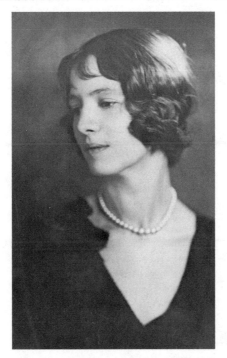

*Fig. 71. Maude Hutchins, undated. Courtesy Special Collections Research Center,
University of Chicago Library*

lesbianism. In a letter that Stein's friend Bernard Faÿ wrote to her on June 11,
1934, to encourage Stein to visit America, he mentions an intimacy between
the Goodspeeds and an unnamed "wife of the president of the university."[41] Faÿ
was a sophisticated gossip with a proclivity for social intrigue (a few years later
he would become a Nazi collaborationist).[42] But if his letter has any truth, the
unnamed wife would be Maude Hutchins (fig. 71), whose beauty was legendary
and whose turbulent marriage of twenty-seven years ended in public catastrophe
when Robert Hutchins left her in 1948 for his much younger secretary. Maude
Hutchins—a visual artist who in the early 1940s began publishing poems in
*Poetry* magazine—then became a writer of sexually provocative novels, many of
which dallied in lesbian fantasy.[43] There is no evidence that Maude Hutchins
and Bobsy Goodspeed were lovers, but it is fair to say that Stein and Toklas met
a particularly receptive group of women in Chicago, who seemed very much
attracted to Stein's gender drag and her performative humor.

Consider for example Stein's inscription in a copy of *Lucy Church Amia-
bly*, gifted to Bobsy Goodspeed: "For Bobsy, Lucy Church Amiably is amiable

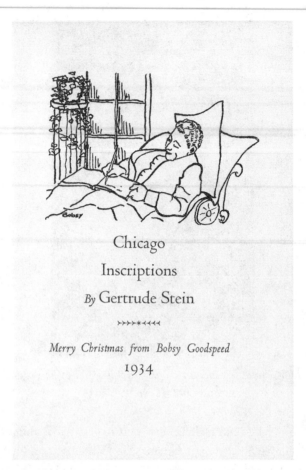

but Bobsy is so sweet and kind and we we like that kind of yes we do like that kind."[44] Or Stein's inscription in a copy of *The Autobiography of Alice B. Toklas* presented to Richard Bokum after he and Fanny Butcher married: "For Dick not bunkum but Kokum for Dick Fanny's Dick."[45] Who knows whether Goodspeed, Butcher, and Bokum understood the double entendre of Stein's "kind," but they certainly would have known the coarse meaning of "dick" and that "fanny" is British slang for vagina. These inscriptions and others amused Bobsy Goodspeed to such an extent that she collected them in a small private press book that she had printed for Christmas presents in 1934, and which Stein also sent as gifts, sometimes even inscribing her book of inscriptions (fig. 72).[46] Stein

was charmed by *Chicago Inscriptions*: "The next best thing is this book and the pictures and they make us so happy and we are pleased and proud," she wrote to Goodspeed. "I must confess I did not know they were so nice when I did them, but right away Chicago inspired me."[47]

"Steinish," as the papers called it, was a compelling language for the Goodspeeds' group of Chicago socialites. It was a language that was both radical for its bluntness and gracious for its playful indirection. Stein sent newspaper clippings to the Goodspeeds about her tour of America that were noticeable for how the reporters evaded her sexuality—by describing Toklas, for instance, as Stein's "friend and secretary": "I am sending you two clippings that I think will amuse you and Barney, you see although indiscreet I am very discreet," Stein wrote.[48] If Stein felt the inability to live and write openly as a lesbian, then her whole aesthetic style excelled under this constraint. Tantalizing with repetition, Stein had a way of saying and not saying it.

## UNDERSTANDING AND ENJOYING

But not everybody in Chicago was "on" to Stein. Fanny Butcher knew that most of Stein's books were not suited to the marketplace, and she admitted in her diary to not understanding Stein's most experimental language. The confusion that Butcher felt in regard to Stein's work is worth considering. It suggests that readers often respond to Stein's work as they respond to Stein herself. That is, how we read Stein's work correlates to how we read her as a person. Butcher at first treated Stein's work as if she needed to decode its meaning. But as she encountered more of Stein's writing, and Stein in person, Butcher shifted her approach, enjoying on her own terms Stein's work without needing to master it. This shift certainly has something to do with Butcher's early aspirations as a student and her eventual authority and repute as a literary critic and editor. But Butcher's response also mirrors the responses of many readers who sensed that Stein's work posed a subversive challenge to the very experience of understanding itself or to models of reading institutionalized by the university.

Butcher read Stein's *Three Lives* when she was a sophomore at the University of Chicago. But she did not read it for a course. Stein's work was not then taught by professors there. Butcher was given *Three Lives* by a mentor whom she met at a Thursday evening salon hosted by a Viennese woman in Chicago.[49] Butcher described the reading experience much later in her autobiography: "I couldn't understand it, but neither did I understand Estonian, and I felt that, if I could

just learn the rudiments, I would have no trouble with the alien Stein tongue."[50] This admission emphasizes both Butcher's ambition and her desire to cultivate an appreciation for European avant-garde art. Stein's language, however, is not compared to French or Italian or Latin. It is like "Estonian"—completely un-related to what Butcher knows and yet perhaps accessible if she can "learn the rudiments."

With the publication of *The Autobiography of Alice B. Toklas*, Stein made her writing more available to readers like Butcher. She wrote for the middle-brow in the sense that this autobiography is a much more accessible version of an avant-garde experiment, aimed at a wide readership. It is "audience writing," as Stein would put it, created to please readers. Butcher's position on Stein's writing may reflect an enthusiasm for a style that she was beginning to under-stand, that she felt she *should* understand. Her response may also indicate that she knows something unusual is at work in Stein's texts—some quality that her University of Chicago education did not train her to recognize, the "moving" language of interpretive openness. Standing outside of the academy, in the case of reading Stein's work, might actually aid her enjoyment of Stein's "foreign" prose.

But how much did knowing Gertrude Stein herself help Butcher compre-hend Stein's writing? How much can a reader understand about a work of lit-erature by knowing something about its author? Nothing, according to English departments all over the country under the critical sway of T. S. Eliot, who was becoming a literary authority lionized in the academy at the same time that an academic readership was resisting Stein. (At Hutchins's invitation, Eliot would spend six weeks lecturing at the University of Chicago in 1950.) "The progress of an artist is a continual self-sacrifice, a continual extinction of personality," Eliot writes in his seminal essay "Tradition and the Individual Talent" (1919), suggest-ing that critics should not aim to find the artist or the artist's "emotions" within a literary work. "Poetry is not a turning loose of emotion," Eliot writes, "but an escape from emotion; it is not the expression of personality, but an escape from personality."[51] The impersonality promoted by Eliot and carried forth as a major modernist tenet considers literature as a kind of science in which complex emo-tions are concentrated through language into something that is not an emotion at all.

But this is not how Stein's work has been read. It is so often that her writing carries with it some quality of how a reader imagines Stein herself. And Stein's writing could be confusing partly because as a person she herself was hard to read. More than twenty years after first reading *Three Lives* but before she wrote

lavish praise for Stein in her pieces for the *Chicago Tribune*, Butcher privately described meeting Stein at her country house in France in 1931 and confessed to not "getting" everything that Stein said. "There lives with [Stein] a strange, over-feminine woman whose name is, I think Alice Toutless," Butcher writes in her diary. "She attends to the household affairs and serves the plates at table, and coquettes with the guests and quotes Gertrude Stein's best mots to Gertrude Stein and the guests." Butcher then describes Stein reading aloud from her own work: "I suppose I looked a little vague," Butcher admits, "because she read it again and said 'Do you get it?' I didn't, but I said I did because I hadn't guts enough to ask her to *make* me get it."[52] Stein's life with Toklas is also Stein's writing. Both, to Butcher, are strange. Instead of giving up on Stein's work, what happens is that Butcher finds a way of appreciating Stein's writing without "getting" it and without fully "getting" Stein.

Indeed, the aggressiveness of Stein's question to Butcher ("Do you get it?") is contrary to Stein's more typical indirectness both in writing and in conversation. It is as if Stein really asks the question to her Chicago visitor with the full knowledge that her writing cannot be "got." The more that Butcher reads of Stein's work and consorts with Stein herself, the more she allows for the idea that "something of the feeling"—as she writes in her review of *The Making of Americans*—can dominate the reading experience.

The Chicago newspapers—especially the society pages—are full of responses to Stein similar to Butcher's. Many people frankly admitted to not understanding Stein while nonetheless enjoying what she had to say. Judith Cass of the *Tribune* describes "Miss Stein" as someone "whom all . . . have met . . . like and admire but whose writing no one I know even pretends to understand."[53] Another *Tribune* writer describes the effect that Stein and Toklas had on the crowd at the Chicago premiere of *Four Saints in Three Acts*:

> Perhaps never before . . . was there so little attention paid to the lovely la-
> dies in the boxes, for short-haired, simply gowned Gertrude Stein was the
> center of attention. Her longsleeved, high-necked gown of a dark plum
> color completely overshadowed the colorful and gorgeous gowns of her
> feminine neighbors, although the huge pendant gold earrings of Miss
> Toklas did cause many to glance her way.[54]

Even as Toklas appeared in the papers as Stein's "friend and secretary" or inaccurately in Butcher's memoir as Stein's "childhood friend," there is clearly a way

that Chicago understands Stein through a reading of her sartorial manliness.[55] She is distinctly not "feminine" with her short hair and "high-necked gown," surface signs of her sexual difference. But Stein's sexuality is comprehended in a way that is never made explicit, expressed as a "feeling." The *Tribune* writer here knows that something meaningful is happening in Stein's presence, but she is unable to state exactly *what*: Is Stein simple ("simply gowned") or is she complex ("a dark plum color")? The description of Stein at the opera is also a description of Stein's very prose: pleasure is found in it even as it is not clear what is signified by Stein's reversals and visual play.

The American public needed a primer on how to read most of Stein's texts. Bennett Cerf, Stein's editor at Random House, encouraged her immediately on arriving in New York to appear on Pathé Newsreels, a program shown in movie theaters across the country. For this short publicity film, Stein gave an overview of the lectures she would give, suggesting that her listeners would understand her if they allowed themselves simply to enjoy the experience. "My lectures are to be a simple way to say that if you understand a thing you enjoy it and if you enjoy a thing you understand it," she says in the film. And then again, she states, "Understanding and enjoying is the same thing."[56]

Stein is the master of the gerund, a part of speech that suggests ongoing movement, nothing at end. Comprehension of her texts is not fixed but moves with potential like the very American language she celebrates. Enjoying *is* understanding. In *Everybody's Autobiography* (1937), the work that Stein wrote after her lecture tour in which she grapples with her new celebrity status, Stein writes:

> They ask me to tell why an author like myself can become popular. It is very easy everybody keeps saying and writing what anybody feels that they are understanding and so they get tired of that, anybody can get tired of anything everybody can get tired of something and so they do not know it but they get tired of feeling they are understanding and so they take pleasure in having something that they feel they are not understanding.[57]

Stein suggests that readers are tired of having literary texts explained to them. Readers want to forego the work of understanding Stein's texts in favor of sensation, the feeling of Stein's rich word associations rather than an analysis of what the text "means," as if meaning could be pinned down as a static quality. Is a reader, then, more important to the text's meaning than the author? It is

unclear whether Stein ever would have wanted her own presence as author to disappear. But her statements about how to understand her work suggest that she was open to various readings apart from finding neat or right or even clearly articulated responses to it.

Perhaps the most striking response to Stein's work came from Richard Wright. It was likely spring 1935—just after Stein had left Chicago—when Wright discovered *Three Lives* at the George Cleveland Hall Branch library, the intellectual haven of Bronzeville. Possibly he read Stein's work after hearing about her in the Chicago newspapers. The *Chicago Defender*, for instance, had praised the November 1934 performances of Thomson and Stein's opera *Four Saints in Three Acts* by an all-black cast at the Auditorium Theatre.[58] That Stein somehow captured southern "negro dialect" was what Wright felt but did not immediately share with those who were part of his left-wing literary circles. Instead, he wanted to know how other members of the working class would respond to Stein's prose. Through a black communist organizer who worked in the stockyards, Wright arranged to read Stein's "Melanctha" to a group of "semi-literate Negro stockyard workers." To Wright's delight, "They understood every word. Enthralled, they slapped their thighs, howled, laughed, stomped and interrupted [Wright] constantly to comment up on the characters."[59] Their reaction verified, for Wright, that Stein's wildly modernist language was wonderfully alive, that it could be sensed and understood. According to Wright's biographer, this moment helped Wright understand modernist writing as legitimate and politically sound. To write in the style of Stein and other writers whom he admired (James Joyce, T. S. Eliot, Marcel Proust) was not a form of decadence but a kind of realism to which Wright also aspired.[60]

What differentiates the wider public's response to Stein—from stockyard workers to literary ladies—in comparison to the response among a more academic readership is a readiness to accept pleasure without textual understanding. Pleasure is its own understanding. The difficulty of Stein's work did not necessarily demand that readers decipher its meaning, but rather it allowed them to simply enjoy it as a sensation: you could laugh, joke, or even howl. This response also held true for the lectures that she gave in Chicago. For many of her listeners, it was Stein's humor and music that emerged from her difficult use of repetition, disconnected syntax, and nonstandard grammar.

Stein's lectures, to be sure, were innovative and arresting as a dress of dark plum. But the arguments that she puts forth were simply gowned. For instance,

in her lecture "What Is English Literature," which she gave at the Arts Club after a dinner in her honor, Stein claims that the glory of English literature comes from the fact that England for hundreds of years had the stability and wealth to sustain writers and a reading public. She traces a trajectory from Geoffrey Chaucer to the twentieth century by way of the continuous "daily island life" that characterizes the greatness of the country's literature. She did not advance a theory of literature that explicitly challenged conventional thinking. Moreover, Stein's argument is kept in broad terms. She does not flaunt her erudition or burden her audience by making them feel as if she is teaching them something. She teaches them what they already know. Stein's lectures appealed to an American public who wanted access to a famous writer at the center of the modernist movement in Paris but who would provide for them recognizable ways of thinking about writing and art. Stein amused the women who organized her visits and indulged her huge auditorium audiences: she was what the middle of America wanted an avant-garde artist to be.

## CITY OF WORDS

What was it about America—or was it Chicago—that made Stein rewrite her lectures for her audience at the University of Chicago? She wrote them while she and Toklas stayed in Thornton Wilder's Hyde Park apartment on their third and longest stay in the city. The women circled back to Chicago on their tour—it was their hub—and the centrality and energy of the city deeply influenced these four lectures, published as *Narration*. It is an important book for many reasons, including the simple fact that it saw print during Stein's lifetime: much of Stein's work was not published until after she died. "Am reading Gertrude Stein's NARRATION, and find it fascinating," wrote Richard Wright in his journal, a response that marked his avid interest in Stein's exploration of American language.[61] Though the lectures expand on the themes of the lectures that Stein gave earlier and elsewhere (published as *Lectures in America*), they are different in that Stein registers her sense of change in American culture as she was seeing it after thirty years away.

The *Narration* lectures emphasize the vitality of the American idiom as Stein read and heard it in advertisements, newspapers, road signs, slang, and local conversations. "Let's make our flour meal and meat in Georgia"—these are words that Stein sees on a road sign, which she recalls at the start of her second *Narration* lecture. "Is that prose or poetry and why," she asks.[62] Stein's sense

of fresh, compelling, modern language is neither solely tied to "What Is English Literature," as she titled her earlier lecture, nor is it even tied to literature at all. The *Narration* lectures demonstrate a shift in Stein's thinking about writing, especially about the audience for it and the value of her writing over time. At the University of Chicago Stein confronted men with very strict claims about literary greatness, and her conflict with them reveals that she wanted her works to be read not just for their "feeling," which would allow personality to govern literary interpretation. She also wanted them to be impersonal, to contain ideas that stood on their own and stood the test of time, but not ideas as defined in academic terms. Stein disagreed with the men of Great Books even as she latched on to their idea of greatness and transformed it with her difference.

Stein was not Henry James, her literary model. Also a longtime expatriate, James returned to the United States in 1904 after twenty years abroad and was alarmed by the immigrant influence on the English language. James walked through the tenement slums of the Lower East Side of Manhattan and was overwhelmed by the "great swarming" of a "Jewry that had burst all bounds."[63] What appalled James would generate great creativity in other American artists and writers. Indeed, in Chicago, a vibrant Jewish community populated the Near West Side, a shtetl-like enclave centered on the Maxwell Street market, which inspired Chicago visual artists like Todros Geller, Emil Armin, and Vivian Maier.[64] And in contrast to James, Stein found that the ethnic diversity, mobility, and lack of convention in American life (the lack of a "daily life") fostered the most dynamic developments in twentieth-century art and literature.[65] Stein emphasizes in her first *Narration* lecture "how the pressure of the non daily life living of the American nation has forced the words to have a different feeling of moving."[66] Her description of American English is also an advertisement for her own, which is to say that her readers might experience her language as a pleasant sensation, a "feeling of moving." Stein suggests that American English is naturally less tied to tradition, and she connects her own purposefully nonstandard English with the innovative spirit of her home country that she was reencountering with such pleasure on her tour.

Stein's emphasis on the movement of American writing takes the form of rejecting classical narrative structure, that is, "a beginning and a middle and an ending."[67] This is a clever refutation of Aristotle. The construction of plot—by means of a beginning, middle, and end—is Aristotle's most important feature of tragedy. But Stein wants to toy with time. What really is the cause of something? How far back should it go? Stein is more interested in middles—in the sense

that a middle points in directions before and after—than she is interested in beginnings and endings, which are fixed in time and signal a work's wholeness and completion. Stein celebrates the dynamic openness of the most important experiences that writing should register, which "exist" rather than "happen." For example, "love" is the example she gives in her third lecture: love has no clear beginning, no defined starting point or ending.[68] Her aesthetic essentially embodies something she was feeling on her American lecture tour, and perhaps most vividly in Chicago: constant movement, shifts in direction, and a sense of all things as present, open, and possible.

Years earlier, in 1922, Stein's friend Sherwood Anderson had praised Stein's writing in a short piece he wrote for the *Little Review* that would also serve as his introduction to her 1922 volume *Geography and Plays*. Anderson drew on metaphors that distinctly called to mind the city of Chicago—which Stein, of course, had yet to visit:

> There is a city of English and American words and it has been a neglected city. Strong broad-shouldered words, that should be marching across open fields under the blue sky. . . . For me the work of Gertrude Stein consists in a rebuilding, an entire new recasting of life, in the city of words.[69]

Anderson here repurposes Sandburg: the "City of the Big Shoulders" is made of "strong broad-shouldered words." And these words, for Anderson, were written by Stein. Stein's use of the English language is like the building of a new structure in which to live, a city on a prairie. For Anderson, the energy motivating Stein's experiments with language is the same energy behind the creation of Chicago itself.

Stein had her devoted fans in Chicago—Anderson among them—but not everyone was impressed by Stein's creation of a language that has "a different feeling of moving" or by her lectures in particular. Thornton Wilder convinced the University of Chicago Press to publish Stein's lectures in 1935—*Narration* was the only work of hers that the press published—but faculty who read the manuscript beforehand for the publisher were not supportive of the project. Professor Robert Lovett from the English department writes in his report: "Briefly, I do not agree with my colleague's, Mr. Thornton Wilder's, appreciation of these utterances. I think, however, that they may be properly published as part of literary history. Gertrude Stein is a fact, as Dadaism is a fact, and records of both ought to be preserved."[70] "Utterances" suggests that Lovett was unable to separate

*Fig. 73. Mortimer Adler, undated. Special Collections Research Center,*
*University of Chicago Library*

Stein's writing from Stein's performance: he reads text and person as one. An-
other English department professor, Edith Foster Flint, writes that although she
enjoyed Stein's lectures when she first heard them, the manuscript of *Narration*
left her with "a feeling of extreme irritation." "I can see no virtue whatever in
the manner of expression," Flint writes, "and the ideas conveyed—so far as I am
able to penetrate to them—do not seem to me so profound or novel as to neces-
sitate, or warrant, the creation of a new medium, to me a grotesque medium."[71]
Flint—like crowds of Chicagoans—found enjoyment in Stein's performance
but not in a more analytical reading of Stein's texts, a reading framed by the
values of an English department composed almost entirely of men.[72]

The figure in whom all of these objections to Stein found their greatest force
was Mortimer Adler. Adler had come to Chicago from Columbia University to
establish a Great Books program (fig. 73). Like Wilder, Adler had been hand-
picked by Robert Hutchins in his first year as president. Hutchins wanted Adler
to help him reform the undergraduate curriculum. But unlike Wilder—who
was very popular at least with students—Adler was not well loved at the univer-
sity, and like Stein, he was somewhat of an outsider to it.[73]

Many faculty members were opposed to Great Books, preferring instead the
implementation of what was called the New Plan, a two-year curriculum culmi-

nating in comprehensive exams across four fields: biological sciences, physical sciences, humanities, and social sciences. Students then went on to specialize in a field.[74] But Hutchins—who team-taught Great Books with Adler—became even more convinced that Great Books was something that the undergraduate curriculum should include because it favored classical training over more recent developments in the arts and sciences. Hutchins's polemical 1933 convocation speech decried the emphasis put on specialization: "The gadgeteers and the data-collectors, masquerading as scientists," Hutchins said, "have threatened to become the supreme chieftains of the scholarly world."[75] When Stein visited the University of Chicago, the debate over liberal arts education versus specialization was still very hot. Hutchins was twice on the cover of *Time* magazine, which reported on the national debate.[76] The country was contending with the Chicago question: should undergraduate students read widely in the liberal arts or should they be trained as specialists? Stein hit a nerve when she questioned Adler and Hutchins about their undergraduate program.

One infamous evening during a dinner party at Robert and Maude Hutchins's Hyde Park home, Stein got into an impassioned discussion with Adler and Robert Hutchins. It was November 27, 1934—before the *Narration* lectures— during Stein's second visit to Chicago.[77] According to Adler, Stein was "infuriated" by the idea that Great Books were read in translation: "She said that great literature was essentially untranslatable." Adler describes how he and Hutchins "tried to argue with her, pointing out that we were concerned mainly with the ideas which were to be found in the Great Books. She might be right, we admitted, that fine writing suffers in translation, but ideas somehow transcended the particular language in which they were first expressed." Apparently Hutchins elaborated, explaining that "the idea of justice" is the "same idea whether it is discussed by Plato in Greek, by Cicero in Latin, by Kant in German, or by John Stuart Mill in English."[78] Stein was stalwart, and unconvinced. Hutchins then challenged Stein to teach their Great Books class the following week. As Stein writes: "I said of course I will and then Adler said something and I was standing next to him and violently telling him and everybody was excited and the maid came and said Madame the police. Adler went a little white and we all stopped and then burst out laughing."[79]

It was indeed the police. But they had not arrived to break up the Great Books debate. Fanny Butcher had arranged through the *Tribune* for Stein and Toklas to accompany the homicide squad unit on their night tour of duty. (Butcher had once covered the *Tribune*'s crime beat.) That rainy night, the famous gangster

Baby Face Nelson was shot and killed in the Chicago suburbs. Stein and Toklas listened with rapt excitement to the events unfolding over the police car radio as they were driven through the comparably quiet neighborhoods of South Side.[80]

Stein and Toklas's exposure to Chicago, the actual "city of words"—far beyond lecture halls, book signings, and dinner parties—happened that night. It was a stark contrast from the Hutchinses' home to the streets of Bronzeville, where Stein and Toklas left the squad car, walked with the police officers, and then visited a family inside their home. To see a side of Chicago otherwise unavailable to them was consistent with Stein's long-standing, voyeuristic interest in African American life. Like her friend Carl Van Vechten, she was attracted to an expressiveness and sensuality that they both attributed—with palpable condescension—to black people. For many readers, Van Vechten took it too far, transforming his familiarity with black culture into works of sensational provocation. The satirical title of his 1926 novel about Harlem, *Nigger Heaven*, was as controversial then as it is now.

In the parlance of Harlem, Stein and Toklas were "van-vechtening" around Chicago, sightseeing where they did not belong.[81] "There were ten or twelve there and others in other rooms men and women, all orderly enough one in a corner cooking, some in bed some just doing nothing and anyway it was all orderly enough," Stein writes in *Everybody's Autobiography*.[82] The home—likely a crowded kitchenette—reminded her of a southern home or "one of those in Baltimore where when I was a medical student we went to deliver a little Negro baby." The officers pretended, jokingly, to be looking for criminals, which made the group "just uneasy enough so that the relief made us all have a pleasant feeling." Stein learned where each person came from—"mostly from somewhere in the South"—and then they left to continue their excursion: through Chinatown and on to witness a "walking marathon" at which couples attempted to dance for weeks without stopping. Part performance and part endurance, the event was strangely American, the kind of thing that captured and held Stein's imagination.

Stein was intensely interested in what new forms were coming out of America. The inspiration that she drew from African American life and speech has been rightly criticized as egregiously primitivist while yet acknowledged as a vital influence on her distinctive style. In 1945, she was interviewed in Paris by Ben Burns, an editor at the most important black newspaper in America, the *Chicago Defender*. She raved about Richard Wright, whose autobiography *Black Boy* (1945) she had borrowed from an American GI in Paris. (She would

finally meet Wright in 1946, after helping Wright and his family obtain visas for a permanent move to France.) "I found Wright was the best American writer today. Only one or two creative writers like him comes along in a generation," Stein said. "Every time he says something it is a distinctive revelation. He tells something never told before in a perfectly distinctive way." For Stein, Wright's story was original, and he told it with great confidence. "The theme is the Negro but the treatment is that of a creative writer," she said.[83] It was as if he had succeeded at the kind of creative autobiography that she herself had written.

And yet Stein's experiences as a writer—as she herself knew—were far different from Wright's. She tried to understand black life in America, a subject about which Wright and Stein corresponded in long, dense letters during 1945–46.[84] He sent her the photo-essay 12 *Million Black Voices* (1941), his pamphlet *How "Bigger" Was Born* (1940), and the groundbreaking sociological study *Black Metropolis: A Study of Negro Life in a Northern City* (1945), by Horace Cayton Jr. and St. Clair Drake, for which Wright had written the introduction. Indeed, Wright told her that he relied on her 1926 essay "Composition as Explanation" in his introduction to *Black Metropolis*, putting forth her "notion" that war accelerated the recognition of a modernist aesthetic in contemporary art.[85] Wright's introduction calls attention to how contemporary writers, including a "Chicago School," articulate an awareness of the particular conditions of urban modernity. He singles out Stein's *Three Lives*.[86] It is an astonishing signal of transatlantic intellectual connection that Stein's ideas about modernist literary expression are embedded in the now classic study of black Chicago.

But Stein had a difficult time actually speaking with black soldiers. This seems predictable, given her awkward rendezvous in a Chicago kitchenette. Stein expressed to Wright her frustration that she was unable to talk with black soldiers on the street in France, despite her being able to talk with "every level of American soldier." "In the last war we talked," she wrote to Wright, "but somehow in this war I do not seem able to say to them hello boys how do you like it as I do to all the others."[87] And so Wright sent Stein a handbook on "jive" and gave her tips: "They will talk to you about music. Just say, Hello boys, I don't dig this jive. What's it all about. Who is this Armstrong and what makes him so hot? They will tell you. I'd awfully like to know what you thought of the jitter bugs."[88] It is almost unimaginable—that Stein would stop black soldiers on the street in Paris and talk to them about the jitterbug. But Wright is serious. Stein presumably wanted to know more about jive.[89] In Wright's next letter to her, he offers a long disquisition:

Jive means fun, play, kidding, hiding things with words, and generally stepping up the tempo of living through talk. Jive is a way of talking invented in the main by urban Negroes who see to have nothing much else to do but play with words. . . . Jive now can be heard on the lips of white boys at Yale and Harvard. Where Negroes cannot usually go, their words and their songs go.

Wright knew what had fantastic appeal for Stein: an American vernacular that is constantly developing, with rhymes that are playful, repetitious, and most importantly, subversive. Jive is speech that white folks cannot control: it "keeps on growing," Wright explained to Stein, "until it reaches a state of development where Negroes can carry on a conversation among themselves within earshot of whites and the whites will not know what they are talking about."[90] Wright understood, nevertheless, how this language could be coopted—by Ivy League undergraduates and presumably by Stein herself, who was then working on her last piece of writing, *Brewsie and Willie*, composed entirely of the speech of American GIs. (Wright read it in galleys and said it was the most incisive thing Stein had written.[91])

Wright believed that Stein was the first white writer who treated Negro life seriously.[92] In Chicago—and through her correspondence with Wright during the last year of her life—Stein listened to the idiomatic transformations of American English. Chicago was a good place to register change. And yet Stein was still somewhat of an outsider to America and especially to black life. She never returned to her home country after her 1934–35 trip, even though it would have been much safer during the war for her to live in the United States. Maybe it was Stein's distance from American culture that allowed her to choose what she wanted from it. Her elevated status, her slightly imperial remove, her ability to step in, absorb a scene, and leave: her separateness sharpened what she observed as America's uniqueness and creativity. In Chicago during her lecture tour, Stein felt like she was seeing and hearing a country that she had not yet known.

## GREATNESS

An evening of Chicago gangsters and South Side slumming put a brief hold on Stein's disagreement with Hutchins and Adler. But she remembered Hutchins's offer to visit their classroom. A few days later she wrote to Van Vechten: "[But]

this is a dead secret nobody knows that I am going to do it."[93] A week later, Stein—unannounced to anyone—showed up to teach the Hutchins and Adler class, a two-hour discussion of Aristophanes and epic poetry.

What happened in that class? By her own account Gertrude Stein had an entertaining time teaching Great Books students. She admitted to "immensely" enjoying the course because "they teach by talking." She wrote to Van Vechten: "They are interesting students and they say good things to you and they catch you up and it goes hammer and tongs pretty well and I liked it I like it a lot, it lasted almost two hours and I guess a good time was enjoyed by all."[94] Stein was a great talker: her problem with Great Books clearly had nothing to do with students in the classroom.

But Stein did have problems with some basic pedagogical methods of university teaching. In *The Autobiography of Alice B. Toklas,* Stein describes her inability to take an examination in William James's philosophy class at Radcliffe. She writes him a note saying, "I am so sorry but really I do not feel a bit like an examination paper in philosophy today." James writes her back the next day to say that he understands "perfectly how you feel" and he "gave her work the highest mark in his course."[95] Learning, for Stein, was not about questions and answers. In *Everybody's Autobiography,* she writes: "To me when a thing is really interesting it is when there is no question and no answer, if there is then already the subject is not interesting and it is so, that is the reason that anything for which there is a solution is not interesting."[96] With this approach to the classroom, Stein was on the other side of Adler. Adler spent years compiling a list of ideas that the Great Books supposedly contain—102, according to him, cataloged and cross-referenced in his 2,428-page appendix with the title "The Syntopicon."[97] As Stein describes his aim, he wanted to find "all the ideas that had been important in the world's history."[98]

Stein had a problem with the pedagogical stiffness of Adler's approach, his humorless aesthetic, and his rules guiding "how to read a book."[99] She also had her own sense of how her work should fit—and was fitting—within a canon of English literature. Stein almost definitely knew that Adler did not allow room for her, especially since the works on his syllabus when she taught from it did not include any works originally written in English or by women.[100] That is, despite Stein's ability to play the "short-haired" man, her gender was clearly an impediment to inclusion in his literary canon. Most importantly, Stein did not believe in ideas in the same sense that Adler did, or rather, she had conceived of a different way in which her works contained ideas.

In *Everybody's Autobiography* Stein includes an extended description of the heated discussion with Adler and Hutchins:

> What are the ideas that are important I asked him. Here said he is the list of them I took the list and looked it over. Ah I said I notice that none of the books read at any time by them was originally written in English, was that intentional I asked him. No he said but in English there have really been no ideas expressed. Then I gather that to you there are no ideas which are not sociological or government ideas. Well are they he said, well yes I said. Government is the least interesting thing in human life, creation and expression of that creation is a damn sight more interesting . . . real ideas are not the relation of human beings as groups but a human being to himself inside him and that is an idea that is more interesting than humanity in groups.[101]

Stein believes that ideas about identity and the language "inside" of her are much more interesting than the "sociological or government ideas" that can be extracted from Great Books, cataloged, and debated in a class. This is not to say that Stein was an introvert or solipsist—hardly the case—but that much of her work explores a relation between language that is a "feeling of moving" and identity that is unfixed. She understands her relation to written words in terms of their capacity to define who she understands herself to be: writing mines the origins and creation of the self, taking the form of puns, dislocations, associations, and rhythms of the English language to emphasize formation and development. Stein's problem with Adler is thus not only intellectual but also aesthetic, in the sense that she believes literary greatness should include the language of movement and fluidity that is the direction American literature (specifically hers) is going.

Furthermore, Stein likely objected to Adler's claim that an idea like "justice" —as purely a "sociological" or "government" idea—is somehow ahistorical and transcends the text. A key point to notice about the very term Great Books is that it emphasizes books, not the people who wrote them or the cultures or histories out of which the texts emerged. The course was not referred to as "The Great Philosophers." Adler believed that Great Books offer a reader a deeper awareness of "the great and enduring truths of human life."[102] The truths endure; the authors do not. One can find meaning in Great Books—at least in the way that Adler and Hutchins taught them—divorced from their historical and biograph-

ical contexts. But Gertrude Stein's use of language suggests that it would have been very difficult for her to separate history and biography from the texts that she wrote. Take, for instance, the last words of *Tender Buttons*, in which Stein's "justice" is framed by the historical moment of the text's production: "The care with which there is incredible justice and likeness, all this makes a magnificent asparagus, and also a fountain." Stein here configures "justice" in context of the poem's celebration of domestic, artistic, and sexual reinvention. The poem's challenge to masculine power, to heterosexual conventions, and to representational art is particularly sharp when considering the text's 1914 publication—when homosexuality was a crime and the Armory Show's presentation of "lewd" women caused scandal.

Moreover, the book that made Stein into a popular literary figure—*The Autobiography of Alice B. Toklas*—was impossible to isolate from history and biography, because the book itself was the story of Stein and Toklas's life together. It centered on their artistic salon in Paris and their relationships with such figures as Picasso, Matisse, and Hemingway. *The Autobiography of Alice B. Toklas* is a kind of twentieth-century local history, not a work in which Adler's ideas would be embedded. If *The Autobiography of Alice B. Toklas* puts forth any ideas, then they are so caught in situation and conversation as to be unrecognizable outside of the context of this work. This book that made Stein famous—and which is still the book that keeps Stein selling—is a book that by Adler's standards would not be called great.

*The Autobiography of Alice B. Toklas*, like many works by Stein, is also very funny. Stein's prose bears resemblance to how she talked. When Stein argued with Adler, she was similarly serious but wry: she and Toklas both used humor to goad him. At the end of the evening, as the party broke up with the arrival of the police, Toklas apparently turned to Adler and said: "This has been a wonderful evening. Gertrude has said things tonight that it will take her 10 years to understand."[103] Adler remembered these words as if they are the final say on Stein. But Toklas's comment may embody Stein's explanation of how to "understand" her language: enjoy the fact that its meaning is not fixed, that it will take more time to appreciate. Toklas is hardly patronizing Stein behind her back. She is, with wit, celebrating Stein's aesthetic.

Stein did not speak straightly—straightness was never her style—including when she questioned Adler about translation. "Ah I said I notice that none of the books read at any time by them was originally written in English," as Stein writes in her account, "was that intentional I asked him."[104] As many knew,

Adler himself spoke no languages other than English. Stein did. As someone herself on the fringes of the academy, Stein would have known exactly how to tweak Adler's intellectual insecurity. Stein did not actually have a problem with translations of literary works. She may have disagreed with Adler's handling of translation—he famously did not consider the quality of the translations he promoted in his Great Books courses—and this would chafe at Stein's attention to the materiality and pleasure in the experience of language. But Stein herself translated texts into English and promoted translations of her work. Several books of hers were translated into French during her lifetime, including *The Autobiography of Alice B. Toklas* and *The Making of Americans*.[105] An excerpt of *Stanzas in Meditation* also appeared in French translation.[106] Like many modernist writers, Stein may have understood translation to be an essentially generative and creative act, not an exercise in merely imparting a text's essential content as Adler treated it.

Stein may also have recognized, on some level, that her language was already a translation of sorts. That is, "Steinish," as the Chicago papers called it (or "Estonian" for Butcher), was the product of being surrounded by foreign languages for her entire life: from the languages of her German Jewish parents and her early childhood years in Paris and Vienna through the cosmopolitan environment of her Paris salon. Though she rarely wrote in French (despite living in France for thirty-five years), her English was undoubtedly influenced by her immersion in a European polyglot, an experience that clarified her own linguistic aims. She listened to languages like she listened to the resonances of African American speech. Stein's familiarity with foreign vocabularies made her sharply aware of the texture and nuance of the English language, especially its rhythms, and she sensed in Adler someone entirely inattentive to its complexities.

Stein did not buy into the Hutchins and Adler program. But these men sharpened her sense of a contrast between her mainstream audience and a masculine university culture. They also made her think about the difference between popularity and literary posterity. Stein agreed with Adler's conviction that only a limited number of books were great: she simply would have included herself and many other works on the list. English-language writers, women writers, and most importantly, according to Stein, modernists with her aesthetic should not be excluded from a definition of what constitutes, in her word, a "master-piece."[107] Though the English department found her lectures akin to Dada, Stein traced her writing back through an English canon that includes,

as she sketches it in "What Is English Literature," Jane Austen, Charles Dickens, Jonathan Swift, Edward Gibbon, Alexander Pope, Samuel Johnson, John Milton, Shakespeare, and Chaucer (among others). Stein believed herself to be part of this literary canon, finally recognized during her American lecture tour by the country's most prestigious colleges and universities.[108] As she frequently proclaimed of herself, she was a "genius," the rare figure whose work transcends the ages. "I should think it makes no difference," she writes in *Stanzas in Meditation*, "That so few people are me. / That is to say in each generation there are so few geniuses."[109]

## MORTIMER AND MAUDE

Was Stein an "invincible force," or was she an "immovable object," as Fanny Butcher remembers her? If Stein's personality exerts itself, then she is also an object of interpretation. As a literary and historical figure, Stein has been affiliated with many movements of her era—the Dadaists of the 1920s, the avant-garde visual artists she befriended, the writers of the Lost Generation—and she has been claimed by scholars of feminism, Jewishness, and gender studies, as well as practitioners of language poetry, to name a few. Her *autobiography*, as she somehow knew, is *everybody's*.

As the Great Books philosophy gained nationwide attention and was promoted as a curriculum in which ordinary men and women outside of the university could participate, it also became a movement with crossover appeal, especially as it drew in readers dubbed middlebrow.[110] Cultural critic Dwight Macdonald—one of Mortimer Adler's most vehement critics—widely disparaged Great Books for being "Midcult," that is, a bastardized version of high culture that could be bought in a fifty-four-volume set.[111] And in his essays criticizing Great Books, Macdonald lumped Gertrude Stein into his example of the kind of artist, in his terms, who was highbrow.[112] But was she?

Mortimer Adler, too, is a difficult man to categorize. In his later years, he became a frequent patron of the exhibits of contemporary art at the Arts Club. Apparently, because his own offices were located in the same building as the club, he regularly shuffled in for lunch, so often that the club named a sandwich after him: the "Mortimer Adler" became a cream cheese sandwich with chopped green olives.[113]

Even more deeply ironic is that at one point Adler was alleged to write in a style very much like Gertrude Stein's. These two adversaries superficially ap-

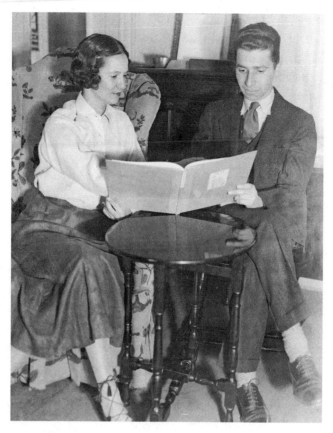

*Fig. 74. Maude Hutchins and Mortimer Adler reading* Diagrammatics, *undated. Special Collections Research Center, University of Chicago Library*

peared to be much closer than they would have acknowledged. One folder in Adler's voluminous and uncataloged archives concerns the publication of a book called *Diagrammatics* (1931), which Adler wrote and Maude Hutchins illustrated (fig. 74). (She was at the time still married to Robert Hutchins.) Random House published *Diagrammatics* in a limited edition three years before Adler met Stein. It is a strange, provocative union of image and text. Hutchins's line drawings of androgynous naked figures in positions that suggest Greek gymnastics give one an indication of her future novels, prolific in their exploration of sexual fantasy and lesbian desire. (Hutchins would also exhibit her drawings and sculptures in a 1937 show at the Renaissance Society.) Adler's prose pieces, by contrast, have titles like "Axiom," "Topic," "Description," and "Analysis." Here is the part titled "Analysis":

It is true that that which is true is true.
It is false that that which is true is false.
It is true that that which is false is false.
It is false that that which is false is true.

If it were false that that which is true is true,
It would be true that that which is true is false.
If it were false that that which is false is false,
It would be true that that which is false is true.

But if it were true that that which is true is true, it could not be
False that that which is false is false.
Hence, were it true that this is false, it could be false that it is true,
And yet this could be false.[114]

*Time* magazine, not surprisingly, called *Diagrammatics* a "bewildering book" and closed its review with this description: "To hardboiled booksellers *Diagrammatics* last week recalled Jacob Epstein's sketches . . . and the literary monotones of Gertrude Stein."[115] Adler replied to *Time* in a livid letter, "I don't know whether you offend Jacob Epstein and Gertrude Stein as much as you do us, by comparing us to them or them to us. The comparison could only rest on the fact that all the things you don't understand look alike."[116]

Adler had a good point: his prose only superficially resembles Stein. The emptiness of his prose—driven by logic, sheer content and no form—is very different from the richness of Stein's wordplay, which enrolled a wide audience into her modernist aesthetic. His purely logical claims lack the humor and associative power of Stein's language, and there is little sense of the person who lies behind Adler's propositions. To compare Stein's prose with Adler's is to emphasize the difference between a style that is attached to its maker and one that is not, a style associated with the personality of the author and a style that seems to have no particular person behind it.

Stein's profound influence on later writers is proof that her writing has achieved some of the qualities that define a great book, not by Adler's standards but by her own. Though *The Autobiography of Alice B. Toklas* established her celebrity status, her more experimental work has had equally strong staying power. Stein's visits to Chicago during 1934 and 1935 illuminate different approaches to reading Stein's texts among the city's various audiences, approaches

that continue to dominate our theoretical understanding of Stein's work today. Her time in Chicago clarifies how and why she oscillated between groups of readers, between the concept of reading as an experience and reading as a pursuit of ideas. Stein was charmed by the attention that she received in America, particularly by her intimacy with Chicago's literary women and by the enthusiasm of the crowds at her public lectures and at the University of Chicago. These experiences strengthened Stein's sense of the literary standard she wanted to achieve: "moving" language that was open and changing, much like the city of Chicago itself.

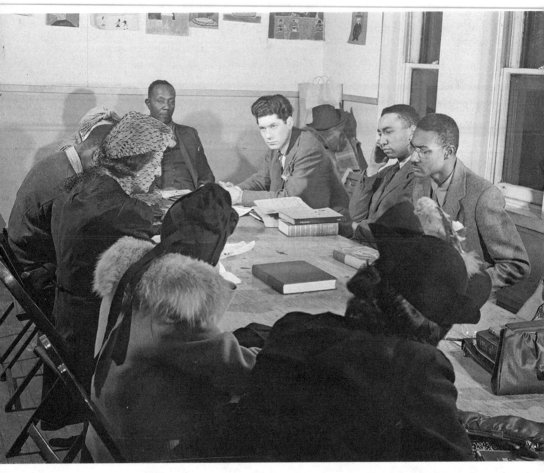

Fig. 75. Jack Delano, *photograph of Inez Cunningham Stark with poetry class at the South Side Community Art Center, ca. 1941. Courtesy Library of Congress*

# Chicago, Fall 1941

DARKNESS FILLED THE WINDOWS OF THE South Side Community Art Center. An old brownstone at Thirty-Eighth and Michigan Avenue, recently renovated by the New Bauhaus School of Design, its wood-paneled walls stretched floor to ceiling in the exhibition galleries, and a sturdy staircase led up to classrooms on the second floor. Here, on a chilly Wednesday night in October, dressed in a pressed white blouse and dark wool skirt and talking excitedly with other students, sat Gwendolyn Brooks. She was relieved to be on time. Her husband, Henry, had been home late from the auto repair shop; dinner had been rushed; and they had left their baby son swaddled with a neighbor. The quick walk to the new center had left them breathless. A few minutes after eight o'clock, Mrs. Stark clicked up the stairs. Slender, erect, and frosted with a marvelous hat loaded with glossy fruits, feathers, and tiny violet flowers, she tripped in, her arms filled with books, which she set down on the long table.

She greeted the students with a smile and took off her hat, placing it next to the books like a holiday wreath. Her hair was red, elegantly parted down the middle and rolled back. She looked around the table, where the students sat with their coats on. Mrs. Stark kept her coat on, too.

Introductions were brief. She explained her position in the literary world of Chicago: how she read submissions at *Poetry*—the only place where she wanted her own poems published—and how she wrote reviews for the *Tribune*. She

had directed exhibits for the Renaissance Society for the past six years. Brooks nodded, recalling the beautiful paintings of her friend Charles Sebree, his sad, black faces with heavy lidded eyes. The Ren had finally seen possibilities in Bronzeville, the cinched corridor bordering campus, which the university aggressively blocked off.

Typical of where her mind went, Brooks imagined what other people thought. Sitting next to her, Brooks's husband, Henry, appeared inscrutable, but she knew that he also shared her ambition. She glanced around the table at the people she knew best. Edward Bland was quietly tapping the eraser of his pencil. He had told Brooks about the intense writing group from a few years back, everyone circling around Richard Wright. Painter and sculptor John Carlis was looking at the titles of Mrs. Stark's books. He had admitted to Brooks that he wanted to try his hand at poems. William Couch was fidgeting with the buttons on his herringbone tweed. Margaret Taylor Goss was looking directly across at him. It was hard not to, with his trimmed hair and educated manner. He was a man to write poems about.

What was Mrs. Stark thinking? Her Gold Coast friends could not have been encouraging. Brooks conjured them drinking tea from pink china cups:

> *You can't mean this.*
> *You might as well be dead.*
> *Society will drop you.*
> *You'll be raped.*
> *Robbed.*
> *Contaminated.*
> *You'll be killed.*
> *They are savages.*

She must have endured the warnings. Her voyage down to the South Side was a mere eight miles, but everyone knew that it was an audacious act.

Mrs. Stark opened one of her books and read aloud: "In expressing a vague mood our diction must be as definite as possible." She pronounced *our* with two syllables. Brooks hungrily took notes, like someone long-starved. Mrs. Stark flipped through a recent issue of *Poetry* and found the right poem, reading slowly:

> Lately I walk lightly
>
> Underneath
>
> In crisscross fashion
>
> Lie young men
>
> Lately dead

A woman from Chicago wrote these lines, she said, a woman far away from the war in Europe. She leaned in. "What do you think?" she repeated. She really seemed to want to know.

Eventually, a rhythm developed. At the start of a class, Mrs. Stark announced a topic and recited poems aloud. She then carefully placed one of her records on the player and they listened together: the Sligo songs of William Butler Yeats; Langston Hughes doing the blues; the drumbeat chants of Vachel Lindsay. Her poets all had ties to *Poetry*. They discussed their own poems with passion and argument. Brooks went to bed hearing Mrs. Stark's unflinching comments: *All you need in this poem are the last four lines. I don't understand too well what it's all about but it has three FINE lines. Dig at this until you have us see all the skeleton and no fat.*

Through a process of intense revision, Brooks shaped her neighborhood streets into poems.

All she had to do was look out the window and there was her material: walking or running or fighting or screaming or singing.

When Mrs. Stark finally invited them up to her home on Cedar Street, where

they held class one evening in early December, her rooms were an eye-opener. Dripping with chandeliers, the twilight dining room sparkled on their pages. Even the mint green wallpaper seemed to gleam. William Couch decided he would do Gertrude Stein. He got up and stepped in front of the tall windows, flashing a smile, the heavy drapes on either side like a stage. *If I told him would he like it. Would he like it if I told him.* Stein's cadences lifted off the page like a song. He read the whole poem, a portrait of Picasso, and bowed dramatically to their applause.

Her chin resting in her hands, Mrs. Stark said nothing but looked ebullient.

One evening, Mrs. Stark announced that Langston Hughes would drop by the workshop. Brooks remembered meeting Hughes for the first time with her mother, years ago, after they attended a reading at the Metropolitan Community Church. Hughes had even read through a few of her poems then, and he urged her to keep on writing. But this year, Brooks knew, had been a dark period for him; he had lost the lease on his Harlem apartment and now was sleeping in a bed at the Parkway Community House, thanks to Horace Cayton and a Rosenwald Fellowship.

They did not hear him coming up the stairs. When he entered the classroom, everyone quickly shuffled out of their chairs and stood up. He shook each person's hand, making the class feel as though he had met each one of them already. Brooks was nervous. Her long poem, the poem she had been working on for months, "The Ballad of Pearl May Lee," was up for discussion that night. When they had taken their seats again, Mrs. Stark asked Brooks to read her poem aloud. Brooks announced the title, took a pause, and began:

> Then off they took you, off to the jail,
> A hundred hooting after.
> And you should have heard me at my house.
> I cut my lungs with laughter,

Laughter,

Laughter.

I cut my lungs with my laughter.

With slow intensity, Brooks became the woman named Pearl, whose lover was seduced by a white woman and then burned alive by a "hundred hooting" men. Between stanzas, she looked up at Hughes, who was shaking his head, moved with sadness and wonder. When she finished reading, Hughes whistled with approval, and began a slow round of applause.

# White City, Black Metropolis

## A VOICE LIKE HERS

In the fall of 1944, Richard Wright read the manuscript of *A Street in Bronzeville*, Gwendolyn Brooks's first poetry collection. The manuscript was sent to Wright through his editor at Harper and Brothers, where Brooks submitted it. Brooks was entirely unaware that Wright, who was by this point a towering literary figure, was arbiter over her poems. They had never met. Wright was a decade older and now lived in New York. But they shared several friends who were part of artistic circles in Chicago, a cohort who tracked Wright's career with envy and astonishment. When Wright's *Native Son* was published in 1940—it sold a quarter million copies in the first month—Brooks read the novel in a single night, "and finally went to bed almost blind and terribly scared of the dark."[1] Wright's autobiography, *Black Boy*, published in 1945 to even greater success, was similarly addictive: "I hated reaching the last page," Brooks later would tell Wright, "I wanted the story to go on and on."[2] Brooks acknowledged Wright as her literary hero.[3]

Wright's fame owed much to his time in Chicago from 1927 to 1937, his most formative years as a writer and a period for him of political and intellectual radicalization. During this decade he was the "exciting hot center" of Bronzeville, in fellow writer Margaret Walker's reverential account.[4] Wright came to Chicago as a stranger, lived as a stranger, and left the city without looking back, as his friend Nelson Algren would claim.[5] But Chicago's impact on Wright was irrevocable. Indeed, Brooks's first volume of poems was a startling dispatch from a deeply familiar neighborhood. Highly crafted, the poems are gripped with a spirit of documentary fact, like portrait photographs. In the short letter to Harper and Brothers that accompanied her manuscript, Brooks indeed suggested that she could provide visual illustrations for the poems

from a "well-known interpreter of Negro life"—possibly sketches by a local Bronzeville artist.[6] The poems also see from within, taking the perspectives of Bronzeville's inhabitants—an old married couple, a girl in the front yard, a preacher, a jilted lover, a blues singer, an overworked domestic, a black soldier. This poetry was a collection of intimate stories, written by a poet who knew *Spoon River Anthology* and *Winesburg, Ohio,* as well as the work of Paul Laurence Dunbar.[7]

A *Street in Bronzeville* presents a place that might have been new to white readers who had never strolled the Promenade down at Forty-Seventh and South Parkway. In fact, Wright felt that Brooks should probably change the title, which was "conceived out of a local frame of reference." And yet, as Wright explained in his detailed letter to his editor at Harper and Brothers, the poems took black experience in Chicago as *human* experience:

> They are hard and real, right out of the central core of Black Belt Negro life in urban areas. . . . She takes hold of reality as it is and renders it faithfully. There is not so much an exhibiting of Negro life to whites in these poems as there is an honest human reaction to the pain that lurks so colorfully in the Black Belt. . . . Only one who has actually lived and suffered in a kitchenette could render the feeling of lonely frustration as well as she does:—of how dreams are drowned out by the noises, smells, and the frantic desire to grab one's chance to get a bath when the bathroom is empty. Miss Brooks is real and so are her poems.

Wright threw his full weight behind Brooks: "I'd say that she ought to be helped at all costs. America needs a voice like hers and anything that can be done to help her to bring out a good volume should be done."[8]

Harper and Brothers published A *Street in Bronzeville* in August 1945, the same month that the Second World War ended. "How 'nice' it was for peace and me to appear together!" Brooks wrote to her editor.[9] The volume's publication is a key moment in American literary history: certainly there were black women writers before Gwendolyn Brooks, but none laid claim to the wide readership that this volume of poetry attracted. One of the achievements of A *Street in Bronzeville* is the representation of black experience—more specifically, black female experience. It is this double lens of race and gender that gives the volume its exceptional, expansive perspective. "The Ballad of Pearl May Lee," for instance, is voiced by a black woman who is both angry with her

lover for sleeping with a white woman and angry with the lynch mob that killed him:

> You paid for your dinner, Sammy boy,
> And you didn't pay with money.
> You paid with your hide and my heart, Sammy boy,
> For your taste of pink and white honey,
>> Honey,
>> Honey,
> For your taste of pink and white honey.[10]

"Pearl," the name ironic for her dark skin, could be one of the inhabitants of Bronzeville: she has fled the Jim Crow South—carrying her folk ballad, the genre of memory—for the hope of freedom in the North. Like other poems in *A Street in Bronzeville*, Pearl's ballad illuminates the complexities of racial injustice, pitched at the level of individual lives. The meaning of Brooks's poem is not an ideology or creed; it is Pearl herself.

Richard Wright valued Brooks's manuscript on its own terms, which is to say, the writing was very different from his own. He had only a few criticisms, and his letter was passed along to Brooks through Harper and Brothers editor Elizabeth Lawrence, who would serve as Brooks's literary confidante for the next twenty years. (Brooks finally met Wright in Lawrence's New York apartment, in late December 1945.[11]) According to Wright, the volume needed to be filled out; perhaps Brooks should write "one real long fine poem" that also "strikes a personal note."[12] Brooks would comply with "The Sundays of Satin-Legs Smith," which inspects the loitering life of a zoot-suiter. And there was a poem that Wright did not like: a dramatic monologue titled "the mother." The poem's opening stanza:

> Abortions will not let you forget.
> You remember the children you got that you did not get,
> The damp small pulps with a little or with no hair,
> The singers and workers that never handled the air.
> You will never neglect or beat
> Them, or silence or buy with a sweet.
> You will never wind up the sucking-thumb
> Or scuttle off ghosts that come.

You will never leave them, controlling your luscious sigh,
Return for a snack of them, with gobbling mother-eye.

Forceful couplets, irregular meter, and surprising reversals calibrate levels of anguish and pain: "the mother" is not an expression of clear regret. Haunted, the speaker imagines the unborn, with a visceral knowledge of the body's biological imperatives, the mythical danger of eating a child with one's consuming love. She is a mother who has chosen not to be a mother; but her choice is qualified: "Believe that even in my deliberateness I was not deliberate."[13]

Like many of the poems in the manuscript that Wright read, "the mother" renders raw emotion with formal dexterity. But for Wright, abortion was not a subject suited for poetry. "Maybe I'm just simply prejudiced, but I don't think poems can be made about abortions," Wright wrote, "or perhaps the poet has not yet been born who can lift abortions to a poetic plane."[14] Was Wright aware of his disturbing irony? "The poet [who] has not yet been born" seems too close to the aborted black baby in Brooks's poem. In any case, Brooks did not heed Wright's advice. She may have agreed with Wright's self-assessment that he was "prejudiced." Eventually, many readers associated the treatment of women in Native Son with an author disinterested in their particularity. As murder victims, women in the novel are viewed entirely through the protagonist (and murderer) Bigger Thomas's eyes; to women's emotional lives, Bigger is blind. Brooks explained to Elizabeth Lawrence that "the stressed thing" in her poem was not the abortions but the woman's desire for children and her acknowledgment that "all she could guarantee them was poverty." Brooks added: "Not that I'm trying to say every abortion has its origin in such altruism."[15] Intricate, ambiguous, political, "the mother" is the third poem of A Street in Bronzeville, following "the old-marrieds" and "kitchenette building."[16] These opening poems articulate how the claustrophobic restrictions on black life diminish hope and curb expression. And yet, the poems are the labor of a vigorous, expansive mind.

From the conditions of Bronzeville, the neighborhood in which she was raised and lived most of her life, Brooks culled her subject matter. But, as Wright maintained, Brooks's work was not merely local observation. It belonged to the nation; he claimed, "America needs a voice like hers." This tension between the particular and the general—or, rather, between the story of being black in America and the story of America—would be a central preoccupation for both Wright and Brooks over their careers. Indeed, after Harper and Brothers accepted her poems, Brooks wrote back to Lawrence, who asked Brooks to tell

her about her "circumstances as they affect your writing."[17] Brooks made clear her aims:

> I'm twenty-seven years old, have been married five years to Henry Blakely, have a little boy who will be four in two weeks, write while scrubbing, sweeping, washing, ironing, cooking: dropping the mop, broom, soap, iron, or carrot grater to write down a line, or word. Writing is the only *work* in which I'm interested. I want to continue, whether in prose or verse, the presentations of Negroes as people. I want to prove to others (by implication, not by shouting) and to such among themselves as have yet to discover it, that they are merely human beings, not exotics.[18]

To "prove to others" is an implicit appeal to white readers, who were integral to Brooks's wide-ranging audience, even as Brooks stayed true to representing the lives of her black community. That she felt a responsibility to prove "Negroes as people" may seem astonishing to us now, but it was an ambition in which she was hardly alone. She joined Wright and other writers and artists of Bronzeville who took black experience as essentially human experience—or, more decidedly, American experience. (Case in point, *Black Boy* was originally titled *American Hunger*.) To portray black life as "exotic" was what had already been done, the "vogue" of a previous moment.[19] It was a flaw that might be attributed both to white writers (Gertrude Stein, Sherwood Anderson, Carl Van Vechten) and also to some of the leading lights of Harlem, who represented black life as if a decadent cabaret or southern juke joint. Wright famously scorned Zora Neale Hurston's *Their Eyes Were Watching God* (1937), for instance, because of the "facile sensuality" of its Negro characters, who pandered to white readers as if characters in a laughing minstrel show.[20] For Wright, it seemed as if Hurston simply stereotyped black life and put it on display: this was not the real work of making art. And in the single ars poetica to emerge out of Bronzeville, "Blueprint for Negro Writing" (1937), Wright collaborated with members of the South Side Writers Group to inveigh against Harlem writers, those "decorous ambassadors who went a-begging to white America" and "were received as though they were French poodles who do clever tricks."[21]

The literary momentum had shifted. In Bronzeville, there was a new energy found among members of the South Side Writers Group, who met on alternate Sundays from 1936 to 1938 at the Abraham Lincoln Centre, an old settlement house originally designed by Frank Lloyd Wright.[22] (Inez Cunningham Stark's

Wednesday evening workshop at the South Side Community Art Center started
five years later.) The South Side Writers Group included Margaret Walker,
journalist and poet Frank Marshall Davis, playwright Theodore Ward, sculptor
Marion Perkins, anthropology student Marian Minus, poet Robert Davis, critic
and essayist Edward Bland, and social worker Fern Gayden, who would later
edit *Negro Story* with Alice Browning. In fall 1937, when "Blueprint for Negro
Writing" appeared with some controversy in the first issue of the New York pe-
riodical *New Challenge*, these writers were all aspiring: no one had published
a book except Frank Marshall Davis.[23] Perhaps that made it easier for them to
say what "Negro Writing" should—and should not—be. First, it must stand
apart from Harlem. Second, it must communicate to the masses, not just to
an educated elite—which, for Wright, meant that literature must find a way
to address the black working classes, not just whites. Third, it must renovate
folklife—"Blues, spirituals, and folk tales"—for the modern consciousness. And
fourth, it must absorb, yet move beyond, the catalyzing influence of Marxism,
retaining what Wright called "the autonomy of craft." The phrase rings with the
spirit of Sherwood Anderson, who is invoked in the essay. "Craft" is the intellec-
tual work of writing; "autonomy" is the work's freedom from the conditions of
its making. More than appealing to audience, "Negro Writing" must ultimately
transcend its moment.

But perhaps what is most striking about "Blueprint" is its final claim for "The
Necessity of Collective Work," which Wright defines as "*among* Negro writers
as well as *between* Negro and white writers." Collaboration across the color line
was essential to intellectual work, a conviction born through Wright's exposure
to the interracial exchanges among proletarian artists and writers of the John
Reed Club in Chicago, which Wright began attending in 1933, and of the Fed-
eral Writers' Project, where Wright worked from 1935 to 1937. When Wright was
elected secretary to the John Reed Club, he was urged to join the Communist
Party, whose politics also disavowed racial division. For Wright, communism was
a complex ideological affiliation and political position with which he battled for
the next several years.[24] As Wright dramatically demonstrates, individual achieve-
ment often emerges out of a specific group of people in a geographic center. ("A
book is the product of somebody living in a particular place at a particular time,"
W. H. Auden wrote in 1932, a deceptively simple claim.[25]) In Bronzeville, no
one worked alone. Literary production was necessarily community-based. With
its steady influx of working-class migrants, black Chicago was not fashioned by a
"talented tenth" of highly educated, exceptional men to raise the race, as vaunted

by the century's greatest black intellectual, W. E. B. Du Bois, whose work was published by one of Chicago's earliest publishers, A. C. McClurg.[26] Even a writer like Wright—a self-proclaimed exile and by nature suspicious of groups—was caught up in Bronzeville's collaborative spirit.

When Wright read Gwendolyn Brooks's first manuscript, it seemed as if she had absorbed and transformed much of what the South Side Writers Group had so aggressively advocated a few years earlier. Here was a poet who saw vivid strains of black folk experience threaded through the urban condition and worked in forms that expressed a variety of lives: free verse, sonnet, vernacular ballad. If Brooks's work exemplified the merits of an oral tradition—in the terms that have come to define the culture of a black diaspora—then her poems also demonstrated a sophisticated textuality, a brilliant arrangement of words on the page.[27] Brooks was a singular poet, and no ideology could capture her politics. *A Street in Bronzeville* reaches beyond its moment, even as the volume expresses the collective life of Brooks's neighborhood, an exceptional place in time.

## WITHOUT FINGER BOWLS

A stalwart of the South Side Writers Group, Margaret Walker sat down at her typewriter just after her twenty-second birthday and wrote her most famous poem in about fifteen minutes. It begins: "For my people everywhere singing their slave songs / repeatedly: their dirges and their ditties and their blues / and jubilees."[28] From the plantation through emancipation through the trials of northern migration, each stanza of "For My People" tracks a moment in an African American journey. Urban life is bewildering: "For my people thronging 47th Street in Chicago and Lenox / Avenue in New York and Rampart Street in New / Orleans, lost disinherited dispossessed and happy." Despite slavery's long legacy, hope survives. When Walker finished writing, though, she felt that the poem still needed something else. With advice from the older writer Nelson Algren, Walker composed the poem's rousing end:

Let a new earth rise. Let another world be born. Let a
bloody peace be written in the sky. Let a second
generation full of courage issue forth; let a people
loving freedom come to growth. Let a beauty full of
healing and a strength of final clenching be the pulsing
in our spirits and our blood. Let the martial songs

be written, let the dirges disappear. Let a race of men now
rise and take control.

Momentous, the voice of the poem calls forth a future. Through a repetition
of biblical jussives—and a nod to Walt Whitman—it looks to the rebirth of a
"race," a "new earth" of free men. A key ambiguity lingers: is this poem a "mar-
tial song" for the black community? That is, do Walker's "people," to whom the
poem is dedicated, include white readers? Where does someone like Algren—
white, working-class—fit into the poem's imagined future?

The question of audience was central to the creative output of what is now
called the Chicago Black Renaissance, a movement with its own distinctive
energy even as it was informed by a set of aesthetic concerns characteristic of
Chicago more broadly.[29] To be sure, "For My People" was composed—like *A
Street in Bronzeville*—for a readership that would include whites, though this
fact does not mean that Walker meant it for them. Walker sent her poem to
*Poetry* editor George Dillon, who published it in the magazine's November
1937 issue. Walker knew Dillon and other *Poetry* staff through fortuitous prox-
imity. The magazine offices were then located just two blocks from the Illinois
Writers Project on Erie Street, where Walker was then working and where she
met Algren.[30] A remarkable experiment in interracial collaboration, the Illi-
nois Writers Project was the government-funded branch of the Federal Writers'
Project (under the auspices of the Works Progress Administration), which sup-
ported writers in the creation of guidebooks concerning the state's history and
culture. Not yet twenty-one when she started, Walker lied about her age to get
the government job.[31] Walker also met Richard Wright, a figure who would
loom large in her literary formation, on her first day at work.

When Walker was seventy-three, she published a psychoanalytical biogra-
phy of Wright subtitled *Daemonic Genius* that unravels their intense, three-year
friendship. Wright was widely regarded as a "genius" figure, perhaps equaled
only by Brooks a few years later. Magnetic, according to Walker, Wright at-
tracted writers and admirers far beyond a black readership. (Walker would play
up Wright's appeal to white people in her biography, and she viewed with sus-
picion his marriages to white women.) But it is an oversight to focus solely on
Wright. Bronzeville in the 1930s and 1940s was a prolific place—it would be
difficult to account for the complete range of writers and artists who were part of
the Chicago Black Renaissance. The works of many brilliant, lesser-known fig-
ures also illuminate the period's ferment, like the paintings and prints of Eldzier

Cortor, the photographs of Wayne Miller, and the autobiography of *Ebony* editor Era Bell Thompson, to name just a few. These artists and writers—along with Walker, Wright, and Brooks—came into their own through an engagement with the people and places of a neighborhood that was defined by the demographic shifts of the Great Migration.[32]

Millions of blacks fled the South in the decades following the First World War, pushed by white supremacy and pulled by opportunities in the northern industrial economy—especially in the stockyards, railroads, and steel mills. They transformed Chicago's black community from a dispersed population of about 44,000 in 1910 to a densely packed neighborhood of 377,000 residents by 1944.[33] Hemmed in by the city's racist, restrictive housing covenants, inhabitants of Bronzeville were also emboldened by their community's quest for economic and cultural self-determination. Here was a neighborhood where black people ran key institutions like the newspapers and the hospital: a self-contained community that certainly informed the ways that its artists and writers thought about their readership. In Walker's "For My People," for instance, the acknowledgment of black experience—giving it voice, writing it down—is the poem's act of taking over "control."

If there is a defining feature of the Chicago Black Renaissance, then it might be identified as a tension that characterizes Chicago modernism more broadly: between a documentary impulse to narrate, *to tell a story*, and a modernist birthright that revels in stylistic experiment. Abstraction and other forms of modernist play are often held in check by the pull of narrative realism—in the works of Bronzeville writers as well as in the works of their white predecessors and contemporaries in Chicago. The 1920s were a watershed moment in modernist literary development; by the 1930s, modernist aesthetic forms were both more pervasive and less coherent in Chicago. Writers across Chicago's racial divide were well informed of transatlantic modernism, but they were a diverse, loose flock of followers. Middlebrow opinion embodied by book critic Fanny Butcher could uphold Stein, Hemingway, and Joyce; and Chicago's arbiters of the visual arts included figures who advocated for the experimental: the audacious, entertaining C. J. Bulliet of the *Chicago Daily News*, and young Katharine Kuh, who in 1935 opened a modern art gallery on Michigan Avenue for contemporary art. By this time, too, Chicago had received with great fanfare the Bauhaus exiles—notably architect Ludwig Mies van der Rohe and artist, photographer, and designer László Moholy-Nagy, both of whom produced their own schools and followers, invigorating Chicago with a sleek, unadorned aesthetic. But despite

an awareness of the new, writers and artists of Bronzeville often chose familiar forms. "For My People" is a good example: it is demonstrably more radical in sentiment and subject than in form. Free verse, by 1937, was everywhere.

For Bronzeville artists, originality lay in exposing their stories with unflinching adherence to social realities. For Wright, moving to the city from Mississippi in 1927 was the most traumatic experience of his life.[34] Perhaps nowhere else in the city were newness and change—the very conditions of modernity—experienced so dramatically as on the South Side. To ride the "freedom train" from the rural South to the urban North was to be transported overnight from an agrarian way of life to circumstances of modern, industrial capitalism. The move north was not just physical but also temporal: "a complex movement of a debased, feudal folk," in his words, to the mechanized hours of the industrial present.[35] If the disaffections of Charles Baudelaire's flaneur and the blasé mentality of Georg Simmel's urban intellectual are characteristic exemplars of modernity, then so too is Richard Wright's anxiety on the train platform, just come off the Illinois Central. Wright arrived in the cold and was stunned by the extremity of Chicago's weather. Echoing Dante and T. S. Eliot, Wright describes in *Black Boy* how Chicago was an intimidating grid of steel and stone, a "machine-city," an "unreal city," "wreathed in palls of gray smoke."[36] For him, Chicago was hardly the promised land but rather a kind of living hell. "Perhaps never in history has a more utterly unprepared folk wanted to go to the city," Wright claims in 12 *Million Black Voices*, his 1941 photo-essay depicting the history of black people in America.[37] Migrants had to learn how to be modern.

In Chicago, there were people to teach them. "Old settlers" were middle-class blacks who had arrived in Chicago at least before 1910 and who embodied values of education, discipline, churchgoing, and respectability.[38] Gwendolyn Brooks came from such a family. They looked on the newcomers with some suspicion, anxious to safeguard their jobs and what tenuous civil rights they had won. Era Bell Thompson—with whom Brooks shared a friendship for forty years—was an unusual migrant to Chicago in that she moved permanently in 1933 from the rural hinterland of North Dakota. Raised among whites, Thompson was shocked by the sheer number of blacks in Chicago. She noted class distinctions with the eyes of an outsider, describing the "loud, coarse manners" of the new migrants, with their "flashy clothes and ostentatious display of superficial wealth." Black solidarity was less of a choice than an imposition: "Yet by his standards, all of us were judged; for his actions, all condemned and imprisoned in a black ghetto, separated from all the other peoples of the city by covenants of

prejudice and segregation."[39] Thompson had been lured to Chicago by reading Robert S. Abbott's *Chicago Defender*, the nation's largest "race" weekly, for which she had contributed articles and quips since the 1920s during her years in North Dakota. She signed her pieces "Dakota Dick." The *Defender* played a tremendous role in the Great Migration by trumpeting the opportunities for blacks in the urban North. And for new migrants, the *Defender* periodically ran a list of "don'ts": "Don't hang out the windows. Don't sit around in the yard and on the porch barefoot and unkempt. Don't talk so loud, we're not all deaf. . . . Don't wear handkerchiefs on your head."[40] Condescending, it seems, these reprimands yet aimed to clarify for migrants the different standards of self-presentation in the North and to avoid conflict with the middle class.[41]

The Chicago Urban League, a resettlement organization founded in 1916 to assist migrants in finding housing and employment, also served as a stern welcome committee. The organization's first board president, the University of Chicago sociologist Robert E. Park, conducted pathbreaking research on the migratory experience. He was influenced both by his earlier work at the Tuskegee Institute under Booker T. Washington and by his brief study with Simmel in Berlin. An advocate of assimilation, Park ultimately oversaw many fieldwork projects under the rubric of the Chicago School of Sociology.[42] (Arthur Aldis, advocate of the Armory Show and the 1927 "Negro in Art Week," was also a founding board member and significant patron of the Urban League.) Members of the Urban League held "Strangers Meetings" for new migrants, passed out leaflets, and walked door to door with "Self-Help" cards:

1. Do not Loaf. Get a job at once.
2. Do not live in crowded rooms. Others can be obtained.
3. Do not carry on loud conversations in street cars and public places.
4. Do not keep your children out of school.
5. Do not send for your family until you get a job.
6. Do not think you can hold your job unless you are industrious, sober, efficient and prompt.[43]

The Urban League card is not quite Benjamin Franklin's do-it-yourself list of thirteen improving virtues—migrants were *told* how to behave—but the emphasis on industriousness, thrift, education, and individualism rings a particularly American note. Here was advice about how to avoid trouble, succeed in a capitalist market, and assimilate to this new land, the North. To retain southern

folk culture—from the work songs of the plantation to speech patterns to soul food—was not only to be stuck in the past but also to conform to white stereotypes. The message of the Urban League was to break from a bygone era, to cast off folk traditions. It was not easy: a sense of identity inhered in habits of the past and kindled memories of the places that migrants had left. The idea of "folk" took on an aura of collective resistance to the industrial metropolis, and it was invoked by Du Bois and writers as unlike one another as Hurston and Wright.[44]

Blacks in Chicago had to adjust to a culture in which they were the victims of systematic discrimination on all fronts: in housing and in education, in where they could work and where they could shop. Race relations were particularly hostile between African and Irish Americans, who competed for jobs and housing. (Industrialists pitted the groups against each other, though they had more in common socioeconomically than either group had with their bosses.) During the summer and fall of 1919, at a moment near national recession, race riots exploded in a number of cities across America—with ferocity in Chicago. The slowdown of industrial manufacturing at the end of the war and the discharge of soldiers now needing jobs created a menacing environment in which white workers resented black migrants in the labor force. The events in Chicago began with racial tensions at the stockyards and the stoning of a black boy who drifted toward a "whites-only" beach (the line was of course imaginary; the water looked the same). A white police officer refused to arrest the white boys, setting off a chain of violence. For eight days, Chicago roiled in arson, looting, and thirty-eight deaths—twenty-three of them black—until the Illinois National Guard restored order.[45] Carl Sandburg covered the story for the *Daily News* in plainspoken prose—he was still a poet of the people despite his fame (he won a Pulitzer for his poetry that same year). Disheartened, Sandburg did not think that his city would soon change: "As usual nearly everybody was more interested in the war than how it got loose."[46] Decades later, the city's neighborhoods are still defined by the race lines that had been hardened by the riots of 1919.

From migration to urbanization to integration to industrial factory work, change was rapid and visceral. The dearth of adequate housing in Bronzeville aggravated a sense of radical displacement. As the black population increased, once-stately homes on the South Side were abandoned by whites or subdivided into so-called kitchenettes for rent—often inhabited by entire families, who shared a bathroom with many other residents. Shortage of space was at the root of a profound, destabilizing anxiety undergirding everyday life, from the constant threat of sickness in squalid living conditions to the psychic toll that mounted

from a lack of privacy. It is remarkable how much of the art and literature of Bronzeville is preoccupied with living spaces and their constriction. In the opening scene of *Native Son*, a rat races around the Thomas family's tiny kitchenette, trapped and terrified, a horrid replica of Bigger. In Brooks's "kitchenette building," a collective "we" voices a fear that no "dream" will survive amid the suffocating stench of "onion fumes" and "yesterday's garbage ripening in the hall." And in Eldzier Cortor's large and dazzling painting *The Room No. VI* (1948), elongated bodies stretch for space, sharing a mattress, their legs and arms cut out by the frame of the painting itself. Strewn on the floor are pages of a newspaper, an old milk bottle, and a pulp magazine—a blond pinup on the cover. A white doll at the baseboard, ugly but plump, raises its arm, as if signaling the cause of black deprivation (fig. 76). Strikingly, Cortor said that this painting seems visually connected to the cramped rooms of *Native Son*.[47] Hungry for space and solitude, residents of Bronzeville kitchenettes sought out privacy in public places—the library, the church, the movie theater, the street.

Consider, for instance, two different and overlapping spheres of public life in Bronzeville, which were also sites of creativity and artistic production. First, the Stroll—the name given to State Street between Twenty-Sixth and Thirty-Ninth Streets, which showcased black-owned music clubs, movie theaters, beauty parlors, restaurants, and sporting venues. The Stroll spread southward in the 1940s when the energy of Bronzeville centered on the Savoy Ballroom and Regal Theatre at Forty-Seventh Street and South Parkway, a crossroads captured in a photograph by Chicago-born Wayne Miller (fig. 77).[48] In *Native Son*, the Regal is where Bigger and his friend go to the movies and masturbate in the darkened theater—a scene that Wright was compelled to delete before the book became a Book-of-the-Month Club selection.[49] Wright understood the contradictory nature of popular film: black-owned theaters could be a source of pride, but it was also believed that theaters could encourage vice to the detriment of the race.[50] So, too, did the Stroll more largely embody pride and pleasure: "Here is all his sculpture and his art / And all his architectural design," writes Brooks about Satin-Legs Smith, stepping out onto the street.[51] This spatial articulation of ownership and display expressed the consciousness of Bronzeville as much as the books, poems, and works of art that emerged from the neighborhood.[52] Or, life fed into art. As Brooks said, "If you wanted a poem, you had only to look out a window."[53]

The bustling spectacle of the Stroll was not far from another important site in Bronzeville: the quiet interior of the George Cleveland Hall Branch library. At Forty-Eighth Street and Michigan Avenue, Hall Branch opened in 1932 and

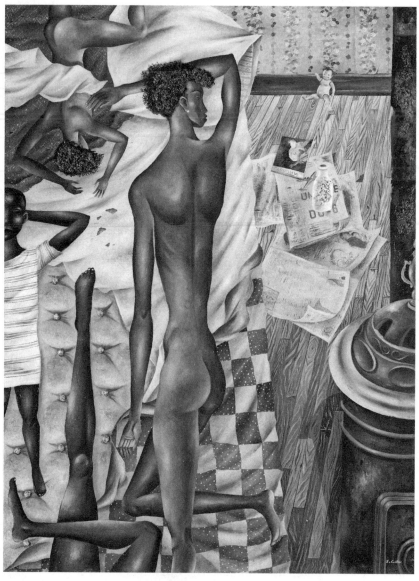

*Fig. 76. Eldzier Cortor, The Room No. VI, 1948. Oil and gesso on masonite, 42 ¼ × 31 ½ in. The Art Institute of Chicago, Image © Estate of Eldzier Cortor, Courtesy Michael Rosenfeld Gallery LLC, New York*

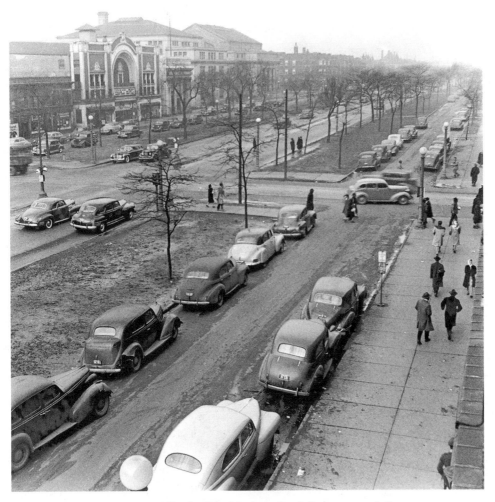

*Fig. 77. Wayne Miller,* Looking North on South Parkway to 47th Street, Crossroads of the South Side, *1947. Courtesy Magnum Photos*

offered relief from the nearby kitchenette buildings. The library was built on land donated by Julius Rosenwald, president of Sears, Roebuck, who supported African American arts and education by building schools and funding fellowships for artists and writers (Rosenwald also helped to found the Chicago Urban League).[54] On stepping through the library's arched stone doorway, one encountered four main rooms opening off an octagonal rotunda, including a fiction room with a central circular browsing seat. Furnishings were dark English oak against pale green walls (figs. 78–80).[55] At Hall Branch, head librarian Vivian

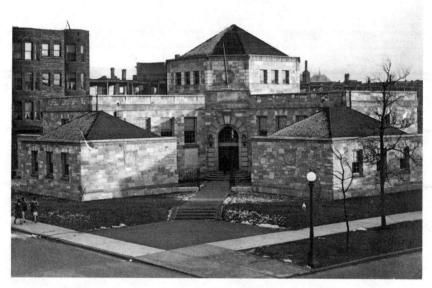

Fig. 78. Exterior, George Cleveland Hall Branch library, 1932. Hall Branch Papers, box 9, folder 21, Vivian G. Harsh Research Collection of Afro-American History and Literature, Chicago Public Library

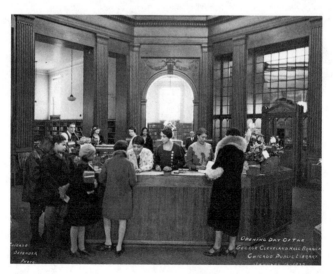

Fig. 79. Reference desk, George Cleveland Hall Branch library, January 25, 1932. Hall Branch Papers, box 10, folder 84, Vivian G. Harsh Research Collection of Afro-American History and Literature, Chicago Public Library

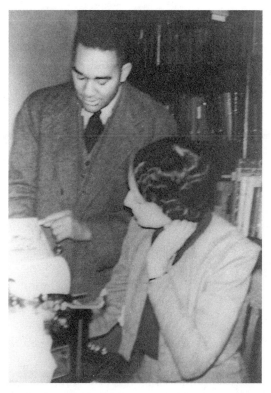

Fig. 80. *Richard Wright and Vivian Harsh donating* Native Son, *1941.
Hall Branch Papers, box 9, folder 18, Vivian G. Harsh Research Collection of
Afro-American History and Literature, Chicago Public Library*

G. Harsh cultivated a "Special Negro Collection" of books, manuscripts, photographs, pamphlets, and other materials by and about African Americans. She hired a team of black female professionals, including children's librarian Charlemae Hill Rollins, who made Hall Branch the center of Bronzeville's book-reading community.

At Hall Branch, Wright discovered Stein's *Three Lives*, among many other books that comprised his fervent self-education. Margaret Walker found newspaper clippings covering the Robert Nixon murder trial, which she sent to Wright, who used them as a basis for *Native Son*.[56] Dramatist Richard Durham did research for his popular weekly radio program, *Destination Freedom*, which dramatized the lives of significant black figures.[57] Alice Browning flipped through the pages of *Esquire* and *Story* magazines to understand how she might launch a similar periodical—*Negro Story*—aimed at reaching a wide black audience.

Langston Hughes—who spent long periods of time in Chicago—worked on material for his theater troupe Skyloft Players, which put on plays at sociologist Horace Cayton's Parkway Community House. And in 1950, Gwendolyn Brooks received a phone call at the Hall Branch from the Pulitzer Prize award committee notifying her that she had won.

Hall Branch was a hub for Bronzeville's literati but it was also, as one scholar has compellingly argued, a "salon for the masses."[58] Harsh hosted black writers and intellectuals as part of the Book Review and Lecture Forum, which ran from 1933 to 1955. Advertised in the *Chicago Defender* and the more politically temperate *Chicago Bee*, the forum attracted a diverse black audience: old settlers, political radicals, scholars, and community residents. Importantly, the event began at 8:00 p.m., after people got off work, and it was free. Never one to take undue credit, Harsh ensured that an organizing committee selected the reviewers and writers, which in the 1930s and 1940s included William Attaway, Arna Bontemps, Gwendolyn Brooks, Horace Cayton, St. Clair Drake, Langston Hughes, Zora Neale Hurston, Alain Locke, Margaret Walker, and Richard Wright. Often the subjects were controversial—with such a list of writers, it could not have been otherwise—especially during the war, when topics focused on issues of democracy, race, and citizenship. "What Is the Negro Up Against?" one series asked. Another outlined "A World View of Color."[59] Harsh knew enough to keep her annual reports to the Chicago Public Library's central committee dry and bureaucratic. The city's white administrators may have questioned funding for discussions of race and politics among blacks on Chicago's South Side.[60] Indeed, the power of books at Hall Branch underscores a resonant trope in black history, in which reading and writing serve as covert instruments of political liberation. The Chicago Public Library's board president worried about Harsh's "Special Negro Collection," which he thought "likely to cause a race riot."[61]

Hall Branch embodied values of racial uplift, respectability, and the high culture sought by old settlers, compared to the earthier pleasures of the Stroll. But these worlds were not separate. Richard Wright sought education as much as pleasure, and Vivian Harsh certainly went to the movies.[62] Both the Stroll and Hall Branch were significantly—if not totally—black public spheres, though the cultural life of Bronzeville was also supported by predominantly white institutions like the School of the Art Institute, *Poetry* magazine, and the Renaissance Society. Like Inez Stark, Katharine Kuh also understood that work by black artists was part of the modernist avant-garde: Charles Sebree was a no-

table Bronzeville artist whose work was exhibited in Kuh's gallery, which was known more for exhibitions of work by European artists like Léger, Matisse, Amedeo Modigliani, and Picasso. Kuh was also the first gallerist in Chicago to display photography, an art form with a strong claim to realism, which many writers and artists of Bronzeville found particularly appealing.[63] And at the South Side Community Art Center, director and photographer Peter Pollack, who was white, worked alongside cofounders Margaret Burroughs and Eldzier Cortor in creating a dynamic range of programs and exhibits.

Interracial collaboration at the Illinois Writers Project was also vital to Bronzeville's creative output. This is where, in 1935, Richard Wright was one of the first to be hired.[64] Wright served as a supervisor at the project and worked closely with Nelson Algren—whom he already knew through the John Reed Club—and Jack Conroy, another white writer and "the old daddy of rebel writing in the United States," as Wright called him.[65] Other writers at the project included the poet Fenton Johnson, novelists Willard Motley and Frank Yerby, and those who would form the South Side Writers Group (including Walker). Several novice white writers also got their start: Saul Bellow, Sam Ross, and Louis "Studs" Terkel.[66] Of the many Roosevelt-era WPA projects across the country, the Illinois Writers Project was the most integrated and politically the most radical.[67] Eventually, the project's central focus became an ambitious, wide-ranging social history, "The Negro in Illinois."[68] It was supervised by Conroy and Arna Bontemps, a writer most associated with the Harlem Renaissance, who was introduced to Conroy through Langston Hughes. The project was envisioned as a book of twenty-nine chapters, covering subjects such as housing, health, religion, literature, music, and culture. The immense research for these chapters—which borrowed from the simultaneous WPA-funded projects overseen by black sociologist Horace Cayton—is rich with anecdotes, folktales, and oral histories.[69] Indeed, the form of the project might be understood as a precursor to a "Chicago style" embodied best by Studs Terkel's vivid oral histories of people from all walks of life. Here was a Chicago impulse: to engage the man or woman on the street, to record the speech of the people, to tell history by telling stories.

In a 1950 article for *Negro Digest*, the publication begun by media-savvy black businessman John H. Johnson before his success with *Ebony*, Arna Bontemps recalls the WPA writers in Chicago who flourished during the Depression. Bontemps does not express nostalgia but rather surprise that the distinctness of the Chicago scene had already faded from memory. He takes note of an earlier

literary culture in Chicago, naming writers such as Theodore Dreiser, Floyd Dell, Edgar Lee Masters, Harriet Monroe, Carl Sandburg, and Ernest Hemingway, who "set the tradition." He then compares Bronzeville to the elegance and formality of Harlem—a contrast that he experienced firsthand, as did Langston Hughes. "What [Harlem] did not dream," Bontemps writes, "was that a second awakening, less gaudy but closer to realities, was already in prospect." During grim economic conditions, creativity in Bronzeville was stimulated by the explorative research of government work, which, for a sustained period, inspired literary invention. A renaissance in Chicago emerged, according to Bontemps, "without finger bowls but with increased power."[70]

That power never drew the national attention it deserved. In part, this was because "The Negro in Illinois" was never finished: the Works Progress Administration, including the Illinois Writers Project, came to an end when America entered the Second World War and funding was diverted to the military.[71] But the project's source material fed into Conroy and Bontemps's hybrid of a book, *They Seek a City* (1945), which illuminates the Great Migration through vivid, anecdotal stories. Cayton's research resulted in his comprehensive study coauthored with St. Clair Drake, *Black Metropolis: A Study of Negro Life in a Northern City* (1945), which took account of Bronzeville's class structure, forms of work and social life, civic and religious organizations, settlement patterns, and race relations. Advancing the claims of the Chicago School of Sociology, Drake and Cayton implicitly argued that the behaviors of Bronzeville were highly determined by social and environmental factors, more so than by biological and personal characteristics. Social determinism would have its later detractors, both literary and scientific, but for Wright in *Native Son*, it seemed that poverty, unemployment, and unbearable living conditions could indeed create a killer.

Recall that Wright sent *Black Metropolis* to Gertrude Stein in Paris. He knew it would interest her: Stein had gone slumming during a visit to Chicago a decade earlier, surprising residents of a crowded Bronzeville kitchenette. Recall, too, Wright's acknowledgment to Stein that his introduction to *Black Metropolis*— which is long, forceful, and luminous—used her idea of war accelerating the recognition of new, experimental modes of artistic expression. *Black Metropolis*, in turn, would teach Stein about Chicago's modernity, nowhere better embodied than in Bronzeville.

When Wright moved to Paris in 1946 with his wife, Ellen Wright, and their young daughter—Stein helped them secure passports—Stein was clearly anxious to meet Wright in person, and to talk. Despite feeling ill, she met the

Wright family on their early morning arrival at the Gare Saint-Lazare.[72] "He interests me immensely, he is strange," Stein writes to Van Vechten soon after, "I have a lot of theories about him and sometime when it all gets straightened out I'll tell you." A week later she explains to Van Vechten that Wright "does not seem to me very Negro," and that she is "meditating about him."[73] One can only speculate about Stein's "theories" or how Wright may have transformed her ideas about race in America, but their conversations lit up the last months of her life.

## OPEN AND RAW

"What would life on Chicago's South Side look like when seen through the eyes of a Freud, a Joyce, a Proust, a Pavlov, a Kierkegaard?" Wright asks in his introduction to *Black Metropolis*. Rich with empirical data, *Black Metropolis* demanded interpretation. Or rather, the city demanded it. "Chicago is the *known* city," Wright claims, "perhaps more is known about it, how it is run, how it kills, how it loves, steals, helps, gives, cheats, and crushes than any other city in the world."[74] So much was "known" about Chicago through sociological analysis, Wright suggests, but there was more to be said, and there were new ways to say it. Wright describes Chicago as "open," a metaphor that meant both the distinctive geographical flatness of the city and also, as Harriet Monroe used the word, freedom from dictating aesthetics. "Chicago is the city from which the most incisive and radical Negro thought has come," Wright claims. "There is an open and raw beauty about that city that seems either to kill or endow one with the spirit of life." Wright's metaphor also suggests a wound—"open and raw"—and yet, from this wound perhaps "beauty" might be born.[75] That is, if Chicago did not destroy you, then it made you feel—and think—more clearly about the racial transformations taking place in America. For Wright, this should be the central subject of great American art.

Photography may have offered the most compelling medium. By the 1940s, photography had established itself as an art form with an aura, although its appeal for Wright also lay in its origins in scientific, documentary truth telling. Shortly after the publication of *Native Son*, Wright collaborated on 12 *Million Black Voices* with the photographer Edwin Rosskam, who helped choose nearly 150 photographs for the book from the Farm Security Administration, a New Deal program set up to combat rural poverty. Work from such photographers as Walker Evans and Dorothea Lange present the sentimental (a mother clinging

to her children), the harrowing (a lynched man surrounded by his killers), and the hopeful (a man in a threshold, eyes raised to the sun). Images of sharecroppers, steelworkers, waiters, churchgoers, children, and inhabitants of kitchenettes give force to Wright's sustained invocation of an all-inclusive "we" in his text, in a tone of voice as if from a pulpit. (Note the title's auditory trope for a book filled with photographs.) 12 *Million Black Voices* presented a black story almost entirely absent in James Agee and Walker Evans's *Let Us Now Praise Famous Men*, published the same year.[76] But like that highly stylized work, 12 *Million Black Voices* used photography as a practice of revelation, a medium that seemed both to expose reality and to give it a formal shape.

Horace Cayton envied 12 *Million Black Voices* for its moving, lyrical presentation of what *Black Metropolis* reported through numbers and graphs. With a trace of destructive self-doubt, Cayton wrote a glowing review: "For years my associates and I have tried to describe [this society] by figures, maps, and graphs. Now, Wright and Rosskam have told the story as it has never been told before."[77] Art trumped sociology's empiricism.

It was the city that gave photography its fitting subject. Arguably, photography's prominence as an art form coincided with the rise of cities and the detached viewpoint of the urban pedestrian. "Photography first comes into its own as an extension of the eye of the middle-class *flaneur*," writes Susan Sontag, "whose sensibility was so accurately charted by Baudelaire."[78] Bronzeville attracted this everyday eye: Wayne Miller, a white war veteran who had seen and recorded the horrors of Hiroshima, returned to Chicago with the aim of helping people "better understand the strangers on the other side of the world—and on the other side of town."[79] At all hours, Miller explored Bronzeville's streets and alleys, taking intimate, vivid photographs of the neighborhood and its people. His 1946–48 Guggenheim-funded project, "The Way of Life of the Northern Negro," was generously aided by Cayton, whose introductions gave Miller access and credibility.

Ben Burns was working out of a rear room at Cayton's Parkway Community House in 1946, and he promptly put Miller on assignment for *Ebony*, a monthly magazine bursting with photographs, which had launched the previous year.[80] White, Jewish, and a member of the Communist Party, Burns was an incongruous choice as associate editor for a publication that preferred to look at "the zesty side of life," as declared in the magazine's first issue. *Ebony* set out to celebrate "all the swell things we Negroes can do and will accomplish."[81] The first issue profiled Richard Wright, at home with his wife and daughter during

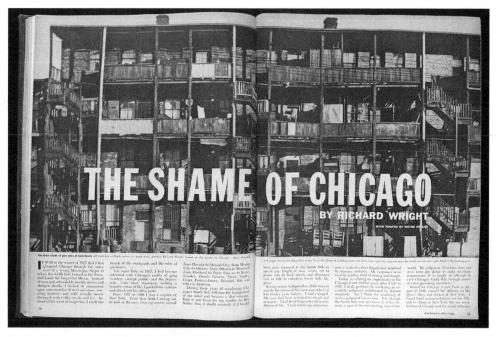

*Fig. 81. Richard Wright, with photographs by Wayne Miller, "The Shame of Chicago,"* Ebony, *December 1951. Courtesy Magnum Photos*

his last year in Brooklyn, but when Wright wrote for the magazine in 1951, he took a tone decidedly at odds with the magazine in which it was published. Titled "Shame of Chicago," Wright's piece is a scathing indictment of the city's segregation, corruption, and filth—in comparison to the arboreal cleanliness of Paris.[82] Again, the role of photography is crucial in illuminating the "truth" of Wright's claims: nine photographs by Wayne Miller accompany "Shame of Chicago," including a two-page spread of dilapidated kitchenettes (fig. 81).

*Ebony* loved celebrity writers, but Wright's piece was too much. Shame was not the emotion that the magazine was in business to promote. An editorial at the back of the issue, penned by Burns, argued that Wright's piece was "honest, sincere and distinguished reporting, yet also a warped, often-naïve and incomplete study of how Negroes live in Chicago."[83] Johnson declined to publish the next piece Wright wrote for the magazine, "I Chose Exile," which was supposed to be about Wright's daily life as a writer in Paris but was instead a blistering critique of racism in America, where Wright would never return: "There is more freedom in one square block of Paris than there is in the entire United States of America!"[84]

It is a sign of the flexibility of Miller's work that his photographs were used for such a critical exposé of Chicago. The same photographs could have been used to advocate racial pride and achievement. One photograph accompanying Wright's piece shows doctors hovering over a newborn at the all-black Provident Hospital; another shows boxer Joe Louis, sleek and exhausted, being handed a towel. If these photographs illustrate the lower life expectancy of blacks and the delusions of idol worship (for Wright), then they also illustrate the success of Bronzeville's medical community and black athletic accomplishment. The aims of Miller himself are also illuminating. Miller said that he tried to take the perspectives of the people he was photographing: "My search was for the everyday realities of life—*their* view of the world, *their* feelings, *their* attitudes, *their* stories."[85] He himself wanted to disappear. And like his then unknown peer Vivian Maier, Miller worked with a camera from a waist-level viewpoint. Miller claimed that there was a distinction between photography as art-making and photography as disclosure: "There are people who make pictures and people who take them. I take them."[86] It is an inspired if not utopian idea: the absence of the photographer's gaze.

Consider a photograph by Miller that was not in Wright's piece for *Ebony*, one of the several photographs that Miller took of Eldzier Cortor. Cortor was well known among Bronzeville's artistic community, though his work has received less attention than the sumptuous portraits and jazz scenes of his older peer Archibald Motley Jr., both of whom studied at the School of the Art Institute of Chicago.[87] Gwendolyn Brooks befriended Cortor through their mutual involvement in the South Side Community Art Center, an institution that Cortor helped found and where Brooks first went to take Stark's poetry workshop and later worked briefly as a secretary. (Intriguingly, in 1949, Brooks sent Elizabeth Lawrence one of Cortor's works.[88]) In Miller's photograph of Cortor, he appears deep in thought, thumb pressed against his head, smoking (fig. 82). Miller took the photograph in Cortor's basement apartment, where water dripped from the ceiling and reclaimed furniture evoked the neighborhood's tonier past.[89] Miller's photograph stylizes these elements: a backdrop appears as if a curtained stage, with a stippled ceiling like clouds in the sky. Cortor sits in a thronelike chair, viewed from below as if a god.

Seeing and being seen have provided dominant metaphors for understanding black identity, from Du Bois's concepts of visibility—including "the Veil" and "second-sight"—to one of the most memorable opening lines in American literature: "I am an invisible man," says Ralph Ellison's unnamed black nar-

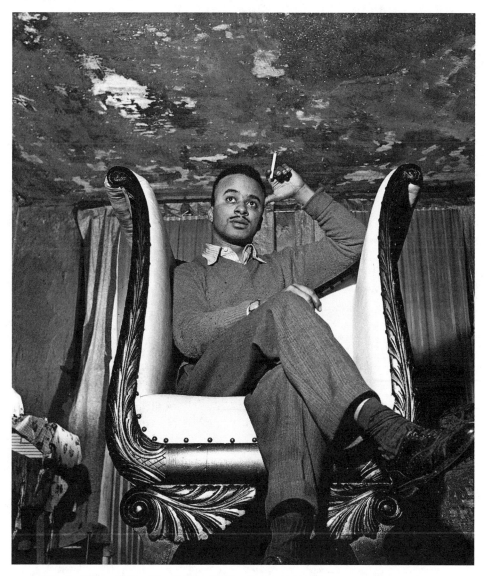

*Fig. 82. Wayne Miller,* The Painter Eldzier Cortor in His Basement Apartment, *1947.*
*Courtesy Magnum Photos*

rator.[90] Ellison's invisible man also lives in a basement, lit by over a thousand lightbulbs, like a stage. The symbolism is clear: will black identity ever be acknowledged in American culture? Du Bois himself collected quasi-scientific photographs of the "American Negro," which he displayed at the 1900 Paris Exposition, a moment in time when photography existed in a liminal position be-

tween science and art.[91] This tension has not entirely disappeared in the WPA-funded documentary photography of the 1930s and 1940s, as in a work like *12 Million Black Voices*. A work of art—it is—but also an expression of proof. The work asks readers to *see*.

There are limits, of course, to the comprehensiveness and clarity of what a photograph depicts. A photograph has a vantage; there is no God's-eye view. Ultimately, Miller's photograph of Cortor confirms the impossibility of removing a level of mediation between artist and subject, even through an art form that seems to have the greatest purchase on mimesis. If Miller's photograph is a nod to Du Bois's evocative concept of "double-consciousness"—a sense of "always looking at one's self through the eyes of others"—then it is also an inversion of the concept.[92] Miller's gaze is decidedly from below, a position of homage and reverence.

Photography, then, might be the most deceptive genre even as it seems to possess qualities of pure realism. Sontag again: "Life is not about significant details, illuminated in a flash, fixed forever. Photographs are."[93] Which is to say, photography's sheer closeness to reality intensifies the knowledge that a photograph is different from real life. Reality moves, changes, exists in time; photographs are the workings of light on a surface, an arrangement of forms, a fragment with defined borders. The dramatic, mass-produced photography that reveals what Bronzeville *really* looked like is also the art form that put pressure on artists and writers working in other mediums, especially painting. To visit the Art Institute of Chicago was to see the effect—from impressionism's blurred experiments with light to the time-lapse increments of Duchamp's *Nude Descending a Staircase, No. 2*, which returned to the museum in 1933 during the Century of Progress International Exposition (a painting now lauded, not mocked). A fairly conventional idea in the history of art proposes that the rise of photography gave permission to painters to follow a dominant modernist tendency—abstraction.[94] This is not because artists gave up on realism but because photography showed how even the most realist of the arts contained abstraction within it.

Consider again Eldzier Cortor. In his undated etching *Trilogy No. II, Verso*, two crimson torsos, horizontal and vertical, seem held in suspension against other mottled shapes, evoking pieces of rock set to be sculpted (fig. 83). These elongated female bodies resonate with forms of abstraction in African and cubist art, in which Cortor was well versed through his School of the Art Institute training and his revelatory visits to the Field Museum.[95] Cortor was also attracted to the New Bauhaus in Chicago and the abstracted light creations

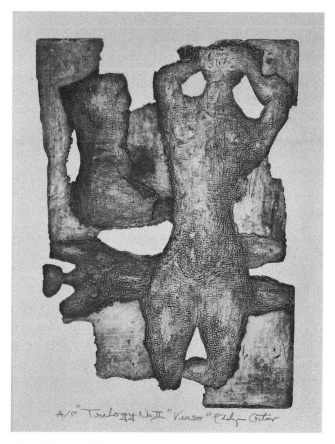

*Fig. 83. Eldzier Cortor,* Trilogy No. II, Verso, *etching and aquatint on paper, undated. Image © Estate of Eldzier Cortor, Courtesy Michael Rosenfeld Gallery LLC, New York*

of Moholy-Nagy.[96] Indeed, Cortor experimented with abstraction while an art student, but he was worried about abstraction's social implications. Influenced by his participation in the WPA Federal Art Project and his contact with the ever-present Cayton—who shared his research for *Black Metropolis* with Cortor before the book was published—Cortor made a conscious decision to work in a more figurative mode. "I felt on the face of it, as a black, to be doing abstract—I just felt I couldn't afford it, that it wouldn't serve my purpose, to get over my message."[97] To deliver a "message" as a visual artist was to work with forms that gesture, even if just slightly, to figuration, a recognizable content.

What did it mean for writing? In Bronzeville, the scale between realism and abstraction arguably hangs heaviest on the side of realism, for writing as for

painting.⁹⁸ Recall Wright's response to Brooks's first manuscript: "She takes hold of reality as it is and renders it faithfully." This is Wright's highest form of praise: to render "reality" is a sign of authenticity. Driven by a desire to represent the everyday plight of the working classes, many writers in Bronzeville sustained a tradition in Chicago established by Henry Blake Fuller, Theodore Dreiser, Carl Sandburg, Upton Sinclair, James T. Farrell, and other writers who worked to represent the larger social and economic forces that shaped the individual condition. (Algren and Saul Bellow would follow.) Chicago begged for the social realist: the power of the city's industries and the vulnerability of its workers to the city's unchecked capitalism were compelling subjects, even if social realism, across genres, sometimes seemed like a conservative aesthetic mode—from masculinist depictions of muscle-clad laborers-as-heroes to compositions that fail to investigate the possibilities within the material medium. Not everyone acknowledged the keynote lesson of photography—and much later, of poststructuralism following Roland Barthes: no medium is transparent; there is no writing degree zero. The greatest social realist, Dreiser, who titled a manifesto "True Art Speaks Plainly" (1903), was known for his awkward, flat-footed prose. (Ford Madox Ford is supposed to have said that Dreiser was a writer of no talent, only genius.) Which is to say, to write "plainly" is itself a style, perhaps no closer to reality than the most difficult modernist text. Certainly, Dreiser was Wright's most commanding forebear, a writer whom he claimed was "the single greatest writer that this nation has yet produced."⁹⁹ In the last interview he gave before his death, Wright provided a long list of writers whom he admired and concluded, "But I would give them all for one of Dreiser's books—it contains them all."¹⁰⁰ To understand Wright as primarily a social realist—in the spirit of Dreiser—is to understand an important literary lineage, with roots in Chicago.

But it is also to miss something. It is to miss what makes Wright's work experimental, strange, and abstract. To read Wright simultaneously as a modernist—or rather, to see the realist impulse in his work as part of what characterizes his modernism—is to read Wright's work against the critical grain. It is also to amplify the political and aesthetic dimensions of the Chicago Black Renaissance, in the sense that Wright's work is as much part of Chicago's literary history as it is of the stylistic revolutions of transatlantic modernism. Take the influence of a visual medium like photography, which might be traced not only in Wright's work but also across a range of modernist styles, from Marcel Proust and Thomas Mann to Virginia Woolf and Christopher Isherwood.¹⁰¹ The lit-

erature of Bronzeville is central to a larger material and aesthetic history that conjoins the invention of the camera and the aesthetics of modernism. It is striking to note that before Wright left the Illinois Writers Project, he proposed a collaborative project titled "20 Years of Negro History through Negro Eyes," which would employ the camera-eye technique of John Dos Passos's 1930s *U.S.A. Trilogy.* (It never materialized.[102]) Wright's experiment with *how to see* was both complicit with the aims of other modernist writers and distinctive to his position as a black writer in Chicago.

Wright's writing pushes against realism and simultaneously keeps to it. In *Black Boy,* he explains how he was drawn to experimenting with language: he tried to make words "disappear, to make them important by making them new, to make them melt into a rising spiral of emotional stimuli."[103] Perhaps the full emotional force of language might emerge through writing that aspires toward utter precision, *le mot juste.* But Wright also expresses, here, a desire for the mesmerizing rhythms that he admired in Stein's "Melanctha." His writing is an exercise in exactitude that is yet a radical style. As much as Wright understood writing as a vehicle for social change, he devoted himself to exploring the formal limits of language; and he worried that his responsibility to the Communist Party would compromise his art. "If the sensory vehicle of imaginative writing is required to carry too great a load of didactic material," Wright claims in "Blueprint for Negro Writing, "the artistic sense is submerged."[104] Though Wright found tremendous intellectual inspiration among his communist friends, eventually he chafed against the party's idea of what art should be: ideological, didactic, vulgarized. This was social realism at its worst.

Even when Wright's political vision was most coherent—that is, before his break with the Communist Party—his stylistic modernism is apparent, from the free verse of his visionary poem "I Have Seen Black Hands" (1934) to the wild typographics of his first novel, *Lawd Today!,* which pays homage to Joyce's *Ulysses* by following a frustrated black postal worker through the streets of the South Side. *Lawd Today!* could not find a publisher during Wright's lifetime, but when it appeared in 1963, it was praised by Brooks in the *Chicago Sun-Times* for its "beautiful prose" and resonant dialogue.[105] With echoes of Eliot's "unreal city" and Stein's experimentations with language, the novel is Wright's first representation of modernity embodied by a black man—a major theme of *Native Son.* It is worth noting, too, that Wright composed more than four thousand haiku between 1958 and his death in 1960, an obsession with a Japanese form central to the Imagist movement.[106]

In *Native Son*, Wright's formal ingenuity is best expressed through Bigger's consciousness or, rather, double-consciousness. Seeing and being seen: this is an explicit leitmotiv of the novel, which borders on the moralistic (Mrs. Dalton is literally blind). How can Bigger transcend the condition of being bound by the perspectives of white people? Is it possible to see Bigger clearly? When Bigger flees his murders, hiding in abandoned buildings on the South Side, he literally tries to disappear. After his capture, the newspapers contain sensational descriptions of Bigger (a "jungle beast," "exceedingly black," possessing "abnormal physical strength").[107] The *Tribune* publishes a photograph showing the Daltons' white cat on Bigger's shoulder, a kind of weird albatross or an inversion of Edgar Allan Poe's Black Cat: "[Bigger] looked solemn and black and his eyes gazed straight and the white cat sat perched upon his right shoulder, its big round black eyes twin pools of secret guilt."[108] Bigger and the cat gaze out while simultaneously holding the gaze of the *Tribune*'s readers: not lowering his eyes is an act of willful defiance.

But even more striking than the novel's riff on the complexity of vision is how double consciousness functions through shifting strategies of focalization: interior dialogue, omniscient narration, free-indirect discourse, and finally through the speech of another. The novel nears its end with a tour-de-force defense of Bigger, given by his lawyer, Max, which Bigger himself does not understand. For over twenty pages, *Native Son* formally demonstrates Bigger's own distance from the interior self that Max articulates.

The flight to interiority, like the flight to abstraction, might be considered one of modernism's most dominant and often criticized aesthetic tendencies. To represent the subjective life of a single individual is not only to abandon the primacy of plot (plotlessness being modernism's great invention) but also to turn away from an engagement with civic and social life, to strip literature of both moral uplift and revolutionary power.[109] This charge, of course, can hardly be leveled at *Native Son*: the novel's plot is a double murder and its aftermath, skillfully structured so as to keep a reader like Gwendolyn Brooks awake all night reading to the novel's end. Moreover, Bigger's inner psychology is given a public forum, exteriorized, spoken aloud in a courtroom, even as Max's lengthy, wide-ranging speech tests the limits of the possible. (As does the number of people who turn up in Bigger's jail cell.) Throughout the novel, Bigger is mired in his nearly destitute material and social circumstances—significant factors in the formation of his character, as the Chicago School of Sociology would have it (in which Max has clearly been schooled). The novel itself was a wake-up call

to white America, like the screaming alarm clock of the novel's first sentence. But the power of Wright's own scream owed something to the modernist modes that he so brilliantly adapted, to the extent that he could create a novel that held "realism in the balance," as one famous critic of modernism put it.[110]

So, too, did many of Wright's peers strike a balance, essentially limiting how abstract, plotless, complex in reference, and stylistically elaborate their works might be. What were the stakes? Publishers and readers, first of all, but also something else. Brooks's stunning—and stunningly difficult—second volume of poems, *Annie Allen* (1950), worried Elizabeth Lawrence when she first read the manuscript, "disturbed by a feeling" that Brooks was "escaping from life itself into a world of words and sounds" and that Brooks was "not always communicating with others."[111] Lawrence urged Brooks to be explicit about the "content" of her poems, and she held out hope that Brooks would someday turn to writing prose, a genre by nature less interiorized than lyric poetry. ("I believe, as I always have, that you have the makings of a first-rate novelist."[112]) Wright thought the same after reading *A Street in Bronzeville*; in a follow-up letter to Brooks, he wrote: "Here's hoping that maybe some fiction might find its way from you to the world, or plays, or short stories. I think you write very straight, and that is the way to write, according to my thinking."[113] Wright and Lawrence voiced a concern, among many artists and critics, that art's clarity of transmission was central to its social purpose.

This pull between a commitment to realism and to experimental modes of modernism is both a valuable way of understanding what was at stake for Bronzeville artists, even as it is also a crude distinction in terms. Modernism, to be sure, was its own kind of realism, whether a movement toward abstraction as a purification of forms or a movement toward consciousness as a trusted form of knowledge. The heterogeneity of modernist styles—even the most difficult—might be partly explained as a desire to get closer to reality, to make literature seem *more real*. (As Samuel Beckett said about drafts of Joyce's *Finnegans Wake*: "His writing is not *about* something; *it is that something itself*."[114]) Furthermore, even at its most private, the interior mind was shaped by external factors—a point dramatized by protagonists from Leopold Bloom to Clarissa Dalloway to Bigger Thomas. The imagination, according to Wright, is "a kind of community medium of exchange," reflecting what a person "has read, felt, thought, seen, and remembered."[115] Our seemingly most private thoughts bear the imprint of a shared culture, to the extent that even the mind of the most pathological protagonist shares something with the mind of many others.

Perhaps the pioneering discoveries of *Black Metropolis* made black artists in Chicago hew closely to the representation of empirical evidence, to stay close to the facts on the ground. From Wright's vantage, *Black Metropolis* proved how central urban life in Chicago was to the formation of black experience in America and called on artists and writers to represent that experience. They could not abandon figuration, plot, or content—whatever it was that made their message palpable, even if that committed them to a mode that was sometimes culturally conservative. The black artist, to some extent, bore a responsibility to represent a people—"my people," in Margaret Walker's words—and it was their duty to communicate with the masses. If there were no black artists who worked in abstraction in Bronzeville during the 1930s and 1940s, then maybe the blame—not the shame of Chicago, to use his title from *Ebony*—is on Richard Wright.

In his introduction to *Black Metropolis*, Wright describes Chicago as a place where black people experienced hope for a better future and yet felt constrained and bewildered by "facts" that held them back: "And there in that great iron city, that impersonal, mechanical city, amid the steam, the smoke, the snowy winds, the blistering suns; there in that self-conscious city, that city so deadly dramatic and stimulating, we caught whispers of the meanings that life could have, and we were pushed and pounded by facts much too big for us."[116] Pushed and pounded, the inhabitants of Bronzeville both experienced the dislocations of modernity and produced works that tried to make sense of it. Wright draws on a collective "we"—also the pronoun of *12 Million Black Voices*, his pledge of allegiance to the black working classes and a sign of resistance to the interiority of "I." A remarkable if somewhat reluctant modernist, Wright maintains his entrenchment in Chicago from which his singular style emerged.

## I FOUND IT FUN

Richard Wright may have been writing from the perspective of a collective black "we," but the looming question—it would not go away—was who he was writing *for*. There was artistic posterity, and there were the racial pressures of the present. Literacy among black audiences presented a tricky set of circumstances for writers. In the first decades of the twentieth century, as access to education improved, the black population achieved literacy at exponential rates. Then as now, however, reading could take many forms, from the experience of pure leisure to a practice of intellectual discipline. To look through the *Defender* or the glossy pages of *Ebony*—publications decidedly aimed for a black market—was

one thing. To mull over the linguistic virtuosity of Brooks's autobiographical sonnet sequence "The Anniad" was quite another. Between these two poles lies 12 *Million Black Voices*, inviting and empowering a black audience while doggedly attending to the viewpoint of whites. Notice, again, Wright's use of pronouns, his preoccupation with the role of the reader: "You may smile when we call the way of life we lived in Africa 'civilization,' but in numerous respects the culture of many of our tribes was equal to that of the lands from which the slave captors came."[117] Perhaps Wright's use of "you" absorbs the language of mass-market journalism and bears resemblance to book reviews by Fanny Butcher or Hemingway's direct address to the reader or Stein's engagement with audience as integral to the making of a literary text. But Wright's "you" is also kept at arm's length. Wright's reader — "you" as opposed to "we" — knows nothing about the culture of Africa. He smiles, Wright imagines, a patronizing white response.

There were many, diverse readers to please. Ideally, black writers were supposed to write for the "Negro Masses," as Wright argues in "Blueprint for Negro Writing," a phrase that suggests the working-class, proletarian left. But they were also responsible for creating readers, which might mean crafting literary works that were accessible, uplifting, and even sentimental. Alice Browning and Fern Gayden's important but short-lived periodical *Negro Story*, published from 1944 to 1946 out of Browning's apartment, attracted readers with its emphasis on a short narrative form, which could be quickly consumed, and a mixture of lighter fare with stories by big-name authors. On its masthead, the magazine presented itself: "Short Stories by or about Negroes for All Americans," ostensibly aiming for a cross-racial readership. Wright gave the magazine rights to republish his story "Almos' a Man," which appeared in the first issue; other writers in *Negro Story* included Chester Himes, Owen Dodson, Ralph Ellison, and Gwendolyn Brooks (before she became famous for *A Street in Bronzeville*). Author biographies were also little narrative gems in *Negro Story*, often trading in literary gossip.[118]

But reaching a wide black audience was difficult, as Langston Hughes had shown. Hughes was a writer with whom Wright shared a strong professional relationship and whom Gwendolyn Brooks adored. Unlike Wright, Hughes longed for attention and affection from blacks, which Hughes's biographer traces back through the intimate experiences of childhood. A substantial black readership was central to Hughes's sense of himself as a writer.[119] When Hughes set out on a lecture tour in 1931, however, he learned quickly that political rad-

icalism could estrange a black audience, especially in the conservative South. Hughes felt that "Marxism helped him to understand the Black masses," as Hughes's biographer explains, "but it did not help the Black masses understand themselves."[120] Hughes could become a different kind of writer—alternatively radical, commercial, or genteel—to accommodate his audience, a flexibility enforced by "the double audience" that a black writer "bearing a racial message but dependent on a white publisher had to keep in mind."[121] This equivocation was all too familiar for the next generation of black writers in Bronzeville.

To put it plainly, black writers at this time had to write for white readers if they wanted to sell books. It was a white audience, for instance, that made *Native Son* a Book-of-the-Month Club best seller. The white judges who chose *Native Son* as a main selection—and asked that Wright delete sexually explicit material—assumed the club's membership to be almost wholly white.[122] It was the first time a black author had been chosen, and the editors calmed anxious readers with an appalling formulation: the book "is quite as human as it is Negro."[123]

*A Street in Bronzeville*, too, was clearly promoted for white readers, at a moment when being a good American meant supporting US troops abroad. On the back of the dust jacket appears a photograph and brief biography of Brooks, along with an injunction to "Buy War Bonds!" though probably not written by Brooks herself (fig. 84). Brooks's identity and the political nuances of her poems are swept into the larger collective struggle for democracy abroad. This poet is a patriot, the back cover suggests, our own native daughter. But for blacks, participation in the war effort was double-edged: how does one fight for democracy abroad without the provision of democracy at home? An "off-rhyme situation," Brooks called it, which she addressed in the final sonnet sequence of the volume, "Gay Chaps at the Bar."[124] The title comes from a phrase in a letter that Brooks received from William Couch, a handsome poet in Inez Stark's poetry group who served in the war. The "bar" is both where soldiers find a drink and a metaphor for where blacks are banned. "Each body has its pose," Brooks writes in the second sonnet, "No other stock / That is irrevocable, perpetual / And its to keep." The implication is that death at last is a leveler, unprejudiced, the fate of soldiers no matter the distinctive "pose" of the living.

There is no record of what Brooks thought about the war bonds advertisement on the back of her first book, but she loved the front cover. A design of black and red bricks is overlaid with the title of the volume in white lettering and a blurb by William Rose Benét, poet and editor of America's popular book weekly the *Saturday Review of Literature* (fig. 85). "The famous Benét!" Brooks wrote to

Elizabeth Lawrence.[125] Brooks thought that the design was "eye-catching, suggestive, and dignified." "How happy I am that there are no little funny figures, with patches, open collars, and so on!"[126] Presumably what Brooks meant is that there are no stock Negro figures, pandering to the stereotypes of her white readers. For many years, as she acknowledged, Brooks wrote for a white audience, supported by teachers and editors who read her work through an Anglo-American lens and literary tradition. Two of Brooks's important early readers were white women: her teacher at the South Side Community Art Center, Inez Stark, who cultivated Brooks's connection to *Poetry*, which Brooks conceived of as "the GOAL," and her Harper and Brothers editor Elizabeth Lawrence, who edited Brooks's poems with a clear eye toward reaching a wide audience.[127] (Brooks introduced the women in 1949, in New York, after a reading that Stark had arranged for Brooks at Howard University in Washington.)

Letters between Brooks and Lawrence reveal a shrewd awareness of Brooks's relationship to her audience, touched with humility and humor. The friendship between these two women became especially important to Brooks after the unexpected success of her debut collection and the Pulitzer Prize for her second. How could she sustain this level of critical and commercial acclaim? Lawrence clearly recognized Brooks's tremendous talent and wanted to understand more about her and how she worked. When the women met in Chicago on October 24, 1945, Lawrence took Brooks and her husband, Henry Blakely, out to dinner and ordered celebratory martinis. Brooks confessed in her next letter that their car broke down afterward. Also: "I never had a martini before! Now I'm sold on them." Lawrence wrote back: "I should feel regret for having introduced you to martinis. It's the wrong time in the world's history to introduce anyone to an expensive habit."[128] Later, when the contract for *A Street in Bronzeville* was crumpled by Brooks's four-year-old son, Brooks wrote to Lawrence: "My baby got into the desk and apparently studied my contract very carefully, inch by inch."[129] Lawrence replied, drolly: "In time it may be a historic document and the more interesting with such defacement."[130] (Lawrence, of course, was right.)

But the key letters between these women are the ones in which Lawrence and Brooks go back and forth about the shape of a poem or the structure of a collection. Lawrence reassured Brooks, for instance, that *A Street in Bronzeville* should retain "The Ballad of Pearl May Lee," which Brooks was ready to cut after another editor at Harper thought the poem "synthetic."[131] Choosing what poems to include in Brooks's *Selected Poems* (1963) produced many letters of negotiation; only once was Brooks aghast: "BUT ELIZABETH. The *only* thing I

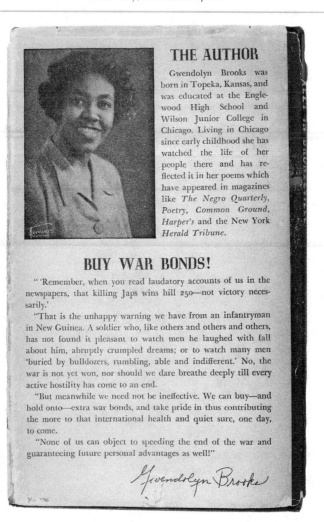

*Fig. 84. Back cover of Gwendolyn Brooks,* A Street in Bronzeville *(1945).
Courtesy Newberry Library*

want to scream over is Riders to the Blood-red Wrath, my salute to the Free-
dom Riders. I'm so old now that I know when I have written a good poem, and
this is one of the best I've ever made."[132] Lawrence quickly demurred and the
poem remained. In a series of letters about Brooks's only work in prose, first
titled "American Family Brown" and eventually published in 1953 as *Maud
Martha*, Lawrence urges Brooks to write a *story*, not "a study of Negro life."
It was the purely documentary impulse of Bronzeville—exemplified by *Black
Metropolis*—from which Brooks needed distance. Lawrence writes, bluntly:

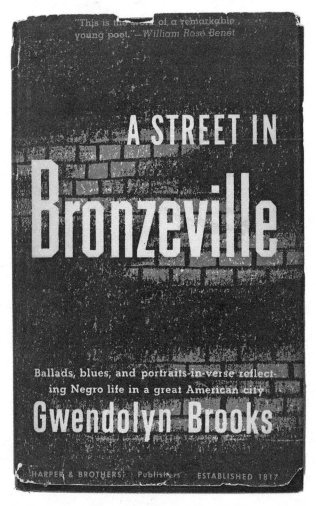

*Fig. 85. Front cover of Gwendolyn Brooks,* A Street in Bronzeville *(1945).*
*Courtesy Newberry Library*

"Your characters are human beings before they are sociological specimens."[133] Brooks agreed: "In this initial submission I seem to have committed all the sins I slam others for and which I vowed I'd not be guilty of."[134] Through several tortuous revisions, Brooks worked to make the book true to the authenticity of black life while avoiding moralism, pandering, or literature as a record of proof. First and foremost, literature was an art.

When Lawrence retired in 1964, Brooks was devastated: "You have been loyal to me and have maintained faith in my potential ability. You have made

each of my books a little work of art, with I believe, not a single error in the twenty years of our association. It is not strange, therefore, that I regard your departure with bleakness and a sense of personal loss."[135] They kept in touch: the last remaining letter from Lawrence to Brooks concerns the subject of belief. No doubt foreseeing her death, Lawrence writes: "That I may have helped release a few talents, helped to sharpen a few books, by way of realizing the author's intention, has been my greatest satisfaction and pleasure. It is for this I am indebted to you and many others."[136]

A few years after Lawrence retired, Brooks made a pivotal turn. Inspired by a black writers' conference at Fisk University—where she was surrounded by younger artists and writers of the Black Arts Movement—Brooks decided to sever ties with Harper and Brothers in favor of black-owned publishing houses in Detroit and Chicago. Her focus would be the black community: publishers, other writers, and readers. In some respects, it was an inevitable move—and a decision that Brooks was in a safe position to make. Political from the start, her poetry often confounded the very white readership that purchased it and attended her readings. She was "repeatedly called bitter," Brooks remembered in a 1971 interview. "That's the glorious thing about today," Brooks claimed, counting herself among the writers of the Black Arts Movement, "we aren't concerned about what whites think of our work."[137]

If this is where Brooks could end up in 1971—unconcerned with white readers —then it was a fundamentally different place in comparison to Richard Wright and his aim decades earlier for *Native Son*. The novel was directly intended for white readers—not *for* them, exactly, but to unsettle and terrify them, "without the consolation of tears," as Wright explains in "How 'Bigger' Was Born."[138] The essay, published soon after *Native Son* and included in many subsequent editions of the novel, describes Wright's distress at finding that his first volume of short stories, *Uncle Tom's Children* (1938), made white readers "feel good."

> I found that I had written a book which even bankers' daughters could read and weep over and feel good about. I swore to myself that if I ever wrote another book, no one would weep over it; that it would be so hard and deep that they would have to face it without the consolation of tears.[139]

Wright, of course, was successful in maddening readers across the racial and political divide, all the while selling lots and lots of books. His protagonist Bigger is an assault on the most famous black man in American fiction: Harriet Beecher

Stowe's Uncle Tom, the pious slave praying to God while his white master flays him. What's more, when *Native Son* appeared, Hollywood had just struck gold with *Gone with the Wind,* in which southern culture flourishes through the happy subservience of slaves. Filled with rage and violence, Bigger Thomas was a decidedly different black man.

"The day *Native Son* appeared," critic Irving Howe claimed, "American culture was changed forever."[140] Bigger Thomas required reckoning. Middle-class blacks wished that Wright had affirmed black characters who were able to overcome their oppressive conditions—a position not so different from Langston Hughes's argument in his 1941 *Crisis* essay, "The Need for Heroes": "If the best of our writers continue to pour their talent into the tragedies of frustration and weakness," Hughes writes, "tomorrow will probably say, on the basis of available literary evidence, 'No wonder the Negroes never amounted to anything. There were no heroes among them.'"[141] Twenty-six-year-old Ralph Ellison—whom Wright befriended in New York (he was best man at Wright's first wedding)—told him with glee that the novel was also an affront to the sensibilities of Harlem: "Native Son shook the Harlem section to its foundation and some of the rot it has brought up is painful to smell." White communist leaders, according to Ellison, were also offended—horrified by Bigger's accidental murder and gruesome dismemberment of the wealthy, white character Mary Dalton: "This and other reactions on part of cp leaders," Ellison writes, "makes me question to what extent they are emancipated from bourgeois taboos."[142]

Wright's friend Nelson Algren seems to have understood that by infuriating white readers—including himself—*Native Son* was an enormous success. Recall that Algren had known Wright since the early 1930s through the John Reed Club and had worked closely with Wright on the Illinois Writers Project. After he read *Native Son,* Algren sent Wright a long letter:

What does get me is it's such a threat. I mean a personal threat. At first I felt it was just a challenge, but it's more. You've done a very, very smart thing: I don't think any white person could read it without being either frightened or angry at the end. My own reaction happened to be anger more than anything else. I mean when someone's threatened out of a clear sky, he starts getting sore. I don't mean I'm angry now. I don't see how anyone could stay angry, assuming he's got a notion of what it's all about, because, of course, you're right, sociologically and psychologically and you can't stay angry at patent truth. You *could* stay scared.

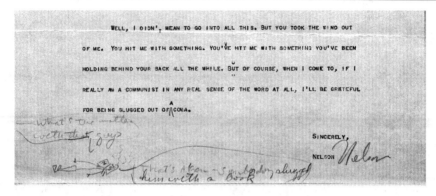

*Fig. 86. Detail of a letter from Nelson Algren to Richard Wright, March 1940. Richard Wright Papers, James Weldon Johnson Collection, Yale Collection of American Literature, Beinecke Rare Book and Manuscript Library*

Algren took "personal" offense, though it was not because the novel's characters bore resemblance to him. It was likely the novel's presentation of communism that irked Algren, particularly the character Jan's idea that race does not matter —only class does.[143] Algren knew better. Two typed pages later, Algren ends: "Well, I didn't mean to go into all this. But you took the wind out of me. You hit me with something. You've hit me with something you've been holding behind your back all the while. But of course, when I come to, if I really am a Communist in any real sense of the word at all, I'll be grateful for being slugged out of a coma."[144] At the bottom of the letter, Algren draws a stick figure of himself, flat on his back, "slugged" with a book (fig. 86).

Offending everyone, Wright became a celebrity. On a return trip to Chicago in summer 1940 to conduct research for 12 *Million Black Voices*, he was a guest of honor along with Langston Hughes at a party for Nelson Algren and Jack Conroy's *New Anvil*, which proclaimed in its spring editorial that the magazine had discovered Wright and would "bring before the public the Richard Wrights and John Steinbecks of tomorrow."[145] Wright was also feted at the American Negro Exposition, a three-month event commemorating the seventy-fifth anniversary of the end of Civil War and emancipation. (Always good for a fair, Chicago had largely excluded blacks in the 1933 Century of Progress International Exposition; the American Negro Exposition was held in response.) Through displays of art, talks, performances, and exhibitions, the American Negro Exposition was a spectacular demonstration of progress made by blacks since slavery—though the event was also plagued by financial problems, a lack of popular entertainments, and poor attendance, including virtually no whites.[146]

Wright gave an interview at the exposition and signed copies of *Native Son*: onlookers noted how comfortable he looked with his newfound fame.[147] He may also have gleaned something from the event: what the exposition overlooked was what any successful black writer had to learn about reaching a broad audience—that a fair also needed a midway. That is, racial uplift also needed the Stroll, without obscuring a history of darkness and violence by the narrative of "how far we've come."

North Dakota transplant Era Bell Thompson, who at this point was working clerical jobs by day and putting herself through Northwestern University's Medill School of Journalism by night, may have known these lessons, but she did not entirely abide by them.[148] Her 1946 autobiography, *American Daughter* —now nearly forgotten—offers a dramatic example of the racial politics of publishing and a black writer's effort to reach a wide (and also white) audience. Thompson first pitched her autobiography to win a fellowship in 1944 at the Newberry Library (which also gave Algren a fellowship in 1948). She was encouraged by Newberry librarian Stanley Pargellis, to whom she described her ideas for writing a story about her experiences in a "rollicking middle class Negro family" in North Dakota, "the Country God forgot" (fig. 87). Thompson would include "humorous incidents," involving blizzards, coyotes, "runaways, rodeos, Indian reservations." Her story was both entirely about race—its hook was the strangeness of being black in the middle of nowhere—and not about race at all. Thompson knew little about black urban life, she told Pargellis, and her move to Chicago had taken courage: "Three times I came down from the prairies to live with 'my people' and twice I returned to my plains; hurt, bewildered and a little bit afraid. I couldn't dance, couldn't even snap my fingers or sing the blues. I was 22 before I ever heard of Paul Lawrence [sic] Dunbar." In her hallmark tone of light irony—perhaps too light—Thompson writes: "It has been a lot of fun, this business of being colored."[149] One of Thompson's working titles for the book was "I Found It Fun."[150]

*American Daughter* is an odd gem of a book, a storehouse of incidents that do not entirely add up. At twelve, Thompson loses her mother and is the only female in a household that includes her father (son of a slave) and three older brothers who gradually leave her to pursue opportunities elsewhere. (One of the book's many unintentional revelations is how Thompson's childhood prepared her to navigate the all-male milieu of *Ebony*.) Often alone and always outcast, Thompson excels at journalism and sports—tying two national records at track—though she is forced to stop running, and drops out of school, after a bout of pleurisy in her second year at the University of North Dakota. Thomp-

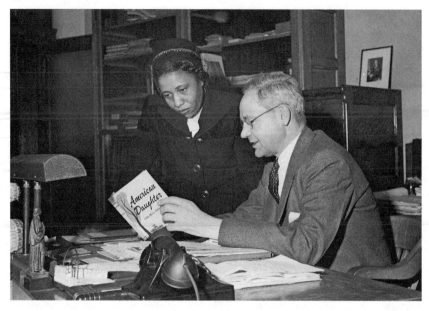

*Fig. 87. Era Bell Thompson and Stanley Pargellis at the Newberry Library, mid-1940s.*
*Courtesy Newberry Library*

son finishes her undergraduate degree at Morningside College in Sioux City, Iowa, through the support of the college's president, "Mr. Riley" in *American Daughter*, who pays Thompson's tuition and gives her a room in his family's home.

Thompson's autobiography is not just worth recuperating for literary history but also revelatory as a counterpoint to how her more famous peers represented race. Thompson treats hardship with humor, stylizing her life through a series of picaresque moments, with masterful indirection that often ends with a punch. In grammar school, for instance, Thompson's teacher asks her if she will take part in a school play about Abraham Lincoln, like other students—in blackface. "I had a vague feeling it wasn't necessary," Thompson writes. She consults her older brother, who rejects the plan:

> The next day I told Teacher I couldn't be in the play; I didn't have to tell her why. "You can have any part you want," she promised hastily, and handed me the script.
>
> The list of characters consisted of four slaves, an overseer, and the master. The master was Rudolph. I didn't like Rudolph—he was pink and

chubby and Teacher's pet. In Norwegian he called me what sounded like "stika naggie." I knew what it meant, but I couldn't prove it. So I took the part of the master. Rudolph said he'd be overseer, then, so the overseer quit. By practice time there was one white slave and one black master. Teacher excused the master and freed the slave. "If Lincoln could do it," she said, wearily, "then so can I!" [151]

If a reader laughs at the absurdity of the story, then Thompson achieves her aim. She explained in an author questionnaire for the University of Chicago Press, which published *American Daughter*: "You can't fight hate with hate, you don't hurt the ones you like. People have fought enough about this business of race. I'd like to see them laugh a little. It is pretty ridiculous, you know." [152]

With its title—a claim to national identity—Thompson's work invites comparison to *Native Son* and *Black Boy*, the latter published just one year before *American Daughter*. Though Thompson and Wright never met, she strangely remained (like Cayton) in Wright's shadow. Both published autobiographies about their travels through Africa, which were published the same week in 1954: Thompson's *Africa, Land of My Fathers* and Wright's *Black Power*. (Though very different in outlook, both books are accounts of disillusionment. [153]) Thompson played up the comparison to Wright, listing *Black Boy* and Zora Neale Hurston's *Dust Tracks on a Road* (1942) as "competitors" to her autobiography in a marketing questionnaire for the University of Chicago Press. She also explains the particular appeal of *American Daughter*: "The book shows, I hope, that there is no essential difference between black and white and that recognition of that fact, as illustrated by my own life, will go far to decrease antagonisms. I have not tried to argue or to preach a sermon, but to tell my own story, on the whole a pleasant one, as simply as possible. It is a less violent and less dramatic story than Richard Wright's, but perhaps equally authentic." [154]

Did she pull it off? Frank Marshall Davis glowingly reviewed the book for the Associated Negro Press, taking the opportunity to exalt Thompson in order to denigrate Wright, whose anger was partly "the result of his own psychosis." [155] Hurston also praised *American Daughter* and was quoted in promotional materials: "Era Bell Thompson reads like a person whom (as we say in the South) I would 'admire' to know." [156] Arna Bontemps wrote in the *New York Herald Tribune Weekly* that *American Daughter* was the "converse" of *Native Son*. "With enough daughters like Era Bell Thompson," Bontemps writes, "America could sit back and relax." [157] It was precisely this idea about how black humor (not

anger) might solve racial conflict that the University of Chicago Press boldly advertised in the *Saturday Review of Literature*. Beneath a cut-paper silhouette of a horse-drawn wagon under a lone prairie tree—the decorous style that black artist Kara Walker, fifty years later, undercuts with uncanny violence—the advertisement for *American Daughter* reads: "The heartwarming story of a Negro girl whose faith and friendliness solved for her one of America's tragic problems" (fig. 88).[158]

Ralph Ellison would have none of this. His exasperated review appeared just a few issues after the press advertisement for *American Daughter* in the same periodical, the *Saturday Review of Literature*. For a relatively unknown writer—*Invisible Man* would not appear until 1952—Ellison handles with severity the central issue of the book's audience. Ellison criticizes Thompson for her unambiguous appeal to white readers: "[Era Bell Thompson] makes an effort to be warm and ingratiating, and for those who forever caution Negroes against 'bitterness,' 'American Daughter' is made to order."

> Despite her Northern birth, her exceptional experiences, and her sharp sense of difference from other Negroes, it is surprising how much like Southern Negroes Miss Thompson has managed to be. Like some of them, we find her hating her color; she indulges in "stepchild fantasies" of transcending the Negro predicament by becoming the symbolic daughter of a white family; and her humor reminds us of the Southern Negro's "laughing-just-to-keep-from-crying" technique of survival. . . . More close to home, we are reminded that writing, too, like the ointments with which some Negroes attempt to bleach their dark skins to a "white" esthetic standard, can be a form of symbolic bleaching.[159]

Here was a woman, according to Ellison, who should know better. Her lack of exposure to southern racism—and to the depth of black culture—does not justify the false dream of being white. Her prose, for Ellison, is bleached. Uncannily, Ellison foresees Thompson's editorial role at *Ebony*, a magazine chock-full of sunny, light-skinned models (often in swimsuits). *Ebony* inspired its own trenchant critique from the Chicago School of Sociology's E. Franklin Frazier, who argued that the magazine was beholden to its advertisers, in love with status, and liable for creating a compensatory world of "make-believe," which only intensified black self-hatred.[160]

This may have been an accurate assessment of *Ebony* magazine—for which

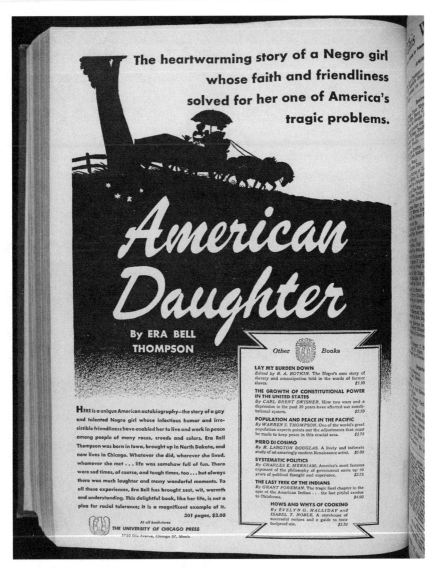

*Fig. 88. Advertisement for Era Bell Thompson,* American Daughter,
Saturday Review of Literature, *April 27, 1946*

Thompson worked for nearly forty years—but it was only partial. *Ebony*'s ability to build a large black market was an accomplishment that recent scholars have considered integral to the formation of a black national community, a set of collective interests and political possibilities.[161] *American Daughter* was written with white readers in mind, but Thompson spent the rest of her professional life

writing for black readers of *Ebony*. She helped to create the magazine's realm of imaginative longing and middlebrow leisure, which frequently offered visual complexity—recall Wayne Miller—and profiles of black personalities through which art, politics, and literature were real concerns. Thompson wrote in-depth articles about decolonization in Africa, for instance, and focused her editorials on issues of race and equality worldwide. Gwendolyn Brooks was one of Thompson's fans and closest friends: they often spoke over the phone, and their surviving notes express an intimacy found in the novelty of their shared situation, two black women making money through writing.[162] *Ebony* was hardly literature, but it had a literary bent, a celebration of culture underwritten by commerce that was distinctive to the boosterism of Chicago since the 1893 World's Fair. Indeed, the magazine as an institution itself became a source of black pride. The eleven-story building on South Michigan Avenue that housed the Johnson Publishing Company—which still exists—stands as a symbol of black accomplishment and the company's international reach. The office interiors, designed in the 1970s, were Afrocentric and avant-garde, patterned in plush fabrics of rust, gold, and red.[163] When African heads of state came to Chicago, a tour of the building was not to be missed.[164] No doubt, Era Bell Thompson found it fun.

### FAIR FABLES

If the Johnson company headquarters is a building resonant with Bronzeville's legacy, then it is also one of the few sites that remain. Like places central to Chicago's literary history—Burnham's White City, the offices of *Poetry*, the little theaters, Fanny Butcher's bookshop, Schlogl's, the Dill Pickle (the list goes on)—the infrastructure of Bronzeville as it existed in the 1930s and 1940s has all but vanished. The Savoy Ballroom and Regal Theatre—at the heart of the Stroll—were bulldozed to make room for high-rises of public housing, an expressway that dramatically erected a barrier between Bronzeville and its white neighbors to the west, and the expanding campus of the Illinois Institute of Technology (IIT), with buildings designed by Mies van der Rohe, perhaps the most famous migrant to Chicago.[165] The local neighborhood was ultimately displaced by an architectural aesthetic with transnational acclaim.

The influence of Miesian architecture on Chicago's built environment—coupled with the 1937 arrival of László Moholy-Nagy's New Bauhaus School of Design—dominated modernist innovation in Chicago through the postwar pe-

riod. Indeed, this is the modernism for which the city is most widely recognized: a Chicago School of architecture that began with the commercial architecture of John Wellborn Root, William Le Baron Jenney, and Louis Sullivan and developed again through the technical advances of the Bauhaus.[166] Powerful, visible, industry-dominated architecture has somewhat obscured the innovations of literary modernism in Chicago. What's more, in many cases Miesian architecture supplanted older infrastructure that was vital to the history of Chicago literature. If there is a lost city or a Lost Chicago—an idea romanticized by Margaret Anderson, who left Chicago in 1916, and by David Lowe's popular, beautiful book illustrating the city's many demolished buildings—then it inheres not only in Chicago's razed structures but also in its narratives.[167] That is, buildings are what visitors to Chicago often come to see, and yet it is the stories of the people who lived and worked in these buildings that have the greatest resonance. In the literature of Chicago, place survives.

It is not quite accurate, however, to invoke the power of place when describing Bronzeville, to appeal to some nostalgic idea of how the specific contours of one's geography exert a hold over memory. If writers and artists were drawn to the dense vitality of Bronzeville, then they were also responding to a fluctuating ecosystem, a nexus of people and places that was constantly changing.[168] Not everybody stayed, and little was static. Buildings were occupied and abandoned with unusual rapidity, as inhabitants were forced out or could not pay rent. Some writers were lured elsewhere, and collaborative projects like "The Negro in Illinois" were left unfinished. It is more accurate, perhaps, to describe Bronzeville as a circulation of people and ideas—in Chicago, certainly, but held together only tenuously by bricks and mortar.

Brooks understood the paradox: that place is extremely important even if place no longer exists. The dust jacket for *A Street in Bronzeville*—the design of black and red bricks—is a premonition. By the time that her 1968 volume *In the Mecca* was published—a volume marking a radical change in Brooks, though perhaps not a radical change in her poems—those Bronzeville bricks were being torn down. The city's dense interior was the new frontier. The language of civic leaders overseeing urban redevelopment on the South Side, recorded in the minutes of a board of trustees meeting, evokes the sinister aims of manifest destiny: "Now is the time to move forward and possess the land."[169] At one point, a member of the Metropolitan Housing and Planning Council suggested that a brick wall should surround the IIT campus, which would be built from the recycled materials of the homes and buildings being destroyed.[170]

This never happened, though Mies van der Rohe was seemingly complacent to how the campus colonized and then cut itself off from its surrounding troubled environment.

"In the Mecca" takes complacency to task. This title poem of the collection refers to a luxury hotel and apartment building constructed in the lead-up to the 1893 World's Fair. Built of brick and terra-cotta, the massive building held ninety-eight housing units that circled a central, skylit atrium.[171] By the 1930s, the Mecca had become a decrepit and overcrowded home for many black residents, housing more than a thousand people. (And the building was best known for inspiring the Chicago blues song "Mecca Flat Blues.") Gwendolyn Brooks knew the place because as a young woman she worked for a dubious spiritual advisor, peddling "Holy Thunderbolts" and other shams from door to door, a job that she had briefly taken out of economic desperation.[172] Demolished in 1952, the Mecca made way for a steel and glass triumph to midcentury modernism—Mies's Crown Hall, which housed the IIT School of Architecture. Brooks's subject is the lives of inhabitants displaced by Mies, though no one in the poem inspires pity. "In the Mecca" begins in perfectly meted out ambivalence:

Sit where the light corrupts your face,
Miës Van der Rohe retires from grace.
And the fair fables fall.[173]

Fair—the word resonates with meaning: the World's Fair, whiteness, fairness as in justice. If you believe in "fables" then you will also see them "fall," like the Mecca building itself. At the center of the poem is the loss of a young child, of "grace," of belief. A mother ransacks the building and suffers the indifference of her neighbors, isolated by their intricate obsessions. Something in the black community has gone awry: light through the building's atrium offers little hope; it is fractured, "corrupt."

The grim beauty of the poem seems directed at black readers, even as many whites were bound to read, at this point, everything that Brooks wrote. The poem's politics—the call for solidarity, for civic engagement beyond interior introspection—is played out through the many small stories within the poem. Ultimately it is stories of people, not the story of buildings, that kept Brooks writing about social realities in America through the lens of her ever-changing city. Certainly, Brooks is the most celebrated poet of Chicago—perhaps the only

other contender is Sandburg. In 1969, Brooks succeeded Sandburg as poet laureate of Illinois. Unlike many writers who began in Chicago, Brooks never left: a literary history that imagines Chicago only as a transitory stop does not take account of the lives of many of Chicago's literary women, especially Brooks.

Brooks was often asked why she didn't live someplace else. Did she not seek nature or solitude or an escape from the city's violence and racial conflict? Or, wouldn't she rather live in New York City? "It does not impede you as a writer in any way?" asked an Illinois historian in a 1967 interview. "It nourishes," Brooks responded. "I intend to live in Chicago for *my* forever."[174]

# Conclusion

n 1997, when Gwendolyn Brooks was seventy-nine years old, I attended a crowded poetry reading she gave in Los Angeles. Standing behind a lectern on a large stage, Brooks exuded an air of royalty, pronouncing every syllable with authoritative deliberation. I knew that Brooks was also a poet of the people. She had served as poetry consultant to the Library of Congress and she was then poet laureate of Illinois. Known for her tireless dedication to young people, especially her school visits across the country, Brooks sponsored poetry contests and dispensed awards out of her own pocket (although she did not like to act as judge). In her advocacy, Brooks shared something with Harriet Monroe, who rejected a grand theory of poetry in favor of an open door policy that led her to publish poems across a range of subjects and styles. Brooks's own poetry itself reflects a kaleidoscope of influences, from her early training in formalist verse to the jazz and spoken word poetry of the Black Arts Movement. Her work eludes every category.

To begin this book with Monroe and finish with Brooks is to underscore how Chicago modernism was created through the vision and work of women. Both Monroe and Brooks could have left Chicago—certainly, both traveled throughout the country and across the world. But I think they both realized, on some level, that everything they wished to see would happen in Chicago or would come through their city. Heterogeneity is a natural byproduct of a city that grew quickly and changed with such frequency that people did not know where Chicago was going or what it might become. Of course, the transformations of modernity were different in Chicago at the turn of the century than at midcentury: it's one thing to witness towering skyscrapers where there was once prairie and another to live in an overcrowded neighborhood and experience a freeway cutting through your community. Writers and artists both celebrated and bemoaned the explicit, often violent nature of Chicago's modernization, a city that sometimes seemed indifferent to beauty, a place of endless *becoming*.

As a site of regeneration, newness, and exchange, Chicago may be the paradigmatic expression of modernity itself.

When I heard Brooks in 1997, she chose several poems that she had written decades earlier, including the much-anthologized short poem "We Real Cool" (1959). The poem describes boys at a pool hall, "THE POOL PLAYERS. / SEVEN AT THE GOLDEN SHOVEL," the epigraph tells us. Brooks said that the boys in the poem—skipping school, staying out late, drinking gin—had no strong definition of themselves, which explained why she inhaled on the repeated "we," making the word a wisp of a sound. But she read the poem with a joy in their hedonism, their existential freedom. She was able to inhabit that "we," as if she were one of those tragic young men whose violent fate is prophesied in the bleak certainty of the poem's last two lines: "Jazz June. We / Die soon."

If Chicago in 1959 had something to say to Los Angeles at the turn of the twenty-first, then it was spoken in a language of cultural collision, of American cities whose sounds are the voices of its many people. Certainly, five years after deadly riots ignited Los Angeles, I heard Brooks's words magnified by the contemporary moment. Brooks's poem recognized a history of racial violence in America from Emmett Till to Rodney King. I felt her words resonate far and wide in a place that was neither hers nor mine. Brooks's "*my* forever"— Chicago—was as much a specific city as a set of American ideas and problems that could travel in the language of her poems. The literature of the city, then and now, circulates as a mobile medium.

From the pages of *Poetry* magazine's early years to the bravura expressions of the Chicago Black Renaissance, the modernist movement exploded the idea of a single voice and made its voices many. This literature—which traversed geographic boundaries and found a wide range of readers—still has something to tell us. Consider the working title of one of modernism's most famous poems, published in 1922, the annus mirabilis of the period: *He do the police in different voices.* This is the phrase that T. S. Eliot lifted from Charles Dickens's 1865 novel *Our Mutual Friend* and scrawled atop a manuscript draft of what would become *The Waste Land.* Though hardly the best title for an epic poem (and scrapped thanks to the editorial input of Ezra Pound), the original title nevertheless describes the poem's aesthetic features: its tumult of languages and speakers, from English aristocrats to bank clerks to bawdy bartenders—the vernaculars of a modern city. A midwesterner who fled to London, Eliot brilliantly represented and lamented this heterogeneity, which he imagined as a threat to the culture and language of England to which he tuned his own accent.

Other writers were less anxious about "different voices," especially if theirs had more in common with the clerk or bartender. The writers of Chicago contributed importantly to the voices of modernism—in ways that were uniquely responsive to the geographic middleness and middlebrow audience to whom they addressed their work. Nobody sounded quite like Gertrude Stein in Chicago, although many writers and artists in this city learned from her revolutionary use of words. An attention to audience inspired literary inventiveness in a variety of ways, as some Chicago writers aimed for accessible yet highly crafted prose; others wrote vers libre; and still others honed their realism through the practice of journalism. Whether Hemingway's distinctive use of the pronoun "you" or Sandburg's poems accompanied by his guitar, the forms that came out of Chicago were created by writers who kept a midwestern audience in mind. In a booming city that never had the illusion of a time-honored English literary tradition, the writing of Chicago adds significant depth to the diversity inherent in modernism itself. Indeed, without Chicago, no consideration of the modernist movement is complete.

Let me finish with a final story, which reveals an outsider's perception of Chicago at a moment when the city's literary community was feeling the excitement of what it was becoming. The story also illuminates Chicago's place in the middle of things, which is to say, its position apart from other modernist metropoles and yet blazing with its own sense of possibility.

On March 1, 1914, the Irish poet William Butler Yeats attended an elaborate banquet sponsored by the guarantors of *Poetry*, a magazine founded just a year and a half earlier. To Harriet Monroe's surprise, Yeats had accepted her invitation to visit Chicago as the magazine's guest of honor. Yeats stayed with Monroe in her small Gold Coast apartment in the Virginia Hotel, which she then shared with her niece Polly Root (and a star-struck Irish maid). Monroe shepherded Yeats to his six lectures around the city, where he also spoke to a gathering of influential Irish Americans and saw a performance of his play *The King's Threshold*. Yeats even went out shopping along Michigan Avenue and returned with a new wardrobe trunk, which he then worried was too small, and so Monroe taught Yeats exactly how to fold and fit his topcoat inside. Later, she helped him elude reporters on a last-minute visit to a spiritual mystic in Edgewater. Most importantly, Monroe placed copies of *Poetry* on Yeats's bedside table, strategically including an issue containing Vachel Lindsay's drum-beating

ode, "General William Booth Enters into Heaven." She suspected that Yeats, who recited his poems like songs, might find something favorable in Lindsay's practice of writing poetry to be chanted aloud.

For the banquet, the all-male Cliff Dwellers Club opened its private quarters atop Orchestra Hall to everyone on Monroe's invitation list, about 150 people. One long speakers' table and numerous round ones were layered with an array of flowers in a room full of woodwork designed in the arts and crafts style. Attending the event were many stalwarts of the city's cultural scene, including those who helped bring the Armory Show to Chicago, like the Art Institute's president of the board of trustees Charles Hutchinson and the real estate baron and arts patron Arthur Aldis, who was joined by his wife, Mary, founder of the little theater in Lake Forest. Mr. and Mrs. Joseph Medill Patterson of the *Chicago Tribune* were present, as were architects, professors, and judges. Editors and friends of *Poetry* filled the room, including Alice Corbin Henderson and her husband, the painter William Penhallow Henderson; Eunice Tietjens; Harriet Vaughn Moody; Henry Blake Fuller; Carl Sandburg and his wife, Paula (who borrowed an evening gown from Monroe); theater director Maurice Browne; actress and teacher Anna Morgan; painter Karl Anderson; poets Maxwell Bodenheim and Arthur Davison Ficke; John Alden and Rue Carpenter; and William and Lucy Calhoun (back from China). Even the fusty editors at the *Dial*, Monroe's rival, could not miss meeting Yeats, who was perhaps the only poet beloved by *all* of Chicago's little magazines—the *Dial*, *Poetry*, and the *Little Review*—the last of which was launched that very month of March. (The first issue of the *Little Review* would include a poem by Lindsay; the second would include the speech Yeats gave at this banquet.) After many toasts and complimentary remarks, during which Yeats looked abstractedly lost in his thoughts, the Irish bard finally stood up to speak.

The art and literature of Chicago, he said, should avoid the temptations of sentimentality, of moral uplift, of all that is artificial. These qualities were especially dangerous in Chicago, he told the rapt audience, "not because you are too far from England, but because you are too far from Paris." According to Yeats, metrical experiment thrived in the work of French poets, and he upheld the model of symbolist provocateur Paul Verlaine, who in 1884 famously urged poets to "prends l'éloquence et tords-lui son cou," or grab eloquence and wring its neck. Yeats understood Paris to be at the center of the literary avant-garde, but he also felt that Chicago was on the cusp of something, and he wanted its writers to stay true to what he perceived was happening here. Indeed, Yeats

had read the issues on his bedside table, and he singled out Lindsay's poetry: it was "stripped bare of ornament" and contained an "earnest simplicity." Yeats then compared the poetry scene in Chicago to his early circle of writers—the Rhymers' Club—who rebelled against high-flown, romantic rhetoric. And he encouraged the Chicago poets "to strive to become very simple, very humble." A manifesto for Chicago writers, Yeats's speech gave expression to what many in Chicago were already doing.

Lindsay's response to Yeats was just as memorable: he later recalled the evening as "the literary transformation scene of my life." He had decided to perform "The Congo," a poem that would bring him great recognition but would also ward off future readers with its blunt, appalling racism. The first stanza is titled "THEIR BASIC SAVAGERY." Shutting his eyes, swaying in his rhythm as if in a trance, Lindsay began: "Fat black bucks in a wine-barrel room, / Barrel-house kings, with feet unstable." Unleashed by his idiosyncratic reading of Joseph Conrad's African sketches and W. E. B. Du Bois's *Souls of Black Folk*, Lindsay's poem imagines the black race as unable to restrain a primitive nature in a civilized white world. What fascinated Lindsay about Africa are specious qualities that succumb to every racial stereotype: violence, rhythm, sexual power. The poem's racial ventriloquism—the refrain "Boomlay, boomlay, boomlay, BOOM"—nonetheless enthralled Lindsay's Chicago audience, most of whom felt his performance was a dramatic success.

The people in that beautiful banquet room were unable—or unwilling—to diagnose the racism in Lindsay's depiction of Africa and African Americans. Indeed, many white, English-language poets actually believed that they were combatting race prejudice by depicting the sensual, antimodern appeal of another culture. Lindsay's "Congo" shares an impulse with Sherwood Anderson's primitivism and Gertrude Stein's experiments with black vernacular. Even Harriet Monroe's more nuanced understanding of native American cultures—including the cliff dwellers of the American Southwest, after which the Chicago club was named—suffers from her misconception about the "aboriginal" roots of American verse. To locate the nascent origins of creative expression in African or Chinese or native American traditions meant that these cultures were imagined as outside of—or, worse, behind—modernity's evolving transformations. To be sure, the desire felt by many twentieth-century writers to rid language of all that was conventional, to strip away the Victorian ruffle, and to locate an essential pulse in language, brought about some of the most dazzling literary styles of the period. But the "simplicity" that Yeats advocated for Chi-

cago writers also inspired reprehensible ideas about nonwhite cultures, perhaps most perversely in "The Congo" because of Lindsay's desire to identify with the irrational, which he conceptualized as being part of a race that was fundamentally other.

As a literary site that expressed the many contradictory ideas of literary modernism—from brazen racism to racial uplift—Chicago was a crucible of creativity, a city expansive enough to contain numerous forms and modes of expression. To be sure, when modernist artists and writers acknowledged the urgent social and political problems of the *present*, then issues of race were often treated with greater nuance and power. Interracial collaborations in Chicago, often difficult but not unusual, occurred through projects sponsored by the Works Progress Administration, through leftist intellectual circles, and through the individual daring of artists and writers. When Margaret Walker deliberated with Nelson Algren over the ending of "For My People," or when Inez Stark engaged young writers at the South Side Community Art Center, they were pushing against the limits of what was possible in Chicago in order to create works of art that transcended the conditions of their making. No work of literary modernism resolved every problem it addressed, but those that still have enduring relevance are often the result of deep imagining, of challenging the ways that we think and speak, of taking language to a place beyond stereotype and convention.

Sometimes, bridging the racial, economic, and social divides in Chicago occurred through the sheer, everyday practice of reading. Fiction's great power is to allow readers to imaginatively inhabit the minds of other people. And fundamentally, this is one reason why it's important to consider how novels and poems were read, to tell a history of modernism that is also a history of literary reception. When we understand the nature of influence and overlap in Chicago, we see that a Chicago Renaissance should not be treated as double events, or two divided movements, white and black. From Theodore Dreiser's frank realism to the abstractions of the Armory Show to the political radicalism of the South Side Writers Group, the Chicago Renaissance must be understood as a continuous set of literary revolutions, for writers and readers alike.

In 1914, when Yeats and Lindsay shook up the Cliff Dwellers Club, many people that evening could look out upon the breathtaking view of Lake Michigan and also see the streets of the city below. Several people there later reflected on Chicago's sense of itself at that time as both outside of the literary avant-garde—otherwise located in New York, London, and Paris—and also part

of it. Neither center nor periphery, Chicago was a thoroughfare, a nexus of exchange, and a place where influential writers like Yeats came and went. But it was probably not Yeats who had the clearest sense of what was happening in Chicago in 1914. It was Harriet Monroe, a person who committed herself to Chicago even as she so frequently traveled beyond it. Monroe knew that greatness is made by more than one person. That evening, as Monroe remembers it, was just as exciting to her as the opening ceremonies of the World's Columbian Exposition, which gathered tens of thousands of people from across the world to the fairgrounds at Jackson Park. "This also was one of my great days," she remembers in her autobiography, "those days which come to most of us as atonement for long periods of drab disappointment or dark despair." Strikingly, Monroe's "great day" hinges on a grand gathering of people; it is not hers alone. To be part of a movement—a collective, a cohort—was for her to feel a larger sense of possibility, of new potential, of optimistic boosterism so distinctive to Chicago.

Makers of Modernism in Chicago,
from the World's Fair through Midcentury

The conditions for the growth of each writer depend too much upon the
good work of other writers. Every first-rate novel, poem, or play lifts the level of
consciousness higher.

RICHARD WRIGHT, 1937

Jane Addams (1860–1935), social worker and reformer
Mortimer Adler (1902–2001), philosopher and educator
Arthur Aldis (1861–1933), real estate developer
Mary Reynolds Aldis (1872–1949), poet and playwright
Nelson Algren (1909–1981), writer
Margaret Anderson (1886–1973), writer, feminist, and editor
Sherwood Anderson (1876–1941), writer
Arna Bontemps (1902–1973), poet, writer, and librarian
Constantin Brancusi (1876–1957), sculptor and artist
Gwendolyn Brooks (1917–2000), poet
Maurice Browne (1881–1955), actor and theater director
Clarence Joseph "C. J." Bulliet (1882–1952), art critic
Daniel Burnham (1846–1912), architect
Margaret T. Burroughs (1915–2010), artist, writer, and organizer
Fanny Butcher (1888–1987), journalist and literary critic
Lucy Monroe Calhoun (1865–1950), journalist, hostess, and photographer
Rue Carpenter (1876–1931), artist and interior designer
Willa Cather (1873–1947), writer
Horace R. Cayton Jr. (1903–1970), sociologist
Jack Conroy (1899–1990), writer, activist, and editor
Eldzier Cortor (1916–2015), painter and printmaker
Margery Currey (1877–1959), writer and feminist
Manierre Dawson (1887–1969), painter and sculptor
Floyd Dell (1887–1969), writer and editor
Theodore Dreiser (1871–1945), writer

Marcel Duchamp (1887–1968), artist
Katherine Dunham (1909–2006), anthropologist, choreographer, and dancer
Arthur Jerome Eddy (1859–1920), lawyer and arts patron
James T. Farrell (1904–1979), writer
Ernest Fenollosa (1853–1908), scholar and writer
William M. R. French (1843–1914), artist and museum director
Henry Blake Fuller (1857–1929), writer
Susan Glaspell (1876–1948), actress, writer, and playwright
Elizabeth "Bobsy" Goodspeed (1893–1979), arts patron and filmmaker
Vivian G. Harsh (1890–1960), librarian
Jane Heap (1883–1964), artist and editor
Ben Hecht (1894–1964), journalist and screenwriter
Ernest Hemingway (1899–1961), writer
Alice Corbin Henderson (1881–1949), writer and editor
Maude Hutchins (1899–1991), artist and writer
Robert Hutchins (1899–1988), educator
Katharine Kuh (1904–1994), gallery owner and curator
Berthold Laufer (1874–1934), sinologist and museum curator
Fernand Léger (1881–1955), artist
Vachel Lindsay (1879–1931), poet
Mabel Dodge Luhan (1879–1962), arts patron
Edgar Lee Masters (1868–1950), poet and writer
H. L. Mencken (1880–1956), writer and literary critic
Ludwig Mies van der Rohe (1866–1969), architect
Wayne Miller (1918–2013), photographer
Tennessee Mitchell (1874–1929), sculptor
László Moholy-Nagy (1895–1946), artist, filmmaker, and designer
Harriet Monroe (1860–1936), poet, writer, and editor
Harriet Vaughn Moody (1857–1932), writer and patron of writers
Georgia O'Keeffe (1887–1986), artist
Ruth Page (1899–1991), dancer and choreographer
Ezra Pound (1885–1972), writer
John Quinn (1870–1924), lawyer and arts patron
John Wellborn Root (1850–1891), architect
Alice Roullier (1883–1963), curator and gallery director
Carl Sandburg (1878–1967), journalist, poet, musician, and biographer
Eva Watson-Schütze (1867–1935), painter and photographer
Inez Cunningham Stark (d. 1958), poet, arts critic, teacher
Gertrude Stein (1874–1946), writer and art collector
Alfred Stieglitz (1964–1946), photographer and gallery owner
Claire Dux Swift (1885–1967), opera singer
Charles Swift (1872–1948), meatpacker
Era Bell Thompson (1905–1986), writer and editor
Eunice Tietjens (1884–1944), poet and editor

Alice B. Toklas (1877–1967), wife and writer
Mark Turbyfill (1896–1991), poet, dancer, and painter
Carl Van Vechten (1880–1964), writer and photographer
Margaret Walker (1915–1998), poet and writer
Ida B. Wells (1862–1931), journalist, feminist, and activist
James Abbott McNeill Whistler (1834–1903), artist
Thornton Wilder (1897–1975), writer and playwright
Frank Lloyd Wright (1867–1959), architect
Richard Wright (1908–1960), writer

INTRODUCTION

1.  Dreiser, *Sister Carrie*, 1. Henry Blake Fuller's earlier novel *The Cliff-Dwellers* (1893) is also set in Chicago.

2.  Wilkerson, *Warmth of Other Suns*, 523.

3.  Wright, *Black Boy*, 249.

4.  Emerson, "Self-Reliance," 144.

5.  Carl Smith, *Plan of Chicago*, 4, aptly describes Chicago's hyperbolic boosterism as a local form of manifest destiny.

6.  Monroe, *Poet's Life*, 10, describes Chicago during her childhood as "the greatest game market in the world."

7.  Bontemps and Conroy, *They Seek a City*, 1.

8.  The Galena and Chicago Union dubbed its first "iron horse" *The Pioneer*, which was followed by the extensive tracks of the Illinois Central, running north and south through the state and later providing a route north for millions during the Great Migration. Several large carriers—the Chicago, Burlington and Quincy, the Chicago, Rock Island and Pacific, and the Michigan Southern—laid track to the west and east. See H. Roger Grant, "Transportation," *Encyclopedia of Chicago*, http://www.encyclopedia.chicagohistory.org/pages/1269.html.

9.  *Chicago Tribune*, October 11, 1871, 2. See also Smith, *Urban Disorder*, 48.

10. A protean subject, the 1893 World's Columbian Exposition is a source of immense scholarship and also, of course, dramatic story-telling. Following the publication of Alan Trachtenberg's *Incorporation of America*, the Chicago World's Fair took on a new life in critical scholarship. Eric Larson brought further attention to the fair in his 2003 novelistic history, *Devil in the White City*.

11. White, *Tastemaker*, 33.

12. Adams, *Education*, 320.

13. "Tastemaker" is Edward White's term for Van Vechten.

14. The now classic account of Chicago's growth, William Cronon's *Nature's Metropolis* begins with the fur trade and culminates with the fair. *Nature's Metropolis* illuminates how Chicago transformed commodities into capital and has provided me with the larger metaphor of Chicago as a threshold and a nexus. For a comparative study of the boomtowns of the American West and the British West, see Belich, *Replenishing the Earth*.

15. This statistic comes from Smith, *Chicago and the American Literary Imagination*, 154.

16. Richard Wright, "Introduction," in Drake and Cayton, *Black Metropolis*, xvii.

17. Wright, "Introduction," xviii.

18. On Chicago as the exemplary modern metropolis, see Park, Burgess, and McKenzie, *The City*. Other examples from the Chicago School include Wirth, *Ghetto*; Zorbaugh, *Gold Coast and Slum*; Znaniecki and Thomas, *Polish Peasant*; and Drake and Cayton, *Black Metropolis*.

19. Bakhtin, *Dialogic Imagination*, 32. Many critical arguments engage this idea about the kind of knowledge that novels and poems impart. Most recently in *The Man Who Invented Fiction* (2016), a provocative literary biography of Cervantes, William Egginton argues for the novel's ability to expand the moral imagination by allowing a reader to hold competing points of view.

20. Dell wrote a series of columns for the *Friday Literary Review* with the title "Chicago in Fiction," each of which focused on one writer. This piece on Frank Norris, however, appeared in one of two pieces that Dell wrote for the New York monthly periodical the *Bookman*. See "Chicago in Fiction: In Two Parts—Part I," *Bookman* 38 (November 1913): 270–77.

21. Dell, "Chicago in Fiction," 275.

22. This phrase appears in Wright's 1937 manifesto, "Blueprint for Negro Writing," 52; the essay is more fully discussed in chapter 5.

23. Dreiser did not initially intend chapter titles for *Sister Carrie*. See Pizer, *New Essays on "Sister Carrie*," on Dreiser's process of revising the novel for Doubleday, Page in order to tone down the novel's frank treatment of sex.

24. Dreiser, *Sister Carrie*, 22.

25. Walter Benn Michaels's key reading of *Sister Carrie* argues that the "power of the novel" comes not from its critique of capitalism but from its "unabashed and extraordinary literal acceptance of the economy that produced those conditions." See Michaels, "*Sister Carrie*'s Popular Economy," *Critical Inquiry* 7, no. 2 (1980): 373–90, which became the first chapter of *The Gold Standard and the Logic of Capitalism* (1987).

26. Cather, *Song of the Lark*, 103.

27. Dell, *Moon-Calf*, 394.

28. Francis Fisher Browne Papers, box 2, folder 106, Newberry Library.

29. *Modernism* is a term with an extensive critical literature. As Michael Levenson recognized years ago in *Genealogy of Modernism*, "vague terms still signify." My understanding of the term comes closest to David Harvey's definitions in *The Condition of Postmodernity*: *modernization*—a process by which mechanization, industrial capitalism, and urbanization enter the realm of everyday life; *modernity*—the condition by which that process is complete; and *modernism*—the response of modern artists and writers to the process of modernization and the condition of modernity. The capaciousness of these definitions does justice to the broadening nature of the new modernist studies. For instance, see Paul Saint-Amour on the "weak theory" of modernism and the "strong field" of modernist studies. See also

Friedman, "Definitional Excursions"; Berman, *All That Is Solid*; Felski, *Gender of Modernity*; Lewis, *Cambridge Introduction to Modernism*; and Nicholls, *Modernisms*.

30. Scholars have more recently turned to global manifestations of modernism in locations far beyond these European and American centers. On global modernisms, see for instance Apparudai, *Modernity at Large*; Brooker and Thacker, *Geographies of Modernism*; Doyle and Winkiel, *Geomodernisms*; and Ramazani, *Transnational Poetics*.

31. Woolf, "Mr. Bennett and Mrs. Brown," 96.

32. Fuller, *With the Procession*, 203.

33. More than thirty years ago, literary historian Carl Smith offered a comprehensive and compelling assessment of the work of these writers in *Chicago and the American Literary Imagination, 1880–1920*. For Smith, what animates the literature of this period is Chicago's materialistic hunger, which is often depicted as inimical to the artist and is embodied in three prevailing images: the railroad, the skyscraper, and the stockyards. See also Timothy B. Spears's persuasive analysis of the city's cultural boosterism and aspirational aims in *Chicago Dreaming*. Other relevant studies include Duffey, *Chicago Renaissance in American Letters*; Kramer, *Chicago Renaissance*; and Duncan, *Rise of Chicago*.

34. For critical literature on the Chicago Black Renaissance, see chap. 5, n. 29. Much of the archival material related to the Chicago Black Renaissance has only recently been cataloged and made accessible. See, in particular, *Mapping the Stacks*, http://mts.lib.uchicago.edu.

35. For studies that claim Langston Hughes as a writer of the Chicago Black Renaissance, see Bone and Courage, *Muse in Bronzeville*; Hine and McCluskey, *Black Chicago Renaissance*; and Hricko, *Genesis of the Chicago Renaissance*.

36. Few studies connect Chicago's first literary renaissance with its second. Hricko's *Genesis of the Chicago Renaissance* tracks the literary naturalism of these four writers and examines the shared influences and relationships among them. Woolley's *American Voices of the Chicago Renaissance* focuses on the work of women and minority writers in Chicago from 1900 to 1930. Dyja's *Third Coast* begins in the late 1930s and offers a vivid cultural history of Chicago that connects Bronzeville to the city's larger community of artists, writers, and architects.

37. The relationship between Stein and Wright and other significant instances of cross-racial collaboration are treated more fully in chapters 4 and 5.

38. See Schulman, "'White City' and 'Black Metropolis.'"

39. Katherine Dunham to Mark Turbyfill, December 3, 1974, Ann Barzel Dance Research Collection, series 1, box 154, Newberry Library.

40. On the establishment of Chicago's early cultural institutions, see Horowitz, *Culture and the City*. On the creation of the Art Institute of Chicago, see Hilliard, "Prime Mover."

41. Horowitz, *Culture and the City*, 75, makes this point in her analysis of Hutchinson's 1888 address, "Art: Its Influence and Excellence in Modern Times."

42. Bone and Courage, *Muse in Bronzeville*, 1.

43. Adam Green, *Selling the Race*, 24, argues that the marketplace played a "cata-

lyzing, rather than diluting or compromising role" in the development of arts in Bronzeville—especially in regard to music.

44. Grossman, *Land of Hope*, 130.
45. Wright, "How 'Bigger' Was Born," 874.
46. This letter from "Mrs. G. E. Bowling Jr. of Chicago" was printed in the January 1952 issue of *Ebony*, following Wright's controversial essay "Shame of Chicago," featured in the December 1951 issue.
47. "Backstage," *Ebony* 1 (November 1945).
48. "Black Boy in Brooklyn," *Ebony* 1 (November 1945), 26–27.
49. Brent, *Seven Stairs*, 209.
50. Mencken, "Literary Capital," 35.
51. Mencken, "Literary Capital," 36–37.
52. Williams, "Sandburg's Complete Poems," 346.
53. Sandburg's populist legacy is slam poetry, which originated in Chicago in the 1980s with poet Marc Smith, who credits Sandburg as an inspiration.
54. Anderson, *Mid-American Chants*, 16–17.
55. Wright, *Black Boy*, 329.
56. This reference is to W. E. B. Du Bois's 1903 essay "The Talented Tenth."
57. Wright, "Blueprint for Negro Writing," 52.
58. "Naturalism" is another capacious term for much of Chicago's well-known fiction, which has been described as realism's "grungier sibling" in the introduction to Jennifer Fleissner's marvelous study *Women, Compulsion, Modernity*.
59. Brooks attached this assessment of Algren to a letter he wrote to her on November 7, 1958. Gwendolyn Brooks Papers, Rare Book and Manuscript Library, University of Illinois, Urbana-Champaign.
60. Fanny Butcher, "Swift, Sharp Prose by a Poet," *Chicago Daily Tribune*, October 4, 1953, I11.
61. Nelson Algren to Richard Wright, March 12, 1940, Richard Wright Papers, box 93, folder 1167, James Weldon Johnson Collection, Yale Collection of American Literature, Beinecke Rare Book and Manuscript Library.
62. Algren, *Chicago*, 23.
63. Algren to Wright, undated, Richard Wright Papers, box 93, folder 1167, James Weldon Johnson Collection, Yale Collection of American Literature, Beinecke Rare Book and Manuscript Library.
64. Hemingway, *Moveable Feast*, 12.
65. Drew, *Nelson Algren*, 210.
66. In 1920, the Philadelphia *Record* accused Monroe of publishing more men than women. But when she looked up the numbers, she found that from April 1919 to March 1920 she had published sixty-four men and forty-one women. See Olson, "100 Years of *Poetry*," http://www.poetryfoundation.org/article/244666.
67. The quotation from Whitman appeared on *Poetry* until 1950, when T. S. Eliot told editor Karl Shapiro to drop it.
68. Joyce Kilmer, "Trees," *Poetry* (August 1913): 160.
69. Brooks to Elizabeth Lawrence, March 12, 1945, Selected Records of Harper and

Brothers, box 5, folder 27, Department of Rare Books and Special Collections, Princeton University Library.

70. Wright to Edward Aswell, September 18, 1944, Selected Records of Harper and Brothers, Manuscripts Division, Department of Rare Books and Special Collections, Princeton University Library.

71. Lawrence to Genevieve Taggard, June 8, 1948, Selected Records of Harper and Brothers, Manuscripts Division, Department of Rare Books and Special Collections, Princeton University Library.

72. J. Saunders Redding to Lawrence, August 10, 1949, Selected Records of Harper and Brothers, Manuscripts Division, Department of Rare Books and Special Collections, Princeton University Library.

73. Langston Hughes included the comments of his secretary Nate White regarding the galleys of *Annie Allen* in Hughes to Brooks, May 26, 1949, Gwendolyn Brooks Papers, Rare Book and Manuscript Library, University of Illinois, Urbana-Champaign.

74. The first epigraph ran from October 1917 to April 1919; the second ran from June 1917 to the January–March 1921 issue. See Alan Golding's essay in *The Oxford Critical and Cultural History of Modernist Magazines*.

75. Anderson, *My Thirty Years' War*, 111.

76. Anderson, *My Thirty Years' War*, 28.

77. Turbyfill recounts his meeting with Margaret Anderson in his unpublished autobiography, contained in the Mark Turbyfill Papers, Newberry Library.

78. Anderson, *My Thirty Years' War*, 91.

79. Margaret Anderson, "Announcement," *Little Review* (March 1914): 2.

80. See Mark Morrisson's persuasive argument about how the *Little Review* "fashioned modernism as a youth movement" in *Public Face of Modernism*.

81. Anderson, *My Thirty Years War*, 231.

82. "Gertrude Stein then and always liked Jane Heap immensely, Margaret Anderson interested her much less," Stein writes in *Autobiography of Alice B. Toklas*, 238.

83. Anderson recounts the courtroom trial in *My Thirty Years' War*, 219–22. The "unnamed lady" is still unidentified.

84. See Stein's "What Are Master-Pieces and Why Are There So Few of Them?" which she wrote in 1935 and delivered as a lecture at Oxford and Cambridge in early 1936.

85. Woolf, *Room of One's Own*, 65. Bonnie Kime Scott quotes Woolf in the epigraph to the chapter "Midwives of Modernism" in *Refiguring Modernism*.

86. Anderson, *My Thirty Years' War*, 42.

87. Frank Lloyd Wright delivered "The Art and Craft of the Machine" at Hull-House in 1901; Yeats visited Hull-House during a lecture tour in January 1904; Harriet Monroe describes her experience at Hull-House in *Poet's Life*, 187, 193.

88. Stein had dinner at Hull-House on March 2, 1935, accompanied by University of Chicago English professor Robert Morss Lovett. See William Rice, "Gertrude Stein's American Lecture Tour," in Burns and Dydo, *Letters of Stein and Wilder*.

89. The fullest treatment of Kuh and her influence in Chicago—to which my account is indebted—is Rossen and Moser, "Primer for Seeing."

90. On Kuh's gallery and the "Sanity in Art" movement, see Berman, "Katharine Kuh Gallery."

91. Quoted in Rossen and Moser, "Primer for Seeing," 20.

92. Harriet Monroe, "Cubist Art a Protest against Narrow Conservatism," *Chicago Daily Tribune*, April 6, 1913.

93. Robert Bruegmann, "Myth of the Chicago School," explains the "myth" of the Chicago School of Architecture as it was advanced by European—especially Marxist—writers, who saw Chicagoans primarily as engineers creating utilitarian works devoid of conscious art—the "inevitable result of a laissez-faire capitalist system that left developers free to extract every possible square inch of land from the site at the least possible cost."

94. Dyja, *Third Coast*, draws a connection between the glass and steel architecture of Mies van der Rohe and the aesthetic of corporate America.

95. *Poetry* 7, no. 5 (1916): 249.

96. Louis Sullivan to Harriet Monroe, April 5, 1905, Harriet Monroe Papers, box 2, folder 9, Special Collections Research Center, University of Chicago Library.

97. The influence of Phoenix Hall on Wright's aesthetic is discussed in Meech, *Wright and Art of Japan*, 30–33.

98. Harriet Monroe, "Do Greek or Gothic Buildings Express American Ideals?" *Chicago Daily Tribune*, July 13, 1913.

99. On Chicago's bookstores—particularly Fanny Butcher's—see Hilliard, "'Lady Midwest.'"

100. See Best, *Passionately Human*.

101. Dill Pickle Club Records, Newberry Library.

102. Sherwood Anderson's piece on the Dill Pickle originally appeared in the Wednesday Book Page of the *Chicago Daily News*, June 18, 1919, and is reprinted in Rosemont, *Rise and Fall of the Dil Pickle*, 47–48.

103. Together, the Nefs cultivated friendships with painter Marc Chagall, composer Arnold Schoenberg, French musician Nadia Boulanger, pianist Artur Schnabel, and T. S. Eliot, who stayed for six weeks in Chicago during a late-career re-engagement with the Midwest of his childhood. On Harriet Moody and Gertrude Abercrombie, see Hast and Schultz, *Women Building Chicago*, 602–4, 12–14.

104. Elinor Nef worked on a reverent, extended essay about Woolf's writing that was eventually published after Nef's death; see Nef, *Letters and Notes*, vol. 1. On the history of collecting Bloomsbury art and literature in America, see Reed, "Only Collect." Rishona Zimring has suggested that the Arts Club of Chicago, by the 1930s, helped to establish the reputation of Bloomsbury and twentieth-century modernist British artists. See http://publications.newberry.org/makingmodernism/exhibits/show/exhibit/bell.

105. Elinor Castle Nef Papers, box 32, folder 11, Special Collections Research Center, University of Chicago Library.

106. Vanessa Bell's work was on display at the Renaissance Society in a 1954 exhibit of prints and drawings from the collection of Elinor and John U. Nef. Nef's descrip-

tion of Bell's work—including the paintings and sketches owned by the Nefs—can be found in Nef, *In Search of the American Tradition*, 136–37, 200–201.

107. Woolf, *Letters*, 144.
108. F. Scott Fitzgerald, *The Great Gatsby* (New York: Scribner, 1925), 212.
109. Hecht, *Charlie*, 69.
110. Robert Cozzolino makes this point about critical "indifference" in *Art in Chicago*, 9.
111. Anderson, *My Thirty Years' War*, 150.

## INTERLUDE: CHICAGO, OCTOBER 21, 1892

From the immense scholarship on the 1893 World's Fair, there are only a few reports of Monroe's contribution to the dedicatory ceremonies. The fullest account is her own in *A Poet's Life*. Lucy Monroe Calhoun's sentimental memoir also recounts the opening ceremonies; see Calhoun, "World's Fair." See also McKinley, "Music for the Dedication Ceremonies," and Massa, "'Columbian Ode.'" The phrase "nervous prostration" and Monroe's description of Columbia moving "through vast virgin spaces towards the splendors and triumphs of modern civilization and an era of universal peace" are from *Poet's Life*, 118, 121. The committee's suggestion to Monroe about editing the *Ode* can be found in the Harriet Monroe Papers, box 15, folder 1, Special Collections Research Center, University of Chicago Library. Quotations from the poem are taken from Monroe, *Columbian Ode*, 7. For the quotation from Henry Adams, see *Education*, 320. On Dreiser at the fair, see Lingeman, *Dreiser*, 121, 274.

## CHAPTER 1. PORKPACKERS AND POETRY

1. Allen Johnson, ed., *Dictionary of American Biography*, vol. 3 (New York, 1943), 420.
2. Ellen Williams's *Harriet Monroe and the Poetry Renaissance* (1977) still offers the most detailed history of *Poetry*'s early years, although it has been criticized for obscuring Monroe's enormous influence on literary modernism. John Timberman Newcomb, Jayne Marek, and Ann Massa have challenged the gender politics behind past critiques of Monroe and argued for Monroe's centrality to modernist literature. See also Helen Carr, "*Poetry: A Magazine of Verse*," and David Ben-Merre's fluent discussion of the poets and the controversies of *Poetry* magazine's early years in "'There Must Be Great Audiences Too'—*Poetry: A Magazine of Verse*," *Modernist Journals Project*, http://dl.lib.brown.edu/mjp/render .php?view=mjp_object&id=mjp.2005.00.110.
3. From 1912 to 1922, the magazine's circulation ranged from 1,030 to 2,706 readers but generally remained under 2,000. See Williams, *Harriet Monroe*, table 3.
4. Monroe, *Poet's Life*, 131.
5. Monroe, *Poet's Life*, 230.
6. Pound and Litz, *Letters*, 264.
7. For Monroe's itinerary, see *Poet's Life*, 222–29.

8. See Monroe, *Poet's Life*, 223 and the text of the dust jacket from the first edition of Pound's *Exultations* (1909).

9. Pound, *Selected Letters*, 10.

10. See Hugh Kenner's monograph of this title. Helen Carr's more recent *Verse Revolutionaries*—also biographically driven—sustains Pound's centrality to the modernist movement.

11. Pound altered several sentences and added footnotes to the passages in which Monroe first describes him in her autobiography. Harriet Monroe Papers, box 7, folder 6, Special Collections Research Center, University of Chicago Library.

12. Turner first read his essay at the meeting of the American Historical Association in Chicago, July 12, 1893. See the last paragraph of his essay for a powerful articulation of American character.

13. Parisi and Young, *Dear Editor*, 174–75.

14. Monroe, "Open Door," 64.

15. Lucy Calhoun to Harriet Monroe, February 26, 1912, Harriet Monroe Papers, box 1, folder 3, Special Collections Research Center, University of Chicago Library.

16. Elinor Pearlstein, "Color, Life, and Moment," provides a singular, vibrant account of Lucy and William Calhoun's life and the political and cultural currents in which they were immersed. For details about William Calhoun's employment, see in particular Pearlstein's note 10.

17. Beginning in March 1893, Lucy Monroe's "Chicago Letter" appeared regularly for 125 weeks. Nine more columns were published after September 1895. See Bennett, *American Women*, 120.

18. Monroe, *Poet's Life*, 234.

19. Lucy Calhoun was a frequent contributor to *Asia Magazine*, founded in 1917 with help from the business executive and diplomat Willard Straight, with whom William Calhoun worked while in Peking. The Minnesota Museum of American Art holds a collection of 1,410 photographic negatives taken by Lucy Calhoun. A 1983 exhibit, "Peking, 1910–1912: A Photographic Diary by Lucy Monroe Calhoun," displayed 83 photographs made from these negatives. Duke University Library is also processing the Lucy Monroe Calhoun Family Photographs and Papers, some of which has been digitized.

20. Stevens, *Letters*, 229.

21. For a description of Lucy Calhoun's home, see Gilbreath, "Ware the Pitcher-Plant!"

22. Henry Blake Fuller Papers, box 4, folder 90, Newberry Library.

23. Monroe, *John Wellborn Root*.

24. For a discussion of the political forces at work during the years 1890–1912, see Spence, *Search for Modern China*, chaps. 10, 11.

25. Calhoun to Monroe, February 26, 1912, Harriet Monroe Papers, box 1, folder 3, Special Collections Research Center, University of Chicago Library.

26. Monroe, *Poet's Life*, 234.

27. Details about Freer and Duan Fang were provided to me by Elinor Pearlstein, associate curator of Chinese art, Art Institute of Chicago.

28. Charles Lang Freer to Frank J. Hecker, July 17, 1902, Freer Gallery of Art.

29. Calhoun to Dora Louise Root, February 18, 1913, Lucy Monroe Calhoun Papers, box 1, folder 1, Newberry Library.

30. Details about this painting were provided to me by Elinor Pearlstein.

31. For a discussion of Laufer's relationship to the Field Museum, see Bronson, "Berthold Laufer."

32. Bronson, "Berthold Laufer," 124, 126.

33. Harriet Monroe, "Wonderful Chinese Art Exhibit in Field Museum," *Chicago Daily Tribune*, March 26, 1911; "Field Museum to Have Collection of Old Chinese Pottery," *Chicago Daily Tribune*, May 25, 1913.

34. Bronson, "Berthold Laufer," 121.

35. Pearlstein, "Asian Art," 109–11.

36. For further details about Wen Yiduo, see Hsu, *Life and Poetry of Wen Yiduo*.

37. Shaughnessy, "Afterword," in *China*, 230–38.

38. Harriet Monroe, "Calamity Threatens World of Art in Present Revolution in China," *Chicago Daily Tribune*, March 24, 1912.

39. Pearlstein, "Early Chicago," 7–42.

40. Harriet Monroe, "Calamity Threatens World of Art in Present Revolution in China," *Chicago Daily Tribune*, March 24, 1912.

41. Monroe, *Poet's Life*, 242.

42. Monroe, *Poet's Life*, 420.

43. Monroe, *Poet's Life*, 425–26.

44. Hemingway, *Farewell to Arms*, 184.

45. Pound, "Hugh Selwyn Mauberly," in *Poems*, 552, 549.

46. Fenollosa and Pound, *Chinese Written Character*, 41.

47. Pound, *Selected Poems*, 39. For Pound's intellectual exchanges with Chinese scholars and poets, see Zhaoming Qian's edition of letters, *Ezra Pound's Chinese Friends*. The vast scholarship on Pound's relationship to China—including Qian's excellent volume—overlooks Monroe's role as editor in mediating an East-West connection.

48. Whistler's *Artist in His Studio* (1865–66) is part of the collection at the Art Institute of Chicago.

49. Pound, *Gaudier-Brzeska*, 100–103.

50. Pound, "A Few Don'ts," 200.

51. Pound, *Lustra*, 45. For the 1914 version with a comma after the word "petals," see Pound, "Vorticism," *Fortnightly Review*, September 1, 1914, 467.

52. Pound's letters to the Indiana-born book designer and typographer Bruce Rogers—whom T. S. Eliot told Pound was "the best now done in America"—illuminate Pound's dislike of typewriting and his preference for white space and wide margins. Bruce Rogers Papers, box 2, folder 129, Newberry Library.

53. See Saussey, "Fenollosa Compounded: A Discrimination," in Fenollosa and Pound, *Chinese Written Character*, 9–10.

54. Fenollosa and Pound, *Chinese Written Character*, 55.

55. Williams, *Harriet Monroe*, 43.

56. Monroe, "Widow Publishes Fenollosa Art Work," *Chicago Daily Tribune*, December 1, 1912.

57. Monroe, "Widow Publishes Fenollosa Art Work."
58. China Diary (3 vols.), Harriet Monroe Papers, box 4, folder 8, Special Collections Research Center, University of Chicago Library.
59. Monroe to Howard Elting, February 24, 1914, *Poetry* Magazine Records, box 44, folder 22, Special Collections Research Center, University of Chicago Library.
60. Monroe, *Poet's Life*, 245.
61. Tietjens, *World at My Shoulder*, 66.
62. Anderson, *My Thirty Years' War*, 44.
63. Monroe, *Poet's Life*, 144.
64. For Monroe's description of her European grand tour, see *Poet's Life*, 145–62. See Robin Schulze for a deft treatment of Monroe's relationship to the American West in context of her appreciation for European art.
65. Monroe, *Poet's Life*, 55.
66. Monroe, *Poet's Life*, 168.
67. Monroe, "The Grand Cañon of the Colorado," *Atlantic Monthly* 84 (1899): 819.
68. Monroe, "Grand Cañon of the Colorado," 820.
69. Monroe, "Arizona," *Atlantic Monthly* 89 (1902): 788.
70. Monroe, "The Great Renewal," *Poetry* 12 (1918): 323.
71. See Hutchinson, *Indian Craze*, 101–3, and also her discussion of Arthur Wesley Dow, a supporter of the arts and crafts movement, a former assistant to Ernest Fenollosa, and the teacher of Georgia O'Keeffe and Max Weber.
72. Hutchinson's *Indian Craze* relates the early twentieth-century widespread passion for collecting native American art to modernist aesthetic ideas.
73. See Ralph Fletcher Seymour's autobiography, *Some Went This Way* (1945), and Henry Regnery, *The Cliff Dwellers* (1990).
74. Alice Corbin Henderson, "The Folk Poetry of These States," *Poetry* 16, no. 5 (1920): 269.
75. See Babcock, "New Mexican Rebecca," 406.
76. Monroe, *Poet's Life*, 170.
77. See Zega for an analysis of how the Atchison, Topeka and Santa Fe Railway shaped popular perception of the Southwest. Particularly striking is how the company employed artists and writers—many from Chicago—to depict native Americans.
78. Cronon, *Nature's Metropolis*.
79. Fletcher, *Life*, 190.
80. Williams, *Harriet Monroe*, 16–17.
81. Pound, *Selected Letters*, 233.
82. Monroe, *Poet's Life*, 291.
83. Archival Biographical File on Gustavus Franklin Swift, 1839–1903, Special Collections Research Center, University of Chicago Library.
84. *Poetry* Magazine Records, box 45, folder 1, Special Collections Research Center, University of Chicago Library.
85. Sinclair, *Autobiography*, 126.
86. *Poetry* Magazine Records, box 40, folder 25, Special Collections Research Center, University of Chicago Library.

87. *Poetry* Magazine Records, box 39, folder 3, Special Collections Research Center, University of Chicago Library.

88. Tietjens, *World at My Shoulder*, 39.

89. "New Lamps for Old," *Dial*, March 16, 1914, 231.

90. Fanny Butcher, "Friends Salute Beloved Poet on 85th Birthday," *Chicago Daily Tribune*, January 6, 1963.

91. *Poetry* Magazine Records, box 45, folder 5, Special Collections Research Center, University of Chicago Library.

92. Archival Biographical File on Charles H. Swift, Special Collections Research Center, University of Chicago Library.

93. Elizabeth Fuller Chapman Papers and Films, box 1, folder 15, Yale Collection of American Literature, Beinecke Rare Book and Manuscript Library.

## INTERLUDE: OHIO AND CHICAGO, 1912

My account of Anderson's breakdown is largely taken from chapter 3 in Kim Townsend's *Sherwood Anderson* (1987), as well as Anderson's own account in *Letters to Bab* (1985). I quote from the Elyria documents—Anderson's letter to his wife and his notes written while in the hospital—which are contained in the Sherwood Anderson Papers, Newberry Library. For Floyd Dell's praise of Anderson's writing, see *Masses* 9 (November 1916): 17. The phrase "little children of the arts" is from Anderson, *Memoirs: Critical Edition*, 344. For Anderson's comment on the "painter's craft," see Anderson, *Story Teller's Story*, 252–53. For "Mid-American Songs," see *Poetry* (September 1917): 281. See also Anderson's introduction to *Mid-American Chants* (1918).

## CHAPTER 2. STINK OF CHICAGO

1. Martinez, "Mixed Reception for Modernism," 54.

2. Anderson wrote and rewrote his memoirs over many years. Anderson's description of the Armory Show appears in the edition of his memoirs published soon after he died. See *Sherwood Anderson's Memoirs* (1942), 234. Anderson would have read *Tender Buttons* after the Armory Show—it was published in 1914. But in this memoir, he conjoins his experience of reading Stein's early work with his experience of the show.

3. Harriet Monroe, "Art Show Opens to Freaks," *Chicago Daily Tribune*, February 17, 1913; "New York Has at Last Achieved a Cosmopolitan Modern Exhibit," *Chicago Daily Tribune*, February 23, 1913. I thank Mark Pohlad for illuminating the excellence of Monroe's art criticism.

4. "Moderns Here on Exhibition Called Art Desecration," *Chicago Examiner*, April 1, 1913, cited in Brown, *Story of the Armory Show*, 174.

5. "Cubists Depart; Students Joyful," *Chicago Daily Tribune*, April 17, 1913.

6. The typescript of "The Portrait of Murray Swift" can be found in the Floyd Dell

Papers, box 22, folder 683, Newberry Library. It has also been digitized: www
.publications.newberry.org/makingmodernism.

7. Quoted in Platt, *"Little Review,"* 142.

8. Floyd Dell Papers, box 10, folder 364, Newberry Library.

9. Bluhm, *Manierre Dawson*, 67.

10. For the story of Dawson's contribution to the Armory Show in Chicago, see
Bluhm, *Manierre Dawson*, 86.

11. Manierre Dawson Journal, 1908–1922, Archives of American Art, quoted in Mar-
tinez, "Mixed Reception for Modernism," 51.

12. On the Boston show, see Troyen, "'Unwept, Unhonored, and Unsung.'"

13. Curator of decorative arts at the Art Institute, Bessie Bennett refers to "our freak
exhibit" in a letter to William French, April 10, 1913, Institutional Records, Art
Institute of Chicago. "Freak" was commonly used in conjunction with the Armory
Show: even Harriet Monroe uses the term in one of her reviews, "Art Show Opens
to Freaks," *Chicago Daily Tribune*, February 17, 1913.

14. My account of the Armory Show draws on Milton Brown's now classic study *The
Story of the Armory Show* (1988), though Brown does not treat Chicago with much
detail or sympathy. Martinez provides a valuable examination of the Armory
Show's Chicago incarnation in "Mixed Reception for Modernism." See also
Kushner and Orcutt's *Armory Show at 100*, a significant and expansive study of
the Armory Show's organizers, artists, and legacy, which includes Barter, "Great
Confusion."

15. Quoted in Martinez, "Mixed Reception for Modernism," 57.

16. Quoted in Martinez, "Mixed Reception for Modernism," 57.

17. William French, "Chicago's Place in Art," *Chicago Daily Tribune*, October 10,
1904.

18. For the rise and fall of Taft's canonical status, see Greenhouse, "Chicago and the
Canon," 10–16.

19. Obituary, "William M. R. French, Director of the Art Institute of Chicago,
1879–1914," *Bulletin of the Art Institute of Chicago* 8, no. 1 (1914): 4.

20. See Schulman, "'White City' and 'Black Metropolis.'" Schulman also generously
shared with me his dissertation on African American students at the School of the
Art Institute. On Hutchinson's efforts, see McCarthy, *Noblesse Oblige*; Horowitz,
*Culture and the City*; and Miller, *City of the Century*.

21. Charles Dawson's 536-page unpublished memoir, "Touching the Fringes of
Greatness," was written in the early 1960s and is owned by the DuSable Museum
of African American History. It is also available on microfilm at the Archives of
American Art, Washington, DC.

22. French to Mrs. Herbert Adams, March 19, 1913, Institutional Records, Art Institute
of Chicago.

23. Little remains of Arthur Aldis's personal papers. In Special Collections at the Uni-
versity of Illinois Chicago, a limited record remains of his financial contributions
to Hull House, the Chicago Urban League, the NAACP, and other organizations.

24. Martinez, "Mixed Reception for Modernism," 36.

25. Kimberly Orcutt, "Arthur B. Davies—Hero or Villain?" in Kushner and Orcutt, *Armory Show at 100*, 32.
26. Many of Kuhn's letters to his wife relating to the Armory Show have been digitized: http://armoryshow.si.edu.
27. Martinez, "Mixed Reception for Modernism," 36.
28. Sherwood Anderson mentions his wife's friendship with Mary Aldis in Anderson to Ferdinand Schevill, box 11, folder 532, September 22, 1923, Sherwood Anderson Papers, Newberry Library.
29. Mary Aldis's lovers may have included the architect Howard van Doren Shaw and Maurice Browne, founder of the Little Theatre in the Fine Arts Building. See Barter, "'Great Confusion,'" n. 15. See also Browne's autobiography, *Too Late to Lament*.
30. Newton Carpenter to Charles Hutchinson, March 25, 1913, quoted in Martinez, "Mixed Reception for Modernism," 47.
31. On Eddy's relationship to the Armory Show, see Kruty, "Arthur Jerome Eddy."
32. Kruty, "Arthur Jerome Eddy," n. 76.
33. Erens, *Masterpieces*, 116–17.
34. This fact was noted by Vivian Barnett in her lecture "The 1913 Armory Show and Chicago—Chicago Collectors in General and Arthur Jerome Eddy in Particular," Art Institute of Chicago, March 28, 2013.
35. See Kruty, "Arthur Jerome Eddy," and Brown, *Story of the Armory Show*, for assessments of Eddy's purchases.
36. "Here She Is: White Outline Shows 'Nude Descending a Staircase,'" *Chicago Tribune*, March 24, 1913.
37. Quoted in Brown, *Story of the Armory Show*, 176.
38. Brown, *Story of the Armory Show*, 176.
39. Brown, *Story of the Armory Show*, 177.
40. These are the words of the painter Jack Yeats, father to W. B. Yeats. See Materer, *Selected Letters*, 2.
41. Quoted in Kruty, "Arthur Jerome Eddy," 45.
42. Sherwood Anderson Papers, box 31, folder 1653, Newberry Library.
43. Anderson, *Letters*, 26.
44. On the significance of Eddy's *Cubists and Post-Impressionism*, see Kruty, "Arthur Jerome Eddy," 44–45.
45. Eddy, *Cubists and Post-Impressionism*, 5–6.
46. Quinn writes to Sally Lewis, a future donor to the Portland Art Museum in Oregon, in a response to her request to lend paintings. See Zilczer, "John Quinn," 69. See also Braddock on the role that private collectors like Quinn and Barnes played in building modernism's cultural authority.
47. Harriet Monroe, "Art Show Opens to Freaks," *Chicago Daily Tribune*, February 17, 1913, 5.
48. Charles H. Bukholder to Charles French, April 2, 1913, Institutional Records, Art Institute of Chicago.
49. Quoted in Naumann, "Explosion," 203.

50. Naumann, "Explosion," 205.

51. Brown, *Story of the Armory Show*, 136.

52. See Neil Harris, "Chicago Setting," and Brown, *Story of the Armory Show*, 174. For the story of "September Morn," see also Hammer, *Attitudes*, 25–26.

53. See "She Bathes—Hey! Screen That Girl," *Chicago Tribune*, March 5, 1913.

54. See "Art Students Acquit Poor 'September Morn,'" *Chicago Tribune*, April 18, 1913.

55. See the letters of Edgar Lee Masters to Carter Harrison in the Carter Harrison Papers, Newberry Library.

56. See White, *Anderson/Stein*, 7.

57. *A Portrait of Mabel Dodge at the Villa Curonia* (Florence: Tipografia Galileiana, 1912).

58. See Everett, *History*, 61–64.

59. Stein, *Portrait of Mabel Dodge*, 5.

60. W. J. T. Mitchell is the originator of this idea of a "pictorial turn." See especially his *Picture Theory*.

61. See "Cubist Art Is Explained Clearly by a Post-Impressionist Writer," *Chicago Inter-Ocean*, March 21, 1913.

62. Stein, "Poetry and Grammar," in *Lectures in America*, 228.

63. "A Line-O'-Type or Two," *Chicago Tribune*, February 28, 1913, 6.

64. Stieglitz, *Camera Work*, 4.

65. See "Pathé," the text of Stein's program in Pathé Newsreels, in Burns and Dydo, *Letters of Stein and Wilder*, 351.

66. The article was reprinted in a small booklet published by the Association of American Painters and Sculptors, which had sponsored the Armory Show. See Frederick James Gregg, ed., *For and Against: Views on the International Exhibition Held in New York and Chicago* (New York: Association of American Painters and Sculptors, 1913).

67. Kruty, "Arthur Jerome Eddy," 45–46.

68. Berman, "Katharine Kuh Gallery," 165.

69. See Harris, "Old Wine in New Bottles."

70. Sarah Kelly Oehler treats the work of Topchevsky and Angel in her insightful analysis of the many contradictory expressions of "progress" at the 1933 fair. See Oehler, *They Seek a City*, 15–25.

71. Jacobson, *Art of Today*.

72. There is an excellent field of scholarship on the art that emerged in Chicago after the Armory Show. See especially Cozzolino, *Art in Chicago*; Greenhouse and Weininger, *Chicago Painting*; Kennedy, *Chicago Modern*; and the website *Modernism in the New City: Chicago Artists, 1920–1950*, http://www.chicagomodern .org. See also the essay by Jennifer Jane Marshall in Bielstein, Cozzolino, and Taft, *Into the City* (forthcoming).

73. Harrison, *Growing Up with Chicago*, 331.

74. Harrison, *Growing Up with Chicago*, 331.

75. Lawton Parker to Carter Harrison, November 1, 1915, Carter Harrison Papers, box 6, folder 383, Newberry Library.

76. A much smaller show of Picasso's work at the Paul Rosenberg gallery in New York in 1919 preceded the 1923 Picasso show at the Arts Club of Chicago.

77. Shaw, "Collection to Remember," 22. Chicago writer Arthur Meeker, *Chicago with Love*, 166, recalls that the first president of the Arts Club—"our old friend Mrs. Robert McGann"—did not have Carpenter's eye for the avant-garde. An artist herself, McGann "painted a number of large and painstaking landscapes, with hills, trees, lawns, and houses in them that looked exactly like hills, trees, lawns and houses."

78. The earliest directory from the Arts Club Papers is dated 1922–23 and lists Monroe as chair of the Literature Committee, which also included Fanny Butcher among five other women. Arts Club Papers, series 8, box 1, folder 8, Newberry Library.

79. "A Report of the Exhibition Committee Submitted by the Chairman," March 16, 1922, Arts Club Papers, series 1, box 1, folder 14, Newberry Library.

80. Arts Club Papers, series 5, box 2, folder 38, Newberry Library.

81. Fernand Leger, "Chicago Seen through the Eyes of a Visiting French Cubist," translated by Thornton Wilder, *Chicago Evening Post*, March 15, 1932. The piece originally appeared in the Paris periodical *Plans* in January 1932.

82. Rue Carpenter, "Problems in Decoration," *Vogue*, August 2, 1930.

83. Arts Club Papers, series 5, box 2, folder 31, Newberry Library.

84. The fullest account of Roullier's biography can be found in Hast and Schultz, *Women Building Chicago*, 766–68. Roullier's correspondence in the Arts Club Papers also illuminates her tact and practical sensibility.

85. For the arrangement between the Arts Club and the Art Institute, see Brettell and Prince in *Old Guard and Avant-Garde*, 216–19.

86. Arts Club Papers, series 8, box 1, folder 7, Newberry Library.

87. See Andreotti, "Brancusi's *Golden Bird*."

88. Loy, "Brancusi's Golden Bird," *Dial* (November 1922): 507–8.

89. Pound, "Brancusi," *Little Review* (Fall 1921): 4.

90. My account of the Brancusi exhibition at the Arts Club derives from Andreotti, "Brancusi's *Golden Bird*."

91. Anderson's paintings were on view first at the Walden Bookstore (formerly the Radical Bookshop) and then at the Arts Club. See Sutton, *Letters to Bab*, 138.

92. Alfred Stieglitz/Georgia O'Keeffe Archive, box 2, folder 35, Yale Collection of American Literature, Beinecke Rare Book and Manuscript Library.

93. Townsend, *Sherwood Anderson*, 200.

94. See Anderson's letters to Alfred Stieglitz and Georgia O'Keeffe in the Alfred Stieglitz/Georgia O'Keeffe Archive, Yale Collection of American Literature, Beinecke Rare Book and Manuscript Library. See also O'Keeffe's letters to Anderson in the Sherwood Anderson Papers, Newberry Library.

95. Anderson to Stieglitz, November 11, 1923, Sherwood Anderson Papers, Newberry Library.

96. From Reno in 1923, Anderson wrote to Stieglitz and O'Keeffe: "Have been trying, a little, to catch the tone and feeling of it [the country] in water color. There is one thing I am almost sure you and O'Keeffe would like. . . . Well I'll bring the

thing back when I come." Alfred Stieglitz/Georgia O'Keeffe Archive, box 2, folder 35, Yale Collection of American Literature, Beinecke Rare Book and Manuscript Library.

97. Alfred Stieglitz/Georgia O'Keeffe Archive, box 2, folder 41, Yale Collection of American Literature, Beinecke Rare Book and Manuscript Library.

98. Eleanor Jewett, "A Riddle Is Posed for You to Read in Arts Club Show," *Chicago Daily Tribune*, January 23, 1921. On Chicago art critics of the period, see Prince, *Old Guard and Avant-Garde*, 95–117.

99. Anderson, *Letters*, 58.

100. Anderson, *Letters*, 58.

101. For a nuanced discussion of Anderson's relationship to Toomer and their ideas about race, sexuality, and masculinity, see Whalen, *Race, Manhood, and Modernism*.

102. Toomer, *Letters*, 102.

103. "Sordid Tales," *New York Evening Post*, July 19, 1919. The full review is included in the Norton Critical Edition of Anderson's *Winesburg, Ohio*.

104. Townsend, *Sherwood Anderson*, 132–34.

105. Anderson, *Letters*, 21.

106. Anderson, *Letters*, 30.

107. William L. Phillips, "How Sherwood Anderson Wrote *Winesburg, Ohio*," *American Literature* 23, no. 1 (1951): 7–30. See also the full manuscript of *Winesburg, Ohio*, Sherwood Anderson Papers, Newberry Library.

108. Anderson, *Winesburg*, 9.

109. Anderson, *Winesburg*, 10.

110. Anderson, *Memoirs: Critical Edition*, 352. Anderson provides several accounts of writing "Hands" in his *Memoirs*. See also Townsend, *Sherwood Anderson*, 107–8.

111. Anderson, *Winesburg*, 136.

112. Kohn, *Hot Time*, 122.

113. *Agricultural Advertising* was the company's publicity magazine, for which Anderson wrote a long-standing column. It ceased publication in 1918. For an analysis of the early columns, see Sutton, "Sherwood Anderson: The Advertising Years."

114. Sherwood Anderson Papers, box 113, Newberry Library.

115. Sherwood Anderson, "The New Note," *Little Review*, March 1914, 23.

116. Hemingway, *Moveable Feast*, 12.

117. See Wright's "Blueprint for Negro Writing" (1937).

118. On the topic of masculinity, advertising, and authenticity in Anderson, see T. J. Jackson Lears, "Looking for the White Spot."

119. Anderson, *Winesburg*, 138.

120. Anderson, *Memoirs: Critical Edition*, 348.

121. Anderson, *Memoirs: Critical Edition*, 339–40, 347, 348, 340, 414.

122. Anderson, *Memoirs: Critical Edition*, 414.

123. Anderson to Ferdinand Schevill, April 1924, Sherwood Anderson Papers, box 11, folder 532, Newberry Library.

## INTERLUDE: PARIS, MAY–JUNE 1929

My account of Fanny Butcher's first trip to Europe is taken from chapter 12 in Butcher's memoir, *Many Lives—One Love* (1972), and from her 1929 diary contained in the Fanny Butcher Papers, Newberry Library. For the quotation from Butcher's dispatch from Paris, see "Notes from a Literary Editor's Journal," *Chicago Daily Tribune*, June 1, 1929. My description of Fanny Butcher and her bookshop draws centrally on two excellent pieces by Celia Hilliard, "'Lady Midwest,'" and Hilliard's entry on Fanny Butcher in Schultz and Hast, *Women Building Chicago*, 131–35. My description of Butcher's conversation with Joyce is taken almost directly from Butcher's account of it in *Many Lives—One Love*. Butcher also states in her memoir that she met Hemingway on this trip, though I have largely imagined that meeting. On the meeting in Paris between Hemingway, Dreiser, and Dreiser's French translator, see Riggio and West, *Dreiser's Russian Diary*, 42. See also Lingeman, *Theodore Dreiser*, 291.

## CHAPTER 3. HEMINGWAY'S READERS

1. "Hemingway Seems Out of Focus in 'The Sun Also Rises,'" *Chicago Daily Tribune*, November 27, 1926. Grace Hall Hemingway to Ernest Hemingway, December 4, 1926, Hemingway Collection, JFK Library.
2. "Hemingway Seems Out of Focus."
3. Grace Hall Hemingway to Ernest Hemingway, December 4, 1926, Hemingway Collection, JFK Library.
4. This appellation was coined by Otto McFeeley, editor of *Oak Leaves*, the town's local paper, for whom Hemingway worked as a boy. Malcolm Cowley Papers, box 104, folder 4974, Newberry Library. McFeeley is quoted (though uncited) in Malcolm Cowley's idolatrous 1940 *Life* magazine piece, "A Portrait of Mister Papa."
5. Wright, *Autobiography*, 78.
6. Hemingway, *Selected Letters*, 243–44.
7. Hemingway, *Selected Letters*, 258.
8. Hemingway's letters are full of references to Chicago newspapers, especially to the *Chicago Tribune*. When these newspapers were not available to him, he often requested copies from his family. For a discussion of journalism in Paris between the wars, with special reference to the *Tribune*'s status, see Weber, *News of Paris*, and Ford, *Left Bank Revisited*.
9. Hemingway, *Selected Letters*, 261.
10. Hemingway, *Selected Letters*, 261.
11. In May and June 1922, Hemingway had two fragments published in a little magazine out of New Orleans called the *Double-Dealer*, though they have been considered juvenilia. Five of the six poems published in *Poetry* 21, no. 4 (1923), on the other hand, were included in Hemingway's first book publication, *Three Stories and Ten Poems* (1923).
12. "Hemingway Seems Out of Focus."

13. Butcher, *Many Lives—One Love*, 267–72.

14. As a major literary arbiter, Butcher has received minimal critical attention. The best description of Butcher is by Celia Hilliard, in Schultz and Hast, *Women Building Chicago*, 131–35.

15. Butcher met Brooks in 1950 at a tea sponsored by the Society of Midland Authors. See "The Literary Spotlight," *Chicago Daily Tribune*, June 18, 1950. Butcher raved over *Maud Martha* in "Swift, Sharp Prose by a Poet," *Chicago Daily Tribune*, October 4, 1953. See her top ten best books of 1940 in *Chicago Daily Tribune*, December 4, 1940.

16. Butcher subscribed to most of the avant-garde magazines published in English in Europe, including *Transatlantic Review*, *This Quarter*, and *Broom*. She read Hemingway's *Three Stories and Ten Poems* when it was published by Robert McAlmon's Contact Press in 1923.

17. In 1937—after its first year of publication—*Life* magazine had a circulation of 1.5 million, "more than triple the first-year circulation of any magazine in American (and likely World) history." In 1938 circulation reached 2.5 million. See Brinkley, *Publisher*, 221, 224.

18. Hemingway to Butcher, November 1, 1952, Fanny Butcher Papers, Newberry Library.

19. Fanny Butcher, "'Happy Sinner' Appears Happy without Sins," *Chicago Daily Tribune*, May 6, 1931.

20. Hansen, *Midwest Portraits*, 199.

21. Sherwood Anderson Papers, box 11, folder 532, Newberry Library.

22. For a pejorative sense of the "middlebrow," see Bourdieu, *Distinction*.

23. Hemingway, *Farewell to Arms*, 184.

24. See Baker, *Hemingway: Writer as Artist*, 3.

25. Malcolm Cowley Papers, box 104, folder 4959, Newberry Library.

26. Malcolm Cowley Papers, box 104, folder 4974, Newberry Library.

27. For a discussion of the Midwest as a place and also as a descriptive concept whose power and meaning changed over time, see Shortridge, *Middle West*. See also Cayton and Onuf, *Midwest and Nation*, and Cayton and Gray, *American Midwest*.

28. The metaphor comes from Cronon, *Nature's Metropolis*.

29. Fannie Biggs taught at Oak Park and River Forest High School from 1912 to 1920 and encouraged Hemingway's dedication to writing. She wrote letters on his behalf to the *Chicago Examiner* and the *Chicago Daily Tribune* trying to secure Hemingway a job. See Hemingway, *Letters*, 1:48n, 381.

30. The most recent additions to Hemingway scholarship are the highly anticipated first three volumes (of a projected seventeen) of his collected letters: Spanier and Trogdon, *Letters of Ernest Hemingway*. Comprehensively annotated and meticulously edited, the first volume includes the letters that Hemingway wrote from Chicago and a highly useful chronology through 1922, Hemingway's first year in Paris. The significance of Hemingway's time in Chicago, however, is not discussed in the volume's introductory essays, nor is there

a map of Chicago (as there are of Oak Park, northern Michigan, Italy, Paris, and Europe).

31. Anderson, *Memoirs: Critical Edition*, 369.
32. Ernest Hemingway Collection, box 6, folder 1, Harry Ransom Center, University of Texas, Austin.
33. See Meyerowitz, *Women Adrift*.
34. Zorbaugh, *Gold Coast and Slum*, 4.
35. See the William Horne Collection, Newberry Library, which includes Hemingway's candid and intimate letters to Horne.
36. Griffin, *Along with Youth*, 139–40.
37. Baker, *Hemingway: A Life Story*, 76–77.
38. Hemingway, *Letters*, 1:285.
39. Baker, *Hemingway: A Life Story*, 78–79; Griffin, *Along with Youth*, 152, 171.
40. Griffin, *Along with Youth*, 152.
41. Hemingway, *Letters*, 1:266.
42. Hemingway, *Letters*, 1:297.
43. In Hemingway's nostalgic memoir set in Paris (and written forty years after he lived there), he recalls studying the paintings of Cézanne, Manet, Monet, "and the other Impressionists that I had first come to know about in the Art Institute of Chicago." Hemingway, *Moveable Feast*, 13.
44. For an insightful summary of Chicago's relationship to impressionism, see Greenhouse, "Local Color."
45. Most of the impressionist paintings at the Art Institute would have been part of the Potter Palmer collection—on view at the World's Fair and formally acquired by the Art Institute in 1922 but on display at the museum earlier. An exhibition of a group of paintings from the Potter Palmer collection was on display at the Art Institute from March 23, 1921, through the fall, according to the Art Institute's online archive of exhibits.
46. I thank Marina Kliger for locating records that detail a range of impressionist works on display during Hemingway's time in Chicago.
47. Woolf, "Sketch of the Past," 85.
48. Hemingway, *Moveable Feast*, 13.
49. Hemingway, *Moveable Feast*, 75.
50. Charles Fenton was an early critic who argued that Hemingway's journalism days, especially in Kansas City, were just as important as the influences of Anderson and Stein. See Fenton, *Apprenticeship of Ernest Hemingway*. The appearance of Matthew Bruccoli's volume of Hemingway's *Kansas City Star* stories, *Ernest Hemingway, Cub Reporter*, strengthened the case. Since then, many scholars trust Hemingway's comments about the influence of the *Kansas City Star* style; see, for instance, Fishkin, *From Fact to Fiction*.
51. See the fold-out style sheet at the back of Bruccoli, *Ernest Hemingway, Cub Reporter*. The *Kansas City Star* also put the 1915 style sheet online, http://www.kansascity.com/entertainment/books/article10632713.ece/BINARY/The%20Star%20Copy%20Style.pdf.

52. "Back to His First Field," *Kansas City Times*, November 26, 1940, 1. See also Hemingway's interview in the *Paris Review* 18 (Spring 1958), http://www.theparisreview.org/interviews/4825/the-art-of-fiction-no-21-ernest-hemingway.

53. See Weber, *Hemingway's Art of Non-Fiction*, and Michael North, "Ernest Hemingway's Media Relations," in North, *Camera Works*, 186–207.

54. For Hemingway's *Toronto Star* pieces, see White, *Dateline*.

55. White, *Dateline*, 58–59, 73–74, 75–77.

56. Hemingway Collection, box 62, JFK Library.

57. Hemingway, *Letters*, 1:48, 250, 255.

58. Griffin, *Along with Youth*, 146; Baker, *Hemingway: Life Story*, 76. Fenton provides details about the magazine's corrupt financial structure and the bankruptcy of Harrison Parker, the Co-Operative Society of America's sole trustee, in *Apprenticeship*, 96–97.

59. Laurence Gronlund, *The Cooperative Commonwealth* (Boston: Lee and Shepard, 1884).

60. Fenton, *Apprenticeship*, 96–98.

61. Fenton, *Apprenticeship*, 96–98.

62. Quoted in Griffin, *Along with Youth*, 190.

63. Hemingway, *Letters*, 1:256.

64. *Co-Operative Commonwealth* 3, no. 3 (October 1, 1921). Hemingway Collection, box 94, JFK Library.

65. Fanny Butcher Papers, box 10, folder 641, Newberry Library.

66. *Co-Operative Commonwealth* 3, no. 3 (October 1, 1921), 4. Hemingway Collection, box 94, JFK Library.

67. Hemingway, *Death in the Afternoon*, 192.

68. Hemingway, *Moveable Feast*, 12.

69. Baker, *Hemingway: A Life Story*, 27.

70. "Mix War, Art and Dancing," *Kansas City Star*, April 21, 1918, quoted in Bruccoli, *Ernest Hemingway*, 56–58.

71. Five stories from this period are included in Griffin, *Along with Youth*.

72. See Smith, "1924," and Smith, "Hemingway's Apprentice Fiction."

73. Griffin, *Along with Youth*, 104.

74. Griffin, *Along with Youth*, 104.

75. Hemingway, *In Our Time*, unpaginated.

76. Hemingway, *Selected Letters*, 62.

77. Hemingway, *Short Stories*, 133.

78. Hemingway, *Letters*, 1:310.

79. Hemingway, *Sun Also Rises*, 152.

80. For the argument that "financial soundness mirrors moral strength" in the novel, see Donaldson, *Force of Will*, 21–37.

81. Hemingway, *Sun Also Rises*, 19.

82. The use of the second person in Hemingway's work has received little critical attention. In the twentieth century, second-person narration is commonly associated with the rhetoric of advertising and journalism. *Kansas City Star* writer Steve Paul

presented an unpublished 2006 conference paper on Hemingway's use of "you" in *For Whom the Bell Tolls* that underscores Hemingway's sustained use of the second person and its connection to Hemingway's journalism through the 1930s. Michael North also briefly treats Hemingway's use of "you" in his chapter on Hemingway in *Camera Works*. See also Morrissette, "Narrative 'You,'" in Morrissette, *Novel and Film*, 108–40.

83. Hemingway, *Sun Also Rises*, 100.
84. Hemingway, *Sun Also Rises*, 67–68.
85. Hemingway, *Sun Also Rises*, 92, 103, 159.
86. Hemingway, *Sun Also Rises*, 44.
87. Hemingway, *Sun Also Rises*, 94.
88. Bruccoli, *Sun Also Rises: Facsimile*, 47–48.
89. Hemingway, *Sun Also Rises*, 102.
90. On the Hemingway "code," see Bruccoli, *Sun Also Rises: Facsimile*, ix.
91. Donaldson, *Force of Will*, 31; Nagel, "Brett," 94. Bruccoli, too, regularly refers to Brett as a "nymphomaniac," though no judgment is made upon the promiscuity of male characters.
92. Hemingway, *Farewell to Arms*, 226.
93. Hemingway, *Sun Also Rises*, 49, 50.
94. Bruccoli, *Fitzgerald and Hemingway*, 82, argues that Hemingway was using a "ploy of ambitious young writers by attacking a prominent literary figure."
95. *American Mercury* 5 (August 1925): xxxviii.
96. H. L. Mencken, "The Spanish Idea of a Good Time," *American Mercury* 27 (December 1932): 506–7.
97. Hemingway, *Letters*, 1:lxvi.
98. Butcher, *Many Lives*, 402–4.
99. Butcher, *Many Lives*, 409.
100. Butcher's copy of *Death in the Afternoon* is held at the Newberry Library.
101. Butcher, "All Bullfight Facts Are Told by Hemingway," *Chicago Daily Tribune*, September 29, 1932.
102. "Hemingway Seems Out of Focus."
103. Lillian Ross, "How Do You Like It Now, Gentlemen?," *New Yorker*, May 13, 1950, 36.
104. Harris, *Chicagoan*, 341.
105. See Shortridge, *Middle West*.
106. Butcher, "The Literary Spotlight," *Chicago Daily Tribune*, March 30, 1947.
107. Hemingway, *Death in the Afternoon*, 33.
108. Hemingway, *Death in the Afternoon*, 190.
109. Fanny Butcher Papers, box 7, folder 459, Newberry Library.
110. Butcher, *Many Lives*, 429.
111. Butcher, *Many Lives*, 427.
112. See obituary, "Fanny Butcher Dead; Literary Critic Was 99," *New York Times*, May 17, 1987.
113. Butcher's attempts at writing fiction animate her profuse and intimate correspon-

dence with Sinclair Lewis, who encouraged her. See Fanny Butcher Papers, box 5, folder 324, Newberry Library.

## INTERLUDE: CHICAGO, NOVEMBER 7, 1934

On the Goodspeeds' apartment at 2430 North Lakeview Avenue, see Harris, *Chicago Apartments*, 310–15. For the fullest treatment of Bobsy Goodspeed, see Geoffrey Johnson, "Portrait of a Lady," *Chicago Magazine* (October 2008), http://www .chicagomag.com/Chicago-Magazine/October-2008/Portrait-of-a-Lady. Thornton Wilder's notes to Gertrude Stein's and Virgil Thomson's opera are contained in the program for *Four Saints in Three Acts*, Auditorium Theatre, November 7, 1934, Inventory of the Auditorium Theatre Programs, Newberry Library. Stein's claim, "If you enjoy a thing you understand it," comes from "Pathé," in Burns and Dydo, *Letters of Stein and Wilder*, 351. Alice Toklas describes the New York City marquee lights in *What Is Remembered*, 144; Stein also describes the marquee in *Everybody's Autobiography*, 180. Bobsy Goodspeed's films are contained in the Elizabeth Fuller Chapman Papers and Films, Yale Collection of American Literature, Beinecke Rare Book and Manuscript Library. Stein's description of how her first view from an airplane looked like the work of cubist and postcubist paintings appears in *Everybody's Autobiography*, 197–98.

## CHAPTER 4. STEIN COMES TO CHICAGO

1. White, *Tastemaker*, 30–57.
2. My account of Stein's first trip to Chicago is derived from Fanny Butcher's 1934 diary in the Fanny Butcher Papers, Newberry Library; the chapter on Stein in Butcher's memoir; and Burns, *Letters of Stein and Van Vechten*.
3. See Leick, *Gertrude Stein and the Making of an American Celebrity*, which usefully details the response of the American press to Stein and her work. For the importance of middlebrow book reviewing in the 1910s–1950s, see Rubin, *Making of Middlebrow Culture*, and Radway, *Feeling for Books*. Leick alternatively argues that Rubin and Radway overlook the interest of the mainstream press in modernism. She regards Stein's fame as comparable to that of such other modernists as Joyce, Pound, and Woolf.
4. Burns, *Letters of Stein and Van Vechten*, 1:277.
5. John Alden Carpenter Papers, box 2, folder 103, Newberry Library.
6. Stein, *Everybody's Autobiography*, 194.
7. Stein wanted her first lecture at the university to be the English department's annual William Vaughn Moody Lecture, named after a professor who had taught Stein at Radcliffe College before coming to Chicago. But the selection committee hedged and eventually chose the well-known poet Edna St. Vincent Millay instead. There were also problems with finding a suitable lecture hall for her lectures, with limiting the audience to five hundred students or fewer (a request that Stein made for all of her American lectures), with overbooking, and with charging students an admission fee.

8. Rice, in Burns and Dydo, *Letters of Stein and Wilder*, 336.

9. Burns and Dydo, *Letters of Stein and Wilder*, 340.

10. Fanny Butcher, Diary, December 1, 1934, Fanny Butcher Papers, Newberry Library.

11. Butcher, *Many Lives*, 419.

12. *New York Herald Tribune*, April 7, 1935, quoted in Mellow, *Charmed Circle*, 409.

13. Woolf, "Middlebrow," 183–84. Woolf may have been more open to the culture of the masses than her middlebrow essay suggests. See Cuddy-Keane, *Woolf, Intellectual, and Public Sphere*, which persuasively challenges the portrait of Woolf as highbrow through a reading of Woolf's essays and reviews.

14. Butcher, *Many Lives*, 210.

15. *Narration* was reprinted by the University of Chicago Press in a limited collector's edition in 1969 and appeared in print again when the press issued a 2010 paperback edition.

16. Burns and Dydo, *Letters of Stein and Wilder*, 24.

17. Burns, *Letters of Stein and Van Vechten*, 1:413.

18. Gertrude Stein and Alice B. Toklas Collection, box 9, folder 107, Yale Collection of American Literature, Beinecke Rare Book and Manuscript Library.

19. Stein, *Narration*, 9.

20. Stein, *Narration*, 25.

21. Stein, "Melanctha," *Three Lives*, 112.

22. Wright's account of reading Stein's work is from his unpublished journal, Richard Wright Papers, box 117, folder 1860, James Weldon Johnson Collection, Yale Collection of American Literature, Beinecke Rare Book and Manuscript Library. See also his review of Stein's *Wars I Have Seen*, published in the leftist daily newspaper *PM*: "Gertrude Stein's Story Is Drenched in Hitler's Horrors," *PM*, March 11, 1945. In *American Hunger*, Wright also describes writing "under the influence" of Stein's *Three Lives*.

23. See, for instance, North, *Dialect of Modernism*, for a critique of "Melanctha" and its racial taxonomizing, which fixates on the sexual lives of its characters as the primary means for understanding African American life.

24. Wright, "Gertrude Stein's Story," 15.

25. In *The Poetics of Indeterminacy* and *Twenty-First-Century Modernism*, Marjorie Perloff advocates the openness and materiality of Stein's language, characteristics that impel a reader's active participation in constructing meaning from Stein's texts. Juliana Spahr similarly upholds the ways in which Stein's work is reader-centered in *Everybody's Autonomy*. Perloff's and Spahr's approaches to reading Stein are extended in various ways by practitioners of language poetry who see Stein as an important model. Alternatively, in *From Modernism to Postmodernism*, Jennifer Ashton argues that Stein herself insisted on the autonomy of the work of art, that is, that the experience of a text (whether an author's or a reader's) is not how meaning is made.

26. Toklas, *Alice B. Toklas Cookbook*, 125.

27. Burns and Dydo, *Letters of Stein and Wilder*, 10.

28. See Stein's letters to Bobsy Goodspeed, Gertrude Stein and Alice B. Toklas Collection, box 9, folders 107–10, Yale Collection of American Literature, Beinecke Rare Book and Manuscript Library.

29. Toklas, *Alice B. Toklas Cookbook*, 125.

30. According to Burns and Dydo, *Letters of Stein and Wilder*, xvii, Wilder's position was "offensive to the professoriat because it implied that a writer could teach as well as a professor and that university credentials were less important than talent." Wilder was "respected and popular as an instructor," nonetheless, and "became one of the first in an American university to teach creative writing."

31. Butcher, *Many Lives*, 26.

32. See Stephen Meyer's "Introduction" to Stein, *Making of Americans*, xiv.

33. Fanny Butcher, "Book Presents Gertrude Stein as She Really Is," *Chicago Daily Tribune*, February 10, 1934.

34. Stein, *Autobiography*, 18.

35. Friday Club Papers, Newberry Library.

36. Stein describes her post-tour writer's block in *Everybody's Autobiography*. In an earlier article for *Vanity Fair*, she explained the immediate effect of the success of *The Autobiography of Alice B. Toklas* on her writing: "For the first time since I had begun to write I could not write . . . I began to think about how my writing would sound to others, how could I make them understand, I who had always lived within myself and my writing." Stein, "And Now," in *How Writing Is Written*, 63.

37. Butcher, *Many Lives*, 417.

38. This point is made by Wanda Corn and Tirza True Latimer in *Seeing Gertrude Stein*, which accompanied a 2012 exhibit organized by the National Portrait Gallery in Washington and the Contemporary Jewish Museum in San Francisco.

39. For Goodspeed's short films, including the film of the Stein dinner party, see Elizabeth Fuller Chapman Papers and Films, Yale Collection of American Literature, Beinecke Rare Book and Manuscript Library.

40. Stein, *Tender Buttons*, 52.

41. Gertrude Stein and Alice B. Toklas Collection, box 106, folder 2097, Yale Collection of American Literature, Beinecke Rare Book and Manuscript Library. Janet Malcolm misquotes this letter in *Two Lives* (2007) in order to suggest a much stronger lesbianism between Bobsy Goodspeed and Maude Hutchins.

42. On the relationship between Stein and Faÿ, see Will, *Unlikely Collaboration*.

43. The *New York Review of Books* reprinted Maude Hutchins's *Victorine* (1959) with a foreword by Terry Castle, who argues that Hutchins's later novels served as a form of "psychic payback" to her ex-husband, who would have been tremendously embarrassed by their explicit sexuality. See Castle, "Introduction," vii–xxxi.

44. Stein, *Chicago Inscriptions*, 13.

45. Stein, *Chicago Inscriptions*, 6.

46. Stein cleverly inscribed a copy of *Chicago Inscriptions* to William Saroyan as a New Year's gift, thus promoting the very means by which her Chicago crowd promoted her. See the Edward C. Hirschland Collection, Chicago.

47. Gertrude Stein and Alice B. Toklas Collection, box 9, folder 107, Yale Collection of American Literature, Beinecke Rare Book and Manuscript Library.

48. Gertrude Stein and Alice B. Toklas Collection, box 9, folder 110, Yale Collection of American Literature, Beinecke Rare Book and Manuscript Library.

49. Butcher, *Many Lives*, 413–15.

50. Butcher, *Many Lives*, 416.

51. Eliot, "Tradition," 40, 43.

52. Fanny Butcher, Diary, July 25, 1931, Fanny Butcher Papers, Newberry Library.

53. Judith Cass, "Society Will Attend Stein Opera Tonight," *Chicago Daily Tribune*, November 7, 1934.

54. India Moffat, "Audience Eyes a Simple Gown at Stein Opera," *Chicago Daily Tribune*, November 8, 1934.

55. Virginia Gardner, "Stein Arrival Exciting Time to Committee," *Chicago Daily Tribune*, November 8, 1934.

56. Stein, "Pathé," in Burns and Dydo, *Letters of Stein and Wilder*, 351.

57. Stein, *Everybody's Autobiography*, 126.

58. Dewey R. Jones, the editor of the *Defender*'s popular poetry column "Lights and Shadows," wrote: "The beauty and significance of the whole work, as far as I was concerned, lay in the fact that an opera which had nothing to do with the race issue, relied upon the singing and enunciation of Race musicians." See "As Our Cartoonist Sees Four Saints," *Defender*, November 17, 1934. See also Beulah Mitchell Hill, "In the Realm of Music," *Chicago Defender*, November 10, 1934.

59. Wright recounts this story in his review of Stein's *Wars I Have Seen*. See Wright, "Gertrude Stein's Story."

60. See Rowley, *Richard Wright*, 102–3.

61. Richard Wright Papers, box 117, folder 1860, James Weldon Johnson Collection, Yale Collection of American Literature, Beinecke Rare Book and Manuscript Library.

62. Stein, *Narration*, 16.

63. James, *American Scene*, 100.

64. See Cutler, *Jews of Chicago*.

65. Stein, *Narration*, 3–10.

66. Stein, *Narration*, 9.

67. Stein, *Narration*, 25.

68. Stein, *Narration*, 38–39.

69. Sherwood Anderson, "The Work of Gertrude Stein," *Little Review* 8, no. 2 (1922): 29–32.

70. University of Chicago Press Records, box 439, folder 2, Special Collections Research Center, University of Chicago Library.

71. University of Chicago Press Records, box 439, folder 2, Special Collections Research Center, University of Chicago Library.

72. In 1934–35 and 1935–36 there were only three women with the rank of assistant professor or higher in the English department at the University of Chicago (from a total of twenty-two and twenty-three professors, respectively). See *Announcements*:

*The College and the Divisions for the Sessions of 1934–35* (Chicago: University of Chicago Press, 1934), 146, and *Announcements: The College and the Divisions for the Sessions of 1935–36* (Chicago: University of Chicago Press, 1935), 153.

73. See Beam, *Great Idea at the Time*, for a popular account of the Great Books program in which Mortimer Adler is the conceited and unloved counterpart to "wonderboy" President Hutchins. Beam notes that Adler did not have another academic job after he left the University of Chicago in 1946; his income came from the continuation of the Great Books program through *Encyclopaedia Britannica* and the Aspen Institute.

74. For a detailed account of "The New Plan," see Boyer, "Twentieth-Century Cosmos."

75. Boyer, "Twentieth-Century Cosmos," 95.

76. *Time* reported the nationwide debate about liberal arts education in June 24, 1935, featuring Robert Hutchins on its cover. He was again on the magazine's cover on November 21, 1949.

77. Rice, in Burns and Dydo, *Letters of Stein and Wilder*, 342.

78. "Gertrude Stein in Chicago: What Is Remembered . . . And What Was Forgotten," *Chicago Daily News Panorama*, Mortimer Adler Papers, box 138, folder 37, Special Collections Research Center, University of Chicago Library.

79. Stein, *Everybody's Autobiography*, 213.

80. For Stein's and Toklas's experience in the homicidal squad unit, see Butcher, *Many Lives*, 422–23, and Stein, *Everybody's Autobiography*, 212–16.

81. White, *Tastemaker*, 214. See also Heap, *Slumming*.

82. Stein's experiences on Chicago's South Side are related in *Everybody's Autobiography*, 214.

83. Ben Burns, "Double-Talk Prose; Common Sense Talk," *Chicago Defender*, October 27, 1945.

84. Wright's letters to Stein are unpublished and contained in the Gertrude Stein and Alice B. Toklas Papers, box 131, folder 2876, Yale Collection of American Literature, Beinecke Rare Book and Manuscript Library.

85. "Composition as Explanation" was reprinted in Stein's 1940 collection *What Are Masterpieces* (Los Angeles: Conference Press, 1940), which Wright cites by title and page number in his letter to Stein. Wright to Stein, October 29, 1945, Richard Wright Papers, box 131, folder 2876, James Weldon Johnson Collection, Yale Collection of American Literature, Beinecke Rare Book and Manuscript Library.

86. Wright, "Introduction," in Drake and Cayton, *Black Metropolis*, xviii, xxxi.

87. Stein to Wright, April 22, 1945, quoted in Rowley, *Richard Wright*, 324.

88. Wright to Stein, May 27, 1945, Gertrude Stein and Alice B. Toklas Papers, box 131, folder 2876, Yale Collection of American Literature, Beinecke Rare Book and Manuscript Library.

89. Most of Stein's letters to Wright have been lost. In her biography of Wright, Rowley cites Ellen Wright's belief that the letters were stolen before she sold the papers to Yale.

90. Wright to Stein, June 23, 1945, Gertrude Stein and Alice B. Toklas Papers, box

131, folder 2876, Yale Collection of American Literature, Beinecke Rare Book and Manuscript Library.

91.  Wright to Stein, March 15, 1946, Gertrude Stein and Alice B. Toklas Papers, box 131, folder 2876, Yale Collection of American Literature, Beinecke Rare Book and Manuscript Library.

92.  Wright to Stein, October 29, 1945, Gertrude Stein and Alice B. Toklas Papers, box 131, folder 2876, Yale Collection of American Literature, Beinecke Rare Book and Manuscript Library.

93.  Burns, *Letters of Stein and Van Vechten*, 1:354.

94.  Burns, *Letters of Stein and Van Vechten*, 1:357.

95.  Stein, *Autobiography of Alice B. Toklas*, 88.

96.  Stein, *Everybody's Autobiography*, 220.

97.  See Beam's account of Adler's work on "The Syntopicon" in *Great Idea at the Time*.

98.  Stein, *Autobiography of Alice B. Toklas*, 212.

99.  Adler details his very specific approach to reading and reading comprehension in *How to Read a Book*, published in 1940.

100.  See Beam's *Great Idea at the Time* for the list of Great Books as *Encyclopaedia Britannica* marketed them in 1952, when a small number of works written in English were then included. No works by women were included until the list was revised in 1990.

101.  Stein, *Everybody's Autobiography*, 212–13.

102.  Adler and Van Doren, *How to Read a Book*, 341.

103.  "Gertrude Stein in Chicago: What Is Remembered . . . And What Was Forgotten," *Chicago Daily News Panorama*, Mortimer Adler Papers, box 138, folder 37, Special Collections Research Center, University of Chicago Library.

104.  Stein, *Everybody's Autobiography*, 212–13.

105.  See Sawyer, *Stein: A Bibliography*, and the selected bibliography in Dydo, *Language That Rises*.

106.  Stein, *Writings, 1932–1946*, 838.

107.  Stein, "What Are Master-Pieces?"

108.  As a point of contrast, Black Mountain College also invited Stein to deliver a lecture there, but she had to turn them down out of lack of time in her schedule. See Burns and Dydo, *Letters of Stein and Wilder*, 15.

109.  Stein, *Stanzas in Meditation*, 139.

110.  See Beam, *Great Idea at the Time*, for an account of how Adler and Hutchins's university curriculum led to the 1952 launch of the fifty-four-volume set of Great Books published and marketed with *Encyclopaedia Britannica*.

111.  See MacDonald, "Masscult and Midcult." See also his scathing review of the set of Great Books, "The Book-of-the-Millennium Club," *New Yorker*, November 29, 1952.

112.  MacDonald, "Masscult and Midcult," 595.

113.  This story of Mortimer Adler at the Arts Club of Chicago was told to me by Kathy Cottong, former director of the club.

114.  Adler and Hutchins, *Diagrammatics*, unpaginated.

115. "Art: Diagrammatics," *Time*, October 31, 1932.
116. Mortimer Adler Papers, box 40, folder 35, Special Collections Research Center, University of Chicago Library.

## INTERLUDE: CHICAGO, FALL 1941

The best account of Stark's poetry group is in Bone and Courage, *Muse in Bronzeville*, 216–19. Over the years, the group would go by different names: the Chicago Poets' Class, the Visionaries, the Creative Forum. When Stark left Chicago for Washington, DC (around 1942–43), the group continued under other staff members at *Poetry* and writer and journalist Marjorie Peters and took place at the Parkway Community House. See also Kent, *Life of Gwendolyn Brooks*, 59–61. My description of Inez Stark—including the phrases from Stark's Gold Coast friends and Stark's unflinching comments—is taken almost verbatim from Gwendolyn Brooks, *Report from Part One*, 65–67. In 1949 Stark wrote to *Poetry* editor Hayden Carruth that there were few places other than *Poetry* where she submitted her work. See *Poetry* Magazine Records, box 51, folder 20, Special Collections Research Center, University of Chicago Library. Gwendolyn Brooks's 1953 novella *Maud Martha* describes a "beau" inspired by William Couch who wears "herringbone tweed" and possesses an "educated smile." See Brooks, *Blacks*, 184–85. The book that Stark quotes is Robert Hillyer, *First Principles of Verse* (Boston: Writer, 1938), and the poem Stark reads is Maude Hutchins's "Lately I Walk Lightly," which appeared in *Poetry* (March 1941): 356. Stark knew Hutchins and exhibited Hutchins's work—including bronze profiles of Mortimer Adler, Rabindranath Tagore, and Bobsy Goodspeed—at the Renaissance Society in 1937. See "Maude Phelps Hutchins Exhibit Portrait of Her Own Progress in Art," *Chicago American*, March 4, 1937. The description of how Brooks found her poetic material is a paraphrase from Brooks's *Report from Part One*, 69. She also describes Stark's apartment as an "eye opener" in *Report from Part One*, 174. On Couch's performance of a poem by Stein, see John Carlis, "Art . . . ," *Chicago Defender*, June 27, 1942. I quote from the first lines of "If I Told Him: A Completed Portrait of Picasso," written in 1923 and one of Stein's best-known poems. On Hughes's time in Chicago, see Rampersad, *Life of Langston Hughes*, vol. 2.

## CHAPTER 5. WHITE CITY, BLACK METROPOLIS

1. Gwendolyn Brooks to Elizabeth Lawrence, March 25, 1945, Selected Records of Harper and Brothers, box 5, folder 27, Department of Rare Books and Special Collections, Princeton University Library.
2. Brooks to Richard Wright, April 9, 1945, James Weldon Johnson Collection, box 94, folder 1234, Yale Collection of American Literature, Beinecke Rare Book and Manuscript Library.
3. Brooks to Wright, April 9, 1945, James Weldon Johnson Collection, box 94, folder

1234, Yale Collection of American Literature, Beinecke Rare Book and Manuscript Library.

4. Walker, *Daemonic Genius*, 71.

5. Nelson Algren, "Remembering Richard Wright," *Nation*, January 28, 1961, 85.

6. Brooks to Harper and Brothers, July 18, 1944, Selected Records of Harper and Brothers, box 5, folder 26, Department of Rare Books and Special Collections, Princeton University Library. Brooks may have been referring to Ernest Alexander, whose work Brooks sent to Lawrence in a March 11, 1949, letter for the dust jacket of *Annie Allen*, box 6, folder 2.

7. Brooks describes her reading habits in her autobiography, *Report from Part One*. Her mother told her as a child that she was "going to be the *lady* Paul Laurence Dunbar." Brooks, *Report from Part One*, 56.

8. Wright to Edward Aswell, September 18, 1944, Selected Records of Harper and Brothers, Manuscripts Division, Department of Rare Books and Special Collections, Princeton University Library. Also quoted, not quite in full, in Fabre, *Richard Wright*, 185–86.

9. Brooks to Lawrence, August 17, 1945, Selected Records of Harper and Brothers, box 5, folder 28, Department of Rare Books and Special Collections, Princeton University Library.

10. Brooks, *Street*, 45.

11. Lawrence arranged a meeting with Richard Wright on December 28, 1945, when Brooks was in New York to accept a prize from *Mademoiselle* magazine. Lawrence to Brooks, December 5, 1945, Selected Records of Harper and Brothers, box 5, folder 28, Department of Rare Books and Special Collections, Princeton University Library.

12. Fabre, *Richard Wright*, 186.

13. Brooks, *Street*, 3.

14. Richard Wright Papers, box 8, folder 166, James Weldon Johnson Collection, Yale Collection of American Literature, Beinecke Rare Book and Manuscript Library.

15. Brooks to Lawrence, September 28, 1944, Selected Records of Harper and Brothers, box 5, folder 26, Department of Rare Books and Special Collections, Princeton University Library.

16. Brooks deliberated at length with Elizabeth Lawrence about the order of poems in *A Street in Bronzeville*. Lawrence offered the suggestion that "the old-marrieds" begin the volume. Brooks to Lawrence, March 12, 1945, Selected Records of Harper and Brothers, box 5, folder 27, Department of Rare Books and Special Collections, Princeton University Library.

17. Lawrence to Brooks, September 22, 1944, Gwendolyn Brooks Papers, Rare Book and Manuscript Library, University of Illinois, Urbana-Champaign. A copy of this letter is also contained in the Selected Records of Harper and Brothers, box 5, folder 26, Department of Rare Books and Special Collections, Princeton University Library.

18. Brooks to Lawrence, September 28, 1944, Selected Records of Harper and Broth-

ers, box 5, folder 26, Department of Rare Books and Special Collections, Princeton University Library.

19. In *The Big Sea* (1940), Langston Hughes describes how Harlem became a tourist destination for whites during the 1920s. David Levering Lewis adapts a phrase from Hughes for the title of his study of the writers, artists, editors, and patrons of the Harlem Renaissance, *When Harlem Was in Vogue*.

20. Richard Wright, "Between Laughter and Tears," *New Masses*, October 5, 1937, 22, 25.

21. "Blueprint for Negro Writing" was published in the only issue of *New Challenge*, edited by Dorothy West, Marian Minus, and Wright. Wright alienated West with his critique of Harlem writers in "Blueprint" and because of his desire to fill the issue with the work of Chicago writers and his friends. See Rowley, *Richard Wright*, 134–38.

22. Bone and Courage, *Muse in Bronzeville*, 165–70.

23. Wright also identified Fenton Johnson and Arna Bontemps as members of the South Side Writers Group, and both had previously published books.

24. Wright describes his experience with the Communist Party in the final three chapters of his autobiography, *Black Boy (American Hunger)*, 300–365. Wright is notoriously unreliable on facts and chronology; see also Rowley, *Richard Wright*, and Bill Mullen, "Chicago and the Politics of Reputation: Richard Wright's Long Black Shadow," in Mullen, *Popular Fronts*, 19–43.

25. Auden, "Writing," 311.

26. A. C. McClurg published *The Souls of Black Folk* in 1903. See also Du Bois, "Talented Tenth."

27. On the issues of orality and textuality in the realm of black cultural production, see Gates, *Signifying Monkey*, and Gilroy, *Black Atlantic*.

28. Walker, "For My People," http://www.poetryfoundation.org/poetrymagazine /poem/11053.

29. Robert Bone coined the term "Chicago Black Renaissance" in "Richard Wright and the Chicago Black Renaissance," *Callaloo* 28 (Summer 1986). The scholarship on the Chicago Black Renaissance is rapidly growing. Key book-length studies include: Baldwin, *Chicago's New Negroes*; Bone and Courage, *Muse in Bronzeville*; Dolinar, *Negro in Illinois*; Green, *Selling the Race*; Hine and McCluskey, *Black Chicago Renaissance*; Hricko, *Genesis of the Chicago Renaissance*; Jackson, *Indignant Generation*; Knupfer, *Chicago Black Renaissance and Women's Activism*; Morgan, *Re-Thinking Social Realism*; Mullen, *Popular Fronts*; Schlabach, *Along the Streets of Bronzeville*; Stewart, *Migrating to the Movies*; and Tracy, *Writers of the Black Chicago Renaissance*.

30. The IWP office was located at 433 East Erie Street, and the *Poetry* magazine office was then located two blocks away, at 232 East Erie Street. For Walker's account of writing "For My People," see her Preface in *This is My Century*, xiv.

31. Dolinar, *Negro in Illinois*, xvi.

32. There is a vast critical literature on the Great Migration; the best comprehensive scholarly work is Grossman, *Land of Hope*. See also Isabel Wilkerson's beautiful work of narrative nonfiction, *Warmth of Other Suns*.

33. Drake and Cayton, *Black Metropolis*, 8, table 1.
34. Rowley, *Richard Wright*, 52.
35. Wright, "Preface," *12 Million*, xx.
36. Wright, *Black Boy*, 249.
37. Wright, *12 Million*, 93.
38. On old settlers, see Grossman, *Land of Hope*, 123–60. Christopher Reed follows the lead of the Old Settlers Club, founded in 1902, in conferring old settler status only to those who were Chicago residents before the 1893 World's Fair. See *Black Chicago's First Century*, 40, 65, and *Knock at the Door of Opportunity*.
39. Thompson, *American Daughter*, 256.
40. "A Few Do and Don'ts," *Chicago Defender*, July 13, 1918, 16.
41. Grossman, *Land of Hope*, 150–51.
42. See Bone and Courage, *Muse in Bronzeville*, 22–26, for a discussion of the impact of Park's work as publicity director under Booker T. Washington at Tuskegee.
43. Grossman, *Land of Hope*, 147.
44. See Du Bois, *Souls of Black Folk*; Hurston, *Mules and Men*; and Wright, "Blueprint for Negro Writing."
45. On the 1919 race riots in Chicago, see Tuttle, *Race Riot*, 3–66. See also Krugler, *1919*.
46. Sandburg, *Chicago Race Riots*, 4.
47. Oral interview with Eldzier Cortor, April 16, 2015. A transcription of this interview with an accompanying essay on Cortor was published in the *Chicago Review* (May 2016): 119–42.
48. Wallace Best, "Regal Theater," *Encyclopedia of Chicago*, http://www.encyclopedia.chicagohistory.org/pages/3211.html.
49. On deletions to *Native Son*, see Rampersad, "Note on the Texts," in Wright, *Early Works*, 911–13.
50. For moviegoing in Bronzeville, see Stewart, *Migrating to the Movies*, chaps. 4, 5.
51. Brooks, *Street*, 26.
52. For the compelling argument that the consumer marketplace of Bronzeville was as important as its literary life and visual arts in producing a distinctive black social sphere, see Davarian Baldwin, "'Chicago's New Negroes': Consumer Culture and Intellectual Life Reconsidered," *American Studies* 44, no. 1–2 (2003): 121–55. See also Baldwin, *Chicago's New Negroes*.
53. Brooks, *Report from Part One*, 69.
54. See Bone and Courage, *Muse in Bronzeville*, 26, 171. See also Schulman, *Force for Change*.
55. Vivian Harsh describes the building in a 1957 essay labeled "Hall Branch Library and Social Environment," Vivian G. Harsh Research Collection, box 3, folder 20, George Cleveland Hall Branch Library Archives.
56. Walker, *Richard Wright*, 42–43.
57. Bone and Courage, *Muse in Bronzeville*, 175.
58. Jacqueline Goldsby argues that the Book Review and Lecture Forum reflects larger features of Bronzeville's intellectual community, which was broad-based,

oriented in collective cohorts, and open to a diverse audience in a public setting. Goldsby has made this argument in several public lectures, including during a 2013 National Endowment for the Humanities summer institute at the Newberry.

59. Michael Flug, "Vivian Harsh," in Hast and Schultz, *Women Building Chicago*, 360.

60. This suggestion was proposed in conversation with Michael Flug, senior archivist at the Vivian G. Harsh Research Collection. Harsh was strategically discreet: her obituary in the *Chicago Defender*, August 29, 1960, refers to Harsh as the "Historian Who Never Wrote."

61. Flug, "Vivian Harsh," 359.

62. See Baldwin, *Chicago's New Negroes*, on the contrast between Bronzeville's old settler community and its pleasure-seeking working classes.

63. For a checklist of exhibitions at Kuh's gallery, see Berman, *Old Guard and Avant-Garde*. Kuh's attention to visual work produced in Bronzeville should not be overstated: she did not fully grasp its significance. Eldzier Cortor, for instance, recounted how Kuh did not "take" to his work in an oral interview of April 16, 2015.

64. At the IWP, Wright worked on a document titled "Ethnographical Aspects of Chicago's Black Belt," which drew heavily on his contact with the Chicago School of Sociology, specifically Horace Cayton and Cayton's mentor Louis Wirth. (Wirth's wife was the social worker for the Wright family.) Wright also wrote articles on the Chicago Urban League, the White City Recreational Center (a tourist destination on the south side that barred blacks), and other "amusements" in his own neighborhood, including the Stroll and farther south. See Dolinar, "Illinois Writers' Project Essays."

65. Jack Conroy Papers, box 45, folder 1904, Newberry Library.

66. On the Illinois Writers Project, see Dolinar, *Negro in Illinois*, and Bone and Courage, *Muse in Bronzeville*, 176–81.

67. See Dolinar, "Introduction," *Negro in Illinois*.

68. The IWP's first big project was *Illinois: A Descriptive and Historical Guide* (Chicago: A. C. McClurg, 1939).

69. Recently, the twenty-nine chapters of *The Negro in Illinois* have been recovered, organized, and edited. See Dolinar, *Negro in Illinois*.

70. Arna Bontemps, "Famous WPA Authors," *Negro Digest* 8, no. 7 (1950): 43–47.

71. See Dolinar, "Introduction," *Negro in Illinois*.

72. Rowley, *Richard Wright*, 331.

73. Burns, *Letters of Stein and Van Vechten*, 2:823, 828.

74. Wright, "Introduction," *Black Metropolis*, xviii.

75. I thank Richard Courage for his suggestion that Wright's metaphor may also allude to Edmund Wilson's version of the myth of Philoctetes in *The Wound and the Bow* (1941).

76. *12 Million Black Voices* and *Let Us Now Praise Famous Men* were part of a notable trend during the late 1930s of books that merged text with documentary photographs from the Farm Security Administration, including Margaret Bourke-White and Erskine Caldwell's *You Have Seen Their Faces* (1937); Archibald MacLeish's

*Land of the Free* (1938); Dorothea Lange and Paul Taylor's *American Exodus* (1939); and Sherwood Anderson's *Home Town* (1940). Sara Blair treats the relationship of major black writers (including Wright) to documentary photography in *Harlem Crossroads* (2007). For further considerations of Wright's 12 *Million Black Voices*, see Rabinowitz, *American Pulp*; Griffin, *"Who Set You Flowin'?"*; Stange, *Bronzeville*; and Allred, *"From Eye to We."*

77. Horace Cayton, "Black Voices," *Pittsburgh Courier*, November 15, 1941, quoted in David T. Bailey, "Horace Cayton," in Hine and McCluskey, *Black Chicago Renaissance*, 121.

78. Sontag, *On Photography*, 55.

79. Miller describes his experience photographing Chicago's South Side in *Chicago's South Side*, xiii–xv.

80. Miller, *Chicago's South Side*, xiii.

81. "Backstage," *Ebony* 1 (November 1945): n.p.

82. Richard Wright, "Shame of Chicago," *Ebony* 7 (December 1951): 24–32.

83. Ben Burns, "Return of the Native Son," *Ebony* 7 (December 1951): n.p.

84. The typescript of "I Chose Exile" and Wright's correspondence with *Ebony* editor Ben Burns are held in the Ben Burns Papers, box 2, folder 10, Vivian G. Harsh Research Collection. Hazel Rowley points out that Burns never returned the manuscript of "I Chose Exile." In 1969, nine years after Wright's death, Burns (who no longer worked at *Ebony*) sold both Wright's essay and Wright's letter to him to Kent State University for five hundred dollars. See Rowley, *Richard Wright*, 399.

85. Miller, *Chicago's South Side*, xiv.

86. Miller, *Chicago's South Side*, x.

87. Cortor was widely known in the 1940s and 1950s; he was profiled in "19 Young Americans," *Life*, March 20, 1950.

88. In a December 21, 1949 letter, Brooks writes to Lawrence: "I sent you a painting by Eldzier Cortor, Chicago's best-known and most successful Negro artist." Selected Records of Harper and Brothers, box 6, folder 3, Department of Rare Books and Special Collections, Princeton University Library.

89. Oral interview with Eldzier Cortor, April 16, 2015.

90. Ellison, *Invisible Man*, 3. On "the Veil" and "second-sight," see Du Bois, *Souls of Black Folk*.

91. For a discussion of Du Bois's collection of photographs and the argument that race itself has been defined by visual culture, see Smith, *Photography on the Color Line*.

92. Du Bois, *Souls of Black Folk*, 8. Du Bois first discusses double-consciousness in "Strivings of the Negro People," published in August 1897 in the *Atlantic Monthly*. The essay became the first chapter, "Of Our Spiritual Strivings," in *The Souls of Black Folk* (1903). On double vision, see Gilroy, *Black Atlantic*.

93. Sontag, *On Photography*, 81.

94. Sontag, *On Photography*, 94, makes a version of this claim but then points out that painting was already retreating from realistic representation, before the ascent of photography.

95. While a student at the School of the Art Institute, Cortor studied with influential artist and art historian Kathleen Blackshear, who emphasized both the Western canon and African art in her history of art courses. See Bearden and Henderson, *History of African-American Artists*, 272–79. On Cortor, see also Oehler, *They Seek a City*, 82–84.

96. Oral interview with Cortor, April 16, 2015.

97. Bearden and Henderson, *History of African-American Artists*, 274.

98. For an examination of social realism in Chicago across genres, see Morgan, *Rethinking Social Realism*.

99. Richard Wright, Diary, January 25, 1945, Richard Wright Papers, box 117, folder 1860, James Weldon Johnson Collection, Yale Collection of American Literature, Beinecke Rare Book and Manuscript Library.

100. In 1960, Wright was interviewed by *France USA*, the semiofficial newspaper of French-American relations in Paris, "Interview with Richard Wright," *France USA*, September–October 1960, 141–42. A copy of the periodical is contained in the Horace Cayton, Jr. Papers, box 18, folder 4, Vivian G. Harsh Research Collection.

101. There is a vast critical scholarship on the relationship between new visual media and modernity. Most relevant is Michael North's persuasive argument for the widespread influence of photography and film on modernist art and literature in *Camera Works*.

102. Dolinar, *Negro in Illinois*, xvi.

103. Wright, *Black Boy*, 267.

104. Wright, "Blueprint," 105.

105. Brooks's review of *Lawd Today!* is included in Brooks, *Report from Part One*, 74–75.

106. Richard Wright, *Haiku: The Last Poems of an American Icon* (New York: Arcade, 1998).

107. Wright, *Native Son*, 279.

108. Wright, *Native Son*, 224.

109. For a definitive disagreement over the political dimensions of modernism's experiments with form, see the 1938 debate between Ernst Bloch and Georg Lukács, which informed later exchanges among Bertolt Brecht, Theodor Adorno, and Walter Benjamin. See Adorno et al., *Aesthetics and Politics*.

110. Georg Lukács, "Realism in the Balance," in Adorno, *Aesthetics and Politics*, 28–59.

111. Lawrence to Brooks, July 14, 1948, Selected Records of Harper and Brothers, box 6, folder 1, Department of Rare Books and Special Collections, Princeton University Library.

112. Lawrence to Brooks, February 15, 1946, Selected Records of Harper and Brothers, box 5, folder 29, Department of Rare Books and Special Collections, Princeton University Library.

113. Wright to Brooks, March 29, 1945, Gwendolyn Brooks Papers, Rare Book and Manuscript Library, University of Illinois, Urbana-Champaign.

114. Beckett, *Our Exagmination*, 14.

115. Wright, "How 'Bigger' Was Born," 853.
116. Wright, "Introduction" to Drake and Cayton, *Black Metropolis*, xvii.
117. Wright, *12 Million*, 13.
118. Browning and Gayden published nine issues in total of *Negro Story*; each issue differs slightly in design and layout; for Wright's story, see May–June 1944; for the masthead, see August–September 1945. On the integrationist aims of the magazine, see Mullen, *Popular Fronts*, 106–25.
119. See Rampersad, *Life of Langston Hughes*, vol. 1, as well as Rampersad, "Introduction" to Hughes, *Big Sea*, xiii–xxvi.
120. Rampersad, *Life of Langston Hughes*, 1:221.
121. Rampersad, *Life of Langston Hughes*, 1:221, 379.
122. See Radway, *Feeling for Books*, 297.
123. Quoted in Gilroy, *Black Atlantic*, 153.
124. Brooks, *Report from Part One*, 156.
125. Brooks to Lawrence, June 7, 1945, Selected Records of Harper and Brothers, box 5, folder 28, Department of Rare Books and Special Collections, Princeton University Library.
126. Brooks to Lawrence, June 30, 1945, Selected Records of Harper and Brothers, box 5, folder 28, Department of Rare Books and Special Collections, Princeton University Library.
127. Brooks, *Poetry* 151, no. 1–2 (1987).
128. Brooks to Lawrence, October 25, 1944, and Lawrence to Brooks, October 30, 1944, Selected Records of Harper and Brothers, box 5, folder 26, Department of Rare Books and Special Collections, Princeton University Library.
129. Brooks to Lawrence, November 2, 1944, Selected Records of Harper and Brothers, box 5, folder 26, Department of Rare Books and Special Collections, Princeton University Library.
130. Lawrence to Brooks, November 8, 1944, Selected Records of Harper and Brothers, box 5, folder 26, Department of Rare Books and Special Collections, Princeton University Library.
131. Lawrence to Brooks, March 20, 1945, Selected Records of Harper and Brothers, box 5, folder 27, Department of Rare Books and Special Collections, Princeton University Library.
132. Brooks to Lawrence, March 20, 1963, Gwendolyn Brooks Papers, Rare Book and Manuscript Library, University of Illinois, Urbana-Champaign.
133. Lawrence to Brooks, February 15, 1946, Selected Records of Harper and Brothers, box 5, folder 29, Department of Rare Books and Special Collections, Princeton University Library.
134. Brooks to Lawrence, February 25, 1946, Selected Records of Harper and Brothers, box 5, folder 29, Department of Rare Books and Special Collections, Princeton University Library.
135. Kent, *Life of Gwendolyn Brooks*, 176.
136. Lawrence to Brooks, November 21, 1976, Gwendolyn Brooks Papers, carton 1, folder 38, Bancroft Library, University of California, Berkeley.

137. Brooks, *Report from Part One*, 176.

138. "How 'Bigger' Was Born" was originally given as a lecture at Columbia University in 1940, repeated a few weeks later at the Schomberg Library in Harlem, then published in the *Saturday Review of Literature*, and then published again in a more condensed version in *Negro Digest*. See Rampersad, "Note on the Texts," in Wright, *Early Works*, 913.

139. Wright, "How 'Bigger' Was Born," 874.

140. Irving Howe, "Black Boys and Native Sons," *Dissent* 10 (Autumn 1963): 353–68.

141. Langston Hughes, "The Need for Heroes," *Crisis* 48, no. 6 (1941): 184.

142. Ralph Ellison to Wright, April 14, 1940, Richard Wright Papers, box 97, folder 1314, James Weldon Johnson Collection, Yale Collection of American Literature, Beinecke Rare Book and Manuscript Library.

143. I thank Bill Savage for this interpretation of Algren's letter to Wright.

144. Richard Wright Papers, box 93, folder 1167, James Weldon Johnson Collection, Yale Collection of American Literature, Beinecke Rare Book and Manuscript Library.

145. Jack Conroy, editorial, *New Anvil* (May–June 1940): 35.

146. On the American Negro Exposition, see Green, *Selling the Race*, chap. 1; Mullen, *Popular Fronts*, 75–81; and Jeffrey Helgeson's essay in Hine and McCluskey, *Black Chicago Renaissance*, 126–46.

147. Fabre, *Unfinished Quest*, 206.

148. For an account of Thompson's life, see Eileen De Freece-Wilson, "Era Bell Thompson: Chicago Renaissance Writer," PhD diss., Rutgers University, 2010.

149. Era Bell Thompson to Stanley Pargellis, May 24, 1944, Newberry Library Archives, Newberry Library. See also http://publications.newberry.org/makingmodernism /exhibits/show/exhibit/thompson.

150. University of Chicago Press Records, box 452, folder 9, Special Collections Research Center, University of Chicago.

151. Thompson, *American Daughter*, 103–4.

152. University of Chicago Press Records, box 452, folder 9, Special Collections Research Center, University of Chicago.

153. James Campbell offers an insightful comparison between Thompson's *Land of My Fathers* and Wright's *Black Power* in *Middle Passages*, chap. 7.

154. University of Chicago Press Records, box 452, folder 9, Special Collections Research Center, University of Chicago Library.

155. Davis's review was sent in a letter to the University of Chicago Press, April 18, 1946, University of Chicago Press Records, box 452, folder 9, Special Collections Research Center, University of Chicago Library.

156. University of Chicago Press Records, box 452, folder 10, Special Collections Research Center, University of Chicago Library.

157. Arna Bontemps, review of *American Daughter*, by Era Bell Thompson, *New York Herald Tribune Weekly*, May 5, 1946, 4.

158. Advertisement for *American Daughter*, by Era Bell Thompson, *Saturday Review of Literature*, April 27, 1946, 2.

159. Ralph Ellison, "Stepchild Fantasy," *Saturday Review of Literature,* June 8, 1946, 25–26.

160. Frazier, *Black Bourgeoisie.* For a challenge to Frazier, see Green, *Selling the Race.*

161. See Green, *Selling the Race,* chap. 4.

162. For instance, Thompson writes to Brooks in 1975: "Don't know how you do all that travelling but the pay is good and you are with me on what to do with money. Amen! More talk later." Gwendolyn Brooks Papers, Rare Book and Manuscript Library, University of Illinois, Urbana-Champaign.

163. Lee Bey, "Soul Survivor: A Look at the Intact and Avant-Garde Interiors of the *Ebony/Jet* Building," January 14, 2013, www.wbez.org/blogs/lee-bey/2013–01 /soul-survivor-look-intact-and-avant-garde-interiors-ebonyjet-building-104868.

164. Campbell, *Middle Passages,* 313.

165. On the design of IIT and its relation to the larger redevelopment of the South Side, see Whiting, "Bas-Relief Urbanism." Thomas Dyja offers a vivid account of the influence of Mies van der Rohe in Chicago and his detachment from the conditions in Bronzeville in *Third Coast,* 3–22.

166. Carl Condit argues for continuity between these periods of architectural development in Chicago in *Rise of the Skyscraper.* Since Condit, many scholars have suggested that there is no such continuity and that the umbrella term "Chicago School" itself is misleading. See in particular Robert Bruegmann, "Myth of the Chicago School," and Daniel Bluestone, *Constructing Chicago,* 105–51. See also Introduction, n. 90, above.

167. Lowe, *Lost Chicago.*

168. For this idea, I am indebted to Jacqueline Goldsby, who favors the term *ecology* to refer to Bronzeville's life system of constant flux and change.

169. Quoted in Whiting, "Bas-Relief Urbanism," 655.

170. Whiting, "Bas-Relief Urbanism," 668.

171. Bluestone, "Chicago's Mecca Flat Blues."

172. Kent, *Life of Gwendolyn Brooks,* 42.

173. Gwendolyn Brooks, *Blacks,* 407.

174. Brooks, *Report from Part One,* 135–36.

## CONCLUSION

My account of the 1914 *Poetry* magazine banquet is synthesized from three sources: Monroe, *Poet's Life,* 329–39; Foster, *W. B. Yeats,* 514–15; and Niven, *Carl Sandburg,* 238–40. Gwendolyn Brooks's poem "We Real Cool" first appeared in the September 1959 issue of *Poetry,* and then in her volume *The Bean Eaters* (New York: Harper & Brothers, 1960). Vachel Lindsay's poem "The Congo" was composed in 1912 and was first published in *The Congo and Other Poems* (New York: MacMillan, 1914).

Adams, Henry. *The Education of Henry Adams* [1918]. New York: Penguin, 1990.

Adler, Mortimer, and Maude Hutchins. *Diagrammatics*. New York: Random House, 1931.

Adler, Mortimer, and Charles Van Doren. *How to Read a Book*. Rev. ed. New York: Simon and Schuster, 1972.

Adorno, Theodor, et al. *Aesthetics and Politics: The Key Texts of the Classic Debate within German Marxism*. New York: Verso, 2007.

Algren, Nelson. *Chicago: City on the Make* [1951]. 50th Anniversary Edition. Chicago: University of Chicago Press, 2001.

Allred, Jeff. "'From Eye to We': Richard Wright's 12 *Million Black Voices*, Documentary, and Pedagogy." *American Literature* 78, no. 3 (2006): 549–83.

Anderson, Margaret. *My Thirty Years' War*. Chicago: Covici, Friede, 1930.

Anderson, Sherwood. *Letters of Sherwood Anderson*. Edited by Howard Mumford Jones with Walter B. Rideout. Boston: Little, Brown, 1953.

——. *Letters to Bab: Sherwood Anderson to Marietta D. Finley, 1916–33*. Edited by William A. Sutton. Urbana: University of Illinois Press, 1985.

——. *Mid-American Chants*. New York: B. W. Huebsch, 1918.

——. *Sherwood Anderson's Memoirs*. New York: Harcourt, Brace, 1942.

——. *Sherwood Anderson's Memoirs: A Critical Edition*. Edited by Ray Lewis White. Chapel Hill: University of North Carolina Press, 1969.

——. *A Story Teller's Story: A Critical Text*. Edited by Ray Lewis White. Cleveland, OH: Case Western Reserve University Press, 1968.

——. *Winesburg, Ohio* [1919]. New York: W. W. Norton, 1996.

Andreotti, Margherita. "Brancusi's *Golden Bird*: A New Species of Modern Sculpture." *Art Institute of Chicago Museum Studies* 19, no. 2 (1993): 134–52, 192–203.

Apparudai, Arjun. *Modernity at Large: Cultural Dimensions of Globalization*. Minneapolis: University of Minnesota Press, 1996.

Ashton, Jennifer. *From Modernism to Postmodernism: American Poetry and Theory in the Twentieth Century*. Cambridge: Cambridge University Press, 2005.

Auden, W. H. "Writing." In *The English Auden: Poems, Essays and Dramatic Writings, 1927–1939*, edited by Edward Mendelson, 303–12. London: Faber and Faber, 1986.

Babcock, Barbara. "A New Mexican Rebecca: Imaging Pueblo Woman." *Journal of the Southwest* 32, no. 4 (1990): 400–437.

335

Baker, Carlos. *Ernest Hemingway: A Life Story*. New York: Charles Scribner's Sons, 1969.

———. *Ernest Hemingway: The Writer as Artist* [1952]. 4th ed. Princeton, NJ: Princeton University Press, 1972.

Bakhtin, Mikhail. *The Dialogic Imagination*. Austin: University of Texas Press, 1982.

Baldwin, Davarian. *Chicago's New Negroes: Modernity, the Great Migration, and Black Urban Life*. Chapel Hill: University of North Carolina Press, 2007.

Barter, Judith. "'The Great Confusion': The Armory Show in Chicago." In *The Armory Show at 100: Modernism and Revolution*, edited by Marilyn Satie Kushner and Kimberly Orcutt, 363–73. New York: New-York Historical Society, 2013.

Beam, Alex. *A Great Idea at the Time: The Rise, Fall, and Curious Afterlife of the Great Books*. New York: Public Affairs, 2008.

Bearden, Romare, and Harry Henderson. *A History of African-American Artists from 1792 to the Present*. New York: Pantheon, 1993.

Beckett, Samuel. "Dante ... Bruno. Vico .. Joyce." In *Our Exagmination Round His Factification for Incamination of Work in Progress* [1929]. London: Faber and Faber, 1984.

Belich, James. *Replenishing the Earth: The Settler Revolution and the Rise of the Angloworld, 1783–1939*. Oxford: Oxford University Press, 2009.

Bennett, Alma J. *American Women Theatre Critics: Biographies and Selected Writings of Twelve Reviewers, 1753–1919*. Jefferson, NC: McFarland, 2010.

Berman, Avis. "The Katharine Kuh Gallery: An Informal Portrait." In *The Old Guard and the Avant-Garde: Modernism in Chicago, 1910–1940*, edited by Sue Anne Prince, 155–69. Chicago: University of Chicago Press, 1990.

Berman, Marshall. *All That Is Solid Melts into Air: The Experience of Modernity* [1982]. New York: Penguin, 1988.

Best, Wallace. *Passionately Human, No Less Divine: Religion and Culture in Black Chicago, 1915–1952*. Princeton, NJ: Princeton University Press, 2007.

Bielstein, Susan, Robert Cozzolino, and Maggie Taft, eds. *Into the City: A History of Chicago Art*. Chicago: University of Chicago Press, forthcoming 2018.

Blair, Sara. *Harlem Crossroads: Black Writers and the Photograph in the Twentieth Century*. Princeton, NJ: Princeton University Press, 2007.

Bluestone, Daniel. "Chicago's Mecca Flat Blues." *Journal of the Society of Architectural Historians* 57, no. 4 (1998): 382–403.

———. *Constructing Chicago*. New Haven: Yale University Press, 1991.

Bluhm, Sharon K. *Manierre Dawson, Inventions of the Mind: A Biography of an Abstract Art Pioneer*. Ludington, MI: Humps Hollow Historical Press, 2012.

Bone, Robert, and Richard Courage. *The Muse in Bronzeville: African American Creative Expression in Chicago, 1932–1950*. New Brunswick, NJ: Rutgers University Press, 2011.

Bontemps, Arna, and Jack Conroy. *They Seek a City*. New York: Doubleday, Doran, 1945.

Bourdieu, Pierre. *Distinction: A Social Critique of the Judgment of Taste* [1979]. Translated by Richard Nice. Cambridge, MA: Harvard University Press, 1984.

Boyer, John W. "A Twentieth-Century Cosmos: The New Plan and the Origins of

General Education at Chicago." *Occasional Papers on Higher Education*, 16. College of the University of Chicago, 2007.

Braddock, Jeremy. *Collecting as Modernist Practice*. Baltimore: Johns Hopkins University Press, 2012.

Brent, Stuart. *The Seven Stairs: An Adventure of the Heart*. New York: Simon and Schuster, 1989.

Brinkley, Alan. *The Publisher: Henry Luce and His American Century*. New York: Alfred A. Knopf, 2010.

Bronson, Bennet. "Berthold Laufer." *Fieldiana*, September 30, 2003, 117–26.

Brown, Milton. *The Story of the Armory Show*. New York: Abbeville, 1988.

Browne, Maurice. *Too Late to Lament: An Autobiography*. London: Victor Gollancz, 1955.

Bruccoli, Matthew J. *Ernest Hemingway, Cub Reporter*. Pittsburgh: University of Pittsburgh Press, 1970.

———. *Fitzgerald and Hemingway: A Dangerous Friendship*. New York: Carroll and Graf, 1994.

———, ed. *The Sun Also Rises: A Facsimile Edition*. Detroit: Omnigraphics, 1990.

Bruegmann, Robert. "Myth of the Chicago School." In *Chicago Architecture: Histories, Revisions, Alternatives*, ed. Charles Waldheim and Katerina Rüedi Ray, 15–29. Chicago: University of Chicago Press, 2005.

Brooker, Peter, and Andrew Thacker, eds. *Geographies of Modernism: Literatures, Cultures, Spaces*. London: Routledge, 2005.

Brooks, Gwendolyn. *A Street in Bronzeville*. New York: Harper and Brothers, 1945.

———. *Blacks*. Chicago: Third World Press, 1994.

———. *Report from Part One*. Detroit: Broadside Press, 1972.

Burns, Edward, ed. *The Letters of Gertrude Stein and Carl Van Vechten*. Vol. 1, 1913–1935. New York: Columbia University Press, 1986.

———. *The Letters of Gertrude Stein and Carl Van Vechten*. Vol. 2, 1935–1946. New York: Columbia University Press, 1986.

Burns, Edward M., and Ulla E. Dydo, with William Rice, eds. *The Letters of Gertrude Stein and Thornton Wilder*. New Haven: Yale University Press, 1996.

Butcher, Fanny. *Many Lives—One Love*. New York: Harper and Row, 1972.

Calhoun, Lucy. "The World's Fair." In *Chicago Yesterdays: A Sheaf of Reminiscences*, ed. Caroline Kirkland, 283–97. Chicago: Daughaday, 1919.

Campbell, James. *Middle Passages: African American Journeys to Africa, 1787–2005*. New York: Penguin, 2006.

Carr, Helen. "*Poetry: A Magazine of Verse* (1912–1936): 'Biggest of Little Magazines.'" In *The Oxford Critical and Cultural History of Modernist Magazines*, vol. 2, *North America, 1894–1960*, edited by Peter Brooker and Andrew Thacker, 40–60. Oxford: Oxford University Press, 2012.

———. *The Verse Revolutionaries: Ezra Pound, H.D. and the Imagists*. London: Jonathan Cape, 2009.

Castle, Terry. "Introduction" to Maude Hutchins's *Victorine*, vii–xxxi. New York: New York Review of Books, 2008.

Cather, Willa. *The Song of the Lark* [1915]. New York: Dover Thrift, 2004.

Cayton, Andrew, and Susan Gray, eds. *The American Midwest: Essays on Regional History.* Bloomington: Indiana University Press, 2001.

Cayton, Andrew, and Peter Onuf, eds. *The Midwest and the Nation: Rethinking the History of an American Region.* Bloomington: Indiana University Press, 1990.

Condit, Carl. *The Rise of the Skyscraper.* Chicago: University of Chicago Press, 1952.

Corn, Wanda, and Tirza True Latimer. *Seeing Gertrude Stein: Five Stories.* Berkeley: University of California Press, 2012.

Cozzolino, Robert. *Art in Chicago: Resisting Regionalism, Transforming Modernism.* Philadelphia: Pennsylvania Academy of the Fine Arts, 2007.

Cronon, William. *Nature's Metropolis: Chicago and the Great West.* New York: W. W. Norton, 1991.

Cuddy-Keane, Melba. *Virginia Woolf, the Intellectual, and the Public Sphere.* Cambridge: Cambridge University Press, 2003.

Cutler, Irving. *The Jews of Chicago: From Shtetl to Suburb.* Urbana: University of Illinois Press, 1996.

Dell, Floyd. *Moon-Calf.* New York: Alfred A. Knopf, 1920.

Dolinar, Brian. "The Illinois Writers' Project Essays: Introduction." *Southern Quarterly* 46, no. 2 (2009): 84–90.

——. *The Negro in Illinois: The WPA Papers.* Urbana: University of Illinois Press, 2013.

Donaldson, Scott. *By Force of Will: The Life and Art of Ernest Hemingway.* New York: Viking, 1977.

Doyle, Laura, and Laura Winkiel, eds. *Geomodernisms: Race, Modernism, Modernity.* Bloomington: Indiana University Press, 2005.

Drake, St. Clair, and Horace Cayton. *Black Metropolis: A Study of Negro Life in a Northern City.* New York: Harcourt, Brace, 1945.

Dreiser, Theodore. *Sister Carrie* [1900]. New York: Signet Classics, 2009.

Drew, Bettina. *Nelson Algren: A Life on the Wild Side.* New York: G. P. Putnam's Sons, 1991.

Du Bois, W. E. B. *The Souls of Black Folk* [1903]. In *W. E. B. Du Bois: Writings*, edited by Nathan Huggins, 357–547. New York: Library of America, 1990.

——. "The Talented Tenth." In Booker T. Washington et al., *The Negro Problem: A Series of Articles by Representative American Negroes of To-Day,* 33–75. New York: James Pott, 1903.

Duffey, Bernard. *The Chicago Renaissance in American Letters: A Critical History.* East Lansing: Michigan State College Press, 1954.

Duncan, Hugh Dalziel. *The Rise of Chicago as a Literary Center from 1885–1920.* Totowa, NJ: Bedminster Press, 1964.

Dydo, Ulla E., with William Rice. *Gertrude Stein: The Language That Rises, 1923–1934.* Evanston, IL: Northwestern University Press, 2003.

Dyja, Thomas. *The Third Coast: When Chicago Built the American Dream.* New York: Penguin, 2013.

Eddy, Arthur Jerome. *Cubists and Post-Impressionism.* Chicago: A. C. McClurg, 1914.

Egginton, William. *The Man Who Invented Fiction: How Cervantes Ushered in the Modern World.* New York: Bloomsbury USA, 2016.

Eliot, T. S. "Tradition and the Individual Talent." In *Selected Prose of T. S. Eliot*, edited by Frank Kermode, 37–44. New York: Harcourt Brace, 1975.

Ellison, Ralph. *Invisible Man*. New York: Vintage, 1989.

Emerson, Ralph Waldo. "Self-Reliance." In *The Essential Writings of Ralph Waldo Emerson*, edited by Brooks Atkinson, 132–53. New York: Modern Library, 2000.

Erens, Patricia. *Masterpieces: Famous Chicagoans and Their Paintings*. Chicago: Chicago Review Press, 1979.

Everett, Patricia R., ed. *A History of Having a Great Many Times Not Continued to Be Friends: The Correspondence between Mabel Dodge and Gertrude Stein, 1911–1934*. Albuquerque: University of New Mexico Press, 1996.

Fabre, Michel. *Richard Wright: Books and Writers*. Jackson: University Press of Mississippi, 1990.

———. *The Unfinished Quest of Richard Wright*. Translated by Isabel Barzun. New York: William Morrow, 1973.

Felski, Rita. *The Gender of Modernity*. Cambridge, MA: Harvard University Press, 1995.

Fenollosa, Ernest, and Ezra Pound. *The Chinese Written Character as a Medium for Poetry*. Edited by Haun Saussey, Jonathan Stalling, and Lucas Klein. New York: Fordham University Press, 2008.

Fenton, Charles. *The Apprenticeship of Ernest Hemingway*. New York: Farrar, Straus and Young, 1945.

Fishkin, Shelly Fisher. *From Fact to Fiction: Journalism and Imaginative Writing in America*. Oxford: Oxford University Press, 1985.

Fleissner, Jennifer. *Women, Compulsion, Modernity: The Moment of American Naturalism*. Chicago: University of Chicago Press, 2004.

Fletcher, John Gould. *Life Is My Song*. New York: Farrar and Rinehart, 1937.

Ford, Hugh, ed. *The Left Bank Revisited: Selections from the Paris "Tribune," 1917–1934*. University Park: Pennsylvania State University Press, 1972.

Foster, Roy. *W. B. Yeats: The Apprentice Mage*. Oxford: Oxford University Press, 1998.

Frazier, E. Franklin. *Black Bourgeoisie: The Rise of a New Middle Class*. New York: Free Press, 1957.

Friedman, Susan Stanford. "Definitional Excursions: The Meanings of Modern/Modernity/Modernism." *Modernism/Modernity* 8, no. 3 (2001): 493–513.

Fuller, Henry Blake. *The Cliff-Dwellers*. New York: Harper and Bros., 1893.

———. *With the Procession* [1895]. Chicago: University of Chicago Press, 1965.

Gates, Henry Louis. *The Signifying Monkey: A Theory of Afro-American Literary Criticism*. New York: Oxford University Press, 1988.

Gilbreath, Olive. "Ware the Pitcher-Plant!" *Asia Magazine* 29 (July 1929): 525–31.

Gilroy, Paul. *The Black Atlantic: Modernity and Double-Consciousness*. Cambridge, MA: Harvard University Press, 1995.

Golding, Alan. "*The Little Review* (1914–29)." In *The Oxford Critical and Cultural History of Modernist Magazines*, vol. 2, *North America, 1894–1960*, edited by Peter Brooker and Andrew Thacker, 61–84. Oxford: Oxford University Press, 2012.

Green, Adam. *Selling the Race: Culture, Community, and Black Chicago, 1940–1955*. Chicago: University of Chicago Press, 2007.

Greenhouse, Wendy. "Chicago and the Canon, Present and Past." In *Re: Chicago*, edited by Louise Lincoln, 10–16. Chicago: DePaul Art Museum and University of Chicago Press, 2011.

———. "Local Color: Impressionism Comes to Chicago." In *Chicago Modern, 1893–1945: Pursuit of the New*, edited by Elizabeth Kennedy, 23–37. Chicago: University of Chicago Press, 2004.

Greenhouse, Wendy, and Susan Weininger. *Chicago Painting 1895 to 1945: The Bridges Collection*. Springfield: University of Illinois Press and Illinois State Museum, 2004.

Griffin, Farah Jasmine. *"Who Set You Flowin'?": The African-American Migration Narrative*. New York: Oxford University Press, 1995.

Griffin, Peter. *Along with Youth: Hemingway, the Early Years*. New York: Oxford University Press, 1985.

Hammer, Ethel Joyce. "Attitudes toward Art in the Nineteen Twenties in Chicago." PhD diss., University of Chicago, 1975.

Hansen, Harry. *Midwest Portraits: A Book of Memories and Friendships*. New York: Harcourt, Brace, 1923.

Harris, Neil. *Chicago Apartments: A Century of Lakefront Luxury*. New York: Acanthus, 2004.

———. "The Chicago Setting." In *The Old Guard and the Avant-Garde*, edited by Sue Ann Prince, 3–22. Chicago: University of Chicago Press, 1990.

———. "Old Wine in New Bottles: Masterpieces Come to the Fairs." In *Designing Tomorrow: America's World's Fairs of the 1930s*, ed. Robert W. Rydell and Laura Burd Schiavo, 41–55. New Haven: Yale University Press, 2010.

———, ed. *The Chicagoan: A Lost Magazine of the Jazz Age*. Chicago: University of Chicago Press, 2008.

Harrison, Carter. *Growing Up with Chicago*. Chicago: Ralph Fletcher Seymour, 1944.

Harvey, David. *The Condition of Postmodernity: An Enquiry into the Origins of Cultural Change*. Malden, MA: Blackwell, 1990.

Hast, Adele, and Rima Lunin Schultz, eds. *Women Building Chicago, 1790–1990*. Bloomington: Indiana University Press, 2001.

Heap, Chad. *Slumming: Sexual and Racial Encounters in American Nightlife, 1885–1940*. Chicago: University of Chicago Press, 2008.

Hecht, Ben. *Charlie*. New York: Harper and Brothers, 1957.

———. *A Thousand and One Afternoons in Chicago*. Chicago: University of Chicago Press, 2009.

Hemingway, Ernest. *Death in the Afternoon* [1932]. New York: Scribner, 2003.

———. *A Farewell to Arms* [1929]. New York: Scribner Classic–Macmillan, 1986.

———. *In Our Time*. New York: Boni and Liveright, 1925.

———. *The Letters of Ernest Hemingway*. Vols. 1–3. Edited by Sandra Spanier and Robert W. Trogdon. Cambridge: Cambridge University Press, 2011–15.

———. *A Moveable Feast* [1964]. New York: Scribner Classic/Collier, 1987.

———. *Selected Letters, 1917–1961*. Edited by Carlos Baker. New York: Charles Scribner's Sons, 1981.

———. *The Short Stories*. New York: Simon and Schuster, 1995.

———. *The Sun Also Rises* [1926]. New York: Scribner, 1954.

Hilliard, Celia. "'Lady Midwest': Fanny Butcher–Books." In *The Rise of the Modernist Bookshop: Books and the Commerce of Culture in the Twentieth Century*, edited by Huw Oxborne, 89–112. Farnham, Surrey: Ashgate, 2015.

———. *"The Prime Mover": Charles L. Hutchinson and the Making of the Art Institute of Chicago*. Chicago: Art Institute of Chicago, 2010.

Hine, Darlene Clark, and John McCluskey Jr., eds. *The Black Chicago Renaissance*. Urbana: University of Illinois Press, 2012.

Horowitz, Helen Lefkowitz. *Culture and the City: Cultural Philanthropy in Chicago from the 1880s to 1917*. Chicago: University of Chicago Press, 1976.

Hricko, Mary. *The Genesis of the Chicago Renaissance: Theodore Dreiser, Langston Hughes, Richard Wright, and James T. Farrell*. London: Routledge, 2009.

Hsu, Kai-yu. *The Life and Poetry of Wen Yiduo*. Cambridge, MA: Harvard-Yenching Institute, 1958.

———. "The Life and Poetry of Wen Yiduo." *Harvard Journal of Asian Studies* 21 (1958): 134–79.

Hughes, Langston. *The Big Sea* [1940]. New York: Hill and Wang, 1993.

Hurston, Zora Neale. *Mules and Men* [1935]. New York: Harper Perennial, 1990.

Hutchinson, Elizabeth. *The Indian Craze: Primitivism, Modernism, and Transculturation in American Art, 1890–1915*. Durham, NC: Duke University Press, 2009.

Jackson, Lawrence. *The Indignant Generation: A Narrative History of African American Writers and Critics, 1934–1960*. Princeton, NJ: Princeton University Press, 2013.

Jacobson, J. Z., ed. *Art of Today: Chicago, 1933*. Chicago: L. M. Stein, 1932.

James, Henry. *The American Scene*. New York: Penguin, 1994.

Kennedy, Elizabeth, ed. *Chicago Modern, 1893–1945: Pursuit of the New*. Chicago: Terra Foundation for the Arts, 2004.

Kenner, Hugh. *The Pound Era*. Berkeley: University of California Press, 1973.

Kent, George. *A Life of Gwendolyn Brooks*. Lexington: University Press of Kentucky, 1990.

Knupfer, Anne Meis. *The Chicago Black Renaissance and Women's Activism*. Urbana: University of Illinois Press, 2006.

Kohn, Edward P. *Hot Time in the Old Town: The Great Heat Wave of 1896 and the Making of Theodore Roosevelt*. New York: Basic Books, 2010.

Kramer, Dale. *Chicago Renaissance: The Literary Life in the Midwest, 1900–1930*. New York: Appleton-Century, 1966.

Krugler, David. *1919, the Year of Racial Violence: How African Americans Fought Back*. Cambridge: Cambridge University Press, 2014.

Kruty, Paul. "Arthur Jerome Eddy and His Collection: Prelude and Postscript to the Armory Show." *Arts Magazine* 61 (February 1987): 40–47.

Kushner, Marilyn Satie, and Kimberly Orcutt, eds. *The Armory Show at 100: Modernism and Revolution*. New York: New-York Historical Society, 2013.

Larson, Eric. *The Devil in the White City: A Saga of Magic and Murder at the Fair that Changed America*. New York: Vintage, 2004.

Lears, T. J. Jackson. "Looking for the White Spot." In *The Power of Culture: Critical Essays in American History*, edited by Richard Wightman Fox and T. J. Jackson Lears, 13–37. Chicago: University of Chicago Press, 1993.

Leick, Karen. *Gertrude Stein and the Making of an American Celebrity*. London: Routledge, 2009.

Levenson, Michael. *A Genealogy of Modernism*. Cambridge: Cambridge University Press, 1984.

Lewis, David Levering. *When Harlem Was in Vogue*. New York: Alfred A. Knopf, 1981.

Lewis, Pericles. *The Cambridge Introduction to Modernism*. Cambridge: Cambridge University Press, 2007.

Lingeman, Richard. *Theodore Dreiser: An American Journey, 1908–1945*. New York: G. P. Putnam's Sons, 1990.

———. *Theodore Dreiser: At the Gates of the City, 1871–1907*. New York: G. P. Putnam's Sons, 1986.

Lowe, David Garrard. *Lost Chicago*. Chicago: University of Chicago Press, 2000.

MacDonald, Dwight. "Masscult and Midcult." *Partisan Review* 27, no. 4 (1960): 589–631.

Malcolm, Janet. *Two Lives: Gertrude and Alice*. New Haven: Yale University Press, 2007.

Marek, Jane. *Women Editing Modernism: "Little" Magazines and Literary History*. Lexington: University Press of Kentucky, 1995.

Martinez, Andrew. "A Mixed Reception for Modernism: The 1913 Armory Show at the Art Institute of Chicago." *Art Institute of Chicago Museum Studies* 19, no. 1 (1993): 30–57, 102–5.

Massa, Ann. "'The Columbian Ode' and *Poetry, A Magazine of Verse*: Harriet Monroe's Entrepreneurial Triumphs." *Journal of American Studies* 20, no. 1 (1986): 51–70.

———. "Form Follows Function: The Construction of Harriet Monroe and *Poetry, A Magazine of Verse*." In *A Living of Words: American Women in Print Culture*, edited by Susan Albertine, 125–29. Knoxville: University of Tennessee Press, 1995.

Materer, Timothy, ed. *The Selected Letters of Ezra Pound to John Quinn: 1915–1924*. Durham, NC: Duke University Press, 1991.

McCarthy, Kathleen D. *Noblesse Oblige: Charity and Cultural Philanthropy in Chicago, 1849–1929*. Chicago: University of Chicago Press, 1982.

McKinley, Ann. "Music for the Dedication Ceremonies of the World's Columbian Exposition in Chicago, 1892." *American Music* (Spring 1985): 42–51.

Meech, Julia. *Frank Lloyd Wright and the Art of Japan*. New York: Japan Society and Harry N. Abrams, 2001.

Meeker, Arthur. *Chicago with Love: A Polite and Personal History*. New York: Alfred A. Knopf, 1955.

Mellow, James R. *Charmed Circle: Gertrude Stein and Company*. New York: Praeger, 1974.

Mencken, H. L. "The Literary Capital of the United States." In *On American Books: A Symposium by Five American Critics as Printed in the London Nation*, ed. Francis Hackett. New York: B. W. Huebsch, 1920.

Meyerowitz, Joanne. *Women Adrift: Independent Wage Earners in Chicago, 1880–1930*. Chicago: University of Chicago Press, 1988.

Michaels, Walter Benn. *The Gold Standard and the Logic of Capitalism.* Berkeley: University of California Press, 1987.

Miller, Donald L. *City of the Century: The Epic of Chicago and the Making of America.* New York: Simon and Schuster, 1996.

Miller, Wayne F. *Chicago's South Side, 1946–1948.* Berkeley: University of California Press, 2000.

Mitchell, W. J. T. *Picture Theory: Essays on Verbal and Visual Representation.* Chicago: University of Chicago Press, 1995.

Monroe, Harriet. *The Columbian Ode.* Souvenir ed. Chicago: W. Irving Way, 1893.

——. *John Wellborn Root: A Study of his Life and Work.* Boston: Houghton, Mifflin, 1896.

——. "The Open Door." *Poetry* 1, no. 2 (1912): 62–64.

——. *A Poet's Life: Seventy Years in a Changing World.* New York: Macmillan, 1938.

Morgan, Stacy. *Re-Thinking Social Realism: African American Art and Literature, 1930–53.* Athens: University of Georgia Press, 2004.

Morrissette, Bruce. *Novel and Film: Essays in Two Genres.* Chicago: University of Chicago Press, 1985.

Morrison, Mark. *The Public Face of Modernism: Little Magazines, Audiences, and Reception 1905–1920.* Madison: University of Wisconsin Press, 2001.

Mullen, Bill. *Popular Fronts: Chicago and African American Cultural Politics, 1935–46.* Urbana: University of Illinois Press, 1999.

Nagel, James. "Brett and the Other Women in *The Sun Also Rises.*" In *The Cambridge Companion to Hemingway,* edited by Scott Donaldson, 87–108. Cambridge: Cambridge University Press, 1996.

Naumann, Francis M. "'An Explosion in a Shingle Factory': Marcel Duchamp's *Nude Descending a Staircase (No. 2).*" In *The Armory Show at 100: Modernism and Revolution,* edited by Marilyn Satie Kushner and Kimberly Orcutt, 203–9. New York: New-York Historical Society, 2013.

Nef, Elinor Castle. *In Search of the American Tradition.* New York: University Publishers, 1959.

——. *Letters and Notes.* Vol. 1. Los Angeles: Ward Ritchie, 1953.

Newcomb, John Timberman. "Poetry's Opening Door: Harriet Monroe and American Modernism." *American Periodicals* 15, no. 1 (2005): 6–23.

Nicholls, Peter. *Modernisms: A Literary Guide.* Berkeley: University of California Press, 1995.

Niven, Penelope. *Carl Sandburg: A Biography.* New York: Charles Scribner's Sons, 1991.

North, Michael. *Camera Works: Photography and the Twentieth-Century Word.* Oxford: Oxford University Press, 2005.

——. *The Dialect of Modernism: Race, Language, and Twentieth-Century Literature.* New York: Oxford University Press, 1994.

Oehler, Sarah Kelly. *They Seek a City: Chicago and the Art of Migration, 1910–1950.* Chicago: Art Institute of Chicago, 2013.

Olson, Liesl. "An Interview with Eldzier Cortor, with an Essay on the Artist." *Chicago Review* 59, no. 4 (2016): 119–42.

———. "100 Years of *Poetry:* 'In the Middle of Major Men.'" *Poetry Foundation* website (October 2012), http://www.poetryfoundation.org/article/244666.

Parisi, Joseph, and Stephen Young, eds. *Dear Editor: A History of* Poetry *in Letters: The First Fifty Years, 1912–1962.* New York: W. W. Norton, 2002.

Park, Robert E., Ernest W. Burgess, and Roderick D. McKenzie. *The City.* Chicago: University of Chicago Press, 1925.

Pearlstein, Elinor. "Asian Art at the Arts Club." In *The Arts Club at 100: Art and Culture in Chicago, 1916–2016,* 109–11. Chicago: University of Chicago Press and Arts Club of Chicago, 2016.

———. "Color, Life, and Moment: Early Chicago Collectors of Chinese Textiles." In John Vollmer et al., *Clothed to Rule the Universe: Ming and Qing Dynasty Textiles at the Art Institute of Chicago,* 80–93. Chicago: Art Institute of Chicago and University of Washington Press, 2000.

———. "Early Chicago Chronicles of Early Chinese Art." In *Collectors, Collections and Collecting the Arts of China: Histories and Challenges,* edited by Jason Steuber, with Guolong Lai, 7–42. Gainesville: University Press of Florida, 2014.

Perloff, Marjorie. *The Poetics of Indeterminacy: Rimbaud to Cage.* Princeton, NJ: Princeton University Press, 1981.

———. *Twenty-First-Century Modernism: The "New" Poetics.* Malden, MA: Blackwell, 2002.

Pizer, Donald. "Note on the Text" and "Introduction." In *New Essays on "Sister Carrie,"* edited by Donald Pizer, ix–x, 1–22. Cambridge: Cambridge University Press, 1991.

Platt, Susan Noyes. "*The Little Review:* Early Years and Avant-Garde Ideas." In *The Old Guard and the Avant-Garde,* edited by Sue Ann Prince, 139–54. Chicago: University of Chicago Press, 1990.

Pound, Ezra. *Exultations.* London: Elkin Mathews, 1909.

———. "A Few Don'ts by an Imagist." *Poetry* 1, no. 6 (1913): 200–206.

———. *Gaudier-Brzeska.* London: John Lane, 1916.

———. *Lustra.* London: Elkin Mathews, 1916.

———. *Poems and Translations.* Edited by Richard Sieburth. New York: Library of America, 2003.

———. *The Selected Letters of Ezra Pound.* Edited by D. D. Paige. New York: New Directions, 1971.

———. *Selected Poems* [1928]. Edited and introduced by T. S. Eliot. London: Faber and Gwyer, 1959.

Pound, Omar, and A. Walton Litz, eds. *Ezra Pound and Dorothy Shakespear: Their Letters, 1909–1914.* New York: New Directions, 1984.

Prince, Sue Ann, ed. *The Old Guard and the Avant-Garde: Modernism in Chicago, 1910–1940.* Chicago: University of Chicago Press, 1990.

Qian, Zhaoming, ed. *Ezra Pound's Chinese Friends: Stories in Letters.* Oxford: Oxford University Press, 2008.

Rabinowitz, Paula. *American Pulp: How Paperbacks Brought Modernism to Main Street.* Princeton, NJ: Princeton University Press, 2014.

Radway, Janice A. *A Feeling for Books: The Book-of-the-Month Club, Literary Taste, and Middle-Class Desire.* Chapel Hill: University of North Carolina Press, 1997.

Ramazani, Jahan. *A Transnational Poetics.* Chicago: University of Chicago Press, 2009.

Rampersad, Arnold. *The Life of Langston Hughes.* Vol. 2, 1941–1967: *I Dream a World.* New York: Oxford University Press.

Reed, Christopher. "Only Collect: Bloomsbury Art in North America." In *A Room of Their Own: The Bloomsbury Artists in American Collections,* edited by Nancy E. Green and Christopher Reed, 58–87. Ithaca, NY: Herbert F. Johnson Museum of Art, 2008.

Reed, Christopher R. *Black Chicago's First Century.* Vol. 1, 1833–1900. Columbia: University of Missouri Press, 2005.

———. *Knock at the Door of Opportunity: Black Migration to Chicago, 1900–1919.* Carbondale: Southern Illinois University Press, 2015.

Regnery, Henry. *The Cliff Dwellers: The History of a Chicago Cultural Institution.* Evanston, IL: Chicago Historical Bookworks, 1990.

Riggio, Thomas P., and James L. W. West III, eds. *Dreiser's Russian Diary.* Philadelphia: University of Pennsylvania Press, 1996.

Rosemont, Franklin, ed. *The Rise and Fall of the Dil Pickle: Jazz-Age Chicago's Wildest and Most Outrageously Creative Hobohemian Nightspot.* Chicago: Charles H. Kerr, 2004.

Rossen, Susan F., and Charlotte Moser. "Primer for Seeing: The Gallery of Art Interpretation and Katharine Kuh's Crusade for Modernism in Chicago." In *Art Institute of Chicago Museum Studies* 16, no. 1 (1990): 6–25, 88–90.

Rothschild, Deborah, ed. *Making It New: The Art and Style of Sara and Gerald Murphy.* Berkeley: University of California Press, 2007.

Rowley, Hazel. *Richard Wright: The Life and Times.* New York: Henry Holt, 2001.

Rubin, Joan Shelly. *The Making of Middlebrow Culture.* Chapel Hill: University of North Carolina Press, 1992.

Saint-Amour, Paul. *Tense Future: Modernism, Total War, Encyclopedic Form.* New York: Oxford University Press, 2015.

Sandburg, Carl. *The Chicago Race Riots.* New York: Harcourt, Brace and Howe, 1919.

———. *The Complete Poems of Carl Sandburg.* New York: Harcourt, 1970.

Sawyer, Julian. *Gertrude Stein: A Bibliography.* New York: Arrow Editions, 1940.

Schlabach, Elizabeth Schroeder. *Along the Streets of Bronzeville: Black Chicago's Literary Landscape.* Urbana: University of Illinois Press, 2013.

Schulman, Daniel, ed. *A Force for Change: African American Art and the Julius Rosenwald Fund.* Chicago: Spertus Museum and Northwestern University Press, 2009.

———. "'White City' and 'Black Metropolis': African American Painters in Chicago, 1893–1945." In *Chicago Modern, 1893–1945: Pursuit of the New,* edited by Elizabeth Kennedy, 39–51. Chicago: University of Chicago Press, 2004.

Schulze, Robin. "Harriet Monroe's Pioneer Modernism: Nature, National Identity, and *Poetry, A Magazine of Verse.*" *Legacy* 21, no. 1 (2004): 50–67.

Scott, Bonnie Kime. *Refiguring Modernism.* Vol. 1, *Women of 1928.* Bloomington: Indiana University Press, 1996.

Seymour, Ralph Fletcher. *Some Went This Way.* Chicago: Ralph Seymour Fletcher, 1945.

Shaughnessy, Edward. *China: Empire and Civilization.* Oxford: Oxford University Press, 2000.

Shaw, Sophia. "A Collection to Remember." In *The Arts Club of Chicago: The Collection, 1916–1996,* ed. Sophia Shaw, 21–30. Chicago: Arts Club, 1997.

Shortridge, James R. *The Middle West: Its Meaning in American Culture.* Lawrence: University Press of Kansas, 1989.

Sinclair, Upton. *The Autobiography of Upton Sinclair.* New York: Harcourt, Brace and World, 1962.

Smith, Carl. *Chicago and the American Literary Imagination, 1880–1920.* Chicago: University of Chicago Press, 1984.

——. *The Plan of Chicago: Daniel Burnham and the Remaking of the American City.* Chicago: University of Chicago Press, 2006.

——. *Urban Disorder and the Shape of Belief: The Great Chicago Fire, the Haymarket Bomb, and the Model Town of Pullman.* Chicago: University of Chicago Press, 1995.

Smith, Paul. "Hemingway's Apprentice Fiction: 1919–1921." In *New Critical Approaches to the Short Stories of Ernest Hemingway,* edited by Jackson J. Benson, 137–48. Durham, NC: Duke University Press, 1990.

——. "1924: Hemingway's Luggage and the Miraculous Year." In *The Cambridge Companion to Hemingway,* edited by Scott Donaldson, 36–54. Cambridge: Cambridge University Press, 1996.

Smith, Shawn Michelle. *Photography on the Color Line: W. E. B. Du Bois, Race, and Visual Culture.* Durham, NC: Duke University Press, 2004.

Sontag, Susan. *On Photography.* New York: Picador, 1990.

Spahr, Juliana. *Everybody's Autonomy: Connective Reading and Collective Identity.* Tuscaloosa: University of Alabama Press, 2001.

Spears, Timothy B. *Chicago Dreaming: Midwesterners and the City, 1871–1919.* Chicago: University of Chicago Press, 2005.

Spence, Jonathan. *The Search for Modern China.* New York: W. W. Norton, 1990.

Stange, Maren. *Bronzeville: Black Chicago in Pictures, 1941–1943.* New York: New Press, 2004.

Stein, Gertrude. *The Autobiography of Alice B. Toklas.* London: Penguin, 1966.

——. *Chicago Inscriptions.* Chicago: Lakeside Press, 1934.

——. *Everybody's Autobiography.* Cambridge: Exact Change, 1993.

——. *How Writing Is Written.* Edited by Robert Bartlett Haas. Los Angeles: Black Sparrow Press, 1974.

——. *Lectures in America.* Boston: Beacon, 1935.

——. *The Making of Americans: Being a History of a Family's Progress.* London: Dalkey Archive Press, 1995.

——. *Narration: Four Lectures.* Chicago: University of Chicago Press, 2010.

——. *Portrait of Mabel Dodge at the Villa Curonia.* Florence: Tipografia Galileiana, 1912.

——. *Stanzas in Meditation: The Corrected Edition.* Edited by Susannah Hollister and Emily Setina. New Haven: Yale University Press and the Beinecke Rare Book and Manuscript Library, 2012.

——. *Tender Buttons* [1914]. New York: Dover, 1997.

——. *Three Lives* [1909]. New York: Penguin, 1990.

——. "What Are Master-Pieces and Why Are There So Few of Them?" In *Gertrude Stein: Writings, 1932–1946*, edited by Catharine R. Stimpson and Harriet Chessman, 353–63. New York: Library of America, 1998.

——. *Writings, 1932–1946.* Edited by Catharine R. Stimpson and Harriet Chessman. New York: Library of America, 1998.

Stevens, Holly, ed. *The Letters of Wallace Stevens.* Berkeley: University of California Press, 1996.

Stewart, Jacqueline. *Migrating to the Movies: Cinema and Black Urban Modernity.* Berkeley: University of California Press, 2005.

Stieglitz, Alfred, ed. *Camera Work.* New York: A. Stieglitz, 1912.

Sutton, William A. "Sherwood Anderson: The Advertising Years, 1900–1906." *Northwest Ohio Quarterly* 22, no. 2 (1950): 120–57.

Thompson, Era Bell. *American Daughter.* Chicago: University of Chicago Press, 1946.

Tietjens, Eunice. *The World at My Shoulder.* New York: Macmillan, 1938.

Toklas, Alice B. *The Alice B. Toklas Cookbook* [1954]. London: Serif, 2004.

——. *What Is Remembered.* New York: Holt, Rinehart and Winston, 1963.

Toomer, Jean. *Cane.* New York: Boni and Liveright, 1923.

——. *The Letters of Jean Toomer, 1919–1924.* Edited by Mark Whalen. Knoxville: University of Tennessee Press, 2006.

Townsend, Kim. *Sherwood Anderson: A Biography.* Boston: Houghton Mifflin, 1987.

Trachtenberg, Alan. *The Incorporation of America: Culture and Society in the Gilded Age.* New York: Hill and Wang, 1982.

Tracy, Steven, ed. *Writers of the Black Chicago Renaissance.* Urbana: University of Illinois Press, 2011.

Troyen, Carol. "'Unwept, Unhonored, and Unsung': The Armory Show in Boston." In *The Armory Show at 100: Modernism and Revolution*, edited by Marilyn Satie Kushner and Kimberly Orcutt, 379–91. New York: New-York Historical Society, 2013.

Turner, Frederick Jackson. "The Significance of the Frontier in American History." In *The Frontier in American History*, 1–38. New York: Henry Holt, 1921.

Tuttle, William M., Jr. *Race Riot: Chicago in the Red Summer of 1919.* New York: Atheneum, 1970.

Walker, Margaret. *Richard Wright: Daemonic Genius.* New York: Amistad, 1988.

——. *This Is My Century: New and Collected Poems.* Athens: University of Georgia Press, 1989.

Weber, Ronald. *Hemingway's Art of Non-Fiction.* London: Macmillan, 1990.

——. *News of Paris: American Journalists in the City of Light between the Wars.* Chicago: Ivan R. Dee, 2006.

Whalen, Mark. *Race, Manhood, and Modernism in America: The Short Story Cycles of*

*Sherwood Anderson and Jean Toomer*. Knoxville: University of Tennessee Press, 2007.

White, Edward. *The Tastemaker: Carl Van Vechten and the Birth of Modern America*. New York: Farrar, Straus and Giroux, 2014.

White, Ray Lewis, ed. *Sherwood Anderson/Gertrude Stein: Correspondence and Personal Essays*. Chapel Hill: University of North Carolina Press, 1972.

White, William, ed. *Dateline: Toronto*. New York: Charles Scribner's Sons, 1985.

Whiting, Sarah. "Bas-Relief Urbanism: Chicago's Figured Field." In *Mies in America*, edited by Phyllis Lambert, 642–91. Montreal: Canadian Center for Architecture, 2001.

Wilkerson, Isabel. *The Warmth of Other Suns: The Epic Story of America's Great Migration*. New York: Vintage, 2011.

Will, Barbara. *Unlikely Collaboration: Gertrude Stein, Bernard Faÿ, and the Vichy Dilemma*. New York: Columbia University Press, 2011.

Williams, Ellen. *Harriet Monroe and the Poetry Renaissance*. Urbana: University of Illinois Press, 1977.

Williams, William Carlos. "Carl Sandburg's Complete Poems." *Poetry* (September 1951): 345–51.

Wirth, Louis. *The Ghetto*. Chicago: Phoenix, 1928.

Woolf, Virginia. *The Letters of Virginia Woolf*. Vol. 6, 1936–1941. Edited by Nigel Nicolson and Joanne Trautman. New York: Harcourt Brace Jovanovich, 1980.

———. "Middlebrow" [1942]. In *The Death of the Moth and Other Essays* [1942], 176–86. New York: Harcourt Brace Jovanovich, 1970.

———. "Mr. Bennett and Mrs. Brown." In *The Captain's Death Bed and Other Essays* [1950]. New York: Harcourt Brace Jovanovich, 1978.

———. *A Room of One's Own* [1929]. New York: Harcourt Brace Jovanovich, 1981.

———. "A Sketch of the Past." In *Moments of Being*, 2nd ed., ed. Jeanne Schulkind, 61–160. New York: Harcourt Brace Jovanovich, 1985.

Woolley, Lisa. *American Voices of the Chicago Renaissance*. DeKalb: Northern Illinois University Press, 2000.

Wright, Frank Lloyd. *An Autobiography*. New York: Longmans, Green, 1932.

Wright, Richard. *Black Boy (American Hunger)* [1945]. New York: Library of America, 1991.

———. "Gertrude Stein's Story Is Drenched in Hitler's Horrors." *PM*, March 11, 1945.

———. "Blueprint for Negro Writing" [1937]. In *African American Literary Theory: A Reader*, ed. Winston Napier, 45–53. New York: New York University Press, 2000.

———. "How 'Bigger' Was Born" [1940]. In *Richard Wright: Early Works*, edited by Arnold Rampersad, 851–81. New York: Library of America, 1991.

———. *Richard Wright: Early Works*. Edited by Arnold Rampersad. New York: Library of America, 1991.

———. *12 Million Black Voices* [1941]. New York: Basic Books, 2008.

Zega, Michael. "Advertising the Southwest." *Journal of the Southwest* 43, no. 3 (2001): 281–315.

Zilczer, Judith. "John Quinn and Modern Art Collectors in America, 1913–1924." *American Art Journal* 14, no. 1 (1982): 56–71.

Znaniecki, Florian, and William I. Thomas. *The Polish Peasant in Europe and America*. Chicago: University of Chicago Press, 1918.

Zorbaugh, Harvey Warren. *The Gold Coast and the Slum: A Sociological Study of Chicago's Near North Side*. Chicago: University of Chicago Press, 1929.

# ACKNOWLEDGMENTS

In a city of boosters and intellectual cohorts, I have written this book and depended on the support of both. I give my deepest thanks to the scholars, librarians, and staff at the Newberry Library, my academic home for a number of years, and the place where this book took root. In 2013, I was very fortunate to direct a summer institute at the Newberry funded by the National Endowment for the Humanities, and every single person during that heady four weeks sharpened my thinking about Chicago modernism. I especially thank the visiting faculty: Neil Harris, Carl Smith, Bill Savage, Tim Spears, and Jackie Goldsby. (And as I write these sentences, I look forward to directing another NEH summer institute in 2017.) I also thank the NEH for a fellowship that got this book started and the American Council of Learned Societies for a fellowship that helped me to finish it.

At the Newberry, many colleagues encouraged me as I worked through archival collections and across disciplines. Jim Grossman saw larger possibility in my earliest ideas, and Danny Greene read every chapter and then asked me terrific, clarifying questions. Special thanks go to Paul Gehl, who has taught me much about book and print history, and to Martha Briggs and Alison Hinderliter, who steered me through the Newberry's illuminating modern manuscript material. I also thank Jim Akerman, Chris Cantwell, Jo Ellen Dickie, Diane Dillon, Leon Fink, Lisa Freeman, Jill Gage, Catherine Gass, Elliott Gorn, Brad Hunt, Toby Higbie, Patricia Marroquin Norby, John Powell, Alice Schreyer, and David Spadafora. I am grateful to Ken Warren and Walter Benn Michaels for making the Newberry a vital place to discuss the study of American literature.

Several good friends in Chicago helped me to shape and refine the project. I thank Deborah Cohen for reading the entire manuscript and offering her luminous comments. I dearly appreciate Anna Kornbluh, who always makes intellectual engagement an invigorating party. And I am filled with thanks for Rachel Galvin, who read drafts when I most needed her intelligence and conversation, especially about twentieth-century poetry.

Chicago newspaperman Harry Hansen claimed that many Chicago artists and writers came in on a freight train and left on a Pullman. I have thought about this coming and going with several friends and colleagues who have passed through Chicago. Of these, my thanks go to Brian Soucek and Matty Lane, whose return visits, in some roundabout way, always inspire me with ideas; to Scott Stevens, who taught me much about Native American cultures; and to Robert Polito, who helped me think about Sandburg, Stein, and the singularity of Chicago poetry.

My deep appreciation goes to many people who read individual chapters, consid-

ered my claims, answered my queries, and clarified my thinking: Ken Alder, Davarian Baldwin, Robert Breugmann, Richard Courage, Kevin Dettmar, Brian Dolinar, Paul Durica, Tom Dyja, Gregory Foster-Rise, Sandra Gustafson, Ursula Heise, Oren Izenberg, Ben Johnson, Matt Laufer, Jonathan Mulrooney, Kinohi Nishikawa, David Pavelich, Andrew Peart, Lawrence Rainey, Paige Reynolds, Tyler Schmidt, Jennifer Smith, and Rishona Zimring. I thank Celia Hilliard for her insights into Fanny Butcher and her Chicago milieu; and I thank Elinor Pearlstein for revealing to me the significance of Lucy Monroe and the China-Chicago connection. I have learned a great deal about visual art in Chicago from Sarah Kelly Oehler, Wendy Greenhouse, Janine Mileaf, and Karen Reimer. Heartfelt thanks go to Michael Cortor and the Michael Rosenfeld Gallery for facilitating my revelatory interview with Eldzier Cortor. I also thank John Berry at the Ernest Hemingway Foundation of Oak Park for twice inviting me to present my work and to Nathaniel Cadle and his colleagues at the Wolfsonian Museum–Florida International University. I am grateful to Michael Flug and Beverly Cook at the Vivian G. Harsh Research Collection; to Nancy Kuhl and Melissa Barton at the Beinecke Rare Book and Manuscript Library; to Anna Chen in Special Collections at the University of Illinois–Urbana Champaign; and to Chalcey Wilding for helping me secure images and permissions. I thank Wendy Strothman and Steve Wasserman for seeing this book's potential and urging me to tell the stories that would bring the literary scene in Chicago to life. And I am very appreciative of Adina Berk, Eva Skewes, Ann-Marie Imbornoni, and Laura Jones Dooley, who shepherded the book through its final stages. Finally, it is my privilege to have the work of Chicago artist Lincoln Schatz grace the cover of this book.

A few people deserve special thanks for being both intellectual and personal ballasts: Sarah Cole has been an inspiring mentor and friend from the beginning; Chicu Reddy read the whole book in various states of readiness; and Suzanne Buffam offered her precise and elegant insights about the shape of the book's interludes. I will forever be thankful to Megan Quigley for being my co-conspirator in this profession. Big thank yous go to Eloise Lawrence, Kim Gilmore, and Linsay Firman for listening to me talk about Chicago for so many years. Brooke Laufer is also one of the world's greatest listeners. My friend Allison Wade and my brother Danny Olson have helped me understand the city by reveling in it with me, from bar stools at the Green Mill to contemporary work at the Ren. And I am deeply grateful to Rosa Gomez, who has given me time and peace of mind in which to think and write.

This book is dedicated to my sons, Teddy, Conor, and John James, who can't wait to see their names in print. My parents and extended family are also a tremendous source of love and support. And John McGuire will always be my biggest booster.

# INDEX

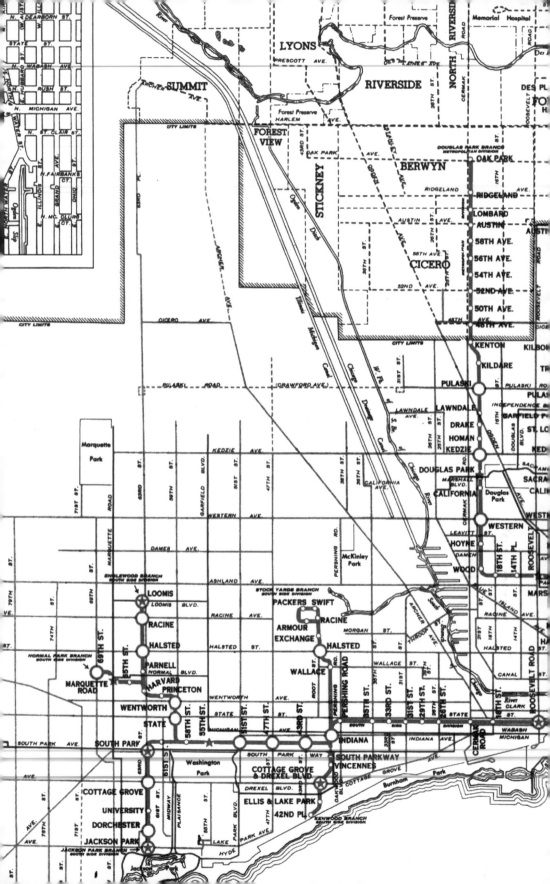